WORLD CINEMA:
A Film Quiz

Bhupinder Singh

PARTRIDGE

Copyright © 2019 by Bhupinder Singh.

ISBN: Softcover 978-1-5437-0542-3
 eBook 978-1-5437-0541-6

All rights reserved. No part of this book may be used or reproduced by any means, graphic, electronic, or mechanical, including photocopying, recording, taping or by any information storage retrieval system without the written permission of the author except in the case of brief quotations embodied in critical articles and reviews.

Because of the dynamic nature of the Internet, any web addresses or links contained in this book may have changed since publication and may no longer be valid. The views expressed in this work are solely those of the author and do not necessarily reflect the views of the publisher, and the publisher hereby disclaims any responsibility for them.

Print information available on the last page.

To order additional copies of this book, contact
Partridge India
000 800 10062 62
orders.india@partridgepublishing.com

www.partridgepublishing.com/india

Movies Quiz

- Historical Background ... 1
 - The Beginning .. 1
 - Early American Studios ... 2
 - Film Companies .. 3
- Films and Literature .. 5
 - Films based on US literature- I .. 5
 - Films based on US literature-II .. 6
 - Films based on US literature- III .. 7
 - Films based on US literature- IV ... 8
 - Films based on British literature I ... 9
 - Films based on British Literature II ... 10
 - Films based on British Literature- III 11
 - Films based on British Literature- IV 12
 - Films based on French Literature .. 13
 - Films based on German literature ... 14
 - Films based on Russian Literature ... 15
 - Films based on Indian Literature ... 16
 - Films based on literature of other countries 16
 - More Films based on literary Works 18
- Biopics .. 20
 - Real Life ... 20
 - Biopics ... 21
 - Films on Male Musicians .. 22
 - Films on Female Musicians .. 23
 - Films on Male Writers .. 23
 - Films on Female Writers .. 24
 - Films on Artists ... 24
 - Films on Sportspersons .. 25
- Films and Music ... 26
 - Film Musicals .. 26
 - Musical Score in Films-I ... 28
 - Musical Score in Films-II .. 29
 - Musical Score in Films III ... 30
 - Theme songs - Vocals .. 31
 - Theme songs – Instrumentals ... 32

- Opera in Films .. 32
- Classical Music in Films ... 33
- Songs-Male ... 34
- Songs-Female .. 34
- Songs-Duets and Groups .. 35
- Mixed Bag- Songs .. 36
- Mixed Bag - Music .. 37

Great Films .. 39
- The Wizard of Oz (1939) ... 39
- The Rules of the Game (1939) .. 40
- Gone with the Wind (1939) ... 40
- Citizen Kane (1941) .. 41
- Casablanca (1942) ... 42
- The Sound of Music (1965) ... 42
- The Godfather Trilogy (1972, 1974, 1990) 43
- Star Wars trilogy (1977, 1980, 1983) 44
- Rocky (1976, 1979, 1982, 1985) .. 45

Genres of Films ... 47
- The Westerns ... 47
- War! Bloody War! ... 48
- World War II Films .. 50
- Vietnam War .. 52
- Courtroom Drama .. 53
- Escape Film .. 54
- Gangster Films ... 55
- Historicals .. 56
- Music Makers ... 58
- Horror films .. 59
- Sports ... 60
- Racing .. 61
- Walt Disney .. 62
- Animated Characters ... 63
- Shakespeare .. 64
- Romance .. 65
- Suspense ... 66
- Comedy .. 67
- Marriage ... 68
- Money Money Money ... 69
- Rights and Wrongs ... 70

- Past is another country 71
- In Foreign Lands 72
- Politics 73
- Friendship 74
- Childhood and Youth 75
- Journalism 77
- Parenting 77
- Women's World 78
- Lives of the Common People 79
- On the Road 80
- Merchant and Ivory Films 81
- Animals 82
- Heroes 83
- Tarzan 84
- More Films 85
- Mixed Bag - Films 87

Opening and Closing Words 90
- Opening Words (Voice) in Films 90
- Opening Words (Text) in Films 91
- Closing Words (Voice) in Films 92

Science Fiction 93
- Sci-Fi Films based on books 93
- War of the Worlds 94
- Robots 94
- Aliens 95
- Future World 96
- Strange Creatures 97
- Mixed Bag- Science Fiction 98

James Bond 99
- James Bond Films 99
- James Bond Going Places 100
- James Bond Girls 101
- James Bond Villains 102
- James Bond Title Songs 103
- Songs from James Bond 103
- Mixed bag - James Bond 104

Comic Book Heroes 105
- Superman 105
- Batman 106

- Spider-Man ...107
- DC Comics ..108
- Marvel Comics ..109
- Alter Egos (Marvel Comics) ..111
- Alter Egos (DC Comics) ..111
- Mixed Bag ...112

Actors ...113
- Charlie Chaplin ..113
- Clint Eastwood ..114
- Robert De Niro ..115
- US Actors I ..116
- US Actors II ...119
- US Actors III ..122
- US Action Heroes ...124
- Afro-American Actors ...125
- British Actors I ...128
- British Actors II ..129
- Shakespearean Actors ...131
- British Working Class Actors ...132
- Canadian Actors ..134
- Australian Actors ..135
- French Actors ..137
- Comedy Stars ..138
- They became Monsters ..140
- Foreign Actors ...141
- German Actors ..144
- Italian Actors ..145
- Indian Actors ...146
- Guess the Actors ..148
- Musican-Actors ...148
- Actor + ...150
- Mixed Bag - Actors ...151

Actresses ..153
- Katharine Hepburn ..153
- Elizabeth Taylor ..154
- Meryl Streep ..155
- US Actresses I ..156
- US Actresses II ...158
- British Actresses ...160

- Afro-American Actresses ... 162
- French Actresses .. 163
- Italian Actresses ... 165
- German Actresses ... 166
- Canadian Actresses ... 167
- Foreign-born Actresses .. 168
- Actresses with India Connection ... 170
- Musicans-Actresses ... 171
- Guess the Actress ... 172
- Mixed Bag - Actresses ... 173

Characters ... 175
- Characters played by Actors - I ... 175
- Characters played by Actors - II .. 176
- Characters played by Indian Actors .. 176
- Actors playing Kings ... 177
- Actors playing Presidents and Prime Ministers 177
- Character Played by Multiple Actors ... 178
- Characters played by Actress .. 179
- Characters played by Indian Actress .. 179
- Actresses playing women in power .. 180

Directors ... 181
- US Directors .. 181
- Foreign-born directors in Hollywood .. 182
- American New Wave Directors .. 184
- More US Directors ... 185
- French Directors .. 187
- Italian Directors ... 189
- John Ford .. 191
- German Directors ... 192
- Hitchcock .. 193
- British Directors .. 195
- David Lean .. 196
- Stanley Kubrick .. 197
- European Directors .. 198
- Russian Directors ... 199
- Akira Kurosawa ... 201
- Luis Bunuel ... 201
- Satyajit Ray ... 203
- Woody Allen ... 204

- Martin Scorsese 205
- Steven Spielberg 206
- Oliver Stone 207
- Women Directors 208
- Australia and New Zealand Directors 210
- Canada 211
- Latin American 212
- Japanese Directors 214
- Actor-Directors 215
- Musican-Directors 216
- Guess the Director 217
- Mixed Bag – Directors 218

Rewards and Recognition 220
- Academy Awards for Best Picture 220
- Big Five Academy Awards 221
- Academy Awards for Best Actor 222
- Academy Awards for Best Actress 223
- Academy Awards for Best Supporting Actor 224
- Academy Awards for Supporting Actress 224
- Academy Awards for Best Director 225
- The Academy Award for Best Foreign Language Film 226
- Academy Award for Best Screenplay 227
- Academy Award for Best Song 227
- Other Academy Awards 228
- Academy Honorary Award Awards 229
- Mixed Bag – Oscars Awards 230

Other Awards 233
- Cannes Film Festival 233
- Venice Film Festival 234
- Berlin Film Festival 235
- Karlovy Vary Film Festival 236
- Mixed Bag – Awards 236

No Mean Roles 238
- Child Stars 238
- Producers 239
- Screenplay Writers 241
- Famous writers 242
- Screenplay Writers 243
- US Cinematographers 244

- British Cinematographers ..245
- Other Cinematographers ..246
- Music Composers ...247
- The Voice behind the Face ..250
- Costume Designers ..251
- Film Critics ..252
- Mixed Bag: No Mean Roles ...253

Trivia ..255
- Film Titles ...255
- Flop Films ...256
- Deaths (Male) ...257
- Deaths (Female) ...258
- Odd Jobs ...258
- Quotations ...259
- What's in a name? (Male) I ..260
- What's in a name? (Male) II ...261
- What's in a name? (Female) ..261
- Star Fathers ..262
- Star mothers ..263
- Star Siblings ...263
- Star Wives ..264
- Star Husbands ...264
- Nicknames (Male) ..265
- Nicknames (Female) ..266
- In their own Words (Male) ..266
- In their own Words (Female) ..267
- Taglines I ..268
- Taglines II ...268
- Famous Cars ..269
- Famous Ships and Boats ...270
- Dog Breeds I ..271
- Dog Breeds II ...271
- Famous Animals ..272
- Mixed Bag- Trivia I ...272
- Mixed Bag- Trivia II ..274
- Mixed Bag- Trivia III ...276

Academy Awards ..278
- Academy Awards ...278

Photo Gallery ..284

Historical Background

The Beginning

The year 1891 heralded the coming of a device that was to change the experience of entertainment forever. That year, Thomas Edison invented Kinetoscope, in which moving pictures could be viewed through a peephole. In 1895, Auguste and Louis Lumière of Lyon invented cinématographe — a three-in-one device that could record, develop, and project motion pictures.

The Lumière brothers shot a footage of workers leaving their factory at the end of the day. **Workers Leaving the Lumière Factory** was screened in Paris in 1895. It was the very first motion picture. Subsequently, on 28 December 1895, the Lumière brothers screened ten short films commercially at the Grand Cafe in Paris. That marked the beginning of commercial cinema.

Can you identify the following early films?

1. Made in 1902, this French film was inspired by Jules Verne's novels. The film shows the trip of Professor Barbenfouillis (George Melies) to moon in a large shell fired by a cannon.
2. Made in 1904, Professor Mabouloff (George Melies), president of Institute of Incoherent Geography, reaches the sun in his invention Automabouloff.
3. Cecil B. DeMille directed this 1914 film which is the first feature length film to be made in Hollywood.
4. D. W. Griffith directed and co-produced this silent 3-hour long movie in 1915. The film was criticized for perpetuating racial stereotypes and glorifying the Ku Klux Klan.

5. This 1923 film with horror elements starred Lon Chaney as Quasimodo. It was directed by Wallace Worsley. The film was Universal Studio's 'Super Jewel' of 1923 and was their most successful silent film.
6. This 1925 silent Soviet film, directed by Sergie Eisenstein, is about a mutiny by sailors on a ship. A famous sequence is set on the Odessa steps, which shows soldiers firing into a crowd of unarmed civilians. Brief sequences show people fleeing or falling, a baby's pram rolling down the steps, a woman shot in the face, broken spectacles and the high boots of the soldiers marching in step.
7. This 1927 film, starring Al Jolson, was the first feature length film with lip-synchronous speech and singing. It heralds the arrival of sound films and the decline of the silent ones.
8. This 1930 film directed by Lewis Milestone is about the experience of a few German soldiers in the First World War.
9. This 1930 German tragicomic film was directed by Josef von Sternberg and starred Emil Jannings and debutant Marlene Dietrich. It was Germany's first feature length talkie.

Answers: 1. *Voyage to the Moon*, 2. *Voyage beyond the Possible*, 3. *The Sqaw Man* 4. *Birth of a Nation*, 5. *The Hunchback of Notre Dame*. 6. *Battleship Potemkin*. 7. *The Jazz Singer*. 8. *All Quiet on the Western Front*. 9. *The Blue Angel*.

Early American Studios

Thomas Edison in 1893, built the first film studio in the US. His employees nicknamed it Black Maria because it resembled a police lockup van. Most of the early studios were built and owned by hard-nosed businessmen, mostly from outside the US.

Can you identify the following early studios?

1. This is the oldest surviving film studio in the US. It was formed in 1912 and Carl Laemmie became its first president.

2. Adolph Zukor formed Famous Players Film Company in 1912. In 1927 the company merged with few other companies resulting in the formation of this major film company.
3. Harry Cohn formed CBC Film Sales Corporation in 1919, specializing in low budget films. In 1924 this company was given a new name.
4. In 1919, Richard A. Rowland, the head of Metro Studios, remarked that the lunatics have taken over the asylum, because Charlie Chaplin, D.W. Griffith, Douglas Fairbanks, and Mary Pickford formed this company.
5. This company formed in 1919, made the first important feature length talkie *The Jazz Singer* (1927). It was formed by four brothers who came from Poland via Canada.
6. This company was founded in 1924 when a theatre magnate Marcus Loew merged his Metro Pictures with Goldwyn Pictures and Louis B. Mayer Pictures. It advertised itself as having more stars than there are in heaven.
7. This studio was created in 1928 by David Sarnoff, but its controlling stakes were bought by the eccentric millionaire Howard Hughes in 1948.
8. Which studio, formed in 1935, was the first to introduce CinemaScope in *The Robe* (1953).

Answers: 1. Universal, 2. Paramount. 3. Columbia. 4. United Artists, 5. Warner Bros, 6. MGM. 7. RKO, 8. 20th Century Fox.

Film Companies

Started in 1895, the French company Gaumont was the oldest film production company. Its logo was ox-eye daisy. Can you identify the following early film companies?

1. Started in 1896, this French company was the second oldest film production company. Its logo was a rooster.
2. In 1904 Gustavo Lombardo (1885–1951) founded a company in Rome which became the third oldest film production company. Its logo was a shield.

3. In 1906 filmmaker Ole Olsen established a film company in Copenhagen, which became the fourth oldest film studio in the world. Its logo was a polar bear. It is the oldest continuously active film studio in the world.
4. Formed in 1912, this is the world's fifth oldest surviving film studio and US's oldest. Its president Carl Laemmie was the first to give actors on-screen credit. Its logo was a globe.
5. The original logo of this company had 22 stars, each standing for actors and actresses who signed for the company.
6. This German company was formed in 1917 in Babelsberg and came under the control of the Nazi party in 1933.
7. The iconic mascot of this studio was Leo the Lion.

Answers: 1. Pathe, 2. Titanus, 3. Nordisk Films, 4. Universal, 5. Paramount, 6. UFA, 7. MGM.

Films and Literature

Films based on US literature- I

Can you name the US authors of the literary works on which the following films were based:

1. Clarence Hays's **Anna Christie** (1930) starring Greta Garbo.
2. John Ford's **The Grapes of Wrath** (1940) starring Henry Fonda.
3. William Wyler's **The Little Foxes** (1941) starring Bette Davis.
4. John Houston's **The Maltese Falcon** (1941) starring Humphrey Bogart.
5. Sam Woods' **For Whom the Bells Toll** (1943) starring Gary Cooper.
6. Howard Hawks' **To Have and Have Not** (1944) starring Humphrey Bogart.
7. Norman Z. McLeod's **The Secret Life of Walter Mitty** (1947) starring Danny Kaye.
8. King Vidor's **The Fountainhead** (1949) starring Gary Cooper.
9. Elia Kazan's **A Streetcar named Desire** (1951) starring Marlon Brando.
10. John Houston's **The Red Badge of Courage** (1951) starring Audie Murphy.
11. Howard Hawk's **Gentlemen Prefer Blondes** (1953) starring Marilyn Monroe.
12. George Stevens' **Shane** (1953) starring Alan Ladd.
13. Elia Kazan's **East of Eden** (1955) staring James Dean.
14. Vincent Minelli's **Lust for Life** (1956) starring Kirk Douglas.
15. Elia Kazan's **Baby Doll** (1956) starring Caroll Baker.

Answers: 1. Eugene O' Neill. 2. John Steinbeck. 3. Lillian Hellman. 4. Dashiell Hammett 5. Ernest Hemingway. 6. Ernest Hemingway. 7. James

Thurber. 8. Ayn Rand. 9. Tennessee Williams. 10. Stephan Crane. 11. Anita Loos. 12. Jack Schaefer. 13 John Steinbeck 14. Irving Stone. 15. Tennessee Williams.

Films based on US literature-II

Can you name the US authors of the literary works on which the following films were based:

1. John Houston's **Moby Dick** (1956) starring Gregory Peck.
2. Charles Vidor's **A Farewell to Arms** (1957) starring Rock Hudson.
3. Richard Brooks' **Cat on a Hot Tin Roof** (1958) starring Liz Taylor.
4. John Sturges' **The Old Man and the Sea** (1958) starring Spencer Tracy.
5. Martin Ritt's **The Sound and the Fury** (1959) starring Yul Brynner.
6. William Wyler's **Ben Hur** (1959) starring Charleston Heston. Lew Wallace.
7. Joseph L. Mankiewicz's **Suddenly, Last Summer** (1959) starring Elizabeth Taylor.
8. Richard Brooks' **Elmer Gantry** (1960) starring Burt Reynolds.
9. Otto Preminger **Exodus** (1960) starring Paul Newman.
10. Blake Edwards' **Breakfast at Tiffany's** (1961) starring Audrey Hepburn.
11. John Houston's **The Misfits** (1961) starring Marilyn Monroe and Clark Gable.
12. Robert Mulligan's **To Kill a Mockingbird** (1962) starring Gregory Peck.
13. Stanley Kubrick's **Lolita** (1962) starring James Mason and Sue Lyon.
14. Peter Ustinov's **Billy Budd** (1962) starring Terence Stamp.
15. Stanley Kramer's **Ships of Fools** (1965) starring Vivien Leigh.
16. Mike Nicholls' **Who is afraid of Virginia Woolf** (1966) starring Richard Burton.
17. François Truffaut's **Fahrenheit 451** (1966) starring Julie Christie and Oskar Werner.

Answers: 1. Herman Melville. 2. Ernest Hemingway. 3. Tennessee Williams. 4. Ernest Hemingway. 5. William Faulkner. 6. Lew Wallace. 7. Tennessee Williams. 8. Sinclair Lewis. 9. Leon Uris. 10. Truman Capote. 11. Arthur Miller. 12 Harper Lee. 13. Vladimir Nabokov. 14. Herman Mellville.15. Katherine Anne Porter. 16. Edward Albee. 17. Ray Bradbury.

Films based on US literature- III

Can you name the US authors of the literary works on which the following films were based:

1. Mike Nicholl's **Catch 22** (1970) starring Jon Voigt, Martin Sheen.
2. Arthur Hiller's **Love Story** (1970) starring Ali McGraw.
3. Jack Clayton's **The Great Gatsby** (1974) starring Robert Redford.
4. Milos Forman's **One Flew over the Cuckoo's Nest** (1975) starring Jack Nicholson.
5. Stephen Spielberg's **Jaws** (1975) starring Roy Scheider.
6. James Ivory's **The European** (1979) starring Lee Remick.
7. Stanley Kubrick's **The Shining** (1980) starring Jack Nicholson.
8. Bob Rafelson's **The Postman Always Rings Twice** (1981) starring Jack Nicholson.
9. Alan J. Pakula's **Sophie's Choice** (1982) starring Meryl Streep.
10. Barbra Streisand's **Yentl** (1983) starring Barbra Streisand.
11. Sergey Bondarchuk's **Ten Days That Shook the World** (1983) starring Franco Nero.
12. James Ivory's **The Bostonian** (1984) starring Vanessa Redgrave.
13. Stephen Speilberg's **The Color Purple** (1985) starring Whoopie Goldberg.
14. Volker Schlondorff's **Death of a Salesman** (1985) starring Dustin Hoffman.
15. David Cronenberg's **Naked Lunch** (1991) starring Peter Weller.

Answers: Joseph Heller. 2. Erich Segal. 3. F. Scott Fitzgerald. 4. Ken Kesey. 5. Peter Blenchley. 6. Henry James. 7. Stephen King. 8. James M. Cain.

9. William Stryon. 10. Isaac Bashevis Singer. 11. John Reed. 12. Henry James. 13. Alice Walker. 14 Arthur Miller. 15. William S. Burroughs.

Films based on US literature- IV

Can you name the US authors of the literary works on which the following films were based:

1. Martin Scorsese's *The Age of Innocence* (1993) starring Daniel Day-Lewis.
2. Wayne Wang's *The Joy Luck Club* (1993) starring Tamlyn Tomita.
3. Frank Darabont's *The Shawshank Redemption* (1994) starring Tim Robbins.
4. Gillian Armstrong's *Little Women* (1994) starring Winona Rider.
5. Jane Campion's *The Portrait of a Lady* (1996) starring Nicole Kidman.
6. Terry Gilliam's *Fear and Loathing in Las Vegas* (1998) starring Johnny Depp.
7. Terrence Malick's *The Thin Red Line* (1998) starring James Caviezel.
8. Tim Burton's *Sleepy Hollow* (1999) starring Johnny Depp.
9. Lasse Hallström's *The Cider House Rules* (1999) starring Tobey MacGuire.
10. Ron Howard's *How the Grinch Stole Christmas* (2000) starring Jim Carrey.
11. James Ivory's *The Golden Bowl* (2000) starring Uma Thurman.
12. Ang Lee's *Brokebank Mountain* (2005) starring Heath Ledger.
13. Steven Zaillian's *All the King's Men* (2006) starring Sean Penn.
14. Ron Howard's *The Da Vinci Code* (2006) starring Tom Hanks.
15. David Fincher's *The Curious Case of Benjamin Button* (2008) starring Brad Pitt.
16. Walter Salles' *On the Road* (2012) starring Sam Riley.

Answers: Edith Wharton. 2. Amy Tan. 3. Stephen King. 4. Louisa M. Alcott. 5. Henry James. 6. Hunter S. Thompson. 7. James Jones. 8. Washington Irving. 9. John Irving. 10. Dr. Seuss. 11. Henry James. 12.

Annie Proulx. 13. Robert Penn Warren. 14. Dan Brown. 15. F. Scott Fitzgerald. 16. Jack Kerouac.

Films based on British literature I

Name the UK authors who wrote the literary works on which the following films were based.

1. John Cromwell's *Of Human Bondage* (1934) starring Bette Davis.
2. Harold Young's *The Scarlet Pimpernel* (1934) starring Leslie Howard.
3. John Ford's *The Informer* (1935) starring Victor McLaglen.
4. Alfred Hitchcock's *The 39 Steps* (1935) starring Robert Donat.
5. William Wyler's *Wuthering Heights* (1939) starring Laurence Olivier.
6. George Stevens' *Gunga Din* (1939) starring Cary Grant.
7. Hitchcock's *Rebecca* (1940) starring Joan Fotaine.
8. Robert Stevenson's *Jane Eyre* (1943) starring Joan Fontaine.
9. David Lean's *Brief Encounter* (1945) starring Celia Johnson and Trevor Howard.
10. Rene Clair's *And Then There Were None* (1945) starring Walter Houston.
11. David Lean's *Great Expectations* (1946) starring John Mills.
12. John Boulting's *Brighton Rock* (1947) starring Richard Attenborough.
13. David Lean's *Oliver Twist* (1948) starring Alec Guinness.
14. Carol Reed's *The Third Man* (1949) starring Joseph Cotten, Orson Welles.
15. Victor Saville's *Kim* (1950) starring Dean Stockton.

Answers: 1. W. Somerset Maugham. 2. Baroness Orczy. 3. Liam O'Flaherty (Ir). 4. John Buchan (Sc). 5. Emily Brontë. 6. Rudyard Kipling. 7. Daphne Du Maurier. 8. Charlotte Brontë. 9. Noel Coward. 10. Agatha Christie. 11. Charles Dickens. 12. Graham Greene. 13. Charles Dickens. 14. Graham Greene. 15. Rudyard Kipling.

Films based on British Literature II

Name the UK authors who wrote the literary works on which the following films were based.

1. John Houston's **The African Queen** (1951) starring Katherine Hepburn.
2. Richard Thorpe's **Ivanhoe** (1952) starring Robert Taylor, Liz Taylor.
3. Tony Richardson's **Look back in Anger** (1959) starring Richard Burton.
4. Jack Clayton's **Room at the Top** (1959) starring Simone Signoret.
5. Tony Richardson's **The Loneliness of Long Distance Runner** (1962).
6. David Lean's **Lawrence of Arabia** (1962) starring Peter O'Toole.
7. Peter Brooks' **Lord of the Flies** (1963).
8. Tony Richardson's **Tom Jones** (1963) starring Albert Finney.
9. George Cukor's **Pygmalion** (1964) film starring Audrey Hepburn.
10. Terence Young's **The Amorous Adventures of Moll Flanders** (1965) starring Kim Novak.
11. Sidney J. Furie's **The Ipcress File** (1965) starring Michael Caine.
12. Richard Brook's **Lord Jim** (1965) starring Peter O' Toole.
13. Fred Zinnemann's **A Man for All Seasons** (1966) starring Paul Scofield.
14. John Schlesinger's **Far from the Madding Crowd** (1967) starring Julie Cristie.
15. Wolfgang Reitherman's **The Jungle Book** (1967).

Answers: C. S. Forster. 2. Sir Walter Scott (Sc). 3. James Osborne. 4. John Braine. 5. Alan Stillitoe. 6. T. E. Lawrence. 7. William Golding. 8. Henry Fielding. 9. George Barnard Shaw. 10. Daniel Defoe. 11. Len Deighton. 12. Joseph Conrad. 13. Robert Bolt. 14. Thomas Hardy. 15. Rudyard Kipling.

Films based on British Literature- III

Can you name the British authors of the literary works on which the following films were based:

1. Carol Reed's **Oliver!** (1968) starring Ron Moody.
2. Ken Hughes' **Chiti Chiti Bang bang** (1968) starring Dick Van Dyke.
3. Brian G. Hutton's **Where Eagles Dare** (1968) starring Richard Burton.
4. Ken Russel's **Women in love** (1969) starring Alan Bates, Glenda Jackson.
5. Irving Lerner's **The Royal Hunt of the Sun** (1969) starring Robert Shaw.
6. Stanley Kubrick's **A Clockwork Orange** (1971) starring Malcolm MacDowell.
7. Mel Stuart's **Willy Wonka & the Chocolate Factory** (1971) starring Gene Wilder.
8. Sidney Lumet's **Murder on the Orient Express** (1974) starring Albert Finney, Ingrid Bergman.
9. Stanley Kubrick's **Barry Lyndon** (1975) starring Ryan O Neal.
10. John Houston's **The Man Who Would Be King** (1975) starring Sean Connery.
11. Francis Ford Coppola's **Apocalypse Now** (1979) starring Marlon Brando.
12. Karel Reisz' **The French Lieutenant's Woman** (1981) starring Jeremy Irons.
13. James Ivory's **Heat and Dust** (1983) starring Greta Scacchi.
14. Milos Forman's **Amadeus** (1984) starring Tom Hulce, F. Murray Abraham.
15. John Byrum's **The Razor Edge** (1984) starring Bill Murray.

Answers: Charles Dickens. 2. Ian Fleming. 3. Alistair Maclean. 4. D. H. Lawrence. 5. Peter Shaffer. 6. Anthony Burgess. 7. Roald Dahl. 8. Agatha Christie. 9. William Makepeace Thackeray. 10. Rudyard Kipling. 11. Joseph Conrad. 12. John Fowles. 13. Ruth Prawer Jhabvala. 14. Peter Shaffer. 15. Somerset Maugham.

Films based on British Literature- IV

Can you name the British authors of the literary works on which the following films were based:

1. J. Lee Thompson's **King Solomon's Mines** (1985) starring Richard Chamberlain, Sharon Stone.
2. James Ivory's **A Room with a View** (1985) starring Maggie Smith, Helena Bonham Carter.
3. Stephen Frears's **My Beautiful Laundrette** (1985) starring Saeed Jaffrey, Roshan Seth.
4. Stephen Frears's **Sammy and Rosie Get Laid** (1987) starring Shashi Kapoor.
5. James Ivory's **Maurice** (1987) starring Hugh Grant, James Wilby.
6. Steven Spielberg's **Empire of the Sun** (1987).
7. Derek Jarman's **Edward** II (1991) starring Steven Waddington.
8. James Ivory's **Howards Ends** (1992) starring Emma Thompson.
9. James Ivory's **Remains of the Day** (1993) starring Anthony Hopkins, Emma Thompson.
10. Michael Winterbottom's **Jude** (1996) starring Christopher Eccleston.
11. Neil Jordan's **The End of the Affair** (1999) starring Ralph Fiennes.
12. Peter Jackson's **The Lord of the Rings** (2001) starring Elijah Wood, Ian McKellen.
13. Tim Burton's **Charlie and the Chocolate Factory** (2005) starring Johnny Depp.
14. Joe Wright's **Pride & Prejudice** (2005) starring Keira Knightley.
15. Andrew Adamson's **The Lion, the Witch and the Wardrobe** (2005).
16. Joe Wright's **Atonement** (2007) starring Keira Knightly.
17. Robert Zemeckis' **Beowulf** (2007) film starring Ray Winstone, Robin Wright Penn.
18. Will Gluck's **Peter Rabbit** (2018) film starring Rose Byrne.

Answers: H. Rider Haggard. 2. E.M. Forster. 3. Hanif Quereshi. 4. Hanif Quereshi. 5. E. M. Forster. 6. J.G. Ballard. 7. Christopher Marlowe. 8. E M Forster. 9. Kazuo Ishiguru. 10. Thomas Hardy. 11. Graham Greene. 12.

J.R.R. Tolkien. **13.** Roald Dahl. **14.** Jane Austen. **15.** C. S. Lewis. **16.** Ian McEvan. **17.** Unknown poet. **18.** Beatrix Potter.

Films based on French Literature

Name the authors who wrote the literary works on which the following films were based:

1. Rupert Julian's *The Phantom of the Opera* (1925) starring Lon Chaney.
2. Jean Renoir's *Nana* (1926, Fr).
3. Clarence Brown's *Night Flight* (1933) starring John Barrymore.
4. Jean Renoir's *La Bête Humaine* (1938, Fr) starring Jean Gabin.
5. William Dieterle's *The Hunchback of Notre Dame* (1939) starring Charles Laughton.
6. Henri-Georges Clouzot's *The Wages of Fear* (1953, Fr) starring Yves Montand.
7. Henri-Georges Clouzot's *Diabolique* (1955, Fr) starring Simone Signoret.
8. Michael Anderson's *Around the World in 80 days* (1956) starring David Niven.
9. Jean Delannoy's *The Hunchback of Notre Dame* (1956) starring Anthony Quinn.
10. Vincent Minelli's *Gigi* (1958) starring Maurice Chevalier.
11. Jean Delannoy's *Inspector Maigret* (1958, Fr) starring Jean Gabin.
12. Peter Glenville's *Becket* (1964) starring Richard Burton and Peter O Toole.
13. Luchino Visconti's *The Stranger* (1967, It) starring Marcello Mastroianni.
14. Franklin J. Schaffner's *Papillon* (1973) starring Steve McQueen.
15. Jean-Paul Rappeneau's *Cyrano de Bergerac* (1990, Fr) starring Gérard Depardieu.
16. Claude Chabrol's *Madame Bovary* (1991, Fr) starring Isabelle Huppert.
17. Stephen Herek's *The Three Musketeers* (1993) starring Charlie Sheen.

18. Randall Wallace's **The Man in the Iron Mask** (1998) starring Leonardo DiCaprio.
19. Tom Hooper's **Les Miserables** (2012) starring Hugh Jackman.

Answers: *Gaston Leroux. 2. Emile Zola. 3. Antoine de Saint-Exupéry. 4. Emile Zola. 5. Victor Hugo.6. Georges Arnaud. 7. Pierre Boileau. 8. Jules Verne. 9. Victor Hugo. 10. Collete. 11. Georges Simenon. 12. Jean Anouilh. 13. Albert Camus. 14. French convict Henri Charrière. 15. Edmond Rostand. 16. Gustave Flaubert. 17. Alexander Dumas. 18. Alexander Dumas. 19. Victor Hugo.*

Films based on German literature

Name the authors who wrote the literary works on which the following films were based:

1. F. W. Murnau's **Faust: A German Folktale** (1926, Ger) starring Emil Jannings as Mephisto.
2. Lewis Milestone's **All Quiet on the Western Front** (1930).
3. G.W. Pabst's **The Three-Penny Opera** (1931, Ger) starring Lotte Lenya.
4. Gerhard Lamprecht's **Emil und die Detektive** (1931, Ger) starring Rolf Wenkhaus.
5. **Snow White and the Seven Dwarfs** (1937).
6. Peter Palitzsch and Manfred Wekwerth's **Mother Courage and Her Children** (1961, Ger) starring Helene Weigel.
7. Orson Welles' **The Trial** (1962) starring Anthony Perkins.
8. Rudolf Noelte's **The Castle** (1968, Ger) starring Maximilian Schell.
9. Luchino Visconti's **Death in Venice** (1971, It) starring Dirk Bogarde.
10. Conrad Rook's **Siddhartha** (1972) starring Shashi Kapoor.
11. Joseph Losey's **Galileo** (1975) starring Topol.
12. Volker Schlöndorff's **The Tin Drum** (1979, Ger) starring David Bennent.
13. Jean-Jacques Annaud's **Seven Years in Tibet** (1997) starring Brad Pitt.

Answers: Johann Wolfgang von Goethe. 2. Erich Maria Remarque. 3. Bertolt Brecht. 4. Erich Kästner. 5. Wilhelm and Jacob Grimms. 6. Bertolt Brecht. 7. Franz Kafka. 8. Franz Kafka. 9. Thomas Mann. 10. Herman Hesse. 11. Bertolt Brecht. 12. Guntar Grass. 13. Heinrich Harrer.

Films based on Russian Literature

Name the authors who wrote the literary works on which the following films were based:

1. Vsevolod Pudovkin's *Mother* (1926, Rus).
2. Jean Renoir's *The Lower Depths* (1936, Fr) starring Jean Gabin.
3. King Vidor's *War and Peace* (1956) starring Henry Fonda.
4. Luchino Visconti's *White Nights* (1957, It) starring Maria Schell, Marcello Mastroianni.
5. Richard Brooks's *The Brothers Karamazov* (1958) starring Yul Brynner.
6. J. Lee Thompson's *Taras Bulba* (1962) starring Yul Brynner.
7. David Lean's *Dr. Zhivago* (1965) starring Omar Sharif.
8. Sergei Bondurchuk's *War and Peace* (1967, Rus) starring Sergei Bondurchuk.
9. Mel Brooks's *The Twelve Chairs* (1970) starring Frank Langella.
10. Caspar Wrede's *One Day in the Life of Ivan Denisovich* (1970) starring Tom Courtenay.
11. Laurence Olivier's *Three Sisters* (1970) starring Alan Bates.
12. Gary Walkow's *Notes from Underground* (1995) starring Henry Czerny.
13. Joe Wright's *Anna Karenina* (2012) starring Keira Knightly.
14. Michael Mayer's *The Seagull* (2018) starring Saoirse Ronan.

Answers: Maxim Gorky. 2. Maxim Gorky. 3. Lev Tolstoy. 4. Fyodor Dostoevsky. 5. Fyodor Dostoevsky. 6. Nikolai Gogol. 7. Boris Pasternak. 8. Lev Tolstoy. 9. Ilya Ilf and Yevgeni Petrov. 10. Aleksandr Solzhenitsyn. 11. Anton Chekov. 12. Fyodor Dostoevsky. 13. Lev Tolstoy. 14. Anton Chekov.

Films based on Indian Literature

Name the authors who wrote the literary works on which the following films were based:

1. Satyajit Ray's **Pather Panchali** (1955, Bn).
2. Satyajit Ray's **Jalsagar** (1958, Bn) starring Chabbi Biswar.
3. Satyajit Ray's **Charulata** (1964, Bn) starring Soumitra Chatterjee.
4. Satyajit Ray's **Shatranj Ke Khiladi** (1977, Hnd) starring Sanjeev Kumar.
5. Ismail Merchant's **In Custody** (1994) starring Shashi Kapoor.
6. Satyajit Ray's **Ghare Baire** (1984, Bn) starring Victor Banerjee.
7. Satyajit Ray's **Pratidwandi** (1970, Bn) starring Dhritiman Chatterjee.
8. Danny Boyle's **Slumdog Millionaire** (2008) starring Dev Patel.

Answers: Bibhutibhushan Bandyopadhyay. 2. Tarashankar Bandhopdhya. 3. Rabindranath Tagore. 4. Premchand. 5. Anita Desai. 6. Rabindranath Tagore. 7. Sunil Gangopadhyay. 8. Vikas Swarup.

Films based on literature of other countries

Name the authors who wrote the literary works on which the following films were based:

1. Mauritz Stiller's **The Saga of Gösta Berling** (1924, Swe) starring Greta Garbo.
2. Walt Disney's **Pinocchio** (1940).
3. Grigoriy Kozintsev's **Don Kikhot** (1957, Ru) starring Nikolay Cherkasov.
4. Vittorrio De Sica's **Two Women** (1960, It) starring Sophia Loren.
5. Luchino Viscont's **The Leopard** (1963, It) starring Burt Lancaster.
6. Robert Stevenson's **Mary Poppins** (1964) starring Julie Andrews.

7. Michael Cacoyannis' ***Zorba the Greek*** (1964, Grk) starring Anthony Quinn.
8. Pier Paolo Pasolini's ***The Decameron*** (1971, It).
9. Arthur Hiller's ***Man of la Mancha*** (1972) starring Peter O'Toole.
10. Joseph Losey's ***A Doll's House*** (1973) starring Jane Fonda.
11. Hector Babenco's ***Kiss of the Spider Woman*** (1985) starring John Hunt.
12. Jean-Jacques Annaud's ***The Name of the Rose*** (1986) starring Sean Connery.
13. Zhang Yimou's ***Red Sorghum*** (1987, Chi) starring Gong Li.
14. Martin Scorsese's ***The Last Temptation of Christ*** (1988) starring Willem Dafoe.
15. Roman Polanski's ***Death and the Maiden*** (1994) starring Sigourney Weaver, Ben Kingsley.
16. Anthony Minghella's ***The English Patient*** (1996) starring Ralph Fiennes.
17. Gillian Armstrong's ***Oscar and Lucinda*** (1997) starring Ralph Fiennes.
18. Sturla Gunnarsson's ***Such a Long Journey*** (1998) starring Roshan Seth.
19. Phillip Kaufman's ***The Unbearable Lightness of Being*** (1998).
20. Wolfgang Petersen's ***Troy*** (2004) starring Brad Pitt.
21. Mike Newell's ***Love in the Time of Cholera*** (2007) starring Javier Bardem.
22. Ang Li's ***Life of Pi*** (2012) starring Suraj Sharma.
23. Steven Spielberg's ***Schlindler's List*** (1993) starring Liam Neeson.
24. Liv Ullman's ***Miss Julie*** (2014) starring Jessica Chastain.

Answers: Selma Lagerlöf (Swe). 2. Carlo Collodi (It). 3. Miguel de Cervantes y Saavedra (Sp). 4. Albert Moravia (It). 5. Giuseppe Tomasi di Lampedusa (It). 6. P. L. Travers (Aus). 7. Nikos Kazantzakis. (Gk). 8. Giovanni Boccaccio (It). 9. Miguel de Cervantes y Saavedra (Sp). 10. Henrik Ibsen (Nor). 11. Manuel Puig (Spa). 12. Umberto Eco (It). 13. Mo Yan. (Chi). 14. Nikos Kazantzakis. (Gk). 15. Ariel Dorfman (Sp). 16. Michael Ondaatje (Sriln). 17. Peter Carey (Aus). 18. Rohinton Mistry (Can). 19. Milan Kundera (Cze). 20. Homer (Gk). 21. Gabriel García Márquez (Spa). 22. Yann Martel (Can). 23. Thomas Keneally (Aus). 24. August Strindberg (Swe).

More Films based on literary Works

Name the films that were based on the following books:

1. D. W. Griffith's 1915 film based on Thomas Dixon's novel *The Klansman*.
2. Erich von Stroheim's 1924 film based on the Frank Norris' novel *McTeague*.
3. Clarence Brown's 1935 film (starring Greta Garbo) based on Leo Tolstoy novel.
4. Michael Curtiz's 1942 film starring Humphrey Bogart based on Murray Burnett and Joan Alison's play *Everybody Comes to Rick's*.
5. Howard Hawk's 1946 film starring Humphrey Bogart based on Raymond Chandler's *Killer in the Rain*.
6. Robert Wise/Jerome Robbins' 1961 film starring Natalie Wood based on Shakespeare's *Romeo and Juliet*.
7. Richard Lester's 1966 film based on a play by Roman Titus Maccius Plautus.
8. Robert Wise's 1969 film based on Maria Von Trapp's *The Story of the Trapp Family Singers*.
9. Fred Zinnemann's 1977 film based on Lillian Hellman's *Pentimento: A Book of Portraits* (1973).
10. Milos Forman's 1989 film starring Colin Firth based on Pierre de Laclos's *Les Liaisons Dangereuses*.
11. Steven Spielberg's 1997 film starring Djimon Hounsou based on William A. Owens' *Slave Mutiny: The Revolt on the Schooner Amistad* (1953), republished in 1968 under the title *Black Mutiny*.
12. Stanley Kubrick's 1999 film starring Tom Cruise based on Austrian novelist Arthur Schnitzler's *Rhapsody* or *Dream Story* (1926).
13. Paul Thomas Anderson's 2007 film starring Daniel Day-Lewis based on Upton Sinclair's *Oil*.
14. Martin Scorsese's 2011 film starring Asa Butterfield based on Brian Selznick's *The Invention of Hugo Cabret*.
15. Robert Zemeckis' 2015 film starring Joseph Gordon-Levitt based on Philippe Petit's *To Reach the Clouds* (Fr).

Answers: The Birth of a Nation. 2. Greed. 3. Anna Karenina. 4. Casablanca. 5. The Big Sleep. 6. West Side Story. 7. A Funny Thing Happened on the Way to the Forum. 8. The Sound of Music. 9. Julia. 10. Valmont. 11. Amistad. 12. Eyes Wide Shut. 13. There Will Be Blood. 14. Hugo. 15. The Walk.

Biopics

Real Life

Name the actors who played the historical character roles in the following films:

1. Abraham Lincoln in John Ford's **Young Mr. Lincoln** (1939).
2. Mexican revolutionary Emiliano Zapata in Elia Kazan's **Viva Zapata!** (1952).
3. Rudolph Valentino in Ken Russel's **Valentino** (1977).
4. John Merick in David Lynch's **The Elephant Man** (1980).
5. Charles Chaplin in Richard Attenborough's **Chaplin** (1992).
6. Gandhi in Richard Attenborough's **Gandhi** (1982).
7. President Nixon in Oliver Stone's **Nixon** (1995).
8. Astronaut Jim Lovell in Ron Howard's **Apollo 13** (1995).
9. Larry Flynt, the publisher of the pornographic magazine The Hustler, in Milos Forman's **The People vs Larry Flynt** (1996).
10. Vietnam veteran Ron Kovic in Oliver Stone's **Born on the Fourth of July** (1989).
11. Apache leader Geronimo in Walter Hill's **Geronimo: An American Legend** (1993).
12. Flop film director Ed Wood in Tim Burton's **Ed Wood** (1994).
13. FBI director J. Edgar Hoover in Clint Eastwood's **J. Edgar** (2011).
14. Daniel Pearl, WSJ reporter who was kidnapped in Karachi and beheaded by supporters of Omar Shiekh, in Michael Winterbottom's **A Mighty Heart** (2007).
15. Nelson Mandela in Justin Chadwick's **Mandela: Long Walk to Freedom** (2013).
16. Walt Disney in John Lee Hancock's **Saving Mr. Banks** (2013).

17. S. Ramanujam in Matt Brown's *The Man Who Knew Infinity* (2015).
18. Frontierman Phillip Glass in Alejandro G. Iñárritu's *The Revenant* (2015).
19. Jacqueline Kennedy in Pablo Larrain's *Jackie* (2016).
20. Ray Kroc in John Lee Hancock's *The Founder* (2016).
21. First Black US Supreme Court Justice Thurgood in Reginald Hudlin's *Marshall* (2017).

Answers: Henry Fonda. 2. Marlon Brando. 3. Rudolf Nureyev. 4. John Hurt. 5. Robert Downley Jr. 6. Ben Kinsley. 7. Anthony Hopkins. 8. Tom Hanks. 9. Woody Harrelson. 10. Tom Cruise. 11. Wes Studi. 12. Johnny Depp. 13. Leonardo DiCaprio. 14. Dan Futterman. 15. Idris Elba. 16. Tom Hanks. 17. Dev Patel. 18. Leonardo DiCaprio. 19. Natalie Portman. 20. Michael Keaton. 21. Chadwick Boseman.

Biopics

Name the real life characters played by the following actors in the following films:

1. James Stewart in Billy Wilder's *The Spirit of St Louis* (1955).
2. Peter O'Toole in David Lean's *Lawrence of Arabia* (1962).
3. Paul Scofield in Fred Zinnemann's *A Man for All Seasons* (1966).
4. Sidney Poitier in James Clavell's *To Sir, with Love* (1967).
5. Anthony Quinn in Moustapha Akkad's *Lion of the Desert* (1980).
6. Denzel Washington in Richard Attenborough's *Cry, Freedom* (1987).
7. John Lone in Bernardo Bertolucci's *The Last Emperor* (1987).
8. Stephen Hawking in Errol Morris's *A Brief History of Time* (1991).
9. Liam Neeson in Steven Spielberg's *Schindler's List* (1993).
10. Seema Biswas in Shekhar Kapur's *Bandit Queen* (1994).
11. Liam Neeson in Michael Caton-Jones's *Rob Roy* (1995).
12. Tenzin Thuthob Tsarong in Martin Scorsese's *Kundun* (1997).
13. Jim Carrey in Milos Forman's *Man on the Moon* (1999).

14. Leonardo DiCaprio in Martin Scorsese's **The Aviator** (2004).
15. Russel Crowe in Ron Howard's **A Beautiful Mind** (2008).
16. Meryll Streep in Phyllida Lloyd's **The Iron Lady** (2011).
17. Michael Sheen in Ron Howard's **Frost/Nixon** (2008).
18. Forest Whitaker in Kevin Macdonald's **The Last King of Scotland** (2006).
19. Chiwetel Ejiofor in Steve McQueen's **12 Years a Slave** (2013).
20. Hugh Jackman in Michael Gracey's **The Greatest Showman** (2017).

Answers: The aviator Charles Lindberg. 2. T. E. Lawrence. 3. Sir Thomas More. 4. E. R. Braithwaite. 5. Omar Mukhtar. 6. Steve Biko. 7. Pu Yi, the last emperor of China. 8. Stephen Hawking. 9. Oskar Schindler. 10. Pholan Devi. 11. Rob Roy. 12. Dalai Lama. 13. Comedian Andy Kaufman. 14. US Billionaire Howard Hughes. 15. Nobel Laureate John Nash. 16. Margaret Thatcher. 17. TV host David Frost. 18. Idi Amin of Uganda. 19. Solomon Northup. 20. P. T. Barnum.

Films on Male Musicians

Match the actor with the real life musician.

S.No	Actor	Musician
1	Robert Alda in **Rhapsody in Blue** (1945)	Hector Berlioz
2	Jean-Louis Barrault in **La Symphonie Fantastique** (1942, Fr)	George Gershwin
3	Richard Chamberlain in **The Music Lovers** (1971)	Franz Liszt
4	Roger Daltry in **Lisztomania** (1975)	Peter Ilych Tchaikovsky
5	Lou Diamond Phillips in **La Bamba** (1987)	Ricky Valens
6	Hugh Grant in **Impromptu** (1991)	Frédéric Chopin
7	Ray Liotta in **The Rat Pack** (1998)	Frank Sinatra
8	Dennis Quaid in **Great Balls of Fire!** (1989)	Johnny Cash
9	Joaquin Phoenix in **Walk the Line** (2005)	Jerry Lee Lewis
10	Tom Hiddleston in **I Saw the Light** (2015)	Hank Willams
11	Rami Malek in **Bohemian Rhapsody** (2018)	Freddy Mercury

Answers: 1. George Gershwin. 2. Hector Berlioz. 3. Peter Ilych Tchaikovsky. 4. Franz Liszt. 5. Ricky Valens. 6. Frédéric Chopin. 7. Frank Sinatra. 8. Jerry Lee Lewis. 9. Johnny Cash. 10. Hank Willams. 11. Freddy Mercury.

Films on Female Musicians

Match the actress with the real life singer.

S. No	Actress	Singer
1	Barbra Streisand in **Funny Girl** (1968)	Tina Turner
2	Diana Ross in **Lady Sings the Blues** (1972)	Nina Simone
3	Sissy Spacek in **Coal Miner's Daughter** (1980).	Loretta Lynn
4	Angela Basset in **What's Love Got to Do with It** (1993)	Fanny Brice
5	Zoe Saldana in **Nina** (2006)	Billie Holiday
6	Marion Cotillard in **La Vie en Rose** (2007)	Edith Piaf.

Answers: 1. Fanny Brice. 2 Billie Holiday. 3. Loretta Lynn. 4. Tina Turner. 5. Nina Simone. 6. Edith Piaf.

Films on Male Writers

Match the actor with the real life writer.

S.No	Actor	Writer
1	John Barrymore in **The Beloved Rogue** (1927)	T. S. Eliot
2	Warren Beatty in **Reds** (1981)	Left-wing journalist John Reed
3	Anthony Hopkins in **Shadowlands** (1993)	C. S. Lewis
4	Willem Dafoe in **Tom & Viv** (1994)	Francois Villon
5	Geoffrey Rush in **Quills** (2000)	James Barrie
6	Johny Depp in **Finding Neverland** (2004)	Marquis De Sade
7	Christopher Plummer in **The Last Station** (2009)	Leo Tolstoy
8	Ben Whishaw in **Bright Star** (2009)	Charles Dickens
9.	Nicholas Hoult in **Rebel in the Rye** (2017)	Oscar Wilde
10	Dan Stevens in **The Man Who Invented Christmas** (2017)	John Keats
11	Domhnall Gleeson in **Goodbye, Christopher Robin** (2017)	A. A. Milne
12.	Rupert Everett in **The Happy Prince** (2018)	J.D. Salinger

Answers: 1. Francois Villon. 2. Left-wing journalist John Reed. 3. C. S. Lewis. 4. T. S. Eliot. 5. Marquis De Sade. 6. James Barrie. 7. Leo Tolstoy. 8. John Keats. 9. J.D. Salinger. 10. Charles Dickens. 11. A. A. Milne. 12. Oscar Wilde.

Films on Female Writers

Match the actress with the real life writer.

S. No.	Actress	Writer
1	Meryl Streep in *Out of Africa* (1985)	Isak Dinesen (Karen Blixen)
2	Kate Winslet and Judi Dench in *Iris* (2000)	Emily Dickinson
3	Gwyneth Paltrow in *Sylvia* (2003)	Sylvia Plath
4	Anne Hathaway in *Becoming Jane* (2007).	Jane Austen
5	Emily Bell and Cynthia Nixon in *A Quiet Passion* (2016)	Iris Murdoch
6	Alba August in *Becoming Astrid* (2018)	Astrid Lindgren (creator of Pippi Longstocking)

Answers: 1. Isak Dinesen (Karen Blixen). 2. Iris Murdoch. 3. Sylvia Plath. 4. Jane Austen. 5. Emily Dickinson. 6. Astrid Lindgren (creator of Pippi Longstocking).

Films on Artists

Match the actor with the real life artist:

S. No.	Actor in Films	Artist
1	José Ferrer in *Moulin Rouge* (1952)	Amedeo Modigliani
2	Kirk Douglas in *Lust for life* (1956)	Michelangelo
3	Gérard Philipe in *Montparnasse 19* (1958, Fr)	Henri de Toulouse-Lautrec
4	Charlton Heston in *Agony and the Ecstasy* (1965)	Vincent Van Gogh
5	Anatoliy Solonitsy in *Andrei Rublev* (1966, Ru)	Andrei Rublev
6	Ed Hrris in *Pollock* (2000)	Jackson Pollock
7	Salma Hayek in *Frida* (2002)	Mexican artist Frida Kahlo
8	Colin Firth in *Girl with a Pearl Earring* (2003)	Jan Vermeer
9	Amy Adams in *Big Eyes* (2014)	Vincent van Gogh
10	Sally Hawkins in *Maudie* (2016)	Maud Lewis
11	Willem Dafoe in *At Eternity's Gate* (2018).	Margaret Keane

Answers: 1. Henri de Toulouse-Lautrec. 2. Vincent Van Gogh. 3. Amedeo Modigliani. 4. Michelangelo. 5. Andrei Rublev. 6. Jackson Polllock. 7.

Mexican artist Frida Kahlo. 8. Jan Vermeer. 9. Margaret Keane. 10. Maud Lewis. 11. Vincent van Gogh.

Films on Sportspersons

Match the actor with the real life sportsperson:

S. No.	Actor	Sportsperson
1	Paul Newman in *Somebody Up there likes me* (1956)	Boxer Jake LaMotta
2	Esther Williams in *Million Dollar Mermaid* (1952)	Annette Kellerman
3	Robert de Niro in *Raging Bull* (1980)	Boxer Rocky Graziano
4	Ben Cross in *Chariots of Fire* (1981)	Olympic athlete Harold Abrahams
5	Ian Charleston in *Chariots of Fire* (1981)	Olympic athlete Eric Liddell
6	John Goodman in *The Babe* (1992)	Baseball legend Babe Ruth
7	Tommy Lee Jones in *Cobb* (1994)	Baseball legend Ty Cobb
8	Denzel Washington in *Hurricane* (1999)	Boxer Rubin Hurricane Carter
9	Will Smith in *Ali* (2001)	Boxer Roberto Duran
10	Quinton Aaron in *The Blind Side* (2009)	Football player Michael Oher
11	Edgar Ramírez in *Hands of Stone* (2016)	Boxer Muhammad Ali

Answers: 1. Boxer Rocky Graziano. 2. Annette Kellerman. 3. Boxer Jake LaMotta. 4. Olympic athlete Harold Abrahams. 5. Olympic athlete Eric Liddell. 6. Baseball legend Babe Ruth. 7. Baseball legend Ty Cobb. 8. Boxer Rubin Hurricane Carter. 9. Boxer Muhammad Ali. 10. Football player Michael Oher. 11. Boxer Roberto Duran.

Films and Music

Film Musicals

Musical films developed from stage musicals. The first talkie film ***The Jazz Singer*** (1927) was a musical in which Al Jolson sang six songs. Can you the name the following film musicals?

1. James Whale (1936). Magnolia Hawks (Irene Dunne), the naive young daughter of a show boat captain falls in love with the gambler Gaylord Ravenal (Alan Jones) and is thrust into the limelight as the company's new leading lady (Clue: Paul Robeson's *"Ah still suits me"*).
2. Michael Curtiz (1942). George M. Cohan (James Cagney) chats with President Roosevelt and recalls his early days on the stage as singer and dancer (Clue: *"Give My Regards To Broadway"*).
3. Fred Zinnemann (1955). Laurey Williams (Shirley Jones) is courted by two rival suitors, cowboy Curly McLain (Gordon MacRae) and the sinister and frightening farmhand Jud Fry (Rod Steiger) (Clue: *"Oh What a Beautiful Morning"*).
4. Charles Walters (1956). Jazz musician C. K. Dexter (Bing Crosby) wants to marry his ex-wife Tracy Lord (Grace Kelly) but she has two more suitors (Clue: *"Who wants to be a millionaire"*).
5. Jerome Robbins, Robert Wise (1961). In New York, rival street gangs battle for supremacy. When white Tony (Richard Beymer) of the Jets and the Puerto Rican Maria (Natalie Wood) of the Sharks fall in love, the gangs are not happy about it *(Clue: "Maria")*.
6. George Cukor (1964). Prof. Higgins (Rex Harrison) trains a Cockney flower seller Eliza Dolittle (Audrey Hepburn) to be a lady (Clue: *"Wouldn't It Be Loverly"*).

7. Ken Hughes (1968). An eccentric inventor Caractacus Potts (Dick Van Dyke) transforms a piece of junk into a flying car in which he and his children fly to the faraway land of Vulgaria (Clue: *"Doll on a Music Box"*).
8. Carol Reed (1968). A young orphan runs away from an orphanage and hooks up with a group of boys trained to be pickpockets by an elderly Fagin (Ron Moody) (Clue: *"Food. Glorious Food"*).
9. Robert Stevenson (1964). A magical nanny (Julie Andrews) brings the dysfunctional Banks family together using songs and magic (Clue: *"Chim Chim Cher-ee"*).
10. Norman Jewison (1971). Russian milkman Tevye (Topol) has five daughters and wants them to marry in the traditional Jewish way but destiny has other plans (Clue: *"If I were a rich man"*).
11. Ken Russel (1975). A young boy becomes blind, deaf and dumb when he sees his father being murdered. Growing up, Tommy (Roger Daltry) finds happiness in playing pinball (Clue: *"Pinball Wizard"*).
12. John Badham (1977): Tony Manero (John Travolta), a working-class young man spends his weekends dancing (Clue: *"Stayin' Alive"*).
13. Herbert Ross (1984). Ren McCormack (Kevin Bacon) moves from Chicago to a small Midwestern town, where, to his shock, rock music and dancing are illegal (Clue: *"Holding out for a hero"*).
14. Baz Luhrman (2001). In Paris poet Christian (Ewen McGregor) falls in love with the cabaret artiste Satine (Nicole Kidman), who is also coveted by the rich Duke (Richard Roxburgh) (Clue: David Bowie's *"Nature Boy"*).
15. Rob Marshall (2002). Both Velma Kelly (Catherine Zeta-Jones) and Roxie (Renee Zelwegger) have blood on their hands, both are hoping that Billy Flynn (Richard Gere), the slimy lawyer, can free them from prison (Clue: *"All that Jazz"*).
16. Julie Taymor (2007). Liverpudlian Jude (Jim Sturgess) visits America to meet his father and falls in love with upper-class Lucy (Evan Rachel Wood) who is involved in anti-war and social protests of the 60s.
17. Tom Hooper (2012). In prison for 19 years, Jean Valjean (Hugh Jackman), breaks parole to become a respectable business

man and a pillar of society. He adopts a factory worker's daughter, Cosette (Anne Hathaway). However, ruthless police officer Javert (Russel Crowe) vows to bring Valjean back to prison (Clue: *"Look Down"*).
18. Damien Chazelle (2016). Aspiring actress Mia (Emma Stone) and jazz pianist Sebastian (Ryan Gosling) are struggling in their careers.
19. Will Gluck (2014). A 10-year-old orphan (Quvenzhané Wallis) is adopted by millionaire Will Stack (Jamie Foxx).

Answers: 1. *Show Boat.* 2. *Yankee Doodle Dandy.* 3. *Oklahoma.* 4. *High Society.* 5. *West Side Story.* 6. *My Fair Lady.* 7 *Chitty-Chitty-Bang-Bang.* 8. *Oliver!* 9. *Mary Poppins.* 10. *Fiddler on the Roof.* 11. *Tommy.* 12. *Saturday Night Fever* 13. *Footloose.* 14. *Moulin Rouge.* 15. *Chicago.* 16. *Across the Universe.* 17. *Les Miserables* 18. *La la Land* 19. *Annie.*

Musical Score in Films-I

The Assassination of the Duke de Guise (1908) was one of first films to feature an original film score. The score was composed by the famous French composer Charles-Camille Saint-Saëns (1835). Match the film with its music composer:

	Film	Composer
1	Merian C Cooper's **King Kong** (1933) starring Fay Wray	Sergie Prokofiev
2	Michael Curtiz' **The Adventures of Robin Hood** (1938) starring Errol Flynn	Erich Wolfgang Korngold
3	Sergei Eisenstein's **Ivan the Terrible, Part I** (1944, Ru) starring Nikolay Cherkasov	Anton Karas (uncredited)
4	Laurence Olivier's **Henry V** (1944) starring Laurence Olivier	Sir William Walton
5	Alfred Hitchcock's **Spellbound** (1945) starring Gregory Peck	Charles Chaplin
6	Carol Reed's **The Third Man** (1949) starring Joseph Cotten	Max Steiner
7	Charles Chaplin's **Limelight** (1952) starring Charles Chaplin	Miklos Rozsa
8	Satyajit Ray's **Pather Panchali** (1955, Bn) starring Subir Bannerjee	Ravi Shankar

	Film	Composer
9	Satyajit Ray's *Jalsagar* (1958, Bn) starring Chabbi Biswas	Ustad Vilayat Khan
10	Loius Malle's *Elevator to the Gallows* (1958)	Miles Davis
11	Alfred Hitchcock's *Psycho* (1960) starring Janet Leigh	Henry Mancini
12	Blake Edwards' *Breakfast at Tiffany's* (1961) starring Audrey Hepburn	Bernard Herrmann
13	J. Lee Thompson's *The Guns of Navarone* (1961) starring Gregory Peck	Dimitri Tiomkin
14	Terence Young's *Dr. No* (1962) starring Sean Connery	Monty Norman

Answers: *1. Max Steiner. 2. Erich Wolfgang Korngold. 3. Sergie Prokofiev. 4. Sir William Walton 5. Miklos Rozsa. 6. Anton Karas. 7. Charles Chaplin. 8. Ravi Shankar. 9. Ustad Vilayat Khan. 10. Miles Davis. 11. Bernard Herrmann. 12. Henry Mancini. 13. Dimitri Tiomkin. 14. Monty Norman.*

Musical Score in Films-II

Maurice Jarre scored the music for David Lean's *Lawrence of Arabia* (1962) starring Peter O' Toole.
Match the film with its music composer:

	Film	Film Composer
1	Grigoriy Kozintsev's *Hamlet* (1964) starring Innokenti Smoktunovsky	Ryuichi Sakamoto
2	Sergio Leone's *Once Upon a Time in the West* (1968) starring Henry Fonda	Ennio Morricone
3	Ralph Nelson's *Charly* (1968) starring Cliff Robertson	Nino Rota
4	Francis Ford Coppola's *Godfather II* (1974) starring Robert De Niro	Ravi Shankar
5	John G. Avildsen's *Rocky* (1976) starring Sylvester Stallone	Bill Conti
6	Hugh Hudson's *Chariots of Fire* (1981) starring Ben Cross	John Williams
7	Steven Spielberg's *The Color Purple* (1985) starring Whoopi Goldberg	Quincy Jones
8	Bernardo Bertolucci's *The Last Emperor* (1987)	Dmitri Shostakovich

	Film	Film Composer
9	Francis Ford Coppola's *Godfather III* (1990) starring Al Pacino	Carmine Coppola
10	Richard Attenborough's *Chaplin* (1992) starring Robert Downey Jr.	John Barry
11	Walter Hill's *Geronimo: An American Legend* (1993) starring Wes Studi	Ry Cooder
12	Steven Spielberg's *Jurassic Park* (1993) starring Liam Neeson	Vangelis
13	Robert Zemeckis' *Forrest Gump* (1994) starring Tom Hanks	Alan Silvestri

Answers: 1. Dmitri Shostakovich. 2. Ennio Morricone. 3. Ravi Shankar. 4. Nino Rota. 5. Bill Conti. 6. Vangelis. 7. Quincy Jones. 8. Ryuichi Sakamoto. 9. Carmine Coppola. 10. John Barry. 11. Ry Cooder. 12. John Williams. 13. Alan Silvestri.

Musical Score in Films III

Gabriel Yared composed the music for Anthony Minghella's *The English Patient* (1996) starring Ralph Fiennes. Match the film with its music composer:

	Film	Film Composer
1	Martin Scorsese's *Kundun* (1996) starring Tenzin Thuthob Tsarong	A. R. Rahman
2	Barry Levinson's *Wag the Dog* (1997) starring Dustin Hoffman	Hans Zimmer
3	Roberto Benigni's *Life is Beautiful* (1997) starring Roberto Benigni	Nicola Piovani
4	Sam Raimi's *Spider-Man* (2002) starring Tobey Maguire.	Danny Elfman
5	Paul Thomas Anderson's *There Will Be Blood* (2007) starring Daniel Day-Lewis	Jonny Greenwood
6	Martin Scorsese *Hugo* (2011) starring Asa Butterfield	Howard Shore
7	Terence Malik's *The Tree of Life* (2011) starring Brad Pitt	Nitin Sawhney
8	Gore Verbinski's *The Lone Ranger* (2013) starring Johnny Depp	Mark Knopfler
9	John Lee Hancock's *Saving Mr Banks* (2013) starring Tom Hanks	Thomas Newman

	Film	Film Composer
10	Jeff Zimbalist's *Pelé: Birth of a Legend* (2016)	Phillip Glass
11	Andy Serkis' *Mowgli: Legend of the Jungle* (2018)	Alexandre Desplat

Answers: Phillip Glass. 2. Mark Knopfler. 3. Nicola Piovani. 4. Danny Elfman. 5. Jonny Greenwood. 6. Howard Shore. 7. Alexandre Desplat. 8. Hans Zimmer. 9. Thomas Newman. 10. A. R. Rahman. 11. Nitin Sawhney.

Theme songs - Vocals

"Singin' in the rain" the theme song of *Singin' in the Rain* (1952) was sung by Gene Kelly. Who sang the following theme songs?

1. "When you wish upon a star", **Pinocchio** (1940).
2. "Georgy Girl", **Georgy Girl** (1966).
3. "Un Homme et une Femme", **A Man and a Woman** (1966, Fr).
4. "To Sir with Love",**To Sir with Love** (1967).
5. "Mrs Robinson", **The Graduate** (1967).
6. Theme from Shaft, **Shaft** (1971).
7. "Gonna Fly Now", **Rocky** (1976). (Comp. Bill Conti).
8. "Stayin' Alive", **Saturday Night Fever** (1977).
9. "Eye of the tiger", **Rocky III**. (1982).
10. "What a Feeling", **Flashdance** (1983).
11. "Ghostbusters", **Ghostbusters** (1984).
12. "Highway to the danger zone", **Top Gun** (1986).
13. "(I've had) The time of my life", **Dirty Dancing** (1987).
14. "I will always love you", **Body guards** (1992).
15. "Will you be there?" **Free Willy** (1993).
16. "Gangsta Paradise", **Dangerous minds** (1995).
17. "My Heart Will Go On", **Titanic** (1997).

Answers: Cliff Edwards. 2. The Seekers. 3. Nicole Croisille and Pierre Barouh. 4. Lulu. 5. Simon and Garfunkel. 6. Issac Hayes. 7. DeEtta West and Nelson Pigford. 8. BeeGees. 9. Survivors. 10. Irene Cara. 11. Ray Parker Jr. 12. Kenny Loggins. 13. Bill Medley, Jennifer Warnes. 14. Whitney Houston. 15. Michael Jackson. 16. Coolio. 17. Celine Dion.

Theme songs – Instrumentals

Ari's Theme from Otto Preminger's **Exodus** (1960) was composed by Ernest Gold. Who composed the following theme songs?

1. James Bond (1962).
2. **From Russia with Love** (1963).
3. **Walk On The Wild Side** (1962).
4. **The Pink Panther** (1963).
5. **For A Few Dollars More** (1965).
6. **Un Homme Et Une Femme (A Man and a Woman)** (1966, Fr).
7. **The Good, the Bad and the Ugly** (1966).
8. Thus Spoke Zarathustra, **2001 A Space Odyssey** (1968).
9. Godfather's Theme, **Godfather** (1972).
10. Darth Vader's theme, aka The Imperial March **Star Wars** (1977).
11. Raiders March **Indiana Jones and the Raiders of the Lost Arc** (1981).

Answers: Monty Norman/John Barry. 2. John Barry. 3. Elmer Bernstein. 4. Henry Mancini. 5. Ennio Morricone. 6. Francis Lai. 7. Ennio Morricone. 8. Richard Strauss. 9. Nino Rota. 10. John Williams. 11. John Williams.

Opera in Films

Richard Wagner's "Ride of the Valkyries" appears in the soundtrack of **Apocalypse Now** (1979). Match the opera with the film in which it appears.

	Opera	Film
1	*La Boheme* by Giacomo Puccini	Wall Street (1987)
2	*Rigoletto* by Giuseppe Verdi	Slumdog Millionaire (2008)
3	*La Traviata* (The Fallen Woman) by Giuseppe Verdi	Godfather III (1990)
4	*Cavalleria Rusticana* (Rustic Chivalry) by Pietro Mascagni	Pretty Woman (1990)
5	*Faust* by Charles Gounod	Life is beautiful (1997).
6	*Marriage of Figaro* by Mozart	Shawshank Redemption (1994)
7	*Tales of Hoffman* by Giacomo Offenbach	The Age of Innocence (1993)
8	Orphée et Eurydice by Christoph Willibald Gluck	Moonstruck (1987)

Answers: *1. Moonstruck (1987). 2. Wall Street (1987). 3. Pretty Woman (1990). 4. Godfather III (1990). 5. The Age of Innocence (1993). 6. Shawshank Redemption (1994). 7. Life is beautiful (1997). 8. Slumdog Millionaire (2008).*

Classical Music in Films

Rachmaninoff's Piano Concerto No. 2 for Piano and Orchestra appears in the soundtrack *of Brief Encounter* (1945). Match the classical music piece with the film in which it occurs.

	Film	Classical Piece
1	Manhattan (1979)	Carl Orff's Carmina Burana
2	Ace Ventura: Pet Detective (1994)	Beethoven's Symphony No. 7: II. Allegretto
3	Misery (1990)	Beethoven's Piano Sonata No. 14 (Moonlight)
4	Atonement (2007)	Mozart's Eine Kleine Nachtmusik: II. Andante
5	The King's Speech (2010)	Debussy's Clair de Lune
6	The Doors (1991)	George Gershwin's Rhapsody in Blue

Answers: *1. George Gershwin's Rhapsody in Blue. 2. Mozart's Eine Kleine Nachtmusik: II. Andante. 3. Beethoven's Piano Sonata No. 14 (Moonlight). 4 Debussy's Clair de Lune (from Suite Bergamasque. 5. Beethoven's Symphony No. 7: II. Allegretto. 6. Carl Orff's Carmina Burana*

Songs-Male

"Ol' Man River" from the musical film **Show Boat** (1936) was sung by the African-American singer and actor Paul Robeson. Match the film song with its singer.

S.No	Song from Film	Singer
1	As Time Goes By, **Casablanca** (1942)	Fred Astaire
2	Stepping Out With My Baby, **Easter Parade** (1948)	Dooley Wilson
3	Jailhouse Rock **Jailhouse Rock** (1957)	Ron Moody
4	You got to pick a pocket or two, **Oliver** (1968)	Elvis Presley
5	Born to be wild, **Easy Rider** (1969)	Leonard Cohen
6	Sisters of Mercy, **McCabe and Mrs Miller** (1971)	Steppenwolf
7	Footloose, **Footloose** (1984)	Kenny Loggins
8	Fight the Power, **Do the Right Thing** (1989)	Public Enemy
9	(Everything I Do) I Do It for You, **Robin Hood: Prince of Thieves** (1991)	Bruce Springsteen
10	Streets of Philadelphia, **Philadelphia** (1993)	Bryan Adams

Answers: 1. Dooley Wilson. 2. Fred Astaire. 3. Elvis Presley. 4. Ron Moody. 5. Steppenwolf. 6. Leonard Cohen. 7. Kenny Loggins. 8. Public Enemy. 9. Bryan Adams. 10. Bruce Springsteen.

Songs-Female

"Someday My Prince Will Come" from the Disney's animated film **Snow White and the Seven Dwarfs** (1937) was sung by Adriana Caselotti. Match the film song with its singer.

S.No.	Song	Singer
1	Somewhere Over the Rainbow, **The Wizard of Oz** (1939)	Carmen Miranda
2	Chica, Chica, Boom, Chic, **That Night in Rio** (1941)	Judy Garland
3	Diamonds are a girl's best friend, **Gentlemen prefer Blondes** (1953)	Audrey Hepburn/ Marni Nixon
4	Secret Love, **Calamity Jane** (1953)	Doris Day
5	There's No Business Like Show Business, **There's No Business Like Show Business** (1954)	Ethel Merman
6	Summertime, **Porgy and Bess** (1959)	Loulie Jean Norman
7	Moon River, **Breakfast at Tiffany's** (1961)	Audrey Hepburn

S.No.	Song	Singer
8	Supercalifragilisticexpialidocious, **Mary Poppins** (1964)	Julie Andrews
9	I Could Have Danced All Night, **My Fair Lady** (1964)	Marilyn Monroe
10	My favorite things, **The Sound of Music** (1965)	Julie Andrews
11	Nine to Five, **9 to 5** (1980)	Dolly Parton
12	Wind Beneath My Wings, **Beaches** (1988)	Bette Midler

Answers: 1. Judy Garland. 2. Carmen Miranda. 3. Marilyn Monroe. 4. Doris Day. 5. Ethel Merman. 6. Loulie Jean Norman. 7. Audrey Hepburn. 8. Julie Andrews. 9. Audrey Hepburn/ Marni Nixon. 10. Julie Andrews. 12. Dolly Parton. 12. Bette Midler.

Songs-Duets and Groups

"If I Only Had a Brain" from **The Wizard of Oz** (1939) was sung by Judy Garland & Ray Bolger. Match the film song with its singers.

S.No	Song	Singers
1	I am Hans Christian Anderson, **Hans Christian Anderson** (1952)	Gordan McCray, Shirley Jones
2	The Surrey with the fringe on top, **Oklahoma** (1955)	Charles Vidor & Danny Kaye
3	Rock Around the Clock, **Blackboard Jungle** (1955)	Topol, Norma Crane & others
4	Well, Did You Evah, **High Society** (1956)	Bing Crosby & Frank Sinatra
5	That's Jazz, **High Society** (1956)	George Rose & Chorus
6	The rain in Spain stays mainly in the plain, **My Fair Lady** (1956)	Audrey Hepburn & Rex Harrison
7	Sunrise, Sunset, **Fiddler on the Roof** (1971)	Bill Haley & the Comets
8	To dream the Impossible Dream, **Man of La Mancha** (1972)	Peter O'Toole, Sophia Loren & James Coco
9	I Am the Very Model of a Modern Major-General, **The Pirates of Penzance** (1983)	Bing Crosby & Louis Armstrong
10	Take my breath away, **Top Gun** (1986)	Wet Wet Wet
11	Love Is All Around, **Four Weddings and a Funeral** (1994)	Berlin
12	You'll Be in My Heart, **Tarzan** (1999)	Phil Collins & Glenn Close

Answers: 1. Charles Vidor, Danny Kaye. 2. Gordan McCray, Shirley Jones. 3. Bill Haley and the Comets. 4. Bing Crosby, Frank Sinatra. 5. Bing Crosby, Louis Armstrong. 6. Audrey Hepburn, Rex Harrison. 7. Topol, Norma Crane and others. 8. Peter O'Toole, Sophia Loren, James Coco. 9. George Rose and Chorus. 10. Berlin. 11. Wet Wet Wet. 12. Phil Collins, Glenn Close.

Mixed Bag- Songs

The song "It's a Small World" was composed by the Sherman brothers for Walt Disney in 1963. It is arguably the single most performed and most widely translated song on earth. The song tune and lyrics are the only Disney creations never to be copyrighted, as UNICEF requested. It can be heard all over the world on musical devices ranging from keyboard demos to ice cream trucks.

Can you identify the following songs?

1. This song written by Mildred J. Hill and Patty S. Hill is heard in many films.
2. For which song from **Mary Poppins** (1964) did brothers Richard M. Sherman and Robert B. Sherman win an Oscar for Best Music, Original Song?
3. This iconic song is played in the background when the character runs up the 72 stone steps leading to the Philadelphia Museum of Art in Philadelphia and raises his arms in a victory pose. It became so popular that it was used in all the movies of the series. Which is this song (whose lyrics are only 30 words long) nominated for an Academy Award for Best Original Song?
4. This song was the first choice of the director Sylvester Stallone as theme song for **Rocky III** (1982). However, Queen refused to give permission. As the result *"Eye of the tiger"* by Survivors became the theme song and was later nominated for an Academy Award for the best original song.
5. In **Groundhog Day** (1993) this song was Phil Connors (Bill Murray) alarm at 6 am every morning.

Answers: "Happy Birthday to You". 2. "Chi Chim Cher-ee". 3. "Gonna Fly Now". 4. "Another one bites the dust". 5. "I've Got You Babe" by Sonny and Cher

Mixed Bag - Music

Theremin is an electronic musical instrument invented by Russian Léon Theremin. The player creates sounds without physical contact with the instrument. Composer Miklós Rózsa pioneered the use of the instrument in films like **Spellbound** (1945) and **The Lost Weekend** (1945). It was used in **The Day the Earth Stood Still** (1951) by Bernard Herrmann.

1. This frequency modulation (FM) synthesizer was very popular in the 80s. The concept was developed in the 1960s by John Chowning at Stanford University, California. In 1975, Yamaha negotiated exclusive rights for the technology. What was it called? Yamaha DX7
2. This soparano dubbed the singing voice of Anna (Deborah Kerr) in **The King and I** (1956), Maria (Natalie Wood) in **West Side Story** (1961), and Eliza (Audrey Hepburn) in **My Fair Lady** (1964).
3. In **Fastasia** (1940), who conducts classical orchestral pieces such as The Nutcracker Suite (Tchaikovsky) and The Rites of Spring (Stravinsky).
4. These brothers were born in 1925 and 1928. Both were hired as Staff Songwriters for Walt Disney Studio. They wrote the lyrics and music of **Mary Poppins** (1964), **The Jungle Book** (1964), and **Chitti Chitti Bang Bang** (1968). In 1965, the brothers won two Academy Awards for **Mary Poppins** (1964).
5. This composer, who died in 2019, won Oscars for Best Scoring of Music—adaptation or treatment — for **Irma Da Douce** (1963) and **My Fair Lady** (1964).
6. The score of **Midnight Express** (1978) won the Academy Award for Best Original Score in 1979.
7. Born in 1964 in California. In addition to writing the musical score of **The Usual Suspects** (1995), **Superman Returns** (2006),

Valkyrie (2008) and ***Bohemian Rhapsody*** (2018), he also edited the films.

Answers: 1. Yamaha DX7. 2. Marni Nixon. 3. Leopold Stokowski. 4. Richard M. Sherman and Robert B. Sherman. 5. Andre Previn. 6. Italian synth-pioneer Giorgio Moroder. 7. John Ottman.

Great Films

The Wizard of Oz (1939)

The Wizard of Oz may be the most watched movie in film history. It was based on L. Frank Baum's novel *The Wonderful Wizard of Oz*, written in 1900.

1. Who plays the role of Dorothy Gale?
2. Which role is played by Margaret Hamilton?
3. Who wears the ruby slippers belonging to the Wicked Witch of the East?
4. Which US state does Dorothy come from?
5. Where does the tornado transport Dorothy's house to?
6. What does Fiyero the Scarecrow want?
7. Who plays the role of the Scarecrow?
8. What does the Tin Woodman want?
9. What does the Cowardly Lion want?
10. Who plays the role of The Cowardly Lion?
11. Where does the Wizard of Oz live?
12. Who became the film director when Victor Fleming left **The Wizard** to direct **Gone with the Wind**?

Answers. Judy Garland. 2. The Wicked Witch of the West (Miss Gulch). 3. Dorothy. 4. Kansas. 5. Muchkinland in the Land of Oz. 6. Brain. 7. Ray Bolger. 8. Heart. 9. Courage. 10. Bert Lahr. 11. Emerald City. 12. King Vidor.

The Rules of the Game (1939)

Jean Renoir's *La Règle du Jeu*, the most expensive French film of its time, was a critical and financial disaster. In October 1939, it was banned by the wartime French government. Since then, **The Rules of the Game** has often been called one of the greatest films in the history of cinema. The plot of the film is based on a virtuous wife, a jealous husband, a despairing lover and an interceding friend.

1. Who was the French poet and dramatist whose play *Les Caprices de Marianne* inspired the film?
2. Which famous fashion designer designed the costumes for the film?
3. Which famous still photographer worked as an assistant director to Jean Renoir for this film?
4. Who played the role of Robert, the Marquis de la Chesnaye, who invites his guest to his country estate?
5. Who played the role of Octave, the buffon who is accidently killed?

Answers: *Alfred de Musset. 2. Coco Chanel. 3. Henri Cartier-Bresson. 4. Marcel Dalio. 5. Jean Renoir.*

Gone with the Wind (1939)

Gone with the Wind was based on Margaret Mitchell's novel of the same name published in 1936. The film was produced by David O. Selznick. It was directed by Victor Fleming, who won the Academy award for best director.

1. Which period of the American history does the film depict?
2. Name the English actress who played the role of Scarlet O' Hara, for which she won an Oscar?
3. Who played the role of Ashley Wilkes, who is the object of Scarlet's romantic pursuit?
4. Who played the role of Scarlet's cousin Melanie Hamilton who is married to Ashley?
5. Who plays the role of Rhett Butler?

6. Who composed the musical score of the film?
7. Hattie MacDonald won the academy award for the best supporting actress for her role. Why was this significant?
8. What is the name of the O' Haras' cotton plantation in Georgia?
9. What is the name of the Wilkes's plantation?
10. In the 12th Academy awards ceremony, the film was nominated for 13 categories. How many did it win?

Answers: *The American Civil war. 2. Vivien Leigh. 3. Lesley Howard. 4. Olivia De Havilland. 5. Clark Gable. 6. Max Steiner. 7. First Afro-American to win an Oscar. 8. Tara. 9. Twelve Oaks. 10. Eight.*

Citizen Kane (1941)

In 1998, Citizen Kane (1941) was voted the greatest American film of all times. Twenty-five years old Orson Welles produced, directed, acted and co-wrote the screenplay of this film, which was also his first feature film. The film tells the rise and fall of Charles Forster Kane. Though the film ranks in top 10 films of most lists, the only one Oscar it won was for Best Writing (Original Screenplay).

1. On whom was the character of Charles Forster Kane is said to have been based?
2. What is the last word spoken by the dying Kane?
3. What is the name of Kane's extravagant mansion?
4. The character of Susan Alexander, Kane's wife, was based on a film actress and mistress of William Randolf Hearst. Who was she?
5. What is the name of the opera that Kane finances so that his wife Susan can sing in it?
6. Who was the debutant composer who scored for Citizen Kane?
7. With whom did Orson Welles share his Oscar for Best Writing (Original Screenplay)?

Answers: *Newspaper magnate William Randolf Hearst. 2. Rosebud. 3. Xanadu. 4. Marion Davis. 5. Salammbo. 6. Bernard Herrmann. 7. Herman J. Mankiewicz.*

Casablanca (1942)

According to Roger Egbert, Casblanca figures in more greatest film lists than any other film. Cynical Rick Blaine (Humphrey Bogart) runs a nightclub in Casablanca, Morocco, where a former lover of his, Ilsa Lund (Ingrid Bergman), and her husband Viktor Laslo (Paul Henreid) walk in.

1. Producer Hal B. Wallis chose a Hungarian Jewish émigré as the director. Who was he?
2. What is the name of the nightclub run by Rick?
3. Who composed the musical score of the film?
4. This 1962 film starring Woody Allen owes a lot to Casablanca, including its title which is borrowed from a misquotation from Casablanca. Humphrey Bogart (Jerry Lacy) is a character in the film who advises Allan (Woody Allen).
5. The title of this 1995 gangster film is borrowed from a memorable line in Casablanca spoken by Captain Louis Renault (Claude Rains).
6. Michael Curtiz won the Academy Award for Best Director. In which category did brothers Julius and Philip Epstein and Howard Koch win the Academy Award?
7. Name the film's cinematographer who had also worked in films like **All Quiet on the Western Front** (1930) and **The Maltese Falcon** (1941)?

Answers: 1. Michael Curtiz. 2. Café Américain. 3. Max Steiner. 4. Play it again, Sam. 5. The Usual Suspects. 6. Best Writing Screenplay. 7. Arthur Edeson.

The Sound of Music (1965)

The 1965 film is set in Austria of 1930s and is an adaptation of the 1959 Broadway musical of the same name. The musical was based on Maria Von Trapp's 1949 memoir, *The Story of the Von Trapp Family Singers*.

1. This film revived the fortune of 20th Century Fox after it was reeling under its massive flop made in 1963..
2. Who composed the Broadway musical on which the film was based?

3. Who won the Oscar for Best Music score?
4. Apart from The best Picture Oscar, **The Sound of Music** (1965) also won the Best Director award. Who directed the musical?
5. Who plays the role of Capt. von Trapp?
6. Who plays the role of the nun Maria?

Answer: 1. Cleopatra. 2. Richard Rodgers with lyrics by Oscar Hammerstein II. 3. Irving Kostal. 4. Robert Wise. 5. Christopher Plummer. 6. Julie Andrews.

The Godfather Trilogy (1972, 1974, 1990)

The Godfather (1972) is based on the 1969 novel of the same name by Mario Puzo. Directed by Francis Ford Coppola, it is widely regarded as one of the greatest gangster films of world cinema.

1. What is the real name of Vito Corleone?
2. Who plays the role of Sonny, Vito Corleone's son?
3. Who plays the role of Fredo, Michael's brother?
4. Who played the role of Connie, Vito Corleone's daughter?
5. Who plays the role of Vito Corleone's adopted son and the consigliere Tom Hagen?
6. Who plays the role of Michael, Vito Corleone's youngest son?
7. Who plays the role of Kay Adam, Michael's girlfriend and later his wife?
8. What is the name of Vito Corleone's godson who is a singer?
9. The character of Johnny Fontane is based on which singer?
10. On whom was the character of movie mogul Jack Woltz based?
11. Why did Al Pacino boycott the academy award ceremony?
12. Who played the role of Vito Corleone in **Godfather II** (1974)
13. Like **The Godfather**, the sequel was nominated in 11 categories for Academy award. How many did it win?
14. Peter Clemenza was one of the two friends of Vito who were his partners in crime initially. Who was the other?
15. What is the first business venture of Vito Corleone?
16. Who is the dictator of Cuba when Michael meets Roth in Cuba, in late 1958?

17. Who wrote the screenplay for **Godfather III** (1990)?
18. How does Don Altobello die?
19. Who plays the role of Vincent Mancini Corleone, Sonny's illegitimate son?
20. Who played the role of Mary, Micheal's daughter?
21. Whose role does Joe Mantegna plays in the movie?
22. The final scenes of **The Godfather Part III** were filmed in the third largest opera house of Europe. Which one?
23. **Godfather III** was nominated for seven Academy awards. How many did it win?

Answers: Vito Andolini. 2. James Caan. 3. John Cazale. 4. Talia Shire. 5. Robert Duvall. 6. Al Pacino. 7. Diane Keaton. 8. Johnny Fontane. 9. Frank Sinatra. 10. Columbia Picture's president Harry Cohn. 11. He felt he should have been nominated for Best Actor award and not best supporting actor award. 12. Robert De Niro. 13. Six. 14. Salvatore Tessio. 15. Genco Pura Olive Oil. 16. Fulgencio Batista. 17. Coppola and Mario Puzo. 18. By eating poisoned cannelloni. 19. Andy Garcia. 20. Sofia Coppola. 21. Joey Zasa. 22. Teatro Massimo in Palermo, Sicily. 23. None.

Star Wars trilogy (1977, 1980, 1983)

Star Wars (1977) was written and directed by George Lukas. It was re-titled and re-released as **Star Wars: Episode IV – A New Hope** in 1981. **Star Wars: Episode V: The Empire Strikes Back** was released in May 1980. The final film in the trilogy, **Episode VI: Return of the Jedi** was released in 1983.

1. In **Star Wars,** who played the role of Princess Leia?
2. Who lived in the remote planet of Tatooine?
3. C3PO was based on the robot Maria from the famous German science fiction film directed by Fritz Lang in 1927. Name the film.
4. What is Darth Vader's signature theme?
5. Who composed the music for **Star Wars**?
6. **Star Wars** became a cultural phenomenon, but it still lost Best Picture at the 1978 Academy Awards. Which film did it lose to?

7. Who played the role of Darth Vader?
8. The 7-foot-2-inch tall Peter Mayhew played which character in the film?
9. Who are the hirsute humanoids who come from the planet Kashyyyk and speak the Shyriiwook. Language.
10. Who is revealed to be Luke Skywalkers's father?
11. George Lukas based the character of Hans Solo on one of his friends. Who?
12. Who was the cinematographer of Star Wars?
13. Who directed the **Episode V: The Empire Strikes Back** (1980)?
14. What dress did Carrie Fisher wear as Princess Leia in Jabba's palace in **The Return of the Jedi**?
15. What is the energy sword which is signature weapon of the Jedi Order called?

Answers: Carrie Fischer. 2, Luke Skywalker. 3. Metropolis. 4. The Imperial March. 5. John Williams. 6. Annie Hall. 7. David Prowse. 8. Chewbacca. 9. Wookiees. 10. Darth Vader. 11. Francis Ford Coppola. 12. Gilbert Taylor. 13. Irving Kershner. 14. Metal Bikini. 15. The lightsaber.

Rocky (1976, 1979, 1982, 1985)

Rocky (1976) was based on the lives of two boxers Chuck Wepner and Rocky Marciano. Sylvester Stallone played the role of the boxer Rocky Balboa. It was directed by John G Avildsen.

1. Name the city where the movie was shot.
2. Who was the World Heavyweight Champion boxer against whom Rocky agrees to fight?
3. Who played the role of Apollo Creed?
4. The character of Apollo Creed was based on which boxer?
5. Who plays the role of Adrian Pennino, Rocky's love interest and wife?
6. Who plays the role of Paulie, Adrian's Italian brother?
7. Who plays the role of Mickey, Rocky's trainer?
8. Who directed **Rocky II** (1979)?
9. In **Rocky II**, what is Rocky's real first name?
10. What is the novel that Rocky reads out to Adrian in hospital?

11. James "Clubber" Lang knocks out Rocky in **Rocky III** (1982) in the second round, making him lose his title. Who plays the role of Clubber Lang?
12. Who plays the role of wrestling champion Thunderlips with whom Rocky agrees to a charity match?
13. In **Rocky IV** (1985) name the Russsian boxer against whom Rocky fights after he killed Apollo Creed.
14. Who plays the role of Duke, the trainer of Creed and then of Rocky?
15. Where does Rocky agree to fight the Siberian Express Drago?
16. Who plays the role of the Russian Ivan Drago?
17. Who plays the role of Ivan Drago's wife Ludmilla Drago?

Answers: 1. *Philadelphia, Pennsylvania.* 2. *Apollo Creed.* 3. *Carl Weathers.* 4. *Muhammad Ali.* 5. *Talia Shire.* 6. *Burt Young.* 7. *Burgess Meredith.* 8. *Sylvester Stallone.* 9. *Robert.* 10. *The Deputy Sheriff of Comanche County by Edgar Rice Burroughs.* 11. *Mr.T.* 12. *Hulk Hogan.* 13. *Ivan Drago.* 14. *Tony Burton.* 15. *Moscow.* 16. *Dolph Lundgren.* 17. *Brigitte Nielsen.*

Genres of Films

The Westerns

Wide and wild open landscape, tough men on horses quick to draw their Colts were the stuff of the Westerns. Can you identify the following Westerns?

1. John Ford (1946). Town marshal Wyatt Earp (Henry Fonda) vows to track down his brother's killers. He kills Billy Clanton (John Ireland), leading to the famous shoot-out at the OK Corral with the Clantons, in which he is assisted by Doc Holliday (Victor Mature).
2. Fred Zinneman (1952). Marshal Will Kane (Gary Cooper) has to face his enemies alone as his fellow townspeople refuse to help him.
3. George Stevens (1953). Gunslinger Shane (Alan Ladd) wants to settle down peacefully as a farmhand. He takes a job on a homesteader's farm, but is drawn into a battle between the townsfolk and ruthless cattle baron Rufus Ryker (Emile Meyer).
4. John Ford (1962). Senator Ransom Stoddard (James Stewart), famous for killing a notorious outlaw, returns for the funeral of Tom Doniphon (John Wayne) and reveals that it was Tom who had killed the ruffian Liberty Valance (Lee Marvin).
5. Harold Hawks (1959). Sheriff John T. Chance (John Wayne) enlists the help of a drunkard Dude (Dean Martin) and a young gunfighter Colorado Ryan (Ricky Nelson) to hold in jail the brother of the local bad guy.
6. John Sturges (1960). Seven gunmen are hired to protect a Mexican village from bandit Calvera (Eli Wallach). Among them are veteran gunslinger Chris (Yul Bryner), Vin (Steve

McQueen), Bernardo O'Reilly (Charles Bronson) and Britt (James Coburn).
7. Sergio Leone (1966). During the American Civil War, Blondie (Clint Eastwood), Angel Eyes (Lee Van Cleef) and Tuco the Rat (Eli Wallach) set off to find gold coins buried in a cemetery.
8. Sam Peckinpah (1969). An outlaw gang led by Pike Bishop (William Holden) tries to rob a railroad office and fails. The gang then moves to Mexico to do one last job.
9. J Lee Thompson (1969). Marshal Mackenna (Gregory Peck) is taken hostage by ruthless Mexican outlaw John Colorado (Omar Sharif), who believes that the sheriff knows about the fabled canyon of gold, the Cañón del Oro.
10. Henry Hathaway (1969). Mattie Ross (Kim Darby) recruits tough old marshal Rooster Cogburn (John Wayne) to avenge her father's death.
11. Andrew Dominik (2007). Robert Ford (Casey Affleck) joins the gang of his idol, outlaw Jesse James (Brad Pitt) and shoots him dead.
12. George P. Cosmatos, (1993) Wyatt Earp (Kurt Russel) and Doc Holliday (Val Kilmer) have a showdown with a band of outlaws led by the Clanton brothers.

Answers: 1. *My Darling Clementine*. 2. *High Noon*. 3. *Shane*. 4. *The Man who shot Liberty Valence*. 5. *Rio Bravo*. 6. *The Magnificent Seven*. 7. *The Good, the Bad and the Ugly*. 8. *The Wild Bunch*. 9. *Mackenna's Gold*. 10. *True Grit*. 11. *The Assassination of Jesse James by the Coward Robert Ford*. 12. *Tombstone*.

War! Bloody War!

The first film to win the Best film Oscar was a war film. Can you identify the following war films?

1. William A. Wellman (1927). Jack Powell (Charles Rogers) and David Armstrong (Richard Arlen), are in love with the same woman, Sylvia (Jobyna Ralston). The two young men both enlist to become combat pilots and end up as fighter pilots in WW1 in the same squadron in France.

2. Raoul Walsh (1941). In 1876, General Custer (Errol Flynn), while leading the 7th Cavalry at the Battle of the Little Big Horn against Native American tribes, is killed along with his entire detachment.
3. Sam Woods (1943). American Richard Jordan (Gary Cooper), fighting for the Republican side in the Spanish Civil war, has been ordered to blow up an important bridge.
4. John Houston (1951). A Union soldier Henry Fleming (Audie Murphy) struggles to find the courage to fight in the heat of battle.
5. Stanley Kubrick (1957). The French generals want to capture the Anthill, a key German-held position on the French-German border in the First World War. Col. Dax (Kirk Douglas) knows that half of his men would die without any guarantee of success. He both leads the doomed charge against the German position and then defend his men for cowardice in the ensuing court-martial.
6. David Lean (1962). British Lieutenant T.E. Lawrence (Peter O' Toole) is sent to Arabia to assist the Arabs in their fight against the Turks in WWI. He organizes a guerrilla army and leads the Arabs in harassing the Turks.
7. Cy Endfield (1964). In South Africa, 150 British troops under the command of Lieutenants Bromhead (Michael Caine) and Chard (Stanley Baker) defend themselves against 4,000 Zulus in one of the most courageous battles in history.
8. Francis Ford Coppola (1979). Captain Willard (Martin Sheen) is sent to assassinate renegade Col. Walter Kurt (Marlon Brando) in the Vietnam War.
9. Edward Zwick (1989). Col. Robert Gould Shaw (Matthew Broderick) of the Union Army leads the first unit of black soldiers in U.S. Army to a suicidal but glorious attack on Fort Wagner in the US Civil War.
10. Ridley Scott (2001). In Somalia's Mogadishu, US Army Rangers plan to capture two top lieutenants of warlord Mohammed Farrah Aidid. However, the mission goes horribly wrong.
11. Zack Snyder (2006). King Leonidas (Gerard Butler) of Sparta and his band of three hundred men fight the Persians under King Xerxes (Rodrigo Santoro) at Thermopylae in 480 B.C.

12. Kathryn Bigelow (2008). Sergeant James (Jeremy Renner) takes over a bomb disposal team in war-torn Iraq. His fellow squad members just want to survive the few days of duty they have, but James' risk-taking drives them all to the edge.

Answers: 1. *Wings.* 2. *They Died with their Boots on.* 3. *For Whom the Bells Toll.* 4. *The Red Badge of Courage.* 5. *Paths of Glory.* 6. *Lawrence of Arabia.* 7. *Zulu.* 8. *Apocalypse Now.* 9. *Glory.* 10. *Black Hawk Down.* 11. *300.* 12. *The Hurt Locker.*

World War II Films

In J. Lee Thompson's Guns of Navarone (1961), an Allied Commando team attempts to destroy two powerful German guns on a Greek island. The team, led by Major Roy Franklin (Anthony Quayle), includes Capt. Keith Mallory (Gregory Peck), Andrea Stavros (Anthony Quinn), and Corporal Miller (David Niven). Can you identify the following films set in the World War II?

1. Ken Annakin, Andrew Marton et al (1962). The Allies troops land on Normandy beaches in France on 6 June 1944 (D-Day). Brig. Gen. Norman Cota (Robert Mitchum), Brig. Gen. Theodore Roosevelt Jr. (Henry Fonda) and Lt. Col. Benjamin Vandervoort (John Wayne) are involved in the landing as a part of the allied attack.
2. Ken Annakin (1965). Lt. Col. Dan Riley (Henry Fonda) is convinced that the Germans will launch a counterattack in Europe. The counter-offensive comes as a fast attack of a secret panzer division under the command of the brilliant German Col. Hessler (Robert Shaw).
3. Robert Aldrich (1967). Twelve military convicts, which include Wladislaw (Charles Bronson), gangster Franko (John Cassavetes), and psychopath Maggott (Telly Savalas), are asked to volunteer for a mission of attacking a fortified and guarded French château being used by the Nazis.
4. Brian G Hutton (1968). British Major Jonathan Smith (Richard Burton) leads a team to rescue American Gen. George

Carnaby (Robert Beatty) whose airplane was shot down over Germany from the Eagle's Castle.
5. Richard Fleischer, Kinji Fukasaku (1970). Though the new Japanese Chief of the Combined Fleet Admiral Yamamoto (Soh Yamamura) is apprehensive of war against US, he orders the planning of a pre-emptive strike at Pearl Harbour.
6. Mike Nichols (1970). Captain John Yossarian (Alan Arkin), a B-25 bombardier, is stationed on a Mediterranean island during World War II. He flies dangerous missions, but after watching his friends die, he seeks a means of escape.
7. Franklin J. Schaffner (1970). Gen. Patton (George C. Scott) takes command of the American army in Tunisia, badly battered by Rommel's Afrika Corps.
8. Richard Attenbrough (1977). Lieutenant General Browning (Dick Bogarde) plans Operation Market Garden, in which men are parachuted behind enemy lines in Netherlands to capture bridges. Among those who participate in the operation are Staff Sergeant Dohun (James Caan), Lt Col. J.O.E. Vandeleur (Michael Caine), Maj. Gen. Urquhart (Sean Connery) and Lt. Gen. Horrocks (Edward Fox).
9. Steven Spielberg (1998). Cpt. Miller (Tom Hanks) leads his squad to bring home Private James Ryan (Matt Damon) after the death of his three brothers. Sgt Horvath (Tom Sizemore) and Private Caparazo (Vin Deisel) are a part of the group.
10. Terence Malik (1998). A group of US soldiers try to snatch an island from the Japanese. US army team included Capt. Staros (Elias Koteas), Pvt. Witt (Jim Caviezel), Sgt Welsh (Sean Penn) and Lt Col Tall (Nick Nolte).
11. Michael Bay (2001). Rafe (Ben Affleck) and Danny (Josh Hartnett) are pilots both in love with Evelyn, a Navy nurse. Their ties are drastically changed after the Japanese attack on Pearl harbour.
12. George Clooney (2014). Frank Stokes (George Clooney) forms a team of men to rescue artistic masterpieces from retreating Nazi.

Answers: *The Longest Day. 2. Battle of the Bulge. 3. The Dirty Dozen. 4. Where Eagles Dare. 5. Tora Tora Tora. 6. Catch 22. 7. Patton. 8. A Bridge*

too Far. 9. *Saving Private Ryan.* 10. *The Thin Red Line.* 11. *Pearl Harbour.* 12. *The Monuments Men.*

Vietnam War

In Michael Cimono's The Deer Hunter (1978), three friends from Pennsylvania, Michael (Robert De Niro), Steven (John Savage) and Nick (Christopher Walken), are called up to serve in Vietnam, with disasterour consequenses. Can you identify the following films based on Vietnam war?

1. Stanley Kubrick (1987). Private Joker (Matthew Modine) finds himself in Vietnam working as a combat journalist where he gets to see the horrors of war first-hand.
2. Barry Levinson (1987). Airman Adrian Cronauer (Robin Williams) arrives in Saigon in 1965 to work as a radio jockey for the US Army. Though his show is an instant hit with the young soldiers, his superiors are annoyed by its irreverence and scatological humour.
3. Brian De Palma (1989). New soldier Max Eriksson (Michael J. Fox) is helpless in stopping Sgt. Tony Meserve (Sean Penn) and other platoon members from kidnapping a Vietnamese girl.
4. Oliver Stone (1986). Young recruit Chris Taylor (Charlie Sheen) finds that Sergeant Elias (Willem Dafoe), and Staff Sergeant Barnes (Tom Berenger) don't see eye to eye about the local Vietnamese people.
5. Oliver Stone (1989). An embittered, crippled Vietnam soldier Ron Kovic (Tom Cruise) becomes an anti-war activist after feeling betrayed by the country he fought for.
6. Phillip Noyce (2002). British journalist in Vietnam Thomas Fowler (Michael Caine) finds out the involvement of CIA operative Alden Pyle (Brendan Fraser) in bombing of civilians in the early stages of Vietnam war.

Answers: 1. *Full Metal Jacket.* 2. *Good Morning Vietnam.* 3. *Casualties of War.* 4. *Platoon.* 5. *Born on the Fourth of July.* 6. *The Quiet American.*

Courtroom Drama

In Sidney Lumet's **12 Angry Men** (1957), a lone man (Henry Fonda) out of a jury made up of 12 men (including and Lee J Cobb) manages to convince others of the innocence of the defendant..Can you identify the following films which feature courtroom drama?

1. Billy Wilder (1957). Lawyer Sir Wilfred Robarts (Charles Laughton) defends a struggling inventor Leonard Vole (Tyrone Power), who is a prime suspect in a murder case but Leonard's wife, Christine (Marlene Dietrich) chooses to appear in court against her husband.
2. Stanley Kramer (1960). In Tennesse teacher B.T. Cates (Dick York) is arrested for teaching Darwin's theories. Famous lawyer Henry Drummond (Spencer Tracy) defends him while fundamentalist politician Matthew Brady (Fredric March) want him to be prosecuted.
3. Robert Mulligan (1962). Lawyer Atticus Finch (Gregory Peck) defends a black man who is accused of raping a white girl.
4. Oliver Stone (1991). Louisiana district attorney Jim Garrison (Kevin Costner) finds that there are many loose ends to the President Kennedy's assassination. His investigation brings a backlash from powerful government and political figures.
5. Rob Reiner (1992). Lt. Daniel Kaffee (Tom Cruise) defends two marines accused of murdering FC William Santiago when Col. Nathan Jessup (Jack Nicolson) acknowledges that he ordered a Code Red against Santiago.
6. Steven Spielberg (1997). In 1839, mutinous slaves led by Cinque (Djimon Hounsou) aboard a Spanish ship reach the United States. The courts must decide whether they are slaves or legally free to go back to Africa. John Quincy Adams (John Hopkins) makes an impassioned and eloquent plea for their release.
7. Niki Caro (2005). When Josey Aimes (Charlize Theron) decides to work in a mine, she is harassed by her male collegues. When she finds the company taking the side of male miners, she decides to sue the company for sexual harassment.

Answers: 1. Witness for the Prosecution. 2. Inherit the Wind. 3. To kill a Mockingbird. 4. JFK. 5. A Few Good Men. 6. Amistad. 7. North Country.

Escape Film

In Jean Renoir's *La Grande Illusion* (1937, Fr), aristocratic Captain de Boeldieu (Pierre Fresnay) helps his friend working-class Lieutenant Maréchal (Jean Gabin) escape from a German fortress prison commanded by Von Rauffenstein (Erich von Stroheim). Can you identify the following films involving escapes?

1. Billy Wilder (1953). In a German POW camp in World War II, Sgt. Sefton (William Holden) is suspected to be an informer for the Germans alerting them about escaping prisoners.
2. John Struges (1963). In World War II, Squadron Leader Bartlett (Richard Attenborough) plans a massive escape of two hundred fifty men through a series of tunnels from a high security German prison. Hilts (Steve McQueen), Hendley (James Garner) and Blyth (Donald Pleasence) are among the escapees who are killed.
3. Franklin J. Schaffner (1973). After numerous attempts, Henri Charrière (Steve McQueen) finally manages to escape from French prisons.
4. Don Spiegel (1979). Bank robber Frank Morris (Clint Eastwood) escapes from a seemingly impenetrable federal penitentiary.
5. John Houston (1981). In World War II, a team composed of Allied Prisoners of War including Capt John Colby (Michael Caine), Cpl. Luis Fernendez (Pele) and Capt. Robert Hatch (Sylvester Stallone) play a Soccer (Football) game against an all-star Nazi team in Paris.
6. Kevin Reynolds (2002). Edmond Dantes (Jim Caviezel), betrayed by his friend Fernand Mondego (Guy Pearce), is jailed in island prison of Chateau d'If for 13 years. He escapes with the help of fellow prisoner Abbe Faria (Richard Harris), who gives him the map of a buried treasure.

Answers: 1. Stalag 17. 2. The Great Escape. 3. Papilion. 4. Escape from Alcatraz. 5. Escape to Victory. 6. The Count of Monte Cristo.

Gangster Films

One of the earliest gangster films was Edwin Porter's **The Great Train Robbery** (1903). The short film shows a group of cowboy outlaws (including Broncho Billy Anderson) robbing a train and passengers. They are later pursued by the Sheriff and his posse. Can you identify the following gangster films?

1. Mervyn LeRoy (1931). A small-time crook Rico (Edward G Robinson) moves to Chicago and joins a gang, ultimately becoming its violent boss.
2. Howard Hawks (1932). Violent Italian immigrant Tony Camonte (Paul Muni) becomes the king of the Chicago underworld. When his sister Cesca (Ann Dvorak) moves out and marries his friend Guino Renaldo (George Raft), he kills him.
3. Howard Hawk (1946). Private investigator Philip Marlowe (Humphrey Bogart), who is hired by a wealthy General to stop his youngest daughter Carmen from being blackmailed about her gambling debts, finds himself falling in love with the older sister Vivian (Lauren Bacall).
4. John Boulting (1947). Pinkie Brown (Richard Attenborough) is a small-town hoodlum whose gang runs a protection racket based at Brighton race course.
5. Carol Reed (1949). Pulp fiction writer Holly Martin (Joseph Cotton) arrives in postwar Vienna at the invitation of his schoolfriend Harry Lime (Orson Wells) but finds that Harry has died under mysterious circumstances.
6. William Friedkin (1971). Two cops, Jimmy Doyle (Gene Hackmann) and Buddy Russo (Roy Scheider), try to intercept a shipment of heroin from France.
7. Michael Crichton (1978). In 1855, Edward Pierce (Sean Connery) plans to rob gold destined for British soldiers fighting in the Crimea.

8. Brian De Palma (1983). Tony Montana (Al Pacino) flees Cuba and finds himself in a Florida refugee camp. He starts working for a drug kingpin whose empire and mistress Elvira (Michelle Pfeiffer) he takes over.
9. Brian De Palma (1987). Eliot Ness (Kevin Costner) vows to take down Chicago gangster Al Capone (Robert de Niro) as he assembles a team that includes veteran policeman Jimmy Malone (Sean Connery).
10. Martin Scorsese (2002). Amsterdam Vallon (Leonardo DiCaprio) returns to New York City in 1863 to hunt down his father Priest Vallon's (Liam Neeson) killer, the ruthless, Bill 'The Butcher' Cutting (Daniel Day-Lewis).

Answers: *1. Little Caesar. 2. Scarface. 3. The Big Sleep. 4. Brighton Rock. 5. The Third Man. 6. The French Connection. 7. The Great Train Robbery. 8. Scarface. 9. The Untouchables. 10. Gangs of New York.*

Historicals

Frank Lloyd's **Mutiny on the Bounty** (1935), disaffected crewmen, led by Fletcher Christian (Clark Gable), seize control of the ship from their captain William Bligh (Charles Laughton) in 1787. Can you identify the following historical films?

1. Sergei Eisenstein (1938). A thirteenth century Russian prince (Nikolai Cherkasov) rallies his people to form a ragtag army to drive back an invasion by the Teutonic knights of the Holy Roman Empire in a battle near Novgorod.
2. Sergei Eisenstein (1944). In 1547, the Archduke of Muscovy (Nikolai Cherkasov) crowns himself as Tsar of all the Russias, amid the murmur of discontent from the aristocratic boyars.
3. William Wyler (1959). Ben Hur (Charleston Heston) is a Jewish merchant in Jerusalem during the Roman times. When his friend, and now a Roman commander, Messala (Stephen Boyd) sends him to slavery, he seeks revenge.
4. Stanley Kubrick (1960). A slave from Thrace (Kirk Douglas) leads a revolt against the mighty Roman Empire in 73 BCE.

Patrician senator Crassus (Laurence Olivier) wants to cruelly suppress the revolt.
5. Joseph L. Mankiewicz (1963). Queen Cleopatra (Elizabeth Taylor) of Egypt has an affair with the Roman General Julius Caesar (Rex Harrison). When Caesar is assassinated in Rome, she returns to Egypt. Mark Antony (Richard Burton) follows her to Egypt and they fall in love.
6. Anthony Mann (1964). After the death of the Roman Emperor Aurelius (Alec Guinness), his vain and licentious son Commodus (Christopher Plummer) takes control of the Empire.
7. Irving Lerner (1969). Spanish conquistador Francisco Pizarro (Robert Shaw) leads an expedition into the heart of the Inca Empire. He captures the Emperor Atahualpa (Christopher Plummer) and claims Peru for Spain.
8. Nicholas Hytner (1994). With aging king (Nigel Hawthorne) showing signs of madness, Queen Charlotte (Helen Mirren) and Prime Minister William Pitt the Younger (Julian Wadham) attempt to keep his enemies from usurping the throne.
9. Ridley Scott (2000). Marcus (Richard Harris) is an old man who is tired of being emperor and wants to designate General Maximus (Russell Crowe) to be his successor. But when he tells his son Commodus (Joaquin Phoenix) about this, he turns against Maximus.
10. Oliver Stone (2004). After Philip (Val Kilmer) is assassinated, his son (Colin Farrell) becomes the king of Macedonia and leads his army to the borders of the river Sind, where he dies in 323 BC.
11. Steven Spielberg (2005). Avner (Eric Bana) leads a covert operation to hunt down and kill all Black September terrorist involved the the killing of Israeli athletes at the Munich Olympics in 1972.
12. José Padilha (2018). Four terrorists hijack an Air France flight from Tel Aviv to Paris and hold the passengers hostage after a forced landing in Entebbe.
13. Ron Howard (1995). In 1970 a mission to the moon commanded by Jim Lovell (Tom Hanks) runs into trouble.

Answers: *1. Alexender Nevsky. 2. Ivan the Terrible, Part I. 3. Ben Hur. 4. Spartacus. 5. Cleopatra. 6. The Fall of the Roman Empire. 7. The Royal*

Hunt of the Sun. 8. The Madness of King George III. 9. Gladiator. 10. Alexander. 11. Munich. 12. 7 days to Entebbe. 13. Apollo 13.

Music Makers

In George Cukor's *A Star is Born* (1954), talented aspiring singer Esther Blodgett (Judy Garland) becomes friends with Norman Maine (James Mason), a film star whose career is in decline. Can you identify the following films based on music?

1. Bob Fosse (1979). Joe Gideon (Roy Scheider) is a Broadway director and filmmaker working on his latest Broadway show.
2. Richard Fleischer (1980). Yussel Rabinovitch (Neil Diamond) is the son of a Jewish cantor. Against the wishes of his rigid father (Laurence Olivier), he becomes a rock singer with the name of Jess Robin.
3. Nancy Walker (1980). Jack Morell (Steve Guttenberg) is a struggling composer, in search for a group to sing his compositions. He forms a group of six "macho men" from his Greenwich Village neighborhood (Clue: YMCA).
4. Milos Forman (1984). Italian composer Antonio Salieri (F. Murray Abraham) is jealous of the brilliant Mozart (Tom Hulce) and becomes obsessed with his downfall.
5. Clint Eastwood (1988). Saxophonist Charlie Bird Parker (Forest Whitaker) makes great music but his addiction to drugs ruins his life and he dies at the age of 34.
6. Alex Cox (1986). Bassist Sid Vicious (Gary Oldman) relationship with The Sex Pistol are frayed when he falls in love with Nancy Spungen (Chloe Webb).
7. Bernard Rose (1994). After Ludwig von Beethoven (Gary Oldman) dies, his assistant Anton Schindler (Jeroen Krabbé) tries to find out who Beethoven's beloved was.
8. Tate Taylor (2014). James Brown (Chadwick Boseman), once imprisoned for stealing a suit, becomes the Godfather of Soul for his dancing and singing.
9. Damien Chazelle (2014). Drummer Andrew (Miles Teller) is pushed to the brink by his senior instructor, Mr. Fletcher (J.K. Simmons).

Answers: 1. *All that Jazz.* 2. *The Jazz Singer.* 3. *Can't Stop the Music.* 4. *Amadeus.* 5. *Bird.* 6. *Sid and Nancy.* 7. *Immortal Beloved.* 8. *Get on Up.* 9. *Whiplash.*

Horror films

In Robert Wiene's *The Cabinet of Dr Caligari* (1920). Dr Caligari (Werner Krauss) uses a sleepwalker Cesare (Conrad Veidt) to commit murders. Can you identify the following horror films?

1. F. W. Murnau (1922). Real estate agent Hutter (Gustav von Wangenheim) manages to sell an isolated house to Count Orlok (Max Schreck) but suspects that the Count may be a vampire.
2. Rupert Julian (1925). A deformed former composer (Lon Chaney) haunts the Paris Opera House and falls in love with young singer Christine Daae (Mary Philbin).
3. Todd Browning (1931). Count Dracula (Bela Lugosi) of Transylvania travels by ship to England and moves into Carfax Abbey which he has bought.
4. Merian C. Cooper (1933). A 25-foot tall gorilla falls in love with starlet Ann Darrow (Fay Wray). He reaches the top of the Empire State Building and fights airplanes.
5. Terence Fisher (1958). Van Helsing (Peter Cushing) kills Count Dracula (Sir Christopher Lee) by exposing him to sunlight.
6. John Guillermin (1976). A gigantic gorilla from Skull Island falls in love with Dwan (Jessica Lange). He is captured and brought to New York. He escapes and reaches the top of the World Trade Center where he is killed by helicopters.
7. William Friedkin (1973). Chris (Ellen Burstyn) seeks the help of two priests to save her teenaged daughter Regan (Linda Blair) who is possessed by a mysterious entity.
8. Roman Polanski (1968). Guy (John Cassavetes) and Rosemary (Mia Farrow) move into an old fashioned New York City apartment and Rosemary becomes paranoid about the safety of her unborn child.
9. Jonathan Demme (1991). FBI agent Clarice Starling (Jodie Forster) seeks the help of psychiatrist turned mass murderer Dr. Hannibal Lecter (Anthony Hopkins) to trap another

psychopathic serial killer Jame "Buffalo Bill" Gumb (Ted Levine).

Answers: 1. *Nosferatu*. 2. *The Phantom of the Opera*. 3. *Dracula*. 4. *King Kong*. 5. *Horror of Dracula*. 6. *King Kong*. 7. *The Exorcist*. 8. *Rosemary's Baby*. 9. *The Silence of the Lambs*.

Sports

In Lindsay Anderson's ***This Sporting Life*** (1963), Frank Machin (Richard Harris) is a tough rugby player in love with the bitter and angry widow Mrs. Margaret Hammond (Rachel Roberts). Can you identify the following films on sports?

1. Martin Scorsese (1980). Jealous and paranoid boxing champion Jake LaMotta (Robert De Niro) ends up as a lonely man antogonising his wife Vickie (Cathy Moriarty) and his brother Joey (Joe Pesci).
2. Hugh Hudson (1981). Harold Abrams (Ben Cross), a Jew, has to battle anti-semitism before he can take part in the 1924 Paris Olympics. Catholic Eric Liddell (Ian Charleson) refuses to run the 100 m race in the same Olympics because it happens on a Sunday.
3. Boaz Yakin (2000). Tensions arise when Herman Boone (Denzel Washington) is made head coach over the highly successful white coach Bill Yoast (Will Patton) to train a desegregated team.
4. Bill Paxton (2005). In the 1913 US Open, 20-year-old amateur Francis Ouimet (Shia LaBeouf) plays against his idol, Englishman and professional golfer Harry Vardon (Stephen Dillane).
5. Ron Howard (2005). James J. Braddock (Russell Crowe) was once a boxing champion but age and Depression have taken a heavy toll on him. Entering the ring after many years, Braddock begins to win all his fights against younger, stronger, and heavier boxers.
6. Clint Eastwood (2005). A poor 31-year old waitress from a dysfunctional family Maggie Fitzgerald (Hillary Swank)

approaches boxing coach Frankie Dunn (Clint Eastwood) to be trained as a boxer.
7. Clint Eastwood (2009). Nelson Mandela (Morgan Freeman) is elected President of South Africa and tries to unite his nation divided by apartheid. He tells Springboks captain Francois Pienaar (Matt Damon) that he wants them to win the 1995 Rugby World Cup.
8. Robert Lorenz (2012). Gus Lobel (Clint Eastwood) is an aging baseball scout. His estranged daughter Mickey (Amy Adams) goes on a recruitment trip with him.
9. Edward Zwick (2015). Bobby Fischer (Tobey MacGuire) challenges Russian grandmaster Boris Spassky in the Match of the Century in Reykjavik, Iceland in 1972.
10. Niki Caro (2015). An assistant football coach Jim White (Kevin Costner) leads a cross-country track team made up of lower-class Latino students to a state championship.
11. Jonathan Jakubowicz (2016). Rising from the slums of Panama, Roberto Duran (Edgar Ramírez) becomes a boxing champion, with the help of trainer Ray Arcel (Robert DeNiro).
12. Jonathan Dayton, Valerie Faris (2017). World number one Billie Jean King (Emma Stone) and former tennis champion and male chauvinist Bobby Riggs (Steve Carell) play a tennis match with each other in 1973.

Answers: *1. The Raging Bull. 2. Chariots of Fire. 3. Remember the Titans. 4. The Greatest Game Ever Played. 5. Cinderella Man. 6. Million Dollar Baby. 7. Invictus. 8. Trouble with the Curve. 9. Pawn Sacrifice. 10. Mc Farland USA. 11. Hands of Stone. 12. Battle of the Sexes.*

Racing

In Clarence Brown's **National Velvet** (1944), 12-year-old Velvet Brown (Elizabeth Taylor) rides on the Pie and wins the Grand National Race. Can you identify the following films based on races?

1. Hal Needham (1981). J.J. McClure (Burt Reynolds) and Victor Prinzi (Dom DeLuise) together participate in an illegal and popular road race from Connecticut to California. Racing

against them are Jamie Blake (Dean Martin) and Seymour Goldfarb (Roger Moore) among others.
2. Gary Ross (2003). Trainer Tom Smith (Chris Copper) and jockey Red Pollard (Tobey Maguire) help an unfancied horse to beat the formidable War Admiral.
3. Roger Donaldson (2005). Elderly New Zealander Burt Munro (Anthony Hopkins) travels to Utah and sets a land speed world record on his customized 1920 Indian motorcycle in 1967.
4. Asif Kapadia (2010). Legendary Brazilian Ayrton Senna arrives in Formula One in the mid 80's, and competes on track against his nemesis, French World Champion Alain Prost.
5. Ron Howard (2013). Rivals British James Hunt (Chris Hemsworth) and Austrian Niki Lauda (Daniel Brühl) clash in the Formula One championship.
6. Randall Wallace (2010). Veteran trainer Lucien Laurin (John Malkovich) trains a stallion owned by housewife and mother Penny Chenery (Diane Lane,) which wins the first Triple Crown in twenty-five years.

Answers: *1. Cannonball Run. 2. Seabiscuit. 3. The World's Fastest Indian. 4. Senna. 5. Rush. 6. Secretariat.*

Walt Disney

Walt Disney was born in 1901 in Chicago, Illinois. He holds the record for most Academy awards won by an individual. He won 22 out of 59 Oscar nominations. Can you identify the following Disney films?

1. This 1928 animated cartoon was Disney's first to be synchronized with sound effects.
2. In 1929, Disney created a cartoon series which included shorts like **Flowers and Trees** and **Three Little Pigs**.
3. In 1932 Disney produced the first cartoon in color for which he won the Oscar for Best Short Subject, Cartoons.
4. In 1937, Disney produced the first sound and colour animated feature film.

5. Disney made his second animated feature film in 1940. It was about a wooden puppet which is brought to life by a fairy.
6. This 1940 animated film features classical orchestral pieces in stereophonic sounds such as *The Nutcracker Suite* (Tchaikovsky), *The Rites of Spring* (Stravinsky), *Pastoral symphony* (Beethoven) and *Night of the Bald Mountain* (Mussorgsky).
7. This 1941 film is about a flying elephant who has large ears.
8. This 1942 film is about a young deer.
9. This 1950 animated feature film was Disney's biggest hit since **Snow White and the Seven Dwarfs** (1937).
10. This 1964 film was the only Disney film to have been nominated for the Best Picture Oscar in Disney's lifetime.
11. This 1967 animated film is about Mowgli, the man-cub who is raised in the jungle.
12. This 1973 film has a fox as the hero and the villains are a snake and a wolf.
13. This 1999 animated film features classical orchestral pieces such as *Symphony No 5* (Beethoven), *Rhapsody in Blue* (Gershwin), *The Carnival of Animals* (Saint-saens), *Pomp and Circumstances March* (Elgar) and *Firebird Suite* (Stravinsky).
14. This 1999 film has characters such as Sabor the leopard, Kerchak the gorilla and Tantor the elephant.

Answers: *1. Steamboat Willie. 2. Silly Symphonies. 3. Flowers and Trees. 4. Snow White and the Seven Dwarfs. 5. Pinocchio. 6. Fastasia. 7. Dumbo. 8. Bambi. 9. Cinderella. 10. Mary Poppins. 11. The Jungle Book. 12. Robin Hood. 13. Fantasia 2000. 14. Tarzan.*

Animated Characters

Koko the Clown was one of the earliest cartoon characters. He was created by Max Fleischer in 1924. His clown costume had three pom-pom buttons. He wore a cone-shaped cap also with three pom-poms. The white face had slit eyes. He had white gloves and white foot coverings. Can you identify the following animated characters?

1. This cartoon character, created by Elzie Crisler Segar, first appeared in a comic strip *Thimble Theatre* in 1929. In 1933,

Max Fleischer adapted him into a series of cartoon shorts for Paramount Pictures. He was a sailor whose love interest was Olive Oyl.
2. This animated cartoon character, created by Max Fleischer, first appeared in **Dizzy Dishes** (1930). She had a large round baby face with big eyes and a nose like a button.
3. The precursor of this cartoon series was **Puss Gets the Boot** (1940) featuring a cat called Jasper. These were created by William Hanna and Joseph Barbera.
4. This character was created by Walter Lantz. He makes his appearance in **Knock Knock** (1940) but gets his name in the next film.
5. This cartoon series, produced by Hanna-Barbera in 1966, features a family in the Stone Age town of Bedrock.
6. Matt Groening created this 1989 animated series about a dysfunctional family in the fictional town of Springfield.

Answers: *1. Popeye the Sailor. 2. Betty Boop. 3. Tom and Jerry. 4. Woody Woodpecker. 5. Flintstones. 6. Simpsons.*

Shakespeare

In Joseph L. Mankiewicz's *Julius Caesar* (1953), Brutus (James Mason), suspicious of a victorious general's growing ambition, assassinates him but Mark Anthony (Marlon Brando) turns the Romans against the conspirators. Can you identify these films based on Shakespeare?

1. Laurence Olivier (1955). The hunchback Richard of Gloucester (Laurence Olivier) removes all who stand between him and the crown and becomes a king himself.
2. Orson Welles (1965). The aging King (John Gielgud) watches disapprovingly as his son Hal (Keith Baxter) enjoys the company of the decadent Sir John Falstaff (Orson Welles).
3. Franco Zeffirelli (1967). Petruchio (Richard Burton), a fortune-hunting scoundrel from Verona, arrives in Padua, and resolves to capture Katharina (Elizabeth Taylor), a woman with fiery temper.

4. Franco Zeffirelli (1968). When two members of the feuding families of Verona, Montague and Capulet, fall in love, trouble is inevitable.
5. Kenneth Branagh (1993). Though sharp-tongued Beatrice (Emma Thompson) hates quick-witted Benedick (Kenneth Branagh), they find themselves drawn towards each other.
6. Oliver Parker (1995). The manipulative soldier Iago (Kenneth Branagh) convinces the Moorish commander of the Venetian army (Laurence Fishburne) that his wife, Desdemona (Irène Jacob) is unfaithful.
7. Julie Taymor (1999). A victorious general (Anthony Hopkins) returns to Rome with his hostage Tamora (Jessica Lange), queen of the Goths. She takes her revenge on him and his family.
8. Julie Taymor (2010). Banished to a forsaken island, the sorceress Prospera (Helen Mirren), with the help of the spirit Ariel (Ben Whishaw), gets a chance to take her revenge on the King of Naples.

Answers: *1. Richard III. 2. Henry IV. 3. The Taming of the Shrew. 4. Romeo and Juliet. 5. Much Ado Over Nothing. 6. Othello. 7. Titus. 8. The Tempest.*

Romance

In Marcel Carne's **Les Enfants Du Paradis** (1943, Fr), set in Paris of 1830s, four men, an aristocrat, an actor, a thief and the mime Baptiste (Jean-Louis Barrault), are in love with the beautiful courtesan Garance (Arletty). Can you identify the following romantic films?

1. Elliott Nugent (1949). The mysterious and *nouveau riche* businesman (Alan Ladd) is obsessed with his lost love Daisy (Betty Field).
2. Dilbert Mann (1955). Marty Piletti (Ernest Borgnine) is a socially awkward butcher who is unmarried at 34 and living with his mother.
3. Blake Edwards (1961). Holly Golightly (Audrey Hepburn) lives alone in New York City and escorts wealthy men. Holly's carefree independence is changed when she meets her

neighbor, aspiring writer Paul (George Peppard), who is suffering from writer's block while being kept by a wealthy woman (Patricia Neal).
4. Arthur Hiller (1970). Wealthy Oliver (Ryan O' Neil) and working class Jenny (Ali MacGraw) fall in love with each other and decide to marry against the wishes of Oliver's father.
5. Jack Clayton (1974). The mysterious and *nouveau riche* businessman (Robert Redford) is obsessed with his lost love Daisy (Mia Farrow).
6. Sydney Pollack (1973). Katie (Barbra Streisand) is an idealistic, uptight, activist and Hubbell (Robert Redford) is an easy-going, athletic, talented writer. They fall in love and marry but the marriage is not smooth.
7. Frank Peirson (1976). An aging rock star John Norman (Kris Kristofferson) falls in love with a young, up-and-coming songstress Esther Hoffman (Barbra Streisand).
8. John Houston (1961). Recently divorced Roslyn (Marilyn Monroe) meets aging cowboy Gay (Clark Gable), and the two fall in love.
9. Ken Russel (1969). Best friends Gerald Crich (Oliver Reed) and Rupert Birkin (Alan Bates) fall in love with a pair of sisters Gudrun (Glenda Jackson) and Ursula Brangwen (Jennie Linden).
10. Wealthy businessman, Edward Lewis (Richard Gere), hires for a week a beautiful hooker, Vivian Ward (Julia Roberts), to accompany him in business events, but finds it hard to let her go.

Answers: *1. The Great Gatsby. 2. Marty. 3. Breakfast at Tiffany's. 4. Love Story. 5. The Great Gatsby. 6. The Way We Were. 7. A Star is Born. 8. The Misfits. 9. Women in Love. 10. Pretty Woman.*

Suspense

In Hitchcock's **Spellbound** (1946), Dr. Constance Petersen (Ingrid Bergman) is a psychiatrist at a mental asylum. Although she falls in love with the renowned Dr. Anthony Edwardes (Gregory Peck) who

has joined the hospital, she suspects that he may be impersonating as Dr Edwardes. Can you identify the following suspense thrillers?

1. Henri-Georges Clouzot (1953). In a South American village, an oil field catches fire. The company hires four derelicts to drive two trucks over mountain dirt roads, loaded with nitroglycerine needed to extinguish the flames.
2. Henri-Georges Clouzot (1955). When the body of a tyrannical Michel Delassalle (Paul Meurisse), who was murdered by his wife Christina (Véra Clouzot) and mistress Nicole Horner (Simone Signoret) appears again alive, the shock kills the frail Christina.
3. Hitchcock (1958). John 'Scottie' Ferguson (James Stewart) is asked by an old college friend, Gavin Elster (Tom Helmore), if he would have a look into his wife Madeleine's (Kim Novak) odd behavior.
4. Roman Polanski (1974). Evelyn Mulray (Faye Dunaway) hires a detective Jake Gittes (Jack Nicholas) to spy on her husband Hollis, who is later murdered.
5. Bryan Singer (1995). A crippled con-man Roger 'Verbal' Kint (Kevin Spacey) tells the police that 27 men dead in a boat explosion are due to legendary Turkish mastermind criminal called Keyser Söze. Could Kint and Soze be the same person?

Answers: *1. The Wages of Fear. 2. Les Diaboliques. 3. Vertigo. 4. Chinatown. 5. The Usual Suspects.*

Comedy

In Buster Keaton and Donald Crisp's **The Navigator** (1924), Rollo Treadway (Buster Keaton) and Betsy (Kathryn McGuire) are the only two passengers in a ship that is set adrift into the Pacific Ocean. Identify the following comic films:

1. Charles Chaplin (1936). The monotony of the assembly line system pushes a worker (Charles Chaplin) over the edge. Though he becomes a misfit in the modern industrial

society, he finds love in the young homeless Gamin (Paulette Goddard).
2. William A. Seiter (1933). Stan and Olie tell their wives they are going to Honolulu to recuperate; Instead they go to Chicago to attend the annual convention of a fraternal organization.
3. Billy Wilder (1955). Richard Sherman (Tom Ewell) sends his family to the country for the summer, while he stays behind in New York to work. However, a voluptuous blonde (Marilyn Monroe) upsets his plans.
4. Billy Wilder (1959). Musicians Joe (Tony Curtis) and Jerry (Jack Lemmon) disguise themselves as women to escape from a gang.
5. Mike Nichols (1970). Yossarian (Alan Arkin), a World War II bombardier, is caught in a situation from which he is unable to stop flying missions.
6. Woody Allen (1977). Alvy Singer (Woody Allen), a middle-age divorcee, neurotic, intellectual Jewish New York stand-up comic reflects on the demise of his latest relationship to aspiring singer Annie (Diane Keaton).
7. Peter Bogdanovich (1972). Dr. Howard Bannister (Ryan O Neal) is a professor of musicology. His life is turned upside down when he meets Judy Maxwell (Barbra Streisand).

Answers: *1. Modern Times. 2. Sons of the Desert. 3. The Seven Year itch. 4. Some Like it Hot. 5. Catch 22. 6. Annie Hall. 7. What's up Doc?*

Marriage

In Richard Brooks **Cat on a hot tin roof** (1958), alcoholic Brick Pollitt (Paul Newman) and his wife Maggie (Liz Taylor) are going through a long rough patch in their marriage. Identify the following films based on the theme of marriage.

1. Tony Richardson (1959). Working class Jimmy Porter (Richard Burton) is rude and abusive towards his middle class wife Alison (Claire Bloom).
2. Jacques Demy (1964). 16-year old Geneviève (Catherine Deneuve) and a 20-year-old mechanic, Guy (Nino

Castelnuovo), are in love and want to get married. When Guy goes to war, Geneviève is forced to marry diamond merchant Roland Cassard (Marc Michel).
3. Mike Nichols (1966). George (Richard Burton) and Martha (Elizabeth Taylor) are a middle-aged married couple who need to hurt each other and those around themselves.
4. Fassbinder (1973). Emmi (Brigitte Mira), a German woman in her sixties, falls in love with Ali, (El Hedi ben Salem) a Moroccan immigrant around twenty-five years younger and the two decide to marry.

Answers: *1. Look back in Anger. 2. The Umbrellas of Cherbourg. 3. Who is afraid of Virginia Woolf? 4. Ali: Fear Eats the Soul.*

Money Money Money

In Sydney Pollack's **They Shoot Horses, Don't They?** (1969), Robert (Michael Sarrazin) and Gloria (Jane Fonda) meet and decide to enter a dance marathon expecting to win the award of US$ 1,500.00. The grueling dance takes its toll on Gloria's weakened spirit, who asks Robert to shoot her. Identify the following films based on the theme of money.

1. Robert Altman (1971). Gambler McCabe (Warren Beatty) arrives in a small town and decides to open a saloon and bordello. Constance Miller (Julie Christie) joins him and the business is a success.
2. Oliver Stone (1987). Unscrupulous corporate raider Gordon Gekko (Michael Douglas) takes young and ambitious Buddy Fox (Charlie Sheen) under his wings.
3. Robert Redford (1994). Disgruntled contestant Herbie Stempel (John Turturro) charges that the national TV quiz game won by Charles Von Doren (Ralph Fiennes) is rigged.
4. Oliver Stone (2010). Jake (Shia Labeouf), a young Wall Street trader, partners with disgraced trader Gordon Gekko (Michael Douglas) to take revenge for the death of his mentor Louis Zabel (Frank Langella).
5. Martin Scorsese (2013). Stockbroker Jordan Belfort (Leonardo DiCaprio) becomes rich when he sets up a

company Stratford-Oakmont which does extremely well. However his greed and wild lifestyle leads to his undoing.

Answers: 1. McCabe and Mrs Miller. 2. Wall Street. 3. Quiz Show. 4. Wall Street: Money Never Sleeps. 5. The Wolf of Wall Street.

Rights and Wrongs

In Roberto Rossellini's **Rome Open City** (1945), Resistant leader Giorgio Manfredi (Marcello Pagliero), looking for a place to hide from the Nazis, visits his friend's fiancee, Pina (Anna Magnani). Meanwhile, Catholic priest Don Pietro Pellegrini (Aldo Fabrizi) is killed for refusing to collaborate with the Nazis. Identify the following films based on the theme of justice and human rights.

1. Elia Kazan (1947). Journalist Philip Green (Gregory Peck) poses as a Jew to investigate anti-Semitism the US and discovers bigotry and hatred even among the well heeled.
2. Stanley Kramer (1951). Dan Haywood (Spencer Tracy) is the lead judge trying four judicial officers of the Nazi era in Nuremberg. Are these four guilty of international crimes or were they just carrying out the laws of their national government?
3. Elia Kazan (1954). Terry Malloy (Marlon Brando) witnesses a murder carried by his union bosses. After meeting Edie Doyle (Eva Maria Saint), the murdered man's sister, Terry feels obligated to stand up to his bosses.
4. Stanley Kramer (1958). Two prisoners John "Joker" Jackson (Tony Curtis) and Noah Cullen (Sidney Poitier) escape while being chained to each other. When they get rid of the chain that binds them, their former hatred turns into friendship.
5. Martin Ritt (1970). Boxer Jack Jefferson (James Earl Jones) is the world's reigning heavyweight boxing champion and his fiancé Eleanor (Jane Alexander) is white. He now has to contend with the racism of early 20th century white America.
6. Hector Babenco (1985). Luis Molina (William Hurt) and Valentin Arregui (Raul Julia) are cell mates in a South American prison. Luis, a gay man, is found guilty of immoral

behavior and Valentin is a political prisoner working for leftist anti-government group.
7. Louis Malle (1987). A young Jewish boy, Jean Bonnet, lives under a false identity in a Catholic residential school in Nazi-occupied France. When Jean's true identity is revealed, he is taken away by the Gestapo, never to be seen again.
8. Alan Parker (1988). After three Civil Rights workers go missing in a small Southern town where segregation divides black and white, the FBI deputes Agents Alan Ward (William Dafoe) and Rupert Anderson (Gene Hackman) to investigate.
9. Steven Spielberg (1993). A German businessman and profiteer of slave labor (Liam Neeson) saves over 1000 Polish Jews from almost certain death during the Holocaust.
10. Nate Parker (2016). Slave Nate Turner (Nate Parker) is a Christian preacher, who collaborates with his owner to subdue unruly slaves with his preaching. When he can withstand atrocities against slaves no more, he orchestrates a bloody uprising.

Answers: 1. Gentleman's Agreement. 2. Judgment at Nuremberg. 3. On the Waterfront. 4. The Defiant Ones. 5. The Great White Hope. 6. Kiss of the Spider Women. 7. Au Revoir les Enfants. 8. Mississippi Burning. 9. Schindler's List. 10. The Birth of a Nation.

Past is another country

In John Ford's **How Green was my Valley** (1941), Huw Morgan (Irving Pichel) looks back on his childhood in the small Welsh mining town where he was born. Huw's sister Angharad (Maureen O'Hara) falls in love with the minister Mr. Gruffydd (Walter Pidgeon) but marries the son of the owner of the mine. Identify the following films based on the theme of nostalgia.

1. William Wyler (1946). Three World War II veterans face difficulties as they re-enter civilian life. Fred (Dana Andrews), unable to compete with more highly skilled workers, has to return to his low-wage job. Bank executive Al (Frederic March) gets into trouble for offering favorable loans to

veterans. After losing both hands in the war, Homer (Harold Russell) is unsure if his fiancée will still love him.
2. Billy Wilder (1950). Norma Desmond (Gloria Swanson), a forgotten silent films star dreams of returning to films..
3. Joseph L. Mankiewicz (1950). Margo Channing (Bette Davis), an aging Broadway actress' career is threatened when her fan Eve Harrington (Anne Baxter) insinuates herself into Margo's life.
4. Elia Kazan (1951). The romantic notions of Blanche DuBois (Vivien Leigh), an aristocratic southern belle, are shattered by the rough and plebeian Stanley Kowalski (Marlon Brando).
5. Luchino Visconti (1971). A composer Aschenbach (Dick Bogarde) travels to a Venice in search of peace after a period of artistic and personal stress..
6. Robert Zemeckis (1985). Marty McFly (Michael J. Fox), a typical Eighties teenager, travels back to fifties in time machine (a plutonium-powered car) invented by Dr. Emmet Brown (Christopher Lloyd).

Answers: 1. The best years of our lives. 2. Sunset Boulevard. 3. All about Eve. 4. A Streetcar named Desire. 5. Death in Venice. 6. Back to the future

In Foreign Lands

In William Wyler's **Roman Holiday** (1953), Princess Anne (Audrey Hepburn) tired of being a royal falls in love with American reporter Joe Bradley (Gregory Peck) in Rome. Identify the following films which were set in foreign lands.

1. Howard Hawks (1953). Entertainers Dorothy Shaw (Jane Russell) and Lorelei Lee (Marilyn Monroe) head for Europe on an ocean liner pursued by a private detective.
2. Melvin Frank (1968). Three U.S. soldiers return to an Italian village after twenty years. They all have fond memories, especially of local girl Carla (Gina Lollobrigida). But she has been telling each of them that he is the father of her daughter Gia (Janet Margolin).
3. Alan Parker (1978). Billy Hayes (Brad Davis), an American college student, is caught smuggling drugs in Turkey and thrown into prison.

4. Sydney Pollack (1985). Danish aristocrat Karen Blixen (Meryl Streep) travels to Africa to join her husband, Bror (Klaus Maria Brandauer). After discovering Bror is unfaithful, Karen develops feelings for hunter Denys (Robert Redford), but realizes he prefers a simplistic lifestyle compared to her upper class background.
5. Baz Luhrmann (2008). A British lady, Sarah Ashley (Nicole Kidman) travels to Australia and finds that her husband has died, leaving her to manage the cattle station.
6. Richard Linklater (1995). Two strangers, American Jesse (Ethan Hawke) and French student Celine (Julie Delpy) met by chance and spend a night in Vienna.
7. Tim Burton (2001). Astronaut Leo Davidson (Mark Wahlberg) lands on a strange planet where talking apes rule over humans.
8. Rob Letterman (2010). Lemuel (Jack Black), sent by travel editor Darcy Silverman (Amanda Peet) on an assignment to write an article on a faraway island, is swept on an island where he finds that everyone is about six inches tall.

Answers: *1. Gentlemen Prefer Blondes. 3. Buona Sera, Mrs. Campbell. 3. Midnight Express. 4. Out of Africa. 5. Australia. 6. Before Sunrise. 7. Planet of the Apes. 8. Gulliver's Travels.*

Politics

In Frank Capra's **Mr. Smith Goes to Washington** (1939), idealistic and naïve Jefferson Smith (James Stewart) is elected to the Senate, where he collides with political corruption. Identify the following political films

1. Richard Attenborough (1982). A lawyer (Ben Kingsley) returns to India from South Africa and mounts a non-violent non-cooperation campaign against the British rule involving millions of Indians.
2. Irwin Winkler (1991). David Merrill (Robert De Niro), returns from abroad to find himself in the middle of the McCarthy era Communist witch-hunt. The House Committee on

Un-American Activities wants him to implicate other Hollywood personnels.
3. Spike Lee (1994). A small-time black gangster (Denzel Washington) becomes an influential Black Nationalist leader, and a member of the Nation of Islam.
4. Neil Jordan (1996). After the Easter Rising of Irish rebels has failed, Michael Collins (Liam Neeson) develops new tactics for Irish Independence which include urban guerrilla tactics and organized assassinations.
5. Steven Zaillian (2006). Willie Stark (Sean Penn), an ambitious and sometimes ruthless politician, uses the support of lower classes to become Louisaina governor.
6. Steve McQueen (2008). North Ireland. IRA leader Bobby Sands (Michael Fassbender) leads a hunger strike in a prison.
7. Gus Van Sant (2008). Gay activist Harvey Milk (Sean Penn) is elected to a San Francisco supervisor seat in 1977.
8. Steven Spielberg (2012). Abraham Lincoln (Daniel Day-Lewis) attempts to pass the constitutional amendment banning slavery from the United States before the Civil War ends.

Answers: *Gandhi. 2. Guilty by Suspicion. 3. Malcolm X. 4. Michael Collins. 5. All the King's Men. 6. Hunger. 7. Milk. 8. Lincoln.*

Friendship

In Peter Glenville's **Becket** (1964), King Henry II (Peter O' Toole) of England and Thomas Becket (Richard Burton) are lifelong friends despite the differences in their rank. But when the King makes Becket the Archbishop of Canterbury, he refuses to let his friendship stand in the way of his duty. Can you identify the following films based on the theme of friendship?

1. John Schlesinger (1969). Texan Joe Buck (Jon Voigt) arrives in New York City and becomes friends with outcast Ratso Rizzo (Dustin Hoffman).
2. Fred Zinnemann (1977). Playwright Lillian Hellman (Jane Fonda) agrees to smuggle $50,000 of her friend Julia's

(Vanessa Redgrave's) money into Nazi Germany to help the anti-fascist movement.
3. James Ivory (1987). School chums Clive (Hugh Grant) and Maurice (James Wilby) find themselves falling in love at Cambridge.
4. Gary Marshal (1988). Friendship develops between a struggling singer CC Bloom (Bette Midler) and successful lawyer Hillary (Barbara Hershey).
5. Ang Lee (2005). In 1963, Ennis Del Mar (Heath Ledger) and Jack Twist (Jake Gyllenhaal) find job as sheep herders and unexpectedly forge a lifelong connection.
6. Sergio Leone (1984). Two Jewish ganster from New York in early 1920s, Noodles (Robert De Niro), and Max (James Woods) meet after many decades.
7. Jonathan Demme (1993). Andrew Beckett (Tom Hanks) is a gay lawyer living with Miguel (Anthony Banderas). When he is dismissed by his firm for having AIDS, he decides to sue them for discrimination. Homophobic lawyer Joe Miller (Denzel Washington) takes up Beckett's case.

Answers: *1. Midnight Cowboy. 2. Julia. 3. Maurice. 4. Beaches. 5. Brokebank Mountain. 6. Once Upon a Time in America. 7. Philadelphia.*

Childhood and Youth

In Gerhard Lamprecht's **Emil und die Detektive** (1931, Ger), Emil (Rolf Wenkhaus) is travelling by train to see his grandmother, when he is offered sweets by a man that make him sleep. When he wakes up he finds all his money is gone. Can you identify the following films which involve children and youth?

1. David Lean (1946). Poor orphan Pip (John Mills) becomes rich because of a mysterious benefactor but cannot forget his childhood love Estella (Jean Simmons).
2. François Truffaut (1959). Antoine Doinel (Jean-Pierre Leaud) is a 13-year-old boy who keeps getting into trouble at school.

3. Satyajit Ray (1955). The young boy Apu (Subir Bannerjee) and his elder sister Durga (Uma Das Gupta) live in a village in Bengal amid poverty.
4. James Clavell (1967). Mark Thackeray (Sidney Poitier) accepts a position as a teacher to teach a class of unruly white children in a London school.
5. Lindsay Anderson (1968). Mick (Malcolm MacDowel) leads a revolution against his private school.
6. Peter Weir (1975). A few students and a teacher from an Australian girls' school vanish without a trace during an excursion.
7. Ingmar Bergman (1982). Alexander and his younger sister live a comfortable life in a Swedish town. When their father dies young, the mother marries a bishop who is a strict disciplinarian.
8. Steven Spielberg (1987). Jim (Christian Bale), a British boy is separated from his family after the Japanese Army invades British controlled areas of China.
9. Gabor Csupo (2007). Adventurous, imaginative and non-conformist Leslie Burke (Anna Sophia Robb) arrives in town and becomes friends with young Jesse (Josh Hutcherson) who comes from a poor family. Together they form a bond and create an imaginary world.
10. Matin Scorsese (2011). Hugo (Asa Butterfield) is an orphan who lives in a Paris railway station, tending to station clocks. He steals mechanical parts from the owner of a toy shop, Georges Melies (Ben Kingsley) to repair a broken automaton he has.
11. Peter Weir (1989). English teacher John Keating (Robin Willaims) urges his students to break out of their shells, and seize the day.
12. Wes Anderson (1999). Tenth grader Max Fischer (Jason Schwartzman) is Rushmore Academy's most extracurricular student. He enters into unlikely friendships with both a lovely first-grade teacher (Olivia Williams) and a melancholy self-made millionaire (Bill Murray).

Answers: 1. Great Expectation. 2. 400 blows. 3. Pather Panchali. 4. To sir, with Love. 5. If... 6. Picnic at Hanging Rock. 7. Fanny and Alexander. 8. Empire of the Sun. 9. Bridge to Terabithia. 10. Hugo. 11. Dead Poets Society. 12. Rushmore.

Journalism

In Alan J Pakula's **All the President's Men** (1976), two Washington Post reporters Bob Woodward (Robert Redford) and Carl Bernstein (Dustin Hoffman) uncover the details of the Watergate scandal that leads to President Richard Nixon's resignation. Can you identify the following films on journalism?

1. Roland Joffe (1984). Schanberg (Sam Waterson) is a journalist covering the war in Cambodia. He is helped by local journalist Dith Pran (Haing S. Ngor). When Khmer Rouge ultimately take over Cambodia, Schanberg escapes in April, 1975. Schanberg's begins a four-year campaign to get Pran out of the country.
2. Peter Weir (1982). Australian journalist Guy Hamilton (Mel Gibson) arrives in Indonesia during the rule of President Sukarno and forms a friendship with dwarf photographer Billy Kwan (Linda Hunt). He falls for British diplomat Jill Bryant (Sigourney Weaver), who gives him key information about an approaching Communist uprising.
3. Joel Schumacher (2003). An Irish journalist (Cate Blanchett) writes on the drug barons and drug lords. When she refuses to heed the warning and threats, she is assassinated by the drug lord John Gilligan (Gerard McSorley).
4. George Clooney (2005). Broadcast journalist Edward R. Murrow (David Strathairn) takes a stand against fear mongering Senator Joseph McCarthy of Wisconsin.
5. Steven Spielberg (2017). Washington Post publisher Kay Graham (Meryl Streep) decides to face the government and publish the Pentagon Papers against the will of the lawyers and investor.

Answers: 1. The Killing Fields. 2. The Year of Living Dangerously. 3. Veronica Guerin. 4. Good Night, and Good Luck. 5. The Post.

Parenting

In Elia Kazan's **East of Eden** (1955), wild and moody Cal (James Dean) is embittered as he believes that his father favors his brother Aron

(Richard Davalos). Things take a turn for the worse when Aron's girlfriend Abra (Julie Harris) start falling in love with Cal. Can you identify the following films on parenting?

1. Nicolas Ray (1955). Troubled teenager Jim Stark (James Dean) becomes friends with Judy (Natalie Wood), who too has an unhappy homelife.
2. Robert Redford (1980). After the accidental death of his brother, Conrad (Timothy Hutton) is overcome by grief and guilt and is in therapy. The mother Beth (Mary Tyler Moore) is having difficulty being supportive to Conrad. The father Calvin (Donald Sutherland) is trapped between the two trying to hold the family.
3. Frank Perry (1981). Joan Crawford (Faye Dunaway) adopts Christina (Diana Scarwid) and her brother Christopher (Xander Berkeley) to fill a void in her life. Yet, her problems with alcohol, men, and the pressures of show business turn her into a mentally abusive wreck.
4. Robert Benton (1979). Joanna (Meryl Streep) decides to leaves her husband of eight years Ted Kramer (Dustin Hoffman) and her son Billy (Justin Henry).

Answers: *Rebel without a Cause. 2. Ordinary people. 3. Mommie Dearest. 4. Kramer vs Kramer.*

Women's World

Clarence Brown's **Anna Christie** (1930). When mysterious Anna (Greta Garbo) returns to her father's house after 15 years, her hidden past can no longer be a secret. Can you identify the following women-centric films?

1. Alan E. Green (1933). Lily Powers (Barbara Stanwyck) coerced into prostitution since she was 14, exploits the hapless men at a big city bank - by gleefully sleeping her way to the top.
2. William Wyler (1941). Regina Hubbard Giddens (Bette Davis) is a cold, calculating woman estranged from her rich dying husband.

3. Alexender Korda (1941). A dance-hall girl Emma (Vivien Leigh) marries Lord Hamilton but becomes the mistress of Admiral Lord Horatio Nelson (Laurence Oliver).
4. Vittorio De Sica (1960). Young widow Cesira (Sophia Loren) and her 12-year daughter Rosetta (Eleonora Brown) flee Rome to survive the war and move towards the mountains where the intellectual Michele (Belmondo) falls in love with Cesira.
5. Ingmar Bergman (1978). A successful concert pianist Charlotte (Ingrid Bergman) visits her married daughter Eva (Liv Ullman).
6. Stephen Spielberg (1985). Celie (Whoopi Goldberg), a young black girl growing up in the early 1900's is physically abused by her stepfather.
7. Sydney Pollack (1992). Unemployed actor Michael Dorsey (Dustin Hoffman) disguises himself as actress Dorothy Michaels in order to win a part in a play.
8. Steven Soderbergh (2000). An unemployed single mother of three (Julia Roberts) almost single-handedly discovers a cover-up of the industrial poisoning of a city's water supply by a multi-billion dollar corporation.

Answers: 1. *Baby Face.* 2. *The Little Foxes.* 3. *That Hamilton Woman.* 4. *Two Women.* 5. *Autumn Sonata.* 6. *The Color Purple.* 7. *Tootsie.* 8. *Erin Brockovich.*

Lives of the Common People

John Ford's **The Grapes of Wrath** (1940). Tom Joad (Henry Fonda), returning home after serving four years in prison for killing a man, finds his family evicted from their land. He travels with his family to California looking for job. Can you identify the following films which deal with lives of the common people?

1. Vittorio De Sica (1948). In Rome Antonio Ricci's (Lamberto Maggiorani) bicycle is stolen by a thief who snatches it when he is hanging up a poster. Unable to get his bicycle, Antonio

attempts robbery and is arrested and maltreated in front of his son (Enzo Staiola).
2. Frederico Fellini (1954). Waif Gelsomina (Giulietta Masina) is sold to strongman Zampano (Anthony Quinn) a traveling showman.
3. Jack Clayton (1959). Social climber Joe Lampton (Laurence Harvey) wants to marry his boss' daughter while being attracted to the French Alice Aisgill (Simone Signoret).
4. John Schlesinger (1963). Though Billy (Tom Courtenay) is a lowly British clerk in a gloomy provincial town, he lives his dreams in his own imaginary world of Ambrosia.

Answers: *1. The Bicycle Thieves. 2. La Strada. 3. Room at the Top. 4. Billy Liar.*

On the Road

Frank Capra's *It Happened One Night* (1934). Rich heiress Ellie Andrews (Claudette Colbert) on the run meets reporter Pete Warne (Clark Gable) and the two find themselves in love with each other. Can you identify the films who are based on journeys?

1. Arthur Penn (1967). Clyde Barrow (Warren Beatty) and Bonnie Parker (Faye Dunaway) are on the run from the police because of bank robberies and murder.
2. Dennis Hopper (1969). Two young bikers, Wyatt (Peter Fonda) and Billy (Dennis Hooper) set off on a trip across America, looking for a way to lead their lives.
3. Ridley Scott (1991). Waitress Louise (Susan Sarandon) and housewife Thelma (Geena Davis) decide to break out of their normal life and hit the road.
4. Peter Farrelly (1994). Harry (Jeff Daniels) and Lloyd (Jim Carrey) set out on a cross country trip from Providence to Aspen, Colorado to return a briefcase full of money to its rightful owner, the beautiful Mary Swanson (Lauren Holly).
5. Walter Salles (2004). In 1952, 23-year old medical student Ernesto Guevara de la Serna (Gael García Bernal) accompanies his 29-year old biochemist friend Alberto (Rodrigo De la Serna) on his four month, 8,000 km long motorcycle trip

throughout South America starting from their home in Buenos Aires.
6. Ethan Coen, Joel Coen (2010). 14-year-old Mattie Ross (Hailee Steinfeld) hires Rooster Cogburn (Jeff Bridges) to search for her father's killer Tom Chaney. She insists on accompanying Cogburn in his trek into the Indian Nations in search of Chaney.
7. Alexander Payne (2013). Aging Woody (Bruce Dern) and his son David (Will Forte) go on a road trip from Montana to Nebraska to claim a million-dollar Sweepstakes Marketing prize.
8. Ken Kwapis (2015). Bill Bryson (Robert Redford) and Stephen Katz (Nick Nolte), both in their seventies, attempt to hike the 2,180 miles Appalachian Trail.
9. Paolo Virzi (2017). Elderly John Spencer (Donald Sutherland) with wife Ella (Helen Mirren) go on an unforgettable journey in an old Recreational vehicle, traveling from Boston to The Ernest Hemingway Home in Key West. They recapture their passion for life and their love for each other on a road trip.

Answers: *1. Bonnie and Clyde. 2. Easy Rider. 3. Thelma and Louise. 4. Dumb and Dumber. 5. The Motorcycle Diaries. 6. True Grit. 7. Nebraska. 8. A Walk in the Woods. 9. The Leisure Seekers.*

Merchant and Ivory Films

Ismail Merchant was born in 1936 in Bombay, now Mumbai, and died in 2005. James Ivory was born in 1938 in California. Ruth Praver Jabhvala who collaborated with many of their films was born in 1927 in Cologne and died in 2013. Can you identify the following Merchant-Ivory films?

1. (1963). Newly-wed Prem (Shashi Kapoor) and Indu (Leela Naidu) have a difficult time adjusting to married life. The first film made by Merchant Ivory Production.
2. (1965). Nomadic British Actor Tony Buckingham (Geoffrey Kendal) perform Shakespearen plays in towns in post-colonial India.

3. (1979). Siblings Felix Young (Tim Woodward) and Eugenia Munster (Lee Remick), who were raised in Europe, visit their cousins, the Westworths, in Boston.
4. (1983). In the British Raj, Olivia (Greta Scacchi), recently married to colonial officer Douglas (Christopher Cazenove), has an illicit affair with a Nawab (Shashi Kapoor).
5. (1984). Lawyer Basil Ransom (Christopher Reeve) and suffragette Olive Chancellor (Vanessa Redgrave) are fascinated by gregarious Verena Tannant (Madeleine Potter).
6. (1992). After the death of his wife Ruth (Vanessa Redgrave), Henry Wilcox (Anthony Hopkins), becomes attracted to Margaret Schlegel (Emma Thompson).
7. (1993). James Stevens' (Anthony Hopkins') position as a butler prevents him from reciprocating the feelings of housekeeper Miss Kenton (Emma Thompson), who falls in love with him.
8. (1994). A professor of Hindi, Devan (Om Puri), arranges for an interview with an aging poet Noor (Shashi Kapoor).
9. (2000). Impoverished Italian Prince Amerigo (Jeremy Northam) marries American socialite Maggie Verver (Kate Beckinsale) though he is in love with Charlotte Stant (Uma Thurman).

Answers: *The Householder. 2. Shakespearewallah. 3. The Europeans. 4. Heat and Dust. 5. The Bostonians. 6. Howards End. 7. Remains of the Day. 8. In Custody. 9. The Golden Bowl.*

Animals

Fred M. Wilcox's **Lassie Come Home** (1943). The Carraclough family is forced to sell their dog to the rich Duke of Rudling (Nigel Bruce). However, Lassie, the dog, is unwilling to leave Joe (Roddy McDowall) and runs away on a long and dangerous journey to rejoin him. Can you identify the following film about animals?

1. Irving Rapper (1956). A Mexican boy Leonardo (Michael Ray) tries to save a bull (Gitano) from a famous bullfighter (Fermin Rivera).

2. James Hill (1966). George (Bill Travers) and Joy Adamson (Virginia McKenna) adopt an orphaned lion cub Elsa in Kenya.
3. Steven Spielberg (1975). Sheriff Brody (Roy Scheider), with archaeologist Hooper (Richard Dreyfuss) and Captain Quint (Robert Shaw) decide to go after a killer shark that is terrorizing the beach.
4. Simon Wincer (1993). Jesse (Jason James Richter), a troubled 12-year-old boy befriends Willy, a surly and uncooperative orca, and helps to release him back to ocean.
5. Chris Noonan (1995). Farmer Hoggett (James Cromwell) brings a piglet, who is raised by sheepdog Fly. Growing up, he does the work of a sheep dog.
6. Steven Spielberg (2011). Young Albert (Jeremy Irvine) enlists to serve in World War I after his horse Joey is sold to the cavalry. Wounded in war, he hears about a horse found in no man's land.

Answers: 1. *The Brave One.* 2. *Born Free.* 3. *Jaws.* 4. *Free Willy.* 5. *Babe.* 6. *War Horse.*

Heroes

Fred Niblo's **The Mark of Zorro** (1920). Atheletic masked hero Zorro (Douglas Fairbanks) is a vigilante dedicated to freeing the people from the oppression of the Governor's regime. Can you identify the following films on heroic figures?

1. Fritz Lang (1924). Siegfried (Paul Richter), son of King Sigmund of Xanten, hears of the beautiful Kriemhild (Margarete Schön), sister of Gunter, King of Worms.
2. Anthony Mann (1961). Spanish hero Rodrigo Diaz de Vivar (Charlton Heston), who is married to Jimena (Sophia Loren), defends Christian Spain against the Moors.
3. Mel Gibson (1995). William Wallace (Mel Gibson), a 13th-century Scottish warrior, leads the Scots in the First War of Scottish Independence against King Edward I (Patrick McGoohan) of England.

4. Wolfgang Petersen (2004). Greek hero Achilles (Brad Pitt) kills the Trojan prince Hector (Eric Bana) and refuses to give his body for burial.
5. Robert Zemeckis (2007). A Geat hero (Ray Winstone), (Geat, pronounced Yat, was a tribe that resided in what is southern Sweden), travels to Denmark to help the Danish king Hrothgar (Anthony Hopkins). He kills the horrible troll Grendel (Crispin Glover) who harasses the Danes in their great hall, Heorot.
6. Ridley Scott (2014). To free the Jewish people from captivity in Egypt, Moses (Christian Bale) leads a rebellion against Pharaoh Ramses II (Joel Edgerton).

Answers: *1. Die Nibelungen: Siegfried. 2. El Cid. 3. Braveheart. 4. Troy. 5. Beowulf. 6. Exodus: Gods and Kings.*

Tarzan

John Clayton is the son of a British lord and Lady, who are marooned in Africa. When his parents die, the one-year old John is adapted by Kala, an ape, as her own son, and is called Tarzan, which means white skin.

The first Tarzan film was Scott Sidney's ***Tarzan of the Apes*** which was released on 27 Jan 1918. Elmo Lincoln played the role of Tarzan and Enid Markey that of Jane. The film was based on the 1912 novel *Tarzan of the Apes* by Edgar Rice Burroughs. Can you identify the following Tarzan films?

1. (1932). First film to star Johnny Weissmuller as Tarzan and Maureen O'Sullivan as Jane.
2. (1933). Featured Olympic swimmer Buster Crabbe as Tarzan.
3. (1938). Tarzan (Glenn Morris) must rescue Eleanor (Eleanor Holm) from her guide Olaf Punch (Joe Sawyer), who wants to deliver her to Ben Alleu Bey (C. Henry Gordon).
4. (1982). Tarzan (Miles O'Keeffe) rescues Jane (Bo Derek) from an African tribe which has abducted her and killed her father James Parker (John Derek).

5. (1984). Capitaine Phillippe D'Arnot (Ian Holm), on discovering that the wild Tarzan (Christopher Lambert) is the son of John Clayton who was killed in Africa, takes him back to Scotland to the home of his grandfather, the Sixth Earl of Greystoke (Ralph Richardson). Jane Porter (Andie McDowel), seeing Tarzan's unease, agrees that he should go back to Africa.
6. (2016). Scottish lord John Clayton (Alexander Skarsgard), raised by an ape and known as Tarzan, returns to his village in Congo with Jane (Margot Robbie). When they arrive, Rom (Christoph Waltz), an emissary of King Leopold of Belgium, attacks their village and captures Tarzan and Jane.

Answers: *1. Tarzan the Ape Man. 2. Tarzan the Fearless. 3. Tarzan's Revenge. 4. Tarzan the Apeman. 5. Greystroke the Legend of Tarzan. 6. The Legend of Tarzan.*

More Films

Fred Zinnemann's **From Here to Eternity** (1953). Set in Hawaii before the war. Capt. Dana Holmes (Philip Ober) puts pressure on Pvt. Robert E. Lee Prewitt (Montgomery Clift), who has given up boxing, to represent his unit's boxing team. Meanwhile Sergeant Warden (Burt Lancaster) starts seeing the captain's wife, Karen Holmes (Deborah Kerr). Can you identify the following films?

1. Ingmar Bergman (1957). Antonius Block, a medieval knight (Max von Sydow) returning home from the Crusades challenges Death (Bengt Ekerot) to a game of chess.
2. Akira Kurosawa (1950). In 12th century Japan, a samurai and his wife are attacked by a notorious bandit, and the samurai ends up dead. This episode is recalled from different point of view.
3. Federico Fellini (1960). Marcello Rubini (Marcello Mastroianni) is a tabloid journalist, or paparazzo. Though married to Emma, he has affairs with local heiress Maddalena (Anouk Aimee) and Swedish actress Sylvia (Anita Ekberg). The title translated in English means the sweet life.

4. Ralph Nelson (1963). Homer Smith (Sidney Poitier) stops at a chapel run by a group of German nuns. He intends to stay only briefly, but ends up building most of the chapel for them.
5. Sergio Leone (1965). Manco (Clint Eastwood) is a bounty killer chasing El Indio (Gian Maria Volonté). He meets Col. Douglas Mortimer (Lee Van Cleef), who has another motive for killing El Indio.
6. Michelangelo Antonioni (1966). Thomas (David Hemmings) is a fashion photographer, who unwittingly captures a murder while filming someone.
7. David Lynch (1980). John Merick (John Hurt) is a severely deformed man and is exhibited as a freak. Dr. Frederick Treves (Anthony Hopkins) rescues him from being exploited and rehabilitates him.
8. Robert Altmann (1970). Two young surgeons, rebellious and mischievous, Duke Forrest (Tom Skerritt) and Hawkeye Pierce (Donald Sutherland) join the military hospital three kilometers for the Korean frontlines.
9. Zhang Yimou (1987). A young woman (Li Gong) is forced to run the winery when her leprous husband dies a few days after his arranged marriage.
10. Barry Levinson (1988). Selfish yuppie Charlie Babbitt's (Tom Cruise) father leaves a fortune to Raymond (Dustin Hoffman), his institutionalized autistic son that Charlie didn't know existed.
11. Jim Sheridan (1989). Though Christy Brown (Daniel Day Lewis) has cerebral palsy and can use only one foot, he starts painting and writing.
12. Mike Figgis (1995). Alcoholic Ben (Nicolas Cage) has lost everything, his wife, his child and job. With his severance money he decides to travel to Las Vegas alone, where he can literally drink himself to death.
13. Robert Zemeckis (1994). A simpleton (Tom Hanks) accomplishes many tasks and wins at last the heart of his life-long friend Jenny Curran (Robin Wright).
14. Peter Bogdanovich (2001). Producer Thomas H. Ince (Cary Elwes) dies mysteriously aboard the yatch of media mogul William Randolph Hearst (Edward Herrmann) in 1924. Among

the guests are film star Charlie Chaplin (Eddie Izzard) and Marion Davies (Kirsten Dunst).
15. Will Gluck (2018). Bea (Rose Byrne) tries to prevent Mr. McGregor (Sam Neill) from catching mischievous rabbits who steal from his vegetable garden.

Answers: 1. The Seventh Seal. 2. Rashomon. 3. La Dolce Vita. 4. Lilies of the Field. 5. For a Few Dollars More. 6. Blow-up. 7. The Elephant Man. 8. M.A.S.H. 9. Red Sorghum. 10. Rain Man. 11. My Left Foot. 12. Leaving Las Vegas. 13. Forrest Gump. 14. Cat's Meow. 15. Peter Rabbit.

Mixed Bag - Films

Napoleon (1927, Fr) was directed by Abel Gance. It incorporated just about every film technique invented and several that were brand new. It was the first film to be shot in widescreen using three cameras next to each other. However, extreme length (six hours) and expensive screening requirements spelt box-office disaster. Can you identify the following films?

1. This film was the most expensive film of its time (1930) and cost $3.95. million. The film used 70 pilots in the film, three of them died during shooting. The film was directed by millionanire Howard Hughes.
2. This 1933 film was the first to use the word "damn", which was noted by Hays' Office.
3. The 1933 film in which Rufus T. Firefly (Groucho) is made president of a bankrupt country Freedonia and declares war on the neighbouring Sylvania.
4. These were a series of musical and entertainment shows in Broadway from 1907 to 1931. Inspired by Folies Bergere of Paris, they were conceived and mounted by Florenz Zeigfield. These shows included many beautiful chorus girls. Actors like WC Fields, Eddie Cantor, Bob Hope and Will Rogers appeared in these shows. What is the name of the 1946 film starring Fred Astaire, Lucille Ball, Judy Garland and Gene Kelly, based on the show?

5. Which was the only film on which two winners of the Nobel Prize of Literature worked (Hemingway and Faulkner worked on its story)?
6. This 1945 film was said to be France's answer to *Gone with the Wind* (1939).
7. The release of this 1953 movie starring Audrey Hepburn put Vespa scooter on the path to cult status.
8. The 1955 film was the only film that was released during James Dean's life time.
9. The 1956 film was filmed near a nuclear test site, and the set was contaminated by nuclear fallout. Photographs exist of John Wayne holding a Geiger counter. After location shooting, contaminated soil was transported back to Hollywood in order to match interior shooting done there. Over the next 20 years, many actors and crew members developed cancer. By November 1980, 91 of the 220 cast and crew members had developed cancer. Forty-six had died, including John Wayne, Susan Hayward, Pedro Armendáriz (who shot himself soon after learning he had terminal cancer), Agnes Moorehead, and director Dick Powell. Lee Van Cleef had throat cancer, but died of a heart attack.
10. Hitchcock made two films with the same title. One in 1934, and other in 1956, starring James Stewart and Doris Day. The title was the same as the title of a book by G K Chesterton.
11. This 1939 film was directed in turns by Norman Taurog, Richard Thorpe, George Cukor, Victor Fleming and King Vidor.
12. The origin of the term "paparazzi" comes from a character called Paparazzo who is a journalist photographing celebrities in a 1960 film of Fellini.
13. This 1960 film was based on the Scopes Monkey Trial of Tennesse 1925 in which a teacher was prosecuted for teaching Darwins' theory of evolution.
14. This 1962 film is the longest one which has no woman speaking parts.
15. About this 1964 film made by Kubrick, a NYT critic wrote that it was a "discredit and even contempt for our whole defense establishment ... the most shattering sick joke I've ever come across.".

16. This 1971 film, starring Malcolm MacDowell, was condemned for its alleged violence and was not available legally in the United Kingdom till 2000..
17. In which 1982 film would you find a turban-wearing character, called Punjab? He was the assistant of Daddy Warbucks (Albert Finney).
18. John Sturges' **The Magnificent Seven** (1960) was a remake of which Akira Kurusawa's film made in 1954?
19. Narendra Bedi's **Rafoo Chakkar** (1975, Hnd) starring Rishi Kapoor: was a remake of which Billy Wilder's film made in 1959 starring Marilyn Monroe?
20. Raj N. Sippy's **Satte pe Satta** (1982, Hnd) starring Amitabh Bacchan was a remake of which Stanley Donen's film made in 1954, starring Jane Powell?
21. Leonard Nimoy's **Three Men and a Baby** (1987) starring Tom Selleck was a remake of which Coline Serreau's French film made in 1985 starring Roland Giraud?
22. This 1991 film is dedicated to "the young in whose spirit the search for truth marches on".
23. This 1996 film directed by Joel Coen is named after a place in north Dakota.
24. The first US film to show a toilet (Hint: Anthony Perkin).
25. The alternate title of this 2014 film starring Michael Keaton is **The Unexpected Virtue of Ignorance**.
26. The alternate title of this 1964 film starring peter Sellers is **How I learnt to stop worrying and love the Bomb**.

Answers: 1. Hell's Angels. 2. Cavalcade. 3. Duck Soup. 4. Ziegfield Follies. 5. To have and have not (1944). 6. Les enfants du paradis (Children of Paradise). 7. Roman Holiday. 8. East of Eden. 9. The Conqueror. 10. The Man who Knew too Much. 11. The Wizard of Oz. 12. Fellini's La Dolce Vita. 13. Inherit the Wind. 14. Lawrence of Arabia. 15. Dr. Strangelove 16. A Clockwork Orange. 17. Annie. 18. Seven Samurai. 19. Some like it Hot. 20. Seven Brides for Seven Brothers. 21. Three Men and a Cradle. 22. JFK. 23. Fargo. 24. Psycho. 25. Birdman. 26. Dr. Strangelove.

Opening and Closing Words

Opening Words (Voice) in Films

Rebecca (1940) opened with the words: Last night, I dreamt I went to Manderley again. Identify the films which open with the following words

1. (1956). Call me Ishmael.
2. (1962). He was the most extraordinary man I ever knew.
3. (1960). Now I want you to remember that no bastard ever won a war by dying for his country. He won it by making the other poor dumb bastard die for his country.
4. (1987). I am Gunnery Sergeant Hartman, your senior drill instructor. From now on, you will speak only when spoken to, and the first and last words out of your filthy sewers will be 'Sir!' Do you maggots understand that?
5. (1990). As far back as I can remember, I always wanted to be a gangster.
6. (2004). Men are haunted by the vastness of eternity.
7. (2005) No one would have believed in the early years of the 21st century that our world was being watched by intelligences greater than our own. As men busied themselves about their various concerns they were observed and studied. With infinite complacency men went to and fro about the globe confident of their empire over this world. Yet across the gulf of space, intellect vast and cruel and unsympathetic, regarded our planet with envious eyes.

Answers: 1. Moby Dick. 2. Lawrence of Arabia. 3. Patton. 4. Full Metal Jacket. 5. GoodFellas. 6. Troy. 7. The War of the Worlds.

Opening Words (Text) in Films

The Wizard of Oz (1939) opened with the words written on screen: For nearly forty years this story has given faithful service to the Young in Heart; and Time has been powerless to put its kindly philosophy out of fashion. To those of you who have been faithful to it in return... and to the Young in Heart...we dedicate this picture. Identify the films which open with the following words

1. (1965). Where life had no value, death, sometimes, had its price. That is why the bounty killers appeared.
2. (1977). A long time ago, in a galaxy far, far away....
3. (1978). This film should be played loud.
4. (1998). He who makes a beast of himself gets rid of the pain of being a man. Dr. Johnson.
5. (1991). To sin by silence when we should protest makes cowards out of men. Ella Wheeler Wilcox..
6. (2003). Revenge is a dish best served cold. An old Klingon proverb.
7. (2004) This isn't a tale of heroice feats. It's about two lives running parallel for a while, with common aspirations and similar dreams (translated). Ernesto Guevara de la Serna (1952).
8. (2004). 3200 years ago. After decades of warfare, Agamemnon, king of Mycenae, has forced the kingdoms of Greece into a loose alliance.
9. (2013). At 600km above planet earth the temperature fluctuates between +258 and -148 degree Fahrenheit.
10. (2014) And did you get what you wanted from this life, even so? I did. And what did you want? To call myself beloved, to feel myself beloved on the earth. Raymond Carver.

Answers: 1. For a Few Dollars More. 2. Star Wars. 3. The Last Waltz. 4. Fear and Loathing in Las Vegas. 5. JFK. 6. Kill Bill Vol. I. 7. The Motorcycle Diaries. 8. Troy. 9. Gravity. 10. Birdman.

Closing Words (Voice) in Films

"Mother of mercy, is this the end of Rico?" These were the closing words in **Little Caesar** (1931) spoken by Rico (Edward G. Robinson). Identify the films which close with the following words

1. (1933).Oh, no. It wasn't the airplanes. It was Beauty killed the Beast.
2. (1935). It's a far, far better thing I do than I have ever done. It's a far, far better rest I go to than I have ever known.
3. (1939). After all, tomorrow is another day!
4. (1940).The soul of man has been given wings and at last he is beginning to fly. He is flying into the rainbow! Into the light of hope! Into the future, the glorious future that belongs to you, to me, and to all of us. Look up, Hannah! Look up!
5. (1942). Louis, I think this is the beginning of a beautiful friendship.
6. (1958). The old man was dreaming about the lions.
7. (1978). The old man was right. Only the farmers won. We lost. We always lose.
8. (1979). The horror. The horror.
9. (1982). When I despair, I remember that all through history the way of truth and love has always won. There have been tyrants and murderers and for a time they can seem invincible, but in the end they always fall. Think of it. Always..
10. (1985). Roads? Where we are going, we don't need roads.

Answers: 1. King Kong. 2. Tale of Two Cities. 3. Gone With the Wind. 4. The Great Dictator. 5. Casablanca. 6. The Old Man and the Sea. 7. The Magnificient Seven. 8. Apocalypse Now. 9. Gandhi. 10. Back to Future.

Science Fiction

Sci-Fi Films based on books

F. W. Murnau's **Nosferato** (1922, Ger) was based on Bram Stoker's 1897 novel Dracula. Identify the books on which the following science fiction films are based.

1. James Whale's **Frankenstein** (1931) starring Boris Karloff.
2. Richard Fleischer's **20,000 Leagues Under the Sea** (1954) staring Kirk Douglas.
3. Philip Kaufman's **Invasion of the Body Snatchers**. (1978), starring Donald Sutherland.
4. Ridley Scott's **Blade Runner** (1982) starring Harrison Ford.
5. John Carpenter's **The Thing** (1982) starring Kurt Russel.
6. Steven Spielberg's **Jurassic Park** (1993) starring Sam Neill.
7. Simon Wells' **The Time Machine** (2002) starring Guy Pearce.
8. Steven Spielberg's **The War of the Worlds** (2005) starring Tom Cruise.
9. Steven Spielberg's **A.I. Artificial Intelligence** (2001).

Answers: 1. Frankenstein by Mary Shelley. 2. 20,000 Leagues Under the Sea by Jules Verne. 3. The Invasion by Jack Finney. 4. Do Androids Dream of Electric Sheep? by Phillip K Dick. 5. Who Goes There? by John W. Campbell Jr. 6. Jurassic Park by Michael Crichton. 7. The Time Machine by H G Wells. 8. The War of the Worlds by H G Wells. 9. Supertoys Last All Summer Long. (2001) by Brian Aldiss.

War of the Worlds

Steven Spielberg's **The War of the Worlds** (2005). The Martians attack earth with their huge three-legged war machine that burn everything and everybody. Ray Ferrier (Tom Cruise) struggles to protect his children from the war machines. Identify these films which feature aliens attacking humans.

1. Roland Emmerich (1996). Powerful aliens launch an all out invasion against the human race, destroying major cities. Can Captain Steven Hiller (Will Smith) and David Levinson (Jeff Goldblum) reach the mother ship and implant the virus to disable it.
2. Philip Kaufman (1978), Dr. Matthew Bennell (Donald Sutherland) watches helplessly as alien pods are transforming humans into emotionless duplicates.
3. John Carpenter (1982). An alien capable of absorbing and perfectly imitating its victims infects an American research station in Antarctica. Of the two who survive the attack is the helicopter pilot R.J. MacReady (Kurt Russell).

Answers: 1. Independence Day. 2. Invasion of the Body Snatchers. 3. The Thing.

Robots

Fritz Lang's **Metropolis** (1927). In a futuristic city where society is divided into the wealthy planners and the workers living underground, a robot is made to lead the workers to revolution. Identify these films which have robots in them.

1. James Whale (1931). Scientist Henry Frankenstein (Colin Clive) creates a man from body parts he has assembled from various sites such as graveyards and the gallows. The experiment grows awry when the man (Boris Karloff) turns into a monster.
2. Stanley Kubrick (1968). In 2001 Discovery One under mission commander Dr. Dave Bowman (Keir Dullea) is on a mission to

Jupiter but it is the artificial intelligent computer HAL 9000 which controls all of the craft's functions.
3. Ridley Scott (1982). In 2019, ex-policeman Rick Deckard (Harrison Ford) is hired to hunt down fugitive replicants including Roy Batty (Rutger Hauer) living undercover in Los Angeles.
4. James Cameron. (1984). A cyborg (Arnold Schwarzenegger) is sent back through time to 1984 to kill waitress Sarah Connor (Linda Hamilton).
5. Paul Verhoeven (1987). In crime-ridden Detriot of the future, policeman Alex Murphy (Peter Weller), killed by a street gang, is resurrected as a cyborg.
6. Chris Columbus (1999). Richard Martin (Sam Neill) who has bought Andrew (Robin Willaims) a robot to perform menial tasks, realizes that he experience emotions and creative thought. It is after 200 years that Andrew is declared a human.
7. Steven Spielberg (2001). David (Haley Joel Osment) is a mecha (robot) who wants to be a real boy so that his 'mother' (Monica Swinton) may love him. Like Pinocchio, he goes on a long journey hoping to find his "Blue Fairy," who can make him real.

Answers: *1. Frankenstein. 2. 2001: A Space Odyssey. 3. Blade Runner. 4. Terminator. 5. RoboCop. 6. Bicentennial Man. 7. A.I. Artificial Intelligence.*

Aliens

Georges Méliès' **A Trip to the Moon** (1902). This 14-minute film shows six astronomers, including Professor Barbenfouillis (Georges Méliès), their president, land their bullet-shaped spaceship on the moon. They encounter the Selenites, the alien inhabitants of the moon. Identify the following films that feature aliens.

1. Ed Wood (1959). Two aliens, Eros (Dudley Manlove) and Tanna (Joanna Lee), land their UFO in a California cemetery and report to their boss that they will activate plan 9: to animate an army of the dead to march on the capitals of the world.

2. Nicolas Roeg (1976). Thomas Jerome Newton, a humanoid alien (David Bowie) from a planet where people are dying of thirst, falls to earth. Here he gets addicted to alcohol and TV and falls in love with maid Mary-Lou (Candy Clark).
3. Ridley Scott (1979). A ferocious and tenacious alien enters the spaceship Nostromo causing havoc in the ship. Only Ripley (Sigourney Weaver) and Jones the cat manage to survive the onslaught.
4. John Carpenter (1984). A peaceful alien enters the house of the recently widowed Jenny Hayden (Karen Allen) and assumes the body of her husband Scott (Jeff Bridges).

Answers: 1. *Plan 9 from Outer Space*. 2. *The Man Who Fell to Earth*. 3. *Alien*. 4. *Starman*.

Future World

Richard Flescher **20,000 Leagues Under the Sea** (1954). A warship, with Prof. Arronax (Paul Lukas) and harpooner Ned Land (Kirk Douglas) onboard, is sent to investigate a mysterious monster that is terrorizing ships. To their surprise, they find that the monster is a submarine commanded by Capt Nemo (James Mason). Identify the following films about the future.

1. Michael Anderson (1956). In the powerful police superstate of Oceania ruled by the omnipresent Big Brother, Winston Smith (Edmond O'Brien) and Julia (Jan Sterling) fall in love with each other.
2. Lana and Lilly Wachowski (1999). Rebel Morpheus (Laurence Fishburne) reveals to computer hacker Neo (Keanu Reeve) that all life on Earth may be nothing more than an elaborate facade created by a malevolent cyber-intelligence.
3. Simon Wells (2002). Dr Alexender (Guy Pierce) constructs a machine that enables him to travel into the future; where he discovers that mankind's descendants have divided into two species, the childlike and vegetarian Eloi and the underground-dwelling Morlocks, who feed on the Eloi.

4. Matt Reeves (2014). A global pandemic has all but wiped out the human civilization while the apes are growing in numbers. The leader of apes Caesar (Andy Serkis) and his human friend Malcolm (Jason Clarke) try to convince their groups to prevent a war between the apes and the humans.

Answers: *1. 1984. 2. Matrix. 3. Time Machine. 4. Dawn of the Planet of the Apes.*

Strange Creatures

Eugène Lourié's **The Beast from 20,000 Fathoms** (1953). A giant dinosaur is brought back to life by nuclear testing in the arctic. The rhedosaurus makes its way to New York, destroying shipping vessels and a lighthouse. Nuclear physicist Tom Nesbitt (Paul Hubschmid) suggests shooting a radioactive isotope into the beast. Identify the following films featuring weird and strange creatures.

1. Ishiro Honda (1954). A 50-meter amphibious reptilian monster goes on a rampage in Japan. He has an anthropomorphic torso with muscular arms, spikes on its back and tail, and a furrowed brow. Only Dr Serizawa (Akihiko Hirata) has a device that could kill the monster.
2. Douglas Hickox, Eugène Lourié (1959). Large amount of radioactive material being buried in British waters resurrects a creature of the paleosaurus family only larger than any specimen found. The creature kills people by the emiting radiation and electric shocks.
3. Roland Emmerich (1988). Scientist Nick Tatopoulous (Matthew Broderick) unveils the mystery behind the origin of the giant lizard which is devastating New York.
4. Peter Jackson (2005). Film maker Carl Denhan (Jack Black) and his team travel to the mysterious Skull Island to investigate legends of a giant gorilla named Kong where they meet many prehistoric creatures.

Answers: *1. Godzilla. 2. The Giant Behemoth. 3. Godzilla. 4. King Kong.*

Mixed Bag- Science Fiction

1. What is the middle name of Capt James Kirk of *Star Trek*?
2. From which planet does Spock (Leonard Nimoy) come?
3. Who was the creator, writer and producer of **Star Trek** (1966), the television series?
4. The mission of which starship is "To boldly go where no man has gone before"?
5. Who played the role of Capt Kirk in the television version?
6. In **Star Trek: The Next Generation** (1987), who played the role of Capt Picard?

Answers: 1. Tiberius. 2. Vulcan. 3. Gene Rodenberry. 4. USS Enterprise. 5. William Shatner. 6. Patrick Stewart.

James Bond

James Bond Films

Ian Fleming created the character of British secret service agent James Bond. The first Bond film was **Dr. No** (1962), starring Sean Connery. Can you identify the following James Bond films?

1. Terence Young (1962). James Bond (Sean Connery) prevents a SPECTRE operative from disrupting the space launch of Mercury from Cape Canaveral using radio beams.
2. Terence Young (1963). James Bond (Sean Connery) manages to obtain the Soviet's cryptographic device Lektor with the help of Tanya.
3. Guy Hamilton (1964). James Bond foils a plan to break into Fort Knox and contaminate its gold.
4. Terence Young (1965). James Bond (Sean Connery) takes on the evil SPECTRE organization which has hijacked a British Vulcan bomber carrying atomic warheads.
5. Ken Hughes et el (1967). This is a spoof on James Bond films and stars David Niven as James Bond.
6. Lewis Gilbert (1987). James Bond (Sean Connery) infiltrates Blofield's (Donald Pleasence) secret island from where he is controlling the capture of a Soviet spacecraft by Bird One spacecraft.
7. Peter Hunt (1969). James Bond (George Lazenby) infiltrates Blofield's allergy-research institute atop Piz Gloria in the Swiss Alps and finds that it is used for brainwashing people.
8. Guy Hamilton (1971). James Bond (Sean Connery) thwarts Blofeld's plan of destroying Washington, D.C. using nuclear weapons.

9. Guy Hamilton (1973). James Bond (Roger Moore) takes on Dr. Kananga (corrupt Caribbean dictator), who is also Mr Big, a druglord in US. He burns down his heroin processing lab.
10. Guy Hamilton (1974). James Bond (Roger Moore) kills Scaramanga (Christopher Lee) in a duel.
11. Lewis Gilbert (1977). James Bond (Roger Moore) prevents Stromberg's plan to trigger a global nuclear war which would destroy the word.
12. Lewis Gilbert (1979). James Bond (Roger Moore) defeats Hugo Drax (Michael Lonsdale) who wanted to create a new master race while destroying the earth by launching 50 globes that would dispense the nerve gas into Earth's atmosphere.
13. John Glen (1981). James Bond (Roger Moore) is sent to find as encryption device ATAC from a sunken submarine.
14. John Glen (1983). James Bond (Roger Moore) foils a plot by renegade Soviet General Orlav to detonate an atomic bomb on a U.S. Air Force Base.

Answers: *1. Dr. No. 2. From Russia with Love. 3. Goldfinger. 4. Thunderball. 5. Casino Royale. 6. You Only Live Twice. 7. On Her Majesty's Secret Service. 8. Diamonds Are Forever. 9. Live and Let Die. 10. The Man with the Golden Gun. 11. The Spy Who Loved Me. 12. Moonraker. 13. For Your Eyes Only. 14. Octopussy.*

James Bond Going Places

From Russia with Love (1963) takes place in Istanbul, Sarajevo, Zagreb and Venice.

Match these Bond films with their locations.

	Film	Places
1	Goldfinger (1964)	Paris, Nassau
2	Thunderball (1965)	Miami Beach, Geneva, Fort Knox, Kentucky
3	Casino Royale (1967)	Ireland, Scotland, England.
4	On Her Majesty's Secret Service (1969)	California, Venice, Rio de Janeiro, Amazon rainforest, space

	Film	Places
5	Diamonds Are Forever (1971)	Amsterdam
6	Live and Let Die (1973)	New York, New Orleans
7	The Man with the Golden Gun (1974)	Beirut, Macaw, Hong Kong, Bangkok.
8	Moonraker (1979)	Portugal, Switzerland (Piz Gloria)
9	Octopussy (1983)	Hong kong, Tokyo, Kobe
10	You Only Live Twice (1987)	Udaipur (India)

Answers: 1. Miami Beach, Geneva, Fort Knox, Kentucky. 2. Paris, Nassau. 3. Ireland, Scotland, England. 4. Portugal, Switzerland (Piz Gloria). 5. Amsterdam. 6. New York, New Orleans. 7. Beirut, Macaw, Hong Kong, Bangkok. 8. California, Venice, Rio de Janeiro, Amazon rainforest, space. 9. Udaipur (India). 10. Hong Kong, Tokyo, Kobe

James Bond Girls

In **Dr. No** (1962), Honey Ryder, played by Swedish actress Ursula Andress, was the first Bond girl.

Match the films with their leading female characters.

	Film	Characters (Actress)
1	From Russia with Love (1963)	Kissy Suzuki (Mie Hama)
2	Goldfinger (1964)	Pussy Galore (Honor Blackman)
4	Thunderball (1965)	Dominique "Domino" Derval (Claudine Auger)
5	Casino Royale (1967)	Vesper Lynd (Ursula Andress)
6	You Only Live Twice (1987)	Tanya Romanova (Daniela Bianchi)
7	On Her Majesty's Secret Service (1969)	Countess Tracy di Vicenzo (Diana Rigg)
8	Diamonds Are Forever (1971)	Tiffany Case (Jill St. John)
9	Live and Let Die (1973)	Solitaire (Jane Seymour)
10	The Man with the Golden Gun (1974)	Mary Goodnight (Britt Ekland)
11	The Spy Who Loved Me (1977)	Octopussy (Maud Adams)
12	Moonraker (1979)	Dr Holly Goodhead (Lois Chiles)
13	For Your Eyes Only (1981)	Melina Havelock (Carole Bouquet)
14	Octopussy (1983)	Anya Amasova (Barbara Bach)
15	A View to a Kill (1985)	Tanya Roberts (Stacey Sutton)
16	Tomorrow Never Dies (1997)	Col. Wai Lin (Michelle Yeoh)

Answers: 1.Tanya Romanova (Daniela Bianchi). 2. Pussy Galore (Honor Blackman). 3. Dominique "Domino" Derval (Claudine Auger). 4. Vesper Lynd (Ursula Andress). 5. Kissy Suzuki (Mie Hama). 6. Countess Tracy di Vicenzo (Diana Rigg). 7. Tiffany Case (Jill St. John). 8. Solitaire (Jane Seymour). 9. Mary Goodnight (Britt Ekland). 10. Anya Amasova (Barbara Bach). 11. Dr Holly Goodhead (Lois Chiles). 12. Melina Havelock (Carole Bouquet). 13. Octopussy (Maud Adams). 14. Tanya Roberts (Stacey Sutton). 15. Col. Wai Lin (Michelle Yeoh)

James Bond Villains

The first villain to star in James Bond films was Joseph Wiseman who played the role of Dr. No in **Dr. No** (1962).

Match the film with its villain.

	Film	Villain
1	**From Russia with Love** (1963)	Goldfinger (Gert Fröbe)
2	**Goldfinger** (1964)	Ernst Stavro Blofeld (Anthony Dawson)
3	**Thunderball** (1965)	Le Chiffre (Orson Welles)
4	**Casino Royale** (1967)	Emilio Largo (Adolfo Celi)
5	**You Only Live Twice** (1967)	Ernst Stavro Blofeld (Donald Pleasence)
6	**On Her Majesty's Secret Service** (1969)	Ernst Stavro Blofeld (Telly Savalas)
7	**Diamonds Are Forever** (1971)	Ernst Stavro Blofeld (Charles Gray)
8	**Live and Let Die** (1973)	Dr. Kananga/Mr. Big (Yaphet Kotto)
9	**The Man with the Golden Gun** (1974)	Francisco Scaramanga (Christopher Lee)
10	**The Spy who loved me** (1977)	Karl Stromberg (Kurt Jurgens)
11	**Moonraker** (1979)	Hugo Drax (Michael Lonsdale)
12	**For Your Eyes Only** (1981)	Aristotle Kristatos (Julian Glover)
13	**Never Say Never Again** (1983)	Ernst Stavro Blofeld (Max von Sydow)
14	**A View to a Kill** (1985)	Max Zorin (Christopher Walken)
15	**Skyfall** (2012)	Tiago "Raoul Silva" Rodriguez (Javier Bardem)

Answers: 1. Ernst Stavro Blofeld (Anthony Dawson). 2. Goldfinger (Gert Fröbe). 3. Emilio Largo (Adolfo Celi). 4. Le Chiffre (Orson Welles). 5. Ernst Stavro Blofeld (Donald Pleasence). 6. Ernst Stavro Blofeld (Telly Savalas). 7. Ernst Stavro Blofeld (Charles Gray). 8. Dr. Kananga/Mr. Big (Yaphet

Kotto). 9. Francisco Scaramanga (Christopher Lee). 10. Karl Stromberg (Kurt Jurgens). 11. Hugo Drax (Michael Lonsdale). 12. Aristotle Kristatos (Julian Glover). 13. Ernst Stavro Blofeld (Max von Sydow). 14. Max Zorin (Christopher Walken). 15. Tiago "Raoul Silva" Rodriguez (Javier Bardem).

James Bond Title Songs

Shirley Bassey sang the title song of **Goldfinger** (1964).

Match the James Bond film with the singer of the title song of the film.

	Film	Singer
1	From Russia with Love (1963)	Tom Jones
2	Thunderball (1965)	Mat Munro
3	You Only Live Twice (1967)	Shirley Bassey
4	Casino Royale (1967)	Herb Alpert & The Tijuana Brass (instrumental)
5	Diamonds are Forever (1971)	Nancy Sinatra
6	Live and Let Die (1973)	Paul McCartney and the Wings
7	The Man with the Golden Gun (1974)	Shirley Bassey
8	Moonraker (1979)	Lulu
9	For Your Eyes Only (1981)	Sheena Easton
10	A View to a Kill (1985)	Duran Duran
11	The Living Daylights (1987)	A-ha
12	GoldenEye (1995)	Tina Turner
13	Tomorrow Never Dies (1997)	Sheryl Crow
14	Die Another Day (2002)	Adele
15	Skyfall (2012)	Madonna

Answers: 1. Mat Munro. 2. Tom Jones. 3. Nancy Sinatra. 4. Herb Alpert & The Tijuana Brass (instrumental). 5. Shirley Bassey. 6. Paul McCartney and the Wings. 7. Lulu. 8. Shirley Bassey. 9. Sheena Easton. 10. Duran Duran. 11. A-ha. 12. Tina Turner. 13. Sheryl Crow. 14. Madonna. 15. Adele

Songs from James Bond

The song "The Look Of Love" from **Casino Royale** (1967) was sung by Dusty Springfield

Match the song with the singer of the song of the James Bond film

	Song	Singer
1	We Have All the Time in the World - **On Her Majesty's Service** (1969)	Chris Cornel
2	Nobody Does It Better - **The Spy Who Loved Me** (1977)	Carly Simon
3	You Know My Name - **Casino Royale** (2006)	Louis Armstrong

Answers: 1. Louis Armstrong. 2. Carly Simon. 3. Chris Cornel

Mixed bag - James Bond

Roger Moore was the oldest person to debut as James Bond. He was 45 in **Live and Let Die** (1973). He played James Bond seven times. Sean Connery also played the role seven times, but one of them was for a non-EON production **Never Say Never Again** (1983).

1. What is James Bond's weapon of choice?
2. In **Live and Let Die** (1973), who is the villain with mechanical arms?
3. What role did Louis Jourdan play in **Octopussy**?
4. Ian Flemming's **Thunderball** was used twice for making films. The first was **Thunderball** (1965) starring Sean Connery. Which was the second movie made in 1983?
5. In which film in which James Bond becomes a Japanese and takes a Japanese wife?
6. Which character does Bernard Lee plays in most of early Bond films?
7. What is the name of the head of MI6?
8. What is the name of the MI6 official who supplies Bond with multipurpose vehicles and gadgets?

Answers: 1. Walther PPK pistol. 2. Tee Hee (Johnson). 3. Kamal Khan. 4. Never Say Never Again also starring Sean Connery. 5. You Only Live Twice. 6. M. 7. M. 8. Q.

Comic Book Heroes

Superman

Superman was created by writer Jerry Siegel and artist Joe Shuster in the first issue of Action Comics in 1938. The bespectacled Clark Kent was modelled after comic actor Harold Lloyd and works for the newspaper the Daily Planet in the city of Metropolis. Superman was also modeled after the swashbuckling actor Douglas Fairbanks. Can you identify the following Superman films?

1. Richard Donner (1978). Jor-el (Marlon Brando) sends his son Kal-El from planet Krypton to Earth, where he grows up like a normal American boy Clark Kent (Christopher Reeve). Kent becomes Superman when he needs to fight villains.
2. Richard Lester (1980). Superman (Christopher Reeve) relinquishes his superpower so that he can marry Lois Lane (Margot Kidder). Three criminals from the planet Krypton led by General Zod (Terence Stamp) descend on earth in order to subjugate it, with the help of criminal Lex Luther (Gene Hackman).
3. Richard Lester (1983). Computer programmer August "Gus" Gorman (Richard Pryor) pits the good Clark Kent (Christopher Reeve) against his evil alter ego Bad Superman (Christopher Reeve). Lana Lang (Annette O'Toole) is Clark Kent's love interest.
4. Sidney J. Furie (1987). Lex Luthor (Gene Hackman) steals a hair of Superman's head from a museum and creates an evil solar-powered version of Superman (Christopher Reeve) called Nuclear Man (Mark Pillow).

5. Bryan Singer (2006). Superman (Brandon Routh) returns to Earth after a five-year absence. He finds that his love interest Lois Lane (Kate Bosworth) has moved on with her life. His arch-enemy Lex Luthor (Kevin Spacey) is plotting a scheme that will destroy Superman and America.
6. Zack Snyder (2013). Superman/ Kal-El /Clark Kent (Henry Cavill) is forced to kill the Kryptonian General Zod (Michael Shannon) who wants to turn Earth into a New Krypton by annihilating its inhabitants. Lois Lane (Amy Adams) is Clark Kent's love interest.

Answers: 1. Superman. 2. Superman II. 3. Superman III. 4. Superman IV: The Quest for Peace. 5. Superman Returns. 6. Man of Steel.

Batman

Batman was created by artist Bob Kane and writer Bill Finger and first appeared in the 27th issue of Detective Comics in 1939. Batman is the alter ego of Bruce Wayne, an American playboy, philanthropist, and owner of Wayne Enterprises. Batman lives in Gotham City with his butler Alfred. Can you identify the following Batman films?

1. Tim Burton (1989). Batman (Michael Keaton) must fight the new boss of the underworld, the Joker (Jack Nicholson) and protect the journalist Vicki Vale (Kim Basinger).
2. Tim Burton (1992). Batman (Michael Keaton) must thwart the plan of crooked businessman Max Schreck (Christopher Walken) and Penguin (Danny DeVito) to take over Gotham City. Max's lowly secretary Selina Kyle (Michelle Pfeiffer) transforms herself into the mysterious Catwoman.
3. Joel Schumacher (1995). District Attorney Harvey Dent (Tommy Lee Jones) accidentally disfigured becomes the evil Two-face and computer genius Edward Nygma (Jim Carrey) becomes (Riddler). Both join forces to take their revenge on Batman (Val Kilmer). Meanwhile Dr. Chase Meridian (Nicole Kidman) falls in love with the Batman.
4. Joel Schumacher (1997). Batman (George Clooney) and Robin (Chris O'Donnell) battle the deadly team of Mr. Freeze

(Arnold Schwarzenegger), who plans to freeze Gotham and venomous Poison Ivy (Uma Thurman) who wants to repopulate it with mutants.
5. Christopher Nolan (2005). Bruce Wayne (Christian Bale) moves to Asia, where he is mentored by Henri Ducard (Liam Neeson) and Ra's Al Ghul (Ken Watanabe) in how to fight evil. He returns to Gotham City and assumes the persona of the Batman.
6. Christopher Nolan (2008). Batman (Christian Bale) fights the sadistic Joker (Heath Ledger), and his erstwhile friend District Attorney Harvey Dent (Aaron Eckhart) becomes his enemy, the villainous Two-Face.
7. Christopher Nolan (2012). Batman (Christian Bale) is forced to come out of his retirement as Bane (Tom Hardy), a former member of the League of Shadows, lets loose a reign of terror in the city. Among the few allies he has, is Catwoman (Anne Hathaway).

Answers: 1. Batman. 2. Batman Returns. 3. Batman Forever. 4. Batman and Robin. 5. Batman Begins. 6. The Dark Knight. 7. The Dark Knight Rises.

Spider-Man

Stan Lee and Steve Ditko created the comic book superhero Spider-Man in 1962 for Marvel Comics publications. Spider-Man is the alias of Peter Parker, an orphan raised by his Aunt May and Uncle Ben in New York City. Spider-Man has many arch-enemies. Some of them are Doctor Octopus, Norman Osborn alias Green Goblin and Venom. Can you identify the following Spider-Man films?

1. Sam Raimi (2002). While on a science class field trip, Peter Parker (Tobey Maguire) is bitten by a genetically-engineered "super spider." As a result, Peter gains superhuman abilities. After his Uncle Ben (Cliff Robertson) is murdered, the teenager realizes that he must use his newfound abilities to protect New York City. Mary Jane Watson (Kirsten Dunst) is his love-interest.

2. **Sam Raimi (2004).** Peter Parker (Tobey Maguire) has to confront not only his former friend Harry Osborn (James Franco) who thinks he is responsible for his father's death but also the brilliant scientist Dr. Otto Octavius (Alfred Molina) who is transformed into Dr. Octopus having four tentacles.
3. **Sam Raimi (2007).** Harry Osborn (James Franco) still seeks vengeance for his father's death. Flint Marko (Thomas Haden Church) and Eddie Brock (Topher Grace) team up to confront Spider-Man.
4. **Marc Webb (2012).** The teenage Peter Parker (Andrew Garfield) has become an alienated social outcast pining over his crush Gwen Stacy (Emma Stone). He finds that Dr. Curt Connors (Rhys Ifans) who mutates into the Lizard was responsible for his father's death.
5. **Marc Webb (2014).** Spider-Man (Andrew Garfield) has to protect New York City from an unknown and mysterious man known as Electro (Jamie Foxx).
6. **Jon Watts (2017).** Peter Parker (Tom Holland), while waiting for Tony Stark (Robert Downey Jr.) to include him in the Avengers, has to overcome the villainous Vulture (Michael Keaton) who also happens to be Adrian Toomes, the father of his girlfriend Liz (Laura Harrier).

Answers: 1. *Spider-Man.* 2. *Spider-Man 2.* 3. *Spider-Man 3.* 4. *The Amazing Spider-Man.* 5. *The Amazing Spider-Man 2.* 6. *Spider-Man: Homecoming.*

DC Comics

DC Comics created iconic heroic characters such as Superman, Batman, Wonder Woman, The Flash, Green Lantern, Green Arrow, Hawkman and Supergirl. They created well-known villains such as The Joker, Lex Luthor and Catwoman. Can you identify the following films based on DC Comics?

1. **Pitof (2004).** Graphic designer Patience Phillips (Halle Berry) is a timid woman who can't stand up for herself. She lets people walk all over her, and has wasted her artistic talent working for a cosmetic company.

2. Francis Lawrence (2005). Supernatural detective John Constantine (Keanu Reeves) teams up with policewoman Angela Dodson (Rachel Weisz) to solve the mysterious suicide of her twin sister.
3. James McTeigue (2005). A shadowy freedom fighter (Hugo Weaving) plots to overthrow a neo-fascist regime in United Kingdom with the help of a young woman Evey (Natalie Portman).
4. Martin Campbell (2011). Reckless test pilot Hal Jordan (Ryan Reynolds) acquires superhuman powers when he is chosen by the Ring, the willpower-fed source of power to defend mankind, from Parallax, a powerful, evil being who feeds on fear. Caroline Ferris (Blake Lively) is Hal's love interest.
5. Zack Snyder (2016). Rivals Batman (Ben Affleck) and Superman (Henry Cavill) are soon forced to confront an even greater threat created by nefarious billionaire Lex Luthor (Jesse Eisenberg).
6. David Ayer (2016). A team of the world's most dangerous, incarcerated Super Villains, including Deadshot (Will Smith), Harley Quinn (Margot Robbie) and El Diablo (Jay Hernandez), is assembled to fight crime.
7. Patty Jenkins (2017). Diana (Gal Gadot), a princess of Amazons, is training to be a warrior. When a US pilot Steve Trevor (Chris Pine) who crashes on her island tells her about the World War I, she wants to join the war.

Answers: 1. *Catwoman*. 2. *Constantine*. 3. *V for Vendetta*. 4. *Green Lantern*. 5. *Batman vs Superman: Dawn of Justice*. 6. *Suicide Squad*. 7. *Wonder Woman*.

Marvel Comics

Marvel Comics superheroes include Spider-Man, Iron Man, Hulk, Thor, Captain America, Black Panther, Doctor Strange, Wolverine, Daredevil and Deadpool. They also created teams of superheroes such as The Avengers, the X-Men, the Fantastic Four, and the Guardians of the Galaxy. They created supervillains including Thanos, Doctor Doom, Magneto, Ultron, Green Goblin, Red Skull, Loki, Doctor Octopus and Venom. Can you identify the following Marvel Comics films?

1. Albert Pyun (1990). Steve Rogers (Matt Salinger), battling Red Skull (Scott Paulin) during World War II, becomes frozen in ice. When he revives after decades, he has to save the President of the United States from an assassination attempt.
2. Stephen Norrington (1998). Eric Brooks (Wesley Snipes), a human with vampire strengths, becomes a vampire-hunter. He battles vampire Deacon Frost (Stephen Dorff) with the help of hematologist Dr. Karen Jenson (N'Bushe Wright).
3. Bryan Singer (2000). Mankind is turning against mutants, persons with superhuman power. While mutants like Magento (Ian McKellen) want revenge against mankind, Professor Charles Xavier (Patrick Stewart) assembles a group of good mutants such as Wolverine (Hugh Jackson) who want to coexist peacefully with mankind.
4. Jon Favreau (2008). Millionaire Tony Stark (Robert Downey Jr.), captured by terrorists in Afghanistan, builds an armour and escapes to the US. In his home workshop, he builds a sleeker, more powerful version of his improvised armor suit and dons it to save people in Afghanistan.
5. Louis Leterrier (2008). Dr Bruce Banner (Edward Norton), seeks a cure to his unique condition, which causes him to turn into a giant green monster under emotional stress.
6. Kenneth Branagh (2011). When the reckless Thor (Chris Hemsworth), son of Odin (Sir Anthony Hopkins), challenges his brother's claim to the throne of Asgard, Odin throws the young warrior down to Earth to live amongst humans, where he falls in love with scientist Jane Foster (Natalie Portman). Meanwhile Loki (Tom Hiddleston) usurps the throne of Asgard and plans revenge.
7. Ryan Coogler (2018). Before T'Challa (Chadwick Boseman) becomes the king of Wakanda following his father's death, he has to face opposition from first the Jabari Tribe's leader M'Baku (Winston Duke) and then from Killmonger (Michael B. Jordan).

Answers: 1. Captain America. 2. Blade. 3. X Men. 4. Iron Man. 5. The Incredible Hulk. 6. Thor. 7. Black Panther.

Alter Egos (Marvel Comics)

The alter ego or alias of Norman Osborn, the head of Oscorp, is Green Goblin.

Match the villains from Marvel Comics with their alter egos

	Character	Alter ego
1	Harry Osborn	The Rhino
2	Aleksei Sytsevich	New Goblin
3	Scott Lang	Ant Man
4	Clint Barton	Hawkeye
5	Dr. Otto Octavius	The Chameleon
6	Dr. Kafka	Doc Ock
7	Dr. Curtis Connors	The Lizard
8	Eddie Brock	Venom
9	Max Dillon	Electro
10	Flint Marko	Sandman
11	Max Eisenhardt	Magento
12	Wade Wilson	Deadpool

Answers: 1. New Goblin. 2. The Rhino. 3. Ant Man. 4. Hawkeye. 5. Doc Ock. 6. The Chameleon. 7. The Lizard. 8. Venom. 9. Electro. 10. Sandman. 11. Magento. 12. Deadpool.

Alter Egos (DC Comics)

The alter ego or alias of Jack Napier the mobster was The Joker in *Batman* (1989)
Match the villains from DC Comics with their alter egos.

	Character	Alter ego
1	Dr. Victor Fries	The Scarecrow
2	Dr. Jonathan Crane	Mr. Freeze
3	Dr. Pamela Isley	Riddler
4	Edward Nygma	Poison Ivy
5	Harvey Dent	Two-Face
6	Oswald Chesterfield Cobblepot	Penguin
7	Selina Kyle	Catwoman

Answers: 1. Mr Freeze. 2. The Scarecrow. 3. Poison Ivy. 4. Riddler. 5. Two-Face. 6. Penguin. 7. Catwoman.

Mixed Bag

DC Comics was started by Major Malcolm Wheeler-Nicholson as National Allied Publications in 1934. This later became Detective Comics Inc. in 1937, which started the series Action Comics.

1. Which company was started by Martin Goodman in 1939 as Timely Comics and then became Atlas Comics?
2. What was created by Bob Kane and Bill Finger in Detective Comics #27 (1939)?
3. Which group was created by 1961 by writer Stan Lee and artist Jack Kirby for Marvel Comics?
4. According to Stan Lee, on whom the character of Tony Stark the hero of Iron Man based?
5. Who created, along with artist Jack Kirby, the comic book characters of the Hulk, Thor, Iron Man, and the X-Men?
6. Who created, along with artist Steve Ditko, the comic book characters of Doctor Strange and Spider-Man?
7. Which fictional character was created in 1919 by American pulp writer Johnston McCulley? His name meant fox. He is portrayed as a masked vigilante who defends the commoners and indigenous peoples against corrupt and tyrannical officials. His wears a mask covering the upper half of his face.
8. What was the name of Peter Parker's hot-tempered boss (played by J K Simmons)?
9. What was the name of the newspaper in which Peter Parker works?
10. Which comic book character was modeled after actress Jean Harlow?

Answers: 1. Marvel Comics. 2. Batman. 3. The Fantastic Four. 4. Howard Hughes. 5. Stan Lee. 6. Stan Lee. 7. Zorro. 8. J. Jonah Jameson. 9. The Daily Bugle. 10. Catwoman.

Actors

Charlie Chaplin

Charles Spencer Chaplin (1898) was born in London. His parents were music hall entertainers. He spent his childhood in and out of Victorian workhouses. Charlie joined a British theatrical touring company, owned by Fred Karno, who originated many silent slapstick routines, such as the 'custard pie in the face' routine. Can you identify the following films starring Chaplin?

1. Henry Lehrman (1914). Chaplin was first seen in the tramp outfit.
2. Mark Sennet (1914). Chaplin's first feature length comedy film.
3. Chaplin (1921). First full length film directed by Chaplin. It feature seven-year-old Jackie Coogan as the Child.
4. Chaplin (1925). A lonely tramp, prospecting for gold in Alaska, battling hunger, inclement weather and other prospectors, finds love in dance hall girl, Georgia (Georgia Hale).
5. Chaplin (1931). The tramp (Chaplin) falls in love with a blind girl selling flowers (Virginia Cherrill).
6. Chaplin (1936). A worker on an assembly (Chaplin) is out of sorts with the modern world until he finds love in a young recently orphaned gamine (Paulette Goddard).
7. Chaplin (1940). A Jewish barber (Chaplin) is forced to impersonate as the ruthless dictator Adenoid Hynkel (Chaplin) who wants to conquer the world.
8. Chaplin (1947). After losing his job, Frenchman Henri Verdoux (Chaplin) finds a new way of earning money. He marries rich women, murders them and takes their money.

9. **Chaplin (1952).** Aging and alcoholic comedian Calvero (Chaplin) saves a suicidal ballet dancer Thereza (Claire Bloom) from killing herself. Charles Chaplin won the only competitive Oscar he ever received was for composing the score.

Answers: 1. *Kid Auto Races at Venice.* 2. *Tillie's Punctured Romance.* 3. *The Kid.* 4. *The Gold Rush.* 5. *City Lights.* 6. *Modern Times.* 7. *The Great Dictator.* 8. *Monsieur Verdoux.* 9. *Limelight.*

Clint Eastwood

Born in 1930 in San Francisco. Tall (6'4") with a deadpan delivery. He has no formal acting training. His breakthrough came in Sergio Leone's spaghetti westerns. In his early western films he often played nameless drifters. Can you identfy these films starring Clint Eastwood?

1. Sergio Leone (1964). A Man with No Name (Clint Eastwood) arrives at a little Mexican town which is torn apart by the feud between the Rojo and the Baxter families.
2. Sergio Leone (1966). During the American Civil War, Blondie (Clint), Tuco (Eli Wallach) and Angeleyes (Lee Van Cleef) search for a treasure of buried gold coins.
3. Ted Post (1968). A US marshal, Jed Cooper (Clint), seeks revenge from vigilantes who had tried to lynch him and left him for dead.
4. Don Siegel (1971). Violent inspector Harry Callahan (Clint) is assigned the task of apprehending the psychopathic sniper Scorpio (Andrew Robinson) who is terrorizing San Francisco.
5. Eastwood (1971). DJ Dave Garver (Clint) is a stalked by Evelyn Draper (Jessica Walter), an obsessive fan, which turns his life upside down.
6. Eastwood (1973). The town of Lago hires the Stranger (Clint Eastwood), a mysterious gunfighter, to help defend itself from three murderous outlaws who have been released from jail.

7. Eastwood (1985). A ruthless landowner Coy LaHood (Richard Dysart) tries to take over a mining village in California but a mysterious preacher (Clint) stands in his way.
8. Eastwood (1992). Aging outlaw and killer William Munny (Clint), attracted by the reward for capturing cowboys who had mutilated a prostitute, arrives at the town of Big Whiskey..
9. Eastwood (1993). Texas Ranger Red Garnet (Clint) is pursuing an escaped convict, Butch Haynes (Kevin Costner), who has kidnapped a boy.

Answers: 1. A Fistful of Dollars. 2. The Good the Bad and the Ugly. 3. Hang 'em High. 4. Dirty Harry. 5. Play Misty for Me. 6. High Plains Drifters. 7. Pale Rider. 8. The Unforgiven. 9. A Perfect World.

Robert De Niro

Robert De Niro was born in 1943 in New York City. He is well known for method acting techniques which involves iIntense physical and mental preparation for roles. Can you identfy these films starring Robert De Niro?

1. Martin Scorsese (1973). In New York City, Italian-American Charlie (Harvey Keitel) wants to protect his recklessly defiant friend, Johnny Boy (Robert De Niro).
2. Martin Scorsese (1974). Robert De Nero won the Best Supporting Actor Oscar for portraying Vito Corleone.
3. Martin Scorsese (1976). Loner veteran Travis become obsessed with volunteer Betsy (Cybill Shepherd) and later with an underage prostitute Iris (Jodie Foster).
4. Martin Scorsese (1977). Saxophonist Jimmy Doyle (Robert De Niro) marries singer Francine Evans (Liza Minnelli) but his violent temper destroys the marriage.
5. Michael Cimono (1978). Mike Vronsky (Robert De Niro), Nick (Christopher Walken), and Steven (John Savage) are captured by Vietnamese soldiers and forced to play Russian roulette.

6. Martin Scorsese (1980). De Niro won the Oscar for Best Actor for playing the role of boxer Jake LaMotta.
7. Sergio Leone (1984). Two boyhood chums from New York meet after many decades; Gangster Noodles (Robert De Niro) finds that his friend Max (James Woods) has become a senator.
8. Roland Joffé (1986). A former slave trader, now a Jesuit, Rodrigo Mendoza (Robert De Niro) defends the Guarani Indians against the Portuguese soldiers who want to capture the natives for slave labor.
9. Brian De Palma (1987). Ruthless Chicago gangster Al Capone (Robert De Niro) is trapped by Federal agent Eliot Ness (Kevin Costner).
10. Martin Scorsese (1990). Gangster Jimmy Conway (Robert DeNiro) lands in Jail as his protégé Henry Hill (Ray Liotta) testifies against him.

Answers: 1. Mean Streets. 2. Godfather II. 3. Taxi Driver. 4. New York, New York. 5. Deerhunter. 6. Raging Bull. 7. Once Upon a Time in America. 8. The Mission. 9. The Untouchables. 10. Goodfellas.

US Actors I

James O'Neil, born in 1847 in Ireland, was a stage actor well known for portraying Edmond Dantes of *The Count of Monte Cristo*. He reprised the same role for the film **The Count of Monte Cristo** (1913). He is the father of the famous American playwright Eugene O'Neil. Can you identify the following American actors?

1. Born in 1878 in Philadelphia, he started as a silent film actor. He won the Best Actor Academy Award for **A Free Soul** (1931). He acted as evil banker Mr. Potter in **It's a Wonderful Life** (1946). His other films were **Key Largo** (1948) and **Duel in the Sun** (1946).
2. Born in 1882 in Philadelphia, he was a stage actor famous for his Hamlet. He acted in **Grand Hotel** (1932) and **The Invisible Woman** (1940).

3. Born in 1900 in Wisconsin. His first major film was Fritz Lang's *Fury* (1936). He received Best Actor Oscars for *Captains Courageous* (1937) and *Boys Town* (1938). In 1942 he teamed with Katherine Hepburn for the first time for *Woman of the Year* (1942). She remained his companion till his death. His last film was *Guess Who's Coming for Dinner* (1967).
4. Born in 1901 in Ohio, he was known as The King. He won an Oscar for *It Happened One Night* (1934). His other films were *Red Dust* (1932), *Mutiny on the Bounty* (1935), and *Gone with the Wind* (1939). His last film was *The Misfits* (1961) starring Marilyn Monroe.
5. Born 1901 in Montana. He said about himself: "Until I came along all the leading men were handsome, but luckily they wrote a lot of stories about the fellow next door." He received Oscars for his roles in *Sergeant York* (1941) and *High Noon* (1952). His other films are *A Farewell to Arms* (1932), *Mr. Deeds Goes to Town* (1936), *Meet John Doe* (1941) and *The Fountainhead* (1949).
6. Born 1908 in Pennsylvania. He won Best Actor Oscar for *The Philadelphia Story* (1940). His other films were *Mr. Smith Goes to Washington* (1939), *It's a Wonderful life* (1946) and *How the West Was Won* (1962). Two well known Hitchcock's films he starred in were *Rear Window* (1954) and *Vertigo* (1958).
7. Born in 1912 in Puerto Rico, he was famous for playing the character Cyrano de Bergerac in films and plays. He received an Academy award for Best Actor for his role in *Cyrano de Bergerac* (1950).
8. Born in 1913 in New York, of Irish origin, he worked as a circus acrobat. He won an Oscar for *Elmer Gantry* (1960). His other films were *From Here to Eternity* (1953), *Atlantic City* (1980), and *Local Hero* (1983).
9. Born in 1913 in New York City as Jacob Julius Garfinkle to Jewish immigrants. He was blacklisted during the McCarthy "Red Scare" era for his left-wing political beliefs. He was nominated for Oscars for his roles in *Four Daughters* (1938) and *Body and Soul* (1947). His other films were *The Postman Always Rings Twice* (1946), *Humoresque* (1946) and *Gentleman's Agreement* (1947).

10. Born in 1915 in New Jersey to Italian immigrant parents. He started singing in clubs and became a top class singer. His first starring role was in **Anchors Aweigh** (1945). He won best supporting actor Oscar for **From Here to Eternity** (1953). He was nominated for Oscar for his role as a heroin addict in **The Man with the Golden Arm** (1955). His other films were **The Manchurian Candidate** (1962), **None but the Brave** (1965) and **Von Ryan's Express** (1965).
11. Born in 1915 in Brooklyn, NY, to Jewish parents who emigrated from Poland. He played the Mexican bandit Calvera in **The Magnificent Seven** (1960). His other films were **The Misfits** (1961), **How the West Was Won** (1962), **Mackenna's Gold** (1969) and **The Godfather Part III** (1990). In 2011, he received an Honorary Award from the Academy for his "indelible screen characters". He is well known for **The Good, the Bad and the Ugly** (1966).
12. Born in 1916 in California. He appeared in Alfred Hitchcock's **Spellbound** (1945) as an amnesia victim accused of murder. He appeared in Westerns like **Duel in the Sun** (1946), **Yellow Sky** (1948) and **The Gunfighter** (1950). He won an Oscar for his performance as Atticus Finch in **To Kill a Mockingbird** (1962). His memorable 50s films are **Moby Dick** (1956) and **Roman Holiday** (1953). He starred in J. Lee Thompson's **Mackenna's Gold** (1969) and **The Guns of Navarone** (1961). His other films are **MacArthur** (1977) and **The Boys from Brazil** (1978).
13. Born in 1917 in New York, he described himself as a ragman's son. His films were **Gunfight at the O.K. Corral** (1957), anti-war epic **Paths of Glory** (1957), the magnificent **Spartacus** (1960) and **20,000 Leagues under the Sea** (1954). In 1996, he was awarded an honorary Academy Award for being "a creative and moral force in the motion picture community."
14. Born in 1920 in New York. He won an Oscar for **The Fortune Cookie** (1966). He formed a comic pair with Jack Lemmon in films such as **The Odd Couple** (1968) and **Grumpy Old Men** (1993). His other films were **Charade** (1963) and **Hello, Dolly!** (1969).
15. Born in 1924 in Omaha. He has a good claim to be the most influential, if not the greatest, Hollywood actor of all times. He was tutored in Method Acting by Lee Strasberg of the

Actors Studio. He won Oscars for **On the Waterfront** (1954) and **The Godfather** (1972). He was nominated for Oscar for Bernardo Bertolucci's **Last Tango in Paris** (1972). His other films were **A Streetcar Named Desire** (1951), **Viva Zapata!** (1952), **Guys and Dolls** (1955), **Mutiny on the Bounty** (1962) and **Superman** (1978). His last important role was that of Col. Kurtz in Francis Ford Coppola's **Apocalypse Now** (1979).
16. Born in 1925 in Massachusetts. He won Oscars for his role in **Mister Roberts** (1955) and **Save the Tiger** (1973). He formed a comic pair with Walter Matthau in films such as **The Odd Couple** (1968) and **Grumpy Old Men** (1993). His other films are **Some like it Hot** (1959), **The Apartment** (1960), and **Irma la Douce** (1963).

Answers: 1. Lionel Barrymore. 2. John Barrymore. 3. Spencer Tracy. 4. Clark Gable. 5. Gary Cooper. 6. James Stewart. 7. Jose Ferrer. 8. Burt Lancaster. 9. John Garfield. 10. Frank Sinatra.11. Eli Wallach. 12. Gregory Peck. 13. Kirk Douglas. 14. Walter Matthau. 15. Marlon Brando. 16. Jack Lemmon.

US Actors II

Born in 1925 in Connecticut, USA. Paul Newman has perhaps the most famous blue eyes in Hollywood films. He played the role of boxer Rocky Graziano in **Somebody up There Likes Me** (1956). His other films include **Cat on a Hot Tin Roof** (1958), **The Hustler** (1961), **Hud** (1963) and **Cool Hand Luke** (1967). Can you identify the following US actors?

1. Born in 1925 in New Jersey to parents of Dutch ancestry. His films were **High Noon** (1952), **How the West Was Won** (1962), **The Man Who Shot Liberty Valance** (1962) and **Escape from New York** (1981). Sergio Leone cast him **For a Few Dollars More** (1965) and **The Good, the Bad and the Ugly** (1966).
2. Born in 1930 in Indiana. He was known as the King of Cool. He starred as Vin Tanner in **The Magnificent Seven** (1960). His other films include **The Great Escape** (1963), **The Thomas Crown Affair** (1968), **Papillion** (1973) and **The Towering Inferno** (1974).

3. Born in 1931 in Indiana. He starred in only three movies before his untimely death at the age of 24. His films were **East of Eden** (1955), **Rebel without a Cause** (1955), and **Giant** (1956).
4. Born in 1937 in Richmond, Virginia. He was nominated for Best Actor Oscars for **Bonnie and Clyde** (1967), **Heaven Can Wait** (1978), **Reds** (1981) and **Bugsy** (1991). His other films are **McCabe & Mrs. Miller** (1971) and **Dick Tracy** (1990).
5. Born in 1937 in New Jersey. He has won Best Actor Oscars twice for **One Flew over the Cuckoo's Nest** (1975) and **As Good as It Gets** (1997). He has won Best Supporting Actor Oscar for **Terms of Endearment** (1983). Making his debut in the fifties, **Easy Rider** (1969) was his first break. He starred in Polanski's **Chinatown** as detective J. J. Gittes. His other memorable roles were in **The Shining** (1980), **The Postman Always Rings Twice** (1981) **Batman** (1989), and **A Few Good Men** (1992).
6. Born in 1939 in Brooklyn, New York City. Martin Scorsese gave him a break in **Mean Streets** (1973). He was nominated for a Best Supporting Actor Oscar for **Bugsy** (1991). He starred in Ridley Scott's **The Duellists** (1977) and **Thelma & Louise** (1991). His other notable films were **Taxi Driver** (1976), **Reservoir Dogs** (1992) **The Piano** (1993) and **Pulp Fiction** (1994).
7. Born in 1940 in Manhattan, New York City, to family of Italian descent. He studied at the prestigious Actors Studio in 1966, under legendary acting coach Lee Strasberg, creator of the Method Approach. He won Best Actor Oscar for **Scent of a Woman** (1992). He was nominated for best actor Oscar for **Serpico** (1973), **The Godfather: Part II** (1974), **Dog Day Afternoon** (1975) and **...and Justice for all.** (1979). He was nominated for Best Supporting Actor Oscar for **The Godfather** (1972). He starred in **Scarface** (1983), and **Carlito's Way** (1993) both directed by Brian De Palma. His other films are **Dick Tracy** (1990), **Donnie Brasco** (1997), **The Insider** (1999) and **Any Given Sunday** (1999).
8. Born in 1943 in New Jersey of Italian American descent. He received Oscar for Best Supporting Actor in **Goodfellas** (1990), His other films are **Raging Bull** (1980), **Once Upon a Time in America** (1984) and **Casino** (1995).

9. Born in 1946 in Texas. He won the Best Supporting Actor Oscar for **The Fugitive** (1993). He played the role of Clay Shaw in **JFK** (1991). His other films were **Love Story** (1970), **Double Jeopardy** (1999), **No Country for Old Men** (2007) and **Lincoln** (2012).
10. Born in 1949 in California. He played the role of the Dude in **The Big Lebowski** (1998). He received a Best Actor Oscar for **Crazy Heart** (2009). His other films were **The Iceman Cometh** (1973), **The Starman** (1984) and **True Grit** (2010).
11. Born 1950 in Illinois. He was nominated for Best Actor Oscar for **Lost in Translation** (2003). His other films are **Tootsie** (1982), **Ghostbusters** (1984), **Groundhog Day** (1993) and **Rushmore** (1998).
12. Born in 1951 in Pennsylvania. He was nominated for a Best Actor Oscar for **Birdman** (2014). His other films are **Bettlejuice** (1988), **Batman** (1989), **Need for Speed** (2014) and **The Founder** (2016).
13. Born in 1953 in Illinois. He was nominated for Oscars for **Places in the Heart** (1984) and **In the Line of Fire** (1993). He played the role of Vicomte de Valmont in **Dangerous Liaisons** (1988). His other films are **The Killing Fields** (1984) and **The Glass Menagerie** (1987).
14. Born in 1955 in Wisconsin. He was nominated for Oscar for **Platoon** (1986). His other films were **Mississippi Burning** (1988), **Born on the Fourth of July** (1989), **The English Patient** (1996) and **The Life Aquatic with Steve Zissou** (2004).
15. Born in 1955 in California. He was nominated for Oscar for **Dances with Wolves** (1990). Played the role of Jim Garrison in **JFK** (1991). His other films are **Robin Hood: Prince of Thieves** (1991) and **McFarland, USA** (2015).

Answers: 1. Lee Van Cleef. 2. Steve McQueen. 3. James Dean. 4. Warren Beaty. 5. Jack Nicholson. 6. Harvey Keitel. 7. Al Pacino. 8. Joe Pesci. 9. Tommy Lee Jones. 10. Jeff Bridges. 11. Bill Murray. 12. Michael Keaton. 13. John Malkovich. 14. Willem Dafoe. 15. Kevin Costner.

US Actors III

Though Jeff Daniels was born in 1955 in Georgia, he grew up in Michigan. He played the role of Flap Horton in the Oscar-winning **Terms of Endearment** (1983). He played Jim Carrey's friend Lloyd in **Dumb and Dumber** (1994). His other films are **The Purple Rose of Cairo** (1985), **The Squid and the Whale** (2005) and **Good Night, and Good Luck**. (2005). Can you identify the following US actors?

1. Born 1956 in California. He won Oscars for **Philadelphia** (1993) and **Forrest Gump** (1994). He played the role of astronaut Jim Lovell in **Apollo 13** (1995). His other films are **Big** (1988), **Sleepless in Seattle** (1993), and **Saving Private Ryan** (1998) and **Castaway** (2000).
2. Born in 1956 in New Jersay of Italian-Irish descent. He was nominated for Oscar for **Saturday Night Fever** (1977) and **Pulp Fiction** (1994). His other films are the musical **Grease** (1978), the comic **Get Shorty** (1995) and the action films **Broken Arrow** (1996).
3. Born in 1957 in New York. He played the role of Herbie Stempel in **Quiz Show** (1994). His other films were **Do the Right Thing** (1989), **Barton Fink** (1991), **The Big Lebowski** (1998) and **The Luzhin Defence** (2000).
4. Born in 1958 in Philadelphia. He starred in **Footloose** (1984), and **Apollo** 13 (1995). **JFK** (1991) and **A Few Good Men** (1992). He is featured in the game of six degree of separation.
5. Born in 1961 in Midland, Texas. He was nominated for Oscars for **The People vs. Larry Flynt** (1996), **The Messenger** (2009) and **Three Billboards Outside Ebbing, Missouri** (2017). Other films in which he starred are **Natural Born Killers** (1994) and **Wilson** (2017). He played the role of Haymitch Abernathy in **The Hunger Games** franchise. His other films are **Indecent Proposal** (1993) and **No Country for Old Men** (2007).
6. Born in 1961 in Kentucky. He won an Oscar in **Syriana** (2005). He was nominated for Oscars for his roles in **Michael Clayton** (2007), **Up in the Air** (2009), and **The Descendants** (2011). He acted as Batman in Joel Schumacher's **Batman & Robin** (1997). His other films are **Three Kings** (1999), **O Brother, Where Art Thou?** (2000) and **Ocean's Eleven** (2001).

7. Born in 1962 in New York. He was nominated for Oscars for **Born on the Fourth of July** (1989) and **Jerry Maguire** (1996). His other films are **Top Gun** (1986), **The Color of Money** (1986), **Rain Man** (1988) and **A Few Good Men** (1992). He played the role of agent Ethan Hunt in **Mission: Impossible** (1996).
8. Born in 1963 in Kentucky. He was nominated for Oscars for **Pirates of the Caribbean: The Curse of the Black Pearl** (2003), **Finding Neverland** (2004) and **Sweeney Todd: The Demon Barber of Fleet Street** (2007). He made his debut in the low-budget horror film, **A Nightmare on Elm Street** (1984). He starred in Tim Burton's **Ed Wood** (1994) and **Sleepy Hollow** (1999). His other films are **Fear and Loathing in Las Vegas** (1998), **Chocolat** (2000), **Alice in Wonderland** (2010). He played Comanche Indian Tonto in **Lone Ranger** (2013). He played the title role in Mike Newell's **Donnie Brasco** (1997).
9. Born in 1963 in Oklahoma. His first major role was in **A River Runs Through It** (1992). He played the role of Tyler Durden in **Fight Club** (1999). He played Achilles in period drama **Troy** (2004). He was nominated for Oscar for **The Curious Case of Benjamin Button** (2008) and **Moneyball** (2011). His other films are **Ocean's Eleven** (2001), **Inglourious Basterds** (2009) and **The Tree of Life** (2011).
10. Born in 1964 in California. He won an Oscar for playing Ben Sanderson in **Leaving Las Vegas** (1995). His other films are **Moonstruck** (1987), **Captain Corelli's Mandolin** (2001) and **The Weather Man** (2005).
11. Born in 1969 in Texas. He starred in coming-of-age drama **Dazed and Confused** (1993). He won an Oscar for **Dallas Buyers Club** (2013). His other films are **Amistad** (1997), **EdTV** (1999) and **The Wolf of Wall Street** (2013).
12. Born in 1970, in Boston. He was nominated for Best Actor Oscars for **Goodwill Hunting** (1997) and **The Martian** (2015). He was nominated for Best Supporting Actor Oscar for **Invictus** (2009). He played the title role in **Saving Private Ryan** (1998). He played Jason Bourne in the "Bourne" movie franchise. His other films are **Geronimo: An American Legend** (1993), **The Talented Mr. Ripley** (1999) and **Ocean's Eleven** (2001).

13. Born in 1970 in Texas. He was nominated for Oscar for **Training Day** (2001) and **Boyhood** (2014). He played the role of Jesse in **Before Sunrise** (1995), **Before Sunset** (2004) and **Before Midnight**. His other films are **Dead Poets Society** (1989) and **Maudie** (2016).
14. Born in 1972 in California. His first big hit was **Good Will Hunting** (1997). He played the role of Tony Mendez in **Argo** (2012). His other films are **Pearl Harbour** (2001), **Gone Girl** (2014), **The Accountant** (2016) and **Batman v Superman: Dawn of Justice** (2016).

Answers: 1.Tom Hanks. 2. John Travolta. 3. John Turturro. 4. Kevin Bacon. 5. Woody Harrelson. 6. George Clooney. 7. Tom Cruise. 8. Johnny Depp. 9. Brad Pitt. 10. Nicolas Cage. 11. Matthew McConaughey. 12. Matt Damon. 13. Ethan Hawke. 14. Ben Affleck.

US Action Heroes

Born in 1883 in Colorado, Douglas Fairbanks was the first swashbuckling star of silent era. He performed most of his stunts himself. He played the title role in **Robin Hood** (1922). He acted in **The Mark of Zorro** (1920), **The Thief of Bagdad** (1924), and **The Private Life of Don Juan** (1934). Can you identify these US action stars?

1. Born in 1907 in Iowa, his real name was Marion Mitchell Morrison. He won an Oscar for playing Rooster Cogburn in **True Grit** (1969). He played the role of Thomas Dunson in **Red River** (1948). He starred in Westerns like **The Stagecoach** (1939), **The Searchers** (1956), **Rio Bravo** (1959) and **The Man who shot Liberty Valance** (1962).
2. Born in 1921 in Pennsylvania to parents of Lithuanian origin. His real name was Charles Buchinsky. He acted as gunslinger Bernardo O'Reilly in **The Magnificent Seven** (1960). He acted in WWII films **The Great Escape** (1963) and **The Dirty Dozen** (1967). His other films were **Once Upon a Time in the West** (1968), **Hard Times** (1975) and **Breakheart Pass** (1975).
3. Born in 1923 in Illinois as John Charles Carter. He played Moses in the biblical film **The Ten Commandments** (1956). He

won an Oscar for **Ben-Hur** (1959). He starred as Spanish hero Rodrigo Diaz de Vivar in **El Cid** (1961). He played the role of Gen. Gordon in **Khartoum** (1966) His other films were **Touch of Evil** (1958), **The Agony and the Ecstasy** (1965) and **Planet of the Apes** (1968).

4. Born in 1928 in Nabaraska. He acted as the knife-throwing Britt in **The Magnificent Seven** (1960). His two well known films are Sam Peckinpah's **Pat Garrett & Billy the Kid** (1973) and Sergio Leone's **Duck, You Sucker** (1971) He won an Oscar for **Affliction** (1997). His other films were **The Great Escape** (1963) and **Our Man Flint**.

5. Born in 1942 in Chicago, Illinois. After a minor role as Bob Falfa in **American Graffiti** (1973), he played the role of Han Solo in **Star Wars: Episode IV - A New Hope** (1977). Another major role was as Indiana Jones in **Raiders of the Lost Ark** (1981). His other films are **Blade Runner** (1982), **Patriot Games** (1992) and **The Fugitive** (1993).

6. Born in 1969 in New York. He was nominated for Best Actor Oscar for **Rocky** (1976). He played the role of Rambo in **First Blood** (1982). This muscular star acted in **Rocky II** (1979). **Rocky III** (1982), **Demolition Man** (1993) and **The Specialist** (1994).

7. Born in 1947 in Austria and emigrated to the United States in 1968. As a bodybuilder, he won five Mr. Universe titles. His first major film was Bob Rafelson's **Stay Hungry** (1976) alongside Jeff Bridges. His **Conan the Barbarian** (1982) kickstarted his career. His other films are **The Terminator** (1984), **Commando** (1985) and **True Lies** (1994). In 2003 he was elected was elected Governor of California.

Answers: 1. John Wayne. 2. Charles Bronson. 3. Charlton Heston. 4. James Coburn. 5. Harrison Ford. 6. Sylvester Stallone. 7. Arnold Schwarzenegger.

Afro-American Actors

Born in 1898 in New Jersey, Paul Robeson started as a professional footballer and a theatre actor, acting in Eugene O' Neil's plays like **The Emperor Jones** and **All God's Chillun Got Wings**. He reprised his stage

successes in films such as **The Emperor Jones** (1933) and **Show Boat** (1936). He played the role of the tribal chief Umbopa in **King Solomon's Mines** (1937). Can you identify the following Afro-American actors?

1. Born 1927 in Florida. He won the Best Actor Oscar for **Lilies of the Field** (1963). His other films are **The Defiant Ones** (1958), **Guess Who's Coming to Dinner** (1967) and **To Sir, with Love** (1967). He played the role of Virgil Tibbs in **In the Heat of the Night** (1967). In 2002, he was given an honorary Oscar for "his extraordinary performances and unique presence on the screen".
2. Born in 1931 in Mississippi. His first major role was in **Dr. Strangelove**. He was nominated an Oscar for his role as the boxer Jack Jefferson in **The Great White Hope** (1970). His other film include **The Hunt for Red October** (1990). He provided the voice for Darth Vader in **Star Wars**.
3. Born in 1937 in Memphis, Tennessee. He received an Oscar (supporting actor) for **Million Dollar Baby** (2004). He was nominated for Oscar (leading role) in **Driving Miss Daisy** (1989), **The Shawshank Redemption** (1994) and **Invictus** (2009). He was nominated for Oscar (supporting role) for **Street Smart** (1987). His other films are **Amistad** (1997), **Glory** (1989) and **Bruce Almighty** (2003). He played Lucius Fox in **The Dark Knight Rises** (2012).
4. Born in 1948 in Washington, DC. He was nominated for Oscar (supporting role) for playing the role of Jules Winnfield in **Pulp Fiction** (1994). He played Mace Windu in **The Star Wars**. Episode 1, II, III. He played Nick Fury in **Avengers** (2012). His other films are **Kingsman: The Secret Service** (2014), **The Legend of Tarzan** (2016) and **Kong: Skull Island** (2017).
5. Born 1954 in New York. He won the Best Supporting Actor Oscar for his portrayal of Tripp, the runaway slave in **Glory** (1989). He played real-life figures such as South African anti-apartheid activist Steve Biko in **Cry Freedom** (1987), Malcolm X in **Malcolm X** (1992) and boxer Rubin Carter in **The Hurricane** (1999). His other films are **Remember the Titans** (2000) and **Fences** (2016). He won Best Actor Oscar for **Training Day** (2001).

6. Born 1961 in Texas. He won the Oscar (leading role) for his performance as Ugandan dictator Idi Amin in **The Last King of Scotland** (2006). He other films are **The Color of Money** (1986). **Good Morning, Vietnam** (1987), **The Crying Game** (1992) and **Ready to Wear** (1994). He portrayed the tortured jazz icon Charlie Parker in Clint Eastwood's **Bird** (1988).
7. Born in 1961 in Brooklyn. Made his feature film debut in **48 Hrs.** (1982), alongside Nick Nolte. He starred as Axel Foley in **Beverly Hill Cops** (1984). His other films are **The Nutty Professor** (1996) and **Dr. Dolittle** (1998).
8. Born in Georgia in 1961, he was nominated for an Oscar (leading role) for **What's Love Got to Do with It** (1993). He played the role of Morpheus in the futuristic sci-fi **The Matrix** (1999). He played the title role in Oliver Parker's **Othello** (1995).
9. Born in 1964 in Benin, West Africa but moved to France when he was 13. He was nominated for Oscars (supporting actor) for **In America** (2002) and **Blood Diamond** (2006). His other films are **Amistad** (1997), **Gladiator** (2000) and **Guardians of the Galaxy** (2014).
10. Born 1967 in Texas. He started his career as a start-up comedian. He won an Oscar (leading role) for his work in the biographical film **Ray** (2004). His other films are **Django Unchained** (2012), **Annie** (2014) and **The Amazing Spider-Man 2** (2014).
11. Born in 1968 in Philadelphia. He started as a rap artist The Fresh Prince. He played the part of Agent Jay in **Men in Black** (1997) and of Muhammad Ali in **Ali** (2001). His other films include **Independence Day** (1996), **Enemy of the State** (1998), **Wild Wild West** (1999) and **The Pursuit of Happyness** (2006).
12. Born in 1968 in New York. He won Oscar (supporting role) for **Jerry McGuire** (1996). His other films were **Boyz 'n the Hood** (1991), **A Few Good Men** (1992) and **Radio** (2003).
13. Born in 1987 in California. He starred in Josh Trank's **Fantastic Four** (2015) and Ryan Coogler's **Creed** (2015). He starred as the villain, Eric Killmonger, in **Black Panther** (2018). He starred as Guy Montag in **Fahrenheit 451** (2018).

Answers: 1. Sidney Poitier. 2. James Earl Jones. 3. Morgan Freeman. 4. Samuel L Jackson. 5. Denzel Washington. 6. Forest Whitaker. 7. Eddie Murphy. 8. Laurence Fishburne. 9. Djimon Hounsou. 10. Jamie Foxx. 11. Will Smith. 12. Cuba Gooding Jr. 13. Michael B. Jordan.

British Actors I

Leslie Howard was born in 1893 in London. He played the role of Sir Percy Blakeney in **The Scarlet Pimpernel** (1934). He played the role of Ashley Wilkes in **Gone with the Wind** (1939). His other films are **The Petrified Forest** (1936) and **Of Human Bondage** (1934). Can you identify the following UK actors?

1. Born in 1899 in Yorkshire. He won the Oscar (leading role) for portraying King Henry VIII in **The Private Life of Henry VIII.** (1933). He was nominated for Oscar (leading role) for his role of Captain Bligh in **Mutiny on the Bounty** (1935). His other films were **The Barretts of Wimpole Street** (1934), **Les Misérables** (1935), **Hobson's Choice** (1954), **Witness for the Prosecution** (1957) and **Spartacus** (1960).
2. Born in 1905 in Manchester. He won an Oscar (leading role) for **Goodbye, Mr. Chips** (1939). His other films were **The Private Life of Henry VIII** (1933), **The Count of Monte Cristo** (1934), **The 39 Steps** (1935) and **The Citadel** (1938).
3. Born in 1908 in Lancashire. He played the role of Julius Ceaser in **Cleopatra** (1963) and of Professor Henry Higgins in **My Fair Lady** (1964). He played Sir John Locksley in **Shalimar** (1978). His other films were **Anna and the King of Siam** (1946) and **Dr Doolittle** (1967).
4. Born in 1909 in Yorkshire. He was nominated for three Oscars for **A Star is Born** (1954), **Georgy Girl** (1966) and **The Verdict** (1982). He played Captain Nemo in **20,000 Leagues Under the Sea** (1954) and Humbert Humbert in Stanley Kubrick's **Lolita** (1962). His other films are **The Desert Fox: The Story of Rommel** (1951) and **The Prisoner of Zenda** (1952).
5. Born in 1921 in London. He received Oscars (supporting role) for **Spartacus** (1960) and **Topkapi** (1964). He played the role of Emperor Nero in **Quo Vadis** (1951). His other films are

Romanoff and Juliet (1961) and *Billy Budd* (1962). He played the role of Hercule Poirot in *Death on the Nile* (1978). He was to interview Indira Gandhi on the day she was assassinated.

6. Born in 1923 in Cambridge. He played the role of the gangster Pinkie Brown in *Brighton Rock* (1948) and of Gen. Outram in Satyajit Ray's *Shatranj Ke Khilari* (1977). His other films were *The Great Escape* (1963), *Dr Dolittle* (1967) and *Jurassic Park* (1993).

7. Born in 1925 in Wales. He was nominated for Oscar (supporting role) for *My Cousin Rachel* (1952). He played the role of angry young man Jimmy Porter in *Look Back in Anger* (1959) and that of Marc Antony opposite Elizabeth Taylor in *Cleopatra* (1963). He was nominated for Oscars (leading role) for *The Robe* (1953), *Becket* (1964), *The Spy Who Came in from the Cold* (1965), *Who's Afraid of Virginia Woolf?* (1966) and *Equus* (1977).

8. Born in 1930 in Limerick, Ireland. He played the "angry young man" in *This Sporting Life* (1963). He played King Arthur in *Camelot* (1967). His other films are *A Man Called Horse* (1970), *The Wild Geese* (1978), *Tarzan the Ape Man* (1981) and *Gladiator* (2000). He played Albus Dumbledore in *Harry Potter and the Sorcerer's Stone* (2001).

9. Born in 1934 in Derbyshire. He played the role of the writer Basil in *Zorba the Greek* (1964) and of Rupert Birkin in *Women in Love* (1969). He was nominated for an Oscar for *The Fixer* (1968). His other films were *The Entertainer* (1960), *Georgy Girl* (1966) and *Far from the Madding Crowd* (1967).

Answers: *1. Charles Laughton. 2. Robert Donat. 3. Rex Harrison. 4. James Mason. 5. Peter Ustinov. 6. Richard Attenborough. 7. Richard Burton. 8. Richard Harris. 9. Alan Bates.*

British Actors II

Tom Courtenay was born in 1937 in Yorkshire. He was twice nominated for Oscar for *Doctor Zhivago* (1965) and *The Dresser* (1983). He played the role of Colin Smith in *The Loneliness of the Long Distance Runner* (1962). His other films are *Billy Liar* (1963) and *One Day in the Life of Ivan Denisovich* (1970). Can you identify the following UK actors?

1. Born in 1937 in Wales. He was nominated for Oscars for **The Remains of the Day** (1993), **Nixon** (1995) and **Amistad** (1997). His other films were **The Mask of Zorro** (1998), **The World's Fastest Indian** (2005) and **Beowulf** (2007). He won best actor Oscar for playing the role of Dr. Hannibal Lecter in **The Silence of the Lambs** (1991).
2. Born in 1940 in Derbyshire. He was nominated for Oscars (leading role) for his performance in **The Elephant Man** (1980) and **Midnight Express** (1978). His other films are **Alien** (1979) and **1984** (1984).
3. Born in 1957 in London. He has won three Oscars for leading roles in **My Left Foot** (1989), **There Will Be Blood** (2007) and **Lincoln** (2012). He played Hawkeye in **The Last of the Mohicans** (1992) and Newland Archer in **The Age of Innocence** (1993). His other films were **Sunday, Bloody Sunday** (1971), **My Beautiful Laundrette** (1985), **A Room with a View** (1985), **The Unbearable Lightness of Being** (1988) and **Gangs of New York** (2002).
4. Born in 1960 in Hampshire. He won an Oscar for playing the role of King George VI in **The King's Speech** (2010). He played Geoffrey Clifton in **The English Patient** (1996). His other films are **Valmont** (1989), **Bridget Jones's Diary** (2001) and **The Railway Man** (2013).
5. Born in London in 1971. He won a Golden Globe for **Borat: Cultural Learnings of America for Make Benefit Glorious Nation of Kazakhstan** (2006). His other film work includes **Hugo** (2011). He played title roles of **Brüno** (2009), **The Dictator** (2012), and **The Brothers Grimsby** (2016).
6. Born in 1972 in London. He was nominated for Oscars for his role in **The Talented Mr. Ripley** (1999) and **Cold Mountain** (2003). He portrayed Dr. Watson in Guy Ritchie's **Sherlock Holmes** (2009). His other films are **Enemy at the Gates** (2001), **Alfie** (2004), **The Holiday** (2006), **Hugo** (2011), **Anna Karenina** (2012), and **The Grand Budapest Hotel** (2014).
7. Born in 1974 in Wales. He started as a juvenile actor in Steven Spielberg's **Empire of the Sun** (1987). He starred in **American Psycho** (2000), **Equilibrium** (2002) and **The Machinist** (2004). Christopher Nolan's cast him in **Batman Begins** (2005), **The Dark Knight** (2008) and **The Dark Knight Rises** (2012). He won

an Oscar for best supporting actor for **The Fighter** (2010). His other films are **The New World** (2005) and **The Prestige** (2006). He played Moses in **Exodus: Gods and Kings** (2014).
8. Born in 1977 in Kent. He played the role of Legolas the elf in **The Lord of the Rings** series (2001, 2002, 2003). The played the role of Will Turner in **Pirates of the Caribbean** series (2003, 2006, 2007). His other films are **Black Hawk Down** (2001) and **Troy** (2004).
9. Born in 1977 in London. He was nominated for Oscar for **12 Years a Slave** (2013). His other films were **Amistad** (1997). **Redbelt** (2008) and **Endgame** (2009). He played Vincent Kapoor in **The Martian** (2015).

Answers: 1. Anthony Hopkins. 2. John Hurt. 3. Daniel Day-Lewis. 4. Colin Firth. 5. Sacha Baron Cohen. 6. Jude Law. 7. Christian Bale. 8. Orlando Bloom. 9. Chiwetel Ejiofor.

Shakespearean Actors

Born in 1904 in London. Sir John Gielgud was among the finest stage actors. He won an Academy award (supporting role) for **Arthur** (1981) and was nominated for leading role for **Becket** (1964). His other films were **Julius Caesar** (1953) and **Gandhi** (1982). Can you identify these British Shakespearean actors?

1. Born in 1907 in Surrey. He was a Shakespearean actor on stage and screen. He received an Oscar for best actor in **Hamlet** (1948). His other Shakespearean films are **Henry V** (1944) and **Richard III** (1955), He played the role of Mr. Darcy in **Pride and Prejudice** (1940). He acted in **Rebecca** (1940), **Spartacus** (1960) and **The Entertainer** (1960).
2. Born in 1914 in London. He won an Oscar for best actor for the role of Col. Nicholson in **The Bridge on the River Kwai** (1957). He played the role of Prof. Godbole in **A Passage to India** (1984) and of Ben Obi-Wan Kenobi in **Star Wars: Episode IV - A New Hope** (1977). His other films are **Our Man in Havana** (1959), **Lawrence of Arabia** (1962) and **Doctor Zhivago** (1965).

3. Born in 1922 in West Sussex. He played the role of Sir Thomas More in **A Man for All Seasons** (1966) for which he received an Oscar (leading role). His other films were **King Lear** (1971) and **Quiz Show** (1994).
4. Born in 1939 in Lancashire. This stage and screen actor acted as Gandalf in **Lord of the Rings** series. His other films are **Gods and Monsters** (1998) and **The Da Vinci Code** (2006). He played Magneto in the **X-Men** film series.
5. Born in 1940 in Yorkshire. He played the role of Captain Jean-Luc Picard in **Star Trek Generations** (1994), **Star Trek: First Contact** (1996), and **Star Trek: Nemesis** (2002). He played Professor Charles Xavier in **X-men** (2000).
6. Born in 1948 in Isle of Wight. He won an Oscar in **Reversal of Fortune** (1990). He played Humbert Humbert in **Lolita** (1997). His other films are **The French Lieutenant's Woman** (1981), **The Mission** (1986) and **The Man in the Iron Mask** (1998).
7. Born in 1962 in Suffolk. He made his debut in **Wuthering Heights** (1992) as Heathcliff. He was nominated for Best Supporting Actor Oscar for portraying a Nazi commander in **Schindler's List** (1993). He was nominated for a Best Actor Oscar for his performance as Count Almásy in **The English Patient** (1996). He played M. Gustave in Wes Anderson's **The Grand Budapest Hotel** (2014). His other films are **Quiz Show** (1994), **Oscar and Lucinda** (1997), **The End of the Affair** (1999) and **The Constant Gardener** (2005) and **The Reader** (2008).

Answers: 1. Laurence Olivier. 2. Alec Guinness. 3. Paul Scofield. 4. Ian McKellen. 5. Patrick Stewart. 6. Jeremy Irons. 7. Ralph Fiennes.

British Working Class Actors

Cary Grant was born in 1904 in Bristol of working class parents. At the age of 14, joined a group of comedians performing for stage. He acted as Sargent Cutter in **Gunga Din** (1939). His other films were **Philadelphia Story** (1940), **To Catch a Thief** (1955), **North by North West** (1959) and **Charade** (1963). Can you identify the following British actors?

1. Born in 1930 in Edinburgh. He is famous for playing the role of a British spy, the first of which was in **Dr. No** (1962). He won the Oscar for Best Supporting Actor for his role in **The Untouchables** (1987). His other films were **Murder on the Orient Express** (1974), **The Man Who Would Be King** (1975), **Highlander** (1986), **The Name of the Rose** (1986), **Indiana Jones and the Last Crusade** (1989), **The Hunt for Red October** (1990) and **Finding Forrester** (2000). He played Allan Quatermain in **The League of Extraordinary Gentlemen** (2003).
2. Born in 1932 in Yorkshire. Stage actor with blue eyes. He was nominated for Oscar for playing T.E. Lawrence in **Lawrence of Arabia** (1962). He played the role of King Henry II in **Becket** (1964) and **The Lion in Winter** (1968), for both of which he was nominated for Oscar. His other films were **Goodbye, Mr. Chips** (1969) and **Troy** (2004). He received a Special Oscar for lifetime achievement in 2003.
3. Born in 1933 in London. His early films were the epic **Zulu** (1964) and **Alfie** (1966). He played the role of counter-espionage agent Harry Palmer in **The Ipcress File** (1965). He won Oscars for his roles in **Hannah and Her Sisters** (1986) and **The Cider House Rules** (1999). His other films were **The Man Who Would Be King** (1975) and **Educating Rita** (1983). He played Alfred in **Batman Begins** (2005).
4. Born in 1936 in Manchester. He made his film debut with **The Entertainer** (1960). He was nominated for Oscar (leading role) for his roles in **Tom Jones** (1963), **Murder on the Orient Express** (1974) and **The Dresser** (1983). He was nominated for Oscar (supporting role) for **Erin Brockovich** (2000). His other films are **Saturday Night and Sunday Morning** (1960) and **Annie** (1982). He died in 2019.
5. Born in 1938 in London. He made his debut in Peter Ustinov's **Billy Budd** (1962), which earned his an Oscar nomination for supporting actor. His other films are **Modesty Blaise** (1966), **Far from the Madding Crowd** (1967) and **Star Wars: Episode I - The Phantom Menace** (1999). He played the evil General Zod in **Superman II** (1980) and transgender woman Bernadette Bassinger in **The Adventures of Priscilla, Queen of the Desert** (1994).

6. Born in 1941 in Surrey. He played the role of the fashion photographer Thomas in Antonioni's **Blow-Up** (1966). His other films are **Gladiator** (2000) and **Gangs of New York** (2002).
7. Born in 1943 in Yorkshire. Lindsay Anderson cast him in the role of a rebellious student in **If....** (1968). He starred as Alex DeLarge in Stanley Kubrick's A **Clockwork Orange** (1971) and as Caligula in **Caligula** (1979).
8. Born in 1958 in London. He played the role of Sid Vicious of the Sex Pistols in **Sid and Nancy** (1986). He played the role of Lee Harvey Oswald in **JFK** (1991), His other films were **Immortal Beloved** (1994), **Harry Potter and the Prisoner of Azkaban** (2004), **Batman Begins** (2005) and **The Dark Knight Rises** (2012). He won an Oscar for **Darkest Hour** (2017) for playing the role of Winston Churchill.

Answers: *1. Sean Connery. 2. Peter O'Toole. 3. Michael Caine. 4. Albert Finney. 5. Terence Stamp. 6. David Hemmings. 7. Malcolm McDowell. 8. Gary Oldman.*

Canadian Actors

Joseph Wiseman was born in 1918 in Montreal, Quebec. He was a Broadway actor in the 1930s. He acted as Dr. No. in **Dr No** (1962). His films include **Viva Zapata!** (1952) and **The Night They Raided Minsky's** (1968). Can you identify the following Canadian actors?

1. Born in 1929, in Toronto. He played the role of Captain Von Trapp in **The Sound of Music** (1965). He won an Oscar (supporting role) for **Beginners** (2010). His other films were **The Royal Hunt of the Sun** (1969), **The Man Who Would Be King** (1975) and **The Last Station** (2009).
2. Born in 1935 in New Brunswick. He played the dimwitted Vernon Pinkley in **The Dirty Dozen** (1967). He played the role of Mister X in **JFK** (1991). His other films were **MASH** (1970), **Klute** (1971), **Ordinary People** (1980) and **The Leisure Seeker** (2017).
3. Born in 1950 in Ontario. This comic actor was famous for his large girth, weighing over 300 pounds. His memorable films

include **Stripes** (1981), **Planes, Trains & Automobiles** (1987), **The Great Outdoor** (1988) and **Uncle Buck** (1989).
4. Born in 1952 in Ottawa. His films include **The Blues Brothers** (1980), **Ghostbusters** (1984) and **Driving Miss Daisy** (1989). He played Mack Sennett in **Chaplin** (1992).
5. Born in 1962 in Ontario. This comic actor was famous for his flexible body movements and weird facial expressions. He starred in **Ace Ventura: Pet Detective** (1994), **Dumb and Dumber** (1994) and **The Mask** (1994). He played the villainous Riddler in **Batman Forever** (1995). He played the nasty Grinch in **How the Grinch Stole Christmas** (2000). His other films are **Man on the Moon** (1999) and **Eternal Sunshine of the Spotless Mind** (2004).
6. Born in 1961 in Edmonton. He played the role of Marty McFly in **Back to the Future** (1985), **Back to the Future: Part II** (1989) and **Back to the Future: Part III** (1990). He starred in Vietnam war film **Casualties of War** (1989).
7. Born in 1963 in Ontario. His first major film was **Wayne's World** (1992). He played Austin Power in **Austin Powers: International Man of Mystery** (1997) and later sequels. He played Guru Pitka in **The Love Guru** (2006). His other films are **Inglourious Basterds** (2009) and **Bohemian Rhapsody** (2018).
8. Born in 1964 in Beirut, his name means "cool breeze" in Hawaiian. He played Siddhartha in Bernardo Bertolucci's **Little Buddha** (1993). His first success was **Speed** (1994). His other films were **A Walk in the Clouds** (1995) and **The Devil's Advocate** (1997). He played the role of Neo in **Matrix** (1999).

Answers: 1. Christopher Plummer. 2. Donald Sutherland. 3. John Candy. 4. Dan Aykroyd. 5. Jim Carrey. 6. Michael J. Fox. 7. Mike Myers. 8. Keanu Reeves.

Australian Actors

Errol Flynn was born in 1909 in Tasmania. A rolling stone, he did a series of odd jobs before reaching England where he was selected by Warner Brothers for their film **Captain Blood** (1935). Flynn was famous for his romantic swashbuckler roles in Hollywood films and for his flamboyant private life. **The Adventures of Robin Hood** (1938)

and **Adventures of Don Juan** (1948) are some of his films. Can you identify the following Australian actors?

1. Born in 1947 in Northern Ireland but moved to New Zealand in 1954. He starred in **Jurassic Park** (1993) and **The Piano** (1993). His other films are **The Horse Whisperer** (1998) and **Bicentennial Man** (1999).
2. Born in 1951 in Queensland. He won an Oscar (leading role) for playing pianist David Helfgott in **Shine** (1996). He was nominated for Best Actor Oscar for **Quills** (2000) and for Best Supporting Actor for **Shakespeare in Love** (1998). His other films were **Pirates of the Caribbean: The Curse of the Black Pearl** (2003) and **The King's Speech** (2010).
3. Born in 1956 in New York, USA but moved to Australia in 1960s. His first hit was **Mad Max** (1979). He made his US debut in **The Bounty** (1984). His other well known films are **Lethal Weapon** (1987), **Braveheart** (1995) and **The Patriot** (2000).
4. Born in 1968 in Melbourne. He acted in **Black Hawk Down** (2001). He was cast as the Trojan Prince Hector in the historical **Troy** (2004). He played the role of Nero in **Star Trek** (2009). Other films he starred in are **Hulk** (2003) and **Munich** (2005).
5. Born in 1979 in Perth. He played The Joker in **The Dark Knight** (2008) for which he won the best Supporting Actor Oscar posthumously. He was nominated for Best Actor Oscar for **Brokeback Mountain** (2005). His other films are **The Patriot** (2000), **A Knight's Tale** (2001) and **Ned Kelly** (2003).
6. Born in 1983 in Melbourne. He played the title role in **Thor** (2011). He played the Formula One car racer John Hunt in **Rush** (2013). His other films are **Snow White and the Huntsman** (2012) and **Avengers: Infinity War** (2018).
7. Born in 1968 in Sydney. He played Logan in **X-Men** (2000). He was nominated for Best Actor Oscar for **Les Misérables** (2012). His other films are **Kate & Leopold** (2001), **Austrailia** (2008) and **The Greatest Showman** (2017).

Answers: 1. *Sam Neill.* 2. *Geoffrey Rush.* 3. *Mel Gibson.* 4. *Eric Bana.* 5. *Heath Ledger.* 6. *Chris Hemsworth.* 7. *Hugh Jackman.*

French Actors

Max Linder was born in 1883 in Gironde. Making he debut in 1905, he became a star of silent comedy on both sides of Atlantic. He created the character of "Max," a dandy wearing a top hat in many short films. **Seven Years Bad Luck** (1921) and **Be My Wife** (1921) were some of his films. Can you identify the following French actors?

1. Born in 1888 in Paris. He received Best Actor Oscar nomination for **The Love Parade** (1929). His other films are **Gigi** (1958) and **Fanny** (1961).
2. Born Israel Moshe Blauschild in 1900 in Paris. He appeared in Jean Renoir's **Rules of the Game** (1939, Fr) and **La Grand Illusion** (1937, Fr). When Germans overran Paris, he fled to Portugal and thence to Canada via Chile. He played the role of a croupier in **Casablanca** (1942). His other films were **To Have and Have Not** (1944) and **Catch-22** (1970).
3. Born in 1902 in Paris. He played the role of Inspector Maigret in three films. He is famous for starring in **The Lower Depths** (1936, Fr), **La Grande Illusion** (1937, Fr) and **La Bête Humaine** (1938, Fr), all directed by Jean Renoir.
4. Born in 1904 in Yvelines. In 1930s he started with comic routines in Paris theatres. In 1949, came his first success, **Jour de Fête** (Fr), in which he plays the role of François the postman of a small country town. He played the role of the bumbling Monsieur Hulot in classics like **Monsieur Hulot's Holiday** (1953, Fr) and **Mon Oncle** (1958, Fr).
5. Born in 1921 in Tuscany, Italy. He acted in Henri-Georges Clouzot's **The Wages of Fear** (1953, Fr). His other films were **Let's Make Love** (1960) with Marilyn Monroe and **Jean de Florette** (1986, Fr) with Gérard Depardieu.
6. Born in 1930 in south France. He first success was Roger Vadim's **And God Created Woman** (1956, Fr) and followed it up with **A Man and a Woman** (1966, Fr). His notable films are Costa-Gavras' **Z** (1969, Fr), **The Conformist** (1970, It) and **Three Colors: Red** (1994, Fr).
7. Born in 1933 in Île-de-France. His breakthrough role was in Jean-Luc Godard's **Breathless** (1960, Fr). His other notable

films are **Seven Days... Seven Nights** (1960, Fr), **Two Women** (1960, It) and **Pierrot le fou** (1965, Fr).
8. Born in 1934 in Valenciennes. He is famous for his comedies in which he plays a clumsy comic. He played François Perrin in **Tall Blond Man with One Black Shoe** (1972, Fr) and **The Toy** (1976, Fr). His other films are **Very Happy Alexander** (1968, Fr) and **The Fugitives** (1986, Fr). He was bestowed an Honorary César in 2006.
9. Born in 1935. He acted in Luchino Visconti's **Rocco and His Brothers** (1960, It) and Joseph Losey's **Mr. Klein** (1976). His other films are **Swann in Love** (1984, Fr) and **Asterix at the Olympic Games** (2008, Fr) in which he played Julius Ceaser.
10. Born in 1948 in Indre, Central France. He was nominated for Oscar for **Cyrano De Bergerac** (1990, Fr). He played the title role in Andrzej Wajda's **Danton** (1983, Fr). His other film in **The Man in the Iron Mask** (1998) and **Asterix at the Olympic Games** (2008).

Answers: 1. Maurice Chevalier. 2. Marcel Dalio. 3. Jean Gabin. 4. Jacques Tati. 5. Yves Montand. 6. Jean-Louis Trintignant. 7. Jean-Paul Belmondo. 8. Pierre Richards. 9. Alain Delon. 10. Gérard Depardieu.

Comedy Stars

Ben Turpin was born in 1869 in New Orleans. He was a cross-eyed actor with a bush moustache. He made many slapstick films for Mack Sennet. He lampooned stars like Rudolph Valentino in films such as **The Shriek of Araby** (1923). He appeared in a Laurel Hardy film **Saps at Sea** (1940). Can you identify the following comedy stars?

1. William Claude Dukenfield was born in 1880 in Pennsylvania. He started selling vegetables from a horse cart at a young age. At 11 he ran away from home and lived a hobo's life. He was featured as a comedian in Ziegfeld Follies from 1915 to 1951. He played the role of Mr. Micawber in **David Copperfield** (1935). Some of his other films are **You Can't Cheat An Honest Man** (1940), **The Bank Dick** (1940) and **Never Give a Sucker an Even Break** (1941). He paired with Mae West in **My Little Chickadee** (1940).

2. Arthur Stanley Jefferson was born in 1890 in England. In 1909 he joined the Fred Karno troupe as a supporting actor and an understudy to Chaplin. He wore an undersized Bowler hat. He was awarded an honorary Oscar in 1961.
3. He was born in 1892 in Georgia. His first onscreen appearance was in the 1914 short comedy **Outwitting Dad**. He appeared in over 100 films before becoming famous as one half of a legendary double act. He wore an oversized Bowler hat.
4. Born in 1893 in Nebraska. This daredevil comedian, who, unlike Chaplin, was in tune with the world. His character wore a straw hat and glasses. His films include **Grandma's Boy** (1922) and **Safety Last** (1923), in which he is seen hanging by the hands of a clock high about the city. Clark Kent's identity was modeled after him. He was awarded an Honorary Award Oscar in 1952.
5. Born in 1895 in Kansas. Famous for his deadpan expression while performing hair-raising stunts. He was awarded an honorary Oscar in 1960. Seen mostly in porky pie hats. His famous movies include **The General** (1926) and **The Navigator** (1924).
6. William Alexander Abbott was born in 1895 in New Jersey. His partner Louis Francis Cristillo was born in 1906 in New Jersey. They made their debut as a comedy team in **One Night in the Tropics** (1940). Their comic routine "Who's on First?" was in **The Naughty Nineties** (1945).
7. Larry Fine, Moe Howard and Curly Howard as appeared in two-reel comedy films from 1934 to 1947. They made classics such as **Hoi Polloi** (1935), **Disorder in the Court** (1936) and **A-plumbing we will go** (1940).
8. Julius Henry Marx was born in 1890 in New York City. He was famous for his cutting wit and repartee. Cigar, greasepaint moustache and waggling eyebrows were his famous trademark. Some of his films are **The Cocoanuts** (1929), **Animal Crackers** (1930), **A Night at the Opera** (1935) and **A Day at the Races** (1937).
9. Born in 1925 in Hampshire. He was a part of the BBC radio comedy "The Goon Show" (1951-1960). He acted in Stanley Kubrick's films **Lolita** (1962) and **Dr. Strangelove** (1964). He played the role of the bumbling French Inspector Jacques

Clouseau in Blake Edward's **Pink Panther** (1963). His other films were **What's New Pussycat?** (1965), **Casino Royale** (1967) and **Revenge of the Pink Panther** (1978).
10. Born in 1951 in Chicago. Robert Altman gave him a break in **Popeye** (1980), He received Best Actor Oscar nomination for **Good Morning, Vietnam** (1987). He played John Keating in **Dead Poets Society** (1989). His other films were **One-Hour Photo** (2002), **Hook** (1991), **Mrs. Doubtfire** (1993), **Jumanji** (1995), and **Night at the Museum** (2006). He won Best Supporting Actor Oscar for **Good Will Hunting** (1997).

Answers: 1. W. C. Fields. 2. Stan Laurel. 3. Oliver Hardy. 4. Harold Lloyd. 5. Buster Keaton. 6. Bud Abbott and Lou Costello. 7. The Three Stooges. 8. Groucho Marx. 9. Peter Sellers. 10. Robin Williams.

They became Monsters

Born in Lugos, Hungary (now Romania) in 1882. Bela Lugosi moved to America after the failed Hungarian communist revolution (1919). He appeared as Count Dracula in **Dracula** (1931). He acted in **The Mysterious Mr. Wong** (1934), **Vampire Over London** (1952) and **Bride of the Monster** (1955). Can you identify the following stars who played monster roles?

1. Born in 1883 in Colorado, he was an American stage and film actor. He was renowned for his characterizations of tortured, often grotesque and afflicted characters. He acted in The **Hunchback of Notre Dame** (1923) and **The Phantom of the Opera** (1925).
2. Born in 1906 in Oklahoma. He gave a memorable performance as the dimwitted Lennie Small in **Of Mice and Men** (1939). He played the role of a werewolf in **The Wolf-Man** (1941). His other films were **The Ghost of Frankenstein** (1942), **The Mummy's Tomb** (1942) and **Son of Dracula** (1943).
3. William Henry Pratt was born in 1887 in London. His memorable roles were Frankenstein in **Frankenstein** (1931) and Imhotep, the high priest of Ancient Egypt in **The Mummy** (1932). He played a role in **Scarface** (1932).

4. Born in 1913 in Surrey. He played the role of Dr. Frankenstein in *The Curse of Frankenstein* (1957) and Dr. Van Helsing in *Horror of Dracula* (1958). He played Sherlock Holmes in *The Hound of the Baskervilles* (1959) and *Sherlock Holmes* (1964).
5. Born in 1922 in London. This tall actor played Dracula in ten films from *Horror of Dracula* (1958) to *Dracula and Son* (1976). He played Frankenstein in *The Curse of Frankenstein* (1957) and Kharis the Mummy in *The Mummy* (1959). His other films were *The Man with the Golden Gun* (1974) and *The Lord of the Rings: The Fellowship of the Ring* (2001).
6. Maila Syrjäniemi was born in 1922 in Finland. She was a niece of legendary runner The Flying Finn Paavo Nurmi. She played the role of Vampira in TV series. She acted in Edward D. Wood Jr.'s *Plan 9 from Outer Space* (1959). Her other films were *The Big Operator* (1959) and *The Magic Sword* (1962).
7. She was born in Kansas in 1951. She started as a lead singer of a rock band. She created and acted as Elvira in many TV serials. Her films are *Elvira: Mistress of the Dark* (1988) and *Elvira's Haunted Hills* (2001).

Answers: 1. Lon Chaney. 2. Lon Chaney Jr. 3. Boris Karloff. 4. Peter Cushing. 5. Christopher Lee. 6. Maila Nurmi. 7. Cassandra Peterson.

Foreign Actors

Erich Von Stroheim was born in 1885 in Vienna. He emigrated to the US in 1909. In his early films, often played the roles of sadistic German officers. Later he moved to France where he acted in several French films. Some of his films were *La Grande Illusion* (1937, Fr) and *Sunset Blvd.* (1950). Can you identify the following stars?

1. Born in Italy in 1895. At the age of 18 he moved to the US. Also known as the "Latin lover", he was a sex symbol of the 1920s. His famous films were *The Four Horsemen of the Apocalypse* (1921), *The Sheik*, (1921) and *The Son of the Sheik* (1926).
2. Meshilem Meier Weisenfreund was born in 1895 in Austria-Hungary. He started acting in the Yiddish theatre in Chicago

and then moved to Broadway. He won a Best Actor Oscar for *The Story of Louis Pasteur* (1936). He played gangster Tony Camonte in *Scarface* (1932). His other films are *I Am a Fugitive from a Chain Gang* (1932), *The Good Earth* (1937) and *The Life of Emile Zola* (1937).

3. José Ramón Gil Samaniego was born in 1899 in Mexico. He moved to the US in 1913. His famous silent films were *The Prisoner of Zenda* (1922) and *Scaramouche* (1923). He played the title character in *Ben-Hur: A Tale of the Christ* (1925). He was called New Valentino and Latin Lover.

4. Born in 1903 in St. Peterburg. This tall (6'6") actor's first major role was in Sergei M. Eisenstein's *Alexander Nevsky* (1938, Ru). He played the role of Ivan in Eisenstein's *Ivan the Terrible*, Part I (1944, Ru) and Part II (1958, Ru). He collaborated with Grigoriy Kozintsev in *Don Quixote'* (1957, Ru).

5. Laszlo Lowenstein was born in 1904 in Austria-Hungary, now Slovakia. He began his stage career in Vienna before moving to Germany. He portrayed a serial killer in the German film *M* (1931). He left Germany when Hitler came to power. His first English-language film was Alfred Hitchcock's *The Man Who Knew Too Much* (1934). He played the role of Japanese detective Mr. Moto in many films. His other films were *The Maltese Falcon* (1941) and *Casablanca* (1942).

6. Born in 1915 in Mexico. He was nominated for Best Supporting Actor Oscars for *Viva Zapata!* (1952) and *Lust for Life* (1956). He played the role of travelling showman Zampanò in Fellini's *La Strada* (1954, It). He won a Best Actor Oscar nomination for playing Zorba in *Zorba the Greek* (1964). His other films were *Attila* (1954), *The Guns of Navarone* (1961) and *Lawrence of Arabia* (1962).

7. Born in 1920 in Vladivostok, Russia. Moved to Paris in 1934 and to US in 1941. Acted in the Broadway musical "The King and I" and in its film version in 1956. Played the role of Ramses in *The Ten Commandments* (1956). His other films were *The Magnificent Seven* (1960) and *Taras Bulba* (1962). Instantly recognized by his bald head.

8. Born in 1922 in Vienna. He played Jules in Truffaut's *Jules and Jim* (1962, Fr). Among his other films were *Ship of*

Fools (1965), *The Spy who came in from the Cold* (1965) and *Fahrenheit 451* (1966).
9. Born in 1929 in Sweden. He was nominated for *Pelle the Conqueror* (1987, Sw) and *Extremely Loud & Incredibly Close* (2011). He acted in many Ingmar Bergman films such as *The Seventh Seal* (1957, Sw) and *Through a Glass Darkly* (1961, Sw). His other films are *The Exorcist* (1973) and *Never Say Never Again* (1983).
10. Born in 1932, in Alexandria, Egypt. He studied acting in Royal Academy of Dramatic Art, London. He converted to Islam to marry an Egyptian actress. He acted in Lean's *Lawrence of Arabia* (1962) and *Dr. Zhivago* (1965). He co-starred with Barbara Streisand in *Funny Girl* (1968). His other films were *MacKenna's Gold* (1969) and *Juggernaut* (1974). His was an expert bridge player.
11. Born in 1944 in Netherlands. This tall, blond and blue-eyed actor played the role of replicant Roy Batty in *Blade Runner* (1982). His other films include *The Wilby Conspiracy* (1975), *The Osterman Weekend* (1983), *Ladyhawke* (1985) and *Batman Begins* (2005).
12. Born in 1959 in Japan, this tall actor was nominated for Oscar in *The Last Samurai* (2003). Some of his other films were *Memoirs of a Geisha* (2005), *Batman Begins* (2005) and *Letters from Iwo Jima* (2006).
13. Born in 1960 in Spain. He starred with Tom Hanks in *Philadelphia* (1993). His other films are *Interview with the Vampire: The Vampire Chronicles* (1994) and *Frida* (2002). In 1998 he acted as Zorro, opposite Catherine Zeta-Jones, in *The Mask of Zorro* (1998) and *The Legend of Zorro* (2005).
14. Born in 1969 in Canary Island, Spain. He played the role of Anton Chigurh in *No Country for Old Men* (2007). His other films are *Vicky Cristina Barcelona* (2008) and *Skyfall* (2012).
15. Born in 1974 in Amritsar. He acted in Wes Anderson's films *The Darjeeling Limited* (2007), *The Life Aquatic with Steve Zissou* (2004) and *The Grand Budapest Hotel* (2014). His other films are *Inside Man* (2006) and *Beeba Boy* (2015).

Answers: 1. Rudolph Valentino. 2. Paul Muni. 3. Ramon Navarro. 4. Nikolay Cherkasov. 5. Peter Lorre. 6. Anthony Quinn. 7. Yul Brynner. 8.

Oskar Werner. 9. Max von Sydow. 10. Omar Sharif. 11. Rutger Hauer. 12. Ken Watanabe. 13. Anthony Banderas. 14. Javier Bardem. 15. Waris Ahluwalia.

German Actors

Emil Jannings was born in Germany in 1884. This fine actor was tarred due to his association with Nazism. He played Professor Immanuel Rath in **The Blue Angel** (1930). He received Best Actor Oscar in 1929 for his role in **The Way of all the Flesh** (1927) and **The Last Command** (1928). Can you identify the following German actors?

1. Born in 1893 in Berlin. He played the role of the murderous somnambulist Cesare in Robert Wiene's masterpiece **The Cabinet of Dr. Caligari** (1920). Though not a Jew, he fled Germany in 1933 after the rise to power of Adolf Hitler. He played the role of Gestapo Maj. Strasser in the classic **Casablanca** (1942), where he was the highest paid actor. His other films are **The Man Who Laughs** (1928) and **The Thief of Bagdad** (1940).
2. Born in 1913 in Saxony, Germany. He played Commisioner Kras in **The 1,000 Eyes of Dr. Mabuse** (1960). This tall (6' 1") and portly actor is famous as the villain of the James Bond film **Goldfinger** (1964). His other films are **Three Penny Opera** (1963, Ger) and **Chitty Chitty Bang Bang** (1968).
3. Born in 1915 in Bavaria, Germany. This tall (6' 4" in height) actor was sent to a concentration camp because of his anti-Nazi opinions. He became an international star with **...And God Created Woman** (1956, Fr). Some of his films were **The Blue Angel** (1959), **The Longest Day** (1962). He played Karl Stromberg in **The Spy Who Loved Me** (1977).
4. Born in 1926 in the Free City of Danzig, now Poland. In 1944, he was imprisoned as a German POW by British forces in Holland. He was famous for his violent temper. He played Count Dracula in **Nosferatu the Vampyre** (1979, Ger). He starred **Aguirre, the Wrath of God** (1972, Ger) and **Woyzeck** (1979, Ger), both directed by Werner Herzog. His other films are **For a Few Dollars More** (1965) and **Doctor Zhivago** (1965).

5. Born in 1930 in Austria. He won an Oscar for Stanley Kramer's *Judgment at Nurenberg* (1961). His other films were *Topkapi* (1964) and *The Castle* (1968).
6. Born in 1933 in Berlin. He achieved fame after *Confessions of Felix Krull* (1957, Ger) and became an international star with *The Magnificent Seven* (1960). His other films were *Fanny* (1961) and *Life Is Beautiful* (1997).
7. Born in 1956 in Vienna. His portrayal of Col Hans Landa in *Inglourious Basterds* (2009) won him an Oscar (supporting roles). He received another supporting actor Oscar in *Django Unchained* (2012). His other films are *Water for Elephants* (2011) and *The Legend of Tarzan* (2016).
8. Born in 1978 in Barcelona, Spain. His starring role in the German film *Good Bye, Lenin!* (2003, Ger) was well received. He played the role of Fredrick Zoller, a German war hero in *Inglourious Basterds* (2009). He played the role of Austrian racing car driver Niki Lauda in *Rush* (2013). His other films are *The Bourne Ultimatum* (2007) and *The Fifth Estate* (2013).

Answers: 1. Conrad Veidt. 2. Gert Fröbe. 3. Curt Jurgens. 4. Klaus Kinski. 5. Maximilian Schell. 6. Horst Buchholz. 7. Christoph Waltz. 8. Daniel Brühl.

Italian Actors

Antonio De Curtis (better known as Toto) was born in 1898 in Naples. He was the most popular Italian film comedian of all times. He was a natural son of a Marquis who accepted him in 1933. Some of his films are *Cops and Robbers* (1951, It), *The Hawks and the Sparrows* (1966, It), *What Ever Happened to Baby Toto?* (1964, It) and *Toto in Color* (1952, It). Can you identify the following stars?

1. Born in 1905 in Rome. He is best known for the role of the heroic priest Don Pietro in Roberto Rossellini's *Rome, Open City* (1945, It). Among his other films are *Cops and Robbers* (1951, It) and *We All Loved Each Other So Much* (1974, It).
2. Born in 1909 in Rome. An amateur actor, he played the role of Antonio in Vittorio De Sica's *The Bicycle Thieves* (1948, It). His

other films were **The Last Judgment** (1961, It) and **Umberto D.** (1952, It).
3. Born in 1924 in Fontana Liri. He starred in Federico Fellini's **La Dolce Vita** (1960, It) and Michelangelo Antonioni's **La Notte** (1961, It). His other notable films are Vittorio De Sica's **Yesterday, Today and Tomorrow** (1963, It), Fellini's **8½** (1963, It) and **A Special Day** (1977, It).
4. Born in 1933 in Milan. Played the villain in Sergio Leone's **A Fistful of Dollars** (1964) and **For a Few Dollars More** (1965). Known as Italian Laurence Olivier, because of the resemblance with the British actor. He played the writer Carlo Levi in **Christ Stopped at Eboli** (1979, It). His other films are **Investigation of a Citizen Above Suspicion** (1970, It), **Lulu the Tool** (1971, It) and **The Mattei Affair** (1972, It).
5. Born in 1935 in Rome. He acted as the Sicilian bodyguard Calo in **The Godfather** (1972) and **The Godfather: Part III** (1990). He acted in **Accattone** (1961, It), **The Decameron** (1971, It) and **The Canterbury Tales** (1972, It), all directed with Pier Pasolini.
6. Born 1941 in Parma. He played the coffin-dragging cowboy in Sergio Corbucci's spaghetti-western **Django** (1966, It). His other films were the musical **Camelot** (1967) and **Force 10 from Navarone** (1978). He played John Reed in **Ten Days That Shook the World** (1983).
7. Born in 1952 in Tuscany. He won Best Actor Oscar for **Life Is Beautiful** (1997). His other films are **The Tiger and the Snow** (2005, It) and **Down by Law** (1986).

Answers: 1. Aldo Fabrizi. 2. Lamberto Maggiorani. 3. Marcello Mastroianni. 4. Gian Maria Volontè. 5. Franco Citti. 6. Franco Nero. 7. Roberto Benigni.

Indian Actors

I. S. Johar was born in 1920 in Tollagannj in British India. Well known as a Hindi film actor he acted in British films such as **Harry Black** (1958), **North-West Frontier** (1959) and **Death on the Nile** (1978). He acted as Gasim, the man who is shot by Lawrence (Peter O'Toole) in **Lawrence of Arabia**. Can you identify the following stars?

1. Born in 1924 in Mysore, he was the son of a mahout (elephant rider). He was discovered by film maker Robert Flaherty, who gave him a role in his **Elephant Boy** (1937). He is remembered for his role in **The Thief of Baghdad** (1940). He also played the role of Mowgli in **The Jungle Book** (1942). Although In 1944, he became an American citizen, he did not succeed much in Hollywood.
2. Born in 1929 in Malerkotla in Punjab. He acted in **The Guru** (1969), **The Wilby Conspiracy** (1975) and **My Beautiful Laundrette** (1985). He acted as Mir Roshan Ali in Satyajit Ray's **Shatranj Ke Khilari** (1977). His other films were **Gandhi** (1982) and **A Passage to India** (1984).
3. Krishna Bhanji was born in 1943 in Yorkshire. His father was a Kenyan-born doctor of Indian descent. He won the Best Actor Oscar for his role in **Gandhi** (1982). He played the role of French director Georges Méliès in **Hugo** (2011). His other films are **Bugsy** (1991), **Schindler's List** (1993), **Sexy Beast** (2000) and **Learning to Drive** (2014).
4. Born in 1946 in Lahore, British India. He acted in Hindi films such as **Kuchhe Dhaage** (1973) and **Manzilein Aur Bhi Hain** (1974) and in English films such as **Ashanti** (1979). He played the main lead in the Italian TV series **Sandokan**. He acted as Gobinda in the James Bond film **Octopussy** (1983).
5. Born in 1969 in London to immigrant parents from Kerala, India. His first major role was as the Sikh sapper Kip Singh in Anthony Minghella's **The English Patient** (1996). He played the role of Dr. Hasnat Khan in **Diana** (2013). His other films are Mira Nair's **Kama Sutra: A Tale of Love** (1996) and Gurinder Chadha's **Bride & Prejudice**.
6. Kalpen Modi was born in 1977 in New Jersey. He starred as Nikhil (Gogol) in **The Namesake** (2006) and as Kumar in **Harold & Kumar Go to White Castle** (2004).
7. Born in London in 1990. He was nominated for an Oscar (Supporting role) for **Lion** (2016). His breakout role was in **Slumdog Millionaire** (2008). His other films are **The Best Exotic Marigold Hotel** (2011) and **The Man Who Knew Infinity** (2015).

Answers: 1. Sabu. 2. Saeed Jaffrey. 3. Ben Kingsley. 4. Kabir Bedi. 5. Naveen Andrews. 6. Kal Penn. 7. Dev Patel.

Guess the Actors

Robert Duvall, who was born in 1931, acted in **The Godfather** (1972), **Apocalypse Now** (1979), **Tender Mercies** (1983) and **Geronimo: An American Legend** (1993). Can you identify the actors who starred in the following films?

1. Born 1941. **The Deep** (1977), **Jefferson in Paris** (1995). **Affliction** (1997) **The Golden Bowl** (2000), **A Walk in the Woods** (2015).
2. Born 1959. **Top Gun** (1986), **The Doors** (1991), **Tombstone** (1993). **Batman Forever** (1995) **Kiss Kiss Bang Bang** (200).
3. Born 1960. **Carlito's Way** (1993), **Dead Man Walking** (1995) **Mystic River** (2003) **Milk** (2008).
4. Born 1961. **Natural Born Killers** (1994), **The People vs. Larry Flynt** (1996), **No Country for Old Men** (2007), **Wilson** (2017).
5. Born 1962. **Foxcatcher** (2014), **The Big Short** (2015), **Battle of the Sexes** (2017), **Vice** (2018).
6. Born 1965. **There's Something About Mary** (1998), **Meet the Parents** (2000), **Zoolander** (2001), **Night at the Museum**.
7. Born 1969. **Primal Fear** (1996), **American History X** (1998), **Fight Club** (1999), **The Incredible Hulk** (2008), **Birdman** (2014).
8. Born 1970. **Scent of a Woman** (1992), **The Three Musketeers** (1993), **Batman & Robin** (1997).
9. Born 1981. **500 Days of Summer** (2009), **50/50** (2011), **The Dark Knight Rises** (2012) **The Walk** (2015).
10. Born 1984. **Little Miss Sunshine** (2006), **There Will Be Blood** (2007). **12 Years a Slave** (2013); **Swiss Army Man** (2016).

Answers: 1. Nick Nolte. 2. Val Kilmer. 3. Sean Penn. 4. Woody Harrelson. 5. Steve Carell. 6. Ben Stiller 7. Edward Norton. 8. Chris O'Donnell 9. Joseph Gordon-Levitt. 10. Paul Dano.

Musican-Actors

Dino Paul Crocetti, better known as Dean Martin, was born in 1917 in Ohio. He teamed up with Jerry Lewis to form a comic duo in films such as **My Friend Irma** (1949) and **Hollywood or Bust** (1956). As a crooner, he had many hits such as "That's Amore" (1953), "Everybody

Loves Somebody" (1964) and "Gentle on My Mind" (1968). His other films are **Rio Bravo** (1959), **Who Was That Lady?** (1960), **Toys in the Attic** (1963) and the disaster film **Airport** (1970). Can you identify the following musician-actors?

1. Born in 1935 in Mississippi but moved to Memphis, Tennessee in 1948. He recorded rock and roll songs, such as "Blue Suede Shoes" and "Hound Dog". His first acting role was in **Love Me Tender** (1956). He starred in over thirty films, mostly musical, which though panned by critics, did well at the box office. His films are **Jailhouse Rock** (1957) and **G.I. Blues** (1960). He died at age 42 in 1977 at his mansion in Graceland, near Memphis.
2. He was born in 1952 in Tokyo. He composed the original score for **The Revenant** (2016), **Snake Eyes** (1998), **Merry Christmas, Mr. Lawrence** (1983) and **The Last Emperor** (1987). He also played acting roles in the last two films.
3. Born in 1956 in California. His song "Wicked Game" was featured in 1990 David Lynch film **Wild at Heart**. He acted in David Lynch's **Twin Peaks: Fire Walk with Me** (1992). His "Baby Did a Bad, Bad Thing" was featured in Stanley Kubrick's final film, **Eyes Wide Shut**. He acted in **Married to the Mob** (1988), **The Silence of the Lambs** (1991), **That Thing You Do!** (1996) and **A Dirty Shame** (2004).
4. Born in 1941 in New York. He is a folk rock singer who acted in **Carnal Knowledge** (1971). His other films were **Catch-22** (1970) and **Bad Timing** (1980).
5. Born in 1947 in London. Influential singer and song writer. He was acclaimed for his acting in **The Man Who Fell to Earth** (1976) and **Merry Christmas, Mr. Lawrence** (1983). His other films are **The Linguini Incident** (1991) and **The Prestige** (2006).
6. Born in 1943 in Kent, U. K. He is a singer and member of a legendary rock and roll band. He starred in **Ned Kelly** (1970), **Performance** (1970) and **Running Out of Luck** (1987).

Answers: 1. Elvis Presley. 2. Ryuichi Sakamoto. 3. Chris Isaak. 4. Art Garfunkel. 5. David Bowie. 6. Mick Jagger

Actor +

Yakima Canutt was born in 1895 on a ranch. He grew up riding horses and starred as a cowboy in many silent westerns. He was Hollywood's most famous stuntsman. He doubled for stars such as Clark Gable and John Wayne. He directed the famed chariot race in **Ben-Hur** (1959). He was awarded a special Oscar in 1966 for his contributions to films. Can you identify these actors who have accomplishments other than acting?

1. Born in 1904, in Timisoara district of Romania. He won five Olympic Gold Medals for swimming between 1924 (Paris) and 1928 (Amsterdam). He was the first man to swim 100 m freestyle in under a minute. Being 6' 3" tall, he was the most famous Tarzan of the screen.
2. Born in 1908 in California. He was a two-time Olympic swimmer. He won the 1932 Olympic gold medal for 400-meter freestyle swimming event. He starred as Tarzan in **Tarzan the Fearless** (1933) He also played the roles of Flash Gordon and Buck Rogers in films.
3. He won the Gold Medal in Decathlon at the 1936 Summer Olympic Games in Berlin, Germany. He played the role of Tarzan in **Tarzan's Revenge** (1938).
4. Born in 1911 in Illinois. His films include **Kings Row** (1942), **The Hasty Heart** (1949) and **Hellcats of the Navy** (1957). He was elected president of the Screen Actors Guild in 1947 and in 1967 the Governor of California.
5. Born in 1924 in Texas. He was the most decorated combat soldier in US history before he was 20. He received the Medal of Honor, the highest award for valor in action against an enemy force. He starred in John Huston's **The Red Badge of Courage** (1951). His other films were **To Hell and Back** (1955) and **Night Passage** (1957).
6. Born in 1901 in Austria. He became the director of the Actors Studio in New York, where he influenced actors such as Robert De Niro, Paul Newman, and Al Pacino. He popularized Method acting derived from the teaching of Russian director Konstantin Stanislavski. He won best supporting actor Oscar for the role of Hyman Roth in **The Godfather: Part II** (1974).

7. Born in 1948 in Latvia. He is a well known name in modern dance. He was nominated for best supporting actor for **The Turning Point** (1977). His other films are **White Nights** (1985) and **Dancers** (1987).

Answers: 1. Johnny Weissmuller. 2. Buster Crabbe. 3. Glenn Morris. 4. Ronald Reagan. 5. Audie Murphy. 6. Lee Strasberg. 7. Mikhail Baryshnikov.

Mixed Bag - Actors

Rat pack is the name given to the informal group that included actors Frank Sinatra, Dean Martin, Sammy Davis Jr., Peter Lawford, and Joey Bishop. Can you identify the following actors?

1. Born in 1918 in France, he was taken to the US, where his first film was **The Man from Hell's River** (1922). His film **Where the North Begins** (1923) was such a big hit that it saved Warner Bros. from bankruptcy. He appeared in 27 Hollywood films. His death in 1932 In Los Angeles was mourned by a grieving nation. In 1960, he was honored with a star on the Hollywood Walk of Fame.
2. What was the name of a group of incompetent policemen in silent comic films produced by Mark Sennet (1912 to 1917)?
3. What is common to Chico, Harpo, Gummo and Zeppo?
4. Which actor is part of the rock group Tenacious D, formed in formed in Los Angeles, California in 1994?
5. Who was married to Mildred Harris, Lita Grey, Paulette Goddard and Oona O'Neill successively?
6. Who was married to Anna Kashfi, Movita Castenada and Tarita Teriipia successively?.
7. Who was married to Jane Wyman and Nancy Davis successively?
8. Who was married to Kalie Holmes and Nicole Kidman successively?
9. Who played the role of King Henry II of England in two films: **The Lion in Winter** and **Becket**?
10. Who was the actor who acted in B grade movies such as **Prisoner Of War** (1954), **Swing your Lady** (1938) and **Love is on the Air** (1937)?

11. Who was the Italian actor who appeared in many spaghetti western such as **They Call me Trinity** (1970) along with Terence Hill?
12. Who in 2009, played a cameo role in a Bollywood film starring Akshaya Kumar Kambhakt Ishq?
13. Which actor claimed to have "Russian, German, Spanish, Italian, French and Ethiopian blood" in his veins?
14. Whose screen test resulted in a talent scout concluding: Can't act. Can't sing. Slightly bald. Can dance a little?
15. Who was voted into the International Boxing Hall of Fame in the non-participant category on 7 December 2010?
16. Born in 1953 in Lagos, Nigeria, 6-foot-10-inch Bolaji Badejo, acted in only one film. He played one of Hollywood's most unlikely character. What role did he play in a 1979 film?
17. Who played the role of Willy in **Free Willy** (1993)?
18. Who was the first actor to appear on the cover of Time magazine?
19. Who was the first male to appear on the cover of Playboy magazine, in April 1964?

Answers: 1. Rin Tin Tin. 2. Keystone Kops. 3. Marx brothers. 4. Jack Black. 5. Charles Chaplin. 6. Marlon Brando. 7. Ronald Reagan. 8. Tom Cruise. 9. Peter O'Toole. 10. Reagan Ronald. 11. Bud Spencer. 12. Sylvester Stallone. 13. Peter Ustinov. 14. Fred Astaire. 15. Sylvester Stallone. 16. Alien in Ridley Scott's 1979 film Alien. 17. Keiko the whale. 18. Charles Chaplin (in 1925). 19. Peter Sellers.

Actresses

Katharine Hepburn

Red-haired and athletic, Katherine Hepburn was born in 1907, Connecticut. Her partner for 26 years was Spencer Tracy, with whom she made nine films. Can you identify the following film?

1. Lowell Sherman (1933). Coming from a provincial town, Eva Lovelace (Hepburn) hopes to make it big in New York City as a stage actress. Katharine Hepburn won an academy award for Best Actress in a leading role in 1934.
2. George Cukor (1940). Two years after her divorce with C.K. Dexter Haven (Cary Grant), socialite Tracy Lord (Hepburn) wants to remarry businessman George Kitteridge (John Howard).
3. John Houston (1951). Charlie Allnut (Humphrey Bogart) agrees to take Rose Sayers (Katherine Hepburn) back to civilization from war ravaged East Africa in his cranky old steamer.
4. Stanley Kramer (1967). Christina Drayton (Katharine Hepburn) and Matt Drayton (Spencer Tracy) are surprised when their daughter Joanna Drayton (Katharine Houghton) invites her fiancé, the high-qualified Dr. John Prentice (Sidney Poitier) to dinner.
5. Anthony Harvey (1968). King Henry II (Peter o'Toole) of England and his wife Eleanor of Aquitaine (Katherine Hepburn) disagree about his successor. Anthony Hopkins (in his first major role) plays the role of Richard the Lionheart.
6. Mark Rydell (1981). Norman Thayer (Henry Fonda), a retired professor, and Ethel (Katherine Hepburn) have a summer

cottage. When their daughter Chelsea (Jane Fonda) visits them after years, the relationship that had soured is healed.

Answers: 1. *Morning Glory.* 2. *The Philadelphia Story.* 3. *The African Queen.* 4. *Guess Who's Coming to Dinner.* 5. *Lion in Winter.* 6. *On Golden Pond.*

Elizabeth Taylor

Born in 1932 in London to American parents. She had dark hair and violet eyes. She is famous for her multiple marriages and divorces. She was nominated for Oscar five times and won it twice. Can you identify the following films starring Liz Taylor?

1. Clarence Brown (1944). Teenager Velvet Brown (Elizabeth Taylor) decides to ride the horse The Pie for the Grand National race.
2. Richard Thorpe (1952). In medieval England Jew Rebecca (Elizabeth Taylor) sacrifices her love for a Saxon knight (Robert Taylor) for Rowena (Joan Fontaine).
3. George Stevens (1956). When Texas cattle ranger Bick (Rock Hudson) stands up for an immigrant family against the racist Sarge in the diner, Leslie (Elizabeth Taylor) tells him that he became a hero for her.
4. Richard Brooks (1958). Scheming Maggie (Elizabeth Taylor) married to alcoholic Brick Pollitt (Paul Newman) pulls off a charade in front of Big Daddy (Burl Ives).
5. Joseph L. Mankiewicz (1959). Catherine (Elizabeth Taylor) is the only witness to her wealthy cousin's death while on vacation but the wealthy widow Violet Venable (Katherine Hepburn) does not want the cause of her son's death to be revealed.
6. Daniel Mann (1960). Call girl Gloria Wandrous (Elizabeth Taylor) has a tragic affair with married socialite Weston Liggett (Laurence Harvey). Elizabeth Taylor won her first Academy award in this film.
7. Joseph L. Mankiewicz (1963). Ambitious Cleopatra (Elizabeth Taylor) becomes queen of Egypt through the help of Roman General Julius Ceaser (Rex Harrison), whom she later marries.

8. Vincente Minnelli (1965). Single unwed mother Laura Reynolds (Elizabeth Taylor) falls in love with married headmaster Dr. Edward Hewitt (Richard Burton).
9. Mike Nichols (1966). Elizabeth Taylor received her second Academy award for the role of loudmouthed, and shrewish Martha, wife of college professor George (Richard Burton).

Answers: 1. *National Velvet*. 2. *Ivanhoe*. 3. *Giant*. 4. *Cat on a Hot Tin Roof*. 5. *Suddenly Last Summer*. 6. *BUtterfield 8*. 7. *Cleopatra*. 8. *Sandpiper*. 9. *Who's Afraid of Virginia Woolf?*

Meryl Streep

Meryl Streep was born in 1949 in New Jersey. She was nominated for Oscar 21 times and won it thrice. Can you identify the following films starring Meryl Streep?

1. Karel Reisz (1981). Turbulent Englishwoman Sarah Woodruff (Meryl Streep), ruined by an affair with a French lieutenant, enters into another relationship with young Charles (Jeremy Irons).
2. Alan J. Pakula (1982). Sophie Zawistowski (Meryl Streep), a beautiful Polish immigrant and her lover, Nathan Landau (Kevin Kline) become friends with Stingo (Peter MacNicol) a young writer.
3. Mike Nichols (1983). Karen (Meryl Streep) blows the whistle on the plutoninium processing plant she works in and suffers consequences for her action.
4. Clint Eastwood (1995). Photographer Robert Kincaid (Clint Eastwood) wanders into the life of housewife Francesca Johnson (Meryl Streep) for four days.
5. David Frankel (2006). Powerful editor of a fashion magazine Miranda Priestly (Meryl Streep) hires Andrea Sach (Anne Hathaway) as her assistant.
6. Phyllida Lloyd (2011). An elderly Margaret Thatcher (Meryl Streep) converses with the ghost of dead husband Denis (Jim Broadbent) and recalls her past life.

7. John Wells (2013). After the death of patriarch Beverly Weston (Sam Shepard), his three daughter visit Violet (Meryl Streep) who has propensity for pills and alcohol.

Answers: 1. The French Lieutenant's Woman. 2. Sophie's Choice. 3. Silkwood. 4. The Bridges of Madison County. 5. The Devil Wears Prada. 6. The Iron Lady. 7. August: Osage County.

US Actresses I

Theda Bara was born in 1885 in Ohio. She was publicized as the daughter of an artist and an Arabian princess and her name was said to be an anagram of Arab Death. In her first film, **A Fool There Was** (1915), she played the sexual vampire to the hilt and the role of "the vamp" was born. She often played the part of a temptress in films like **Salome** (1918), **Cleopatra** (1917) and **Camille** (1917). Can you identify the following actresses?

1. Born in 1885 in Pennsylvania. Though she did several vamp and supporting roles, she is better known as an influential newspaper gossip columnist. In later years, she played herself in **Sunset Boulevard** (1950) and **The Patsy** (1964).
2. Born in 1889 in Chicago. Starting in silent films, she transitioned well into sound films. She was nominated for Best Actress Oscars for **Sadie Thompson** (1928), **The Trespasser** (1929) and **Sunset Boulevard** (1950). She was married six times and her lovers included Joseph Kennedy.
3. Born in 1893 in New York. She starred **She Done him Wrong** (1932), **I am no Angel** (1933) and **My Little Chickadee** (1940). She often wrote screenplays for the films she starred in. Her films were replete with sexual innuendos and she made fun of a puritanical society.
4. Born in 1895 in Nevada. She was Charles Chaplin's favorite co-star from the silent era, and remained close to Chaplin throughout her life. She acted in **The Kid** (1921) and rarely worked in films after the 1920s. Chaplin kept her on his payroll until her death in 1958.

5. Born in 1902 in Alabama. She acted as Catherine the Great in **A Royal Scandal** (1945). Her other films were **Devil and the Deep** (1932) and **Lifeboat** (1944). She missed out playing Scarlett O' Hara's role in **Gone with the Wind** (1936) because of her wild social life.
6. Born in 1903 in Saint Mande, France. She won the Academy Award for Best Actress in **It Happened One Night** (1934). Her other films include **Cleopatra** (1934) and **The Palm Beach Story** (1942).
7. Born in 1905 in Texas. She was a silent film actress who transitioned well into talking films. She won an Oscar for Best Actress in **Mildred Pierce** (1945). She acted in **Grand Hotel** (1932) and **Possessed** (1947). Her rivalry with Bette Davis is legendary.
8. Born in 1905 in New York, she was raised in poverty and violence in Brooklyn. Known as the "It Girl", she was Hollywood's first sex symbol. She acted in **It** (1927) and **Wings** (1927).
9. Born in 1908 in Massachusetts, she was famous for her large, distinctive eyes. She is often ranked as the greatest American movie actress. She acted as Mildred Rogers in **Of Human Bondage** (1934). She received Best Actress Oscars for **Dangerous** (1935) and **Jezebel** (1938). She was nominated for Oscar for her role as Margo Channing in **All About Eve** (1950).
10. Born in 1911 in Missouri as Harlean Carpenter. She was the reigning sex symbol of the thirties. She frequently played bad girl characters. She starred in **Platinum Blonde** (1931), **Red-Headed Woman** (1932) and **Saratoga** (1937). She died at the age of twenty-six.
11. Born in 1911 in New York. Her major starring role was in **The Big Street** (1942) opposite Henry Fonda. Her other films were **Stage Door** (1937) and **Du Barry Was a Lady** (1943). She fell in love with a young Cuban actor-musician named Desi Arnaz. She is better known for her comic television seriels.
12. Born in 1916 in Tokyo to British parents. She received her first Oscar nomination for **Gone with the Wind** (1939). She won an Oscar for **To Each His Own** (1946). Her other films are **They Died with Their Boots On** (1941) and **My Cousin Rachel** (1952).

13. Born in 1917 in Tokyo to British parents. She received her first Oscar nomination for **Rebecca** (1940) but next year she won the award for Alfred Hitchcock's **Suspicion** (1941). Her other films were **Jane Eyre** (1943) and **Ivanhoe** (1952).
14. Born in 1922 in Minnesota, she had an early success with **The Wizard of Oz** (1939). But due to her involvement with men and drugs, her life was full of ups and downs. Her musical films were **A Star Is Born** (1937), **Meet Me in St. Louis** (1944) and **Easter Parade** (1948). She acted in **Judgment at Nuremberg** (1961).
15. Born in 1929 in Philadelphia. She won an Oscar for **The Country Girl** (1954). She appeared in the Western **High Noon** (1952), along with Gary Cooper. She appeared in **Dial M for Murder** (1954), **Rear Window** (1954) and **To Catch a Thief** (1955), all directed by Hitchcock. Her other films were **Mogambo** (1953) and **High Society** (1956).

Answers: 1. Hedda Hopper. 2. Gloria Swanson. 3. Mae West. 4. Edna Purviance. 5. Tallulah Bankhead. 6. Claudette Colbert. 7. Joan Crawford. 8. Clara Bow. 9. Bette Davis. 10. Jean Harlow. 11. Lucile Ball. 12. Olivia de Havilland. 13. Joan Fontaine. 14. Judy Garland. 15. Grace Kelly.

US Actresses II

Marilyn Monroe, born in 1926 in California, was probably the most famous Hollywood blonde. **Niagara** (1953) and **Gentlemen Prefer Blondes** (1953) launched her as a sex symbol. Her other films were **The Seven-Year Itch** (1955) and **Some Like It Hot** (1959). Her last film was John Huston's **The Misfits** (1961) starring Clark Gable. Can you identify the following actresses?

1. Born in 1930 in Georgia. She won a Best Actress Oscar for **The Three Faces of Eve** (1957), in which she plays a woman with multiple personality disorder. Her other films are **The Sound and the Fury** (1959), **Signpost to Murder** (1964) and **Rachel, Rachel** (1968).
2. Born in 1930 in Minnesota, she acted in **The Birds** (1963) and **Marnie** (1964), both directed by Alfred Hitchcock.

3. Born in Iowa in 1938. Her first major role was in Godard's *Breathless* (1960, Fr). Her other films are *Lillith* (1964) and *Paint Your Wagon* (1969). Her last film was *The Wild Duck* (1976).
4. Born in 1941 in Florida. She won an Oscar for *Network* (1976). Her first hit was in Arthur Penn's controversial *Bonnie and Clyde* (1967). Her other films were *Chinatown* (1974) and *Mommie Dearest* (1981).
5. Born in 1945 in California. She played Daisy Buchanan in *The Great Gatsby* (1974). Her other films were *Rosemary's Baby* (1968), *Hannah and Her Sisters* (1974) and *The Purple Rose of Cairo* (1985).
6. Born in 1946 in Beverly Hills, California. Her first film was Sidney Lumet's *The Group* (1966). She starred in Claude Lelouch's *Live for Life* (1967, Fr). Her other films were *Carnal Knowledge* (1971) and *Gandhi* (1982).
7. Born in 1946 in California, she won an Oscar for her performance as Sally Bowles in *Cabaret* (1972). Her other films are *New York, New York* (1977) and *Arthur* (1981).
8. Born in 1949 in New York. She played the role of the tough, uncompromising Ellen Riple in *Alien* (1979). Her other films were *The Year of Living Dangerously* (1982), *The Village* (2004) and *Avatar* (2009).
9. She was born in 1949 in Minnesota. She got a break in films with *King Kong* (1976). She won an Oscar for *Tootsie* (1982). Her other films are *The Postman Always Rings Twice* (1981), *Frances* (1982) and *Blue Sky* (1994).
10. Born in 1949 in Texas. She studied acting at the Lee Strasberg Institute. She won the Best Actress Oscar for *Coal Miner's Daughter* (1980). Her other films were *Badlands* (1973), *Carrie* (1976) and *The Help* (2011).
11. Born in 1964 in Virginia. She won best Actress Oscar for *The Blind Side* (2009). Her first big blockbuster was *Speed* (1994). Her other films were *Demolition Man* (1993), *The Proposal* (2009) and *Gravity* (2013).
12. Born in 1965 in New York. She made her debut at age 12 in *Pretty Baby* (1978). Her film *The Blue Lagoon* (1980) was a blockbuster. She was married to tennis star Andre Agassi.

13. Born in 1969 in Texas. She won an Oscar for Best Supporting Actress for **Cold Mountain** (2003). She received best actress Oscars nominations for **Bridget Jones's Diary** (2001) and **Chicago** (2002), Her other films are **The Whole Wide World** (1996) and **Jerry Maguire** (1996).
14. Born in 1975 in Los Angeles. She won Oscar (Supporting role) for **Girl, Interrupted** (1999). She was nominated for Oscar (leading role) for **Changeling** (2008). Her other films are as **Mr. & Mrs. Smith** (2005), **A Mighty Heart** (2007), **Salt** (2010). She in involved in humanitarian work and was appointed as a Goodwill Ambassador for the United Nations High Commissioner for Refugees (UNHCR).
15. Born in 1984 in New York City. Her early film was **The Horse Whisperer** (1998). She starred in **Lost in Translation** (2003) and **Girl with a Pearl Earring** (2003). She starred as Black Widow /Natasha Romanoff in **Avengers** (2012).

Answers: 1. Joanne Woodward. 2. Tippi Hedren. 3. Jean Seberg. 4. Faye Dunaway. 5. Mia Farrow. 6. Candice Berger. 7. Liza Minnelli. 8. Sigourney Weaver. 9. Jessica Lange. 10. Sissy Spacek. 11. Sandra Bullock. 12. Brooke Shields. 13. Renée Zellweger. 14. Angelina Jolie. 15. Scarlett Johansson.

British Actresses

Jessica Tandy was born in 1909 in London. She won the Best actress Oscar for **Driving Miss Daisy** (1989), becoming the oldest actress to win the award. Her other films include **The Bostonians** (1984) and **Fried Green Tomatoes** (1991). Can you identify the following British actresses?

1. Born in 1929 in Brussels, Belgium. She won an Oscar as Best Actress for **Roman Holiday** (1953). She played Holly Golightly in **Breakfast at Tiffany's** (1961), for which she received an Oscar nomination. Her other films were **Charade** (1963) and **My Fair Lady** (1964).
2. Born in 1934 in Essex. She won an Oscar (leading role) for **The Prime of Miss Jean Brodie** (1969) and an Oscar (supporting role) for **California Suite** (1978). Her other films are **A Room**

with a View (1985), **Gosford Park** (2001) and **Harry Potter and the Sorcerer's Stone** (2001).
3. Born in 1937 in London. She won the Best actress award for **Isadora** (1968) at Cannes film festival. Her other films were **Blow-Up** (1966, It) **Camelot** (1967), **Julia** (1977) and **Morgan!** (1966).
4. Born in 1945 in London. She won an Oscar for her role of Elizabeth II in **The Queen** (2006). She was nominated for Oscar for **The Madness of King George** (1994), **Gosford Park** (2001) and **The Last Station (2009)**. Her other films are **Calendar Girls** (2003), **The Tempest** (2010), **Hitchcock** (2012), and **The Hundred-Foot Journey** (1914).
5. Born in 1946 in London. She started her acting career in films such as Michelangelo Antonioni's **Blow-up** (1966) and acted in many French films. Her other films are **Death on the Nile** (1978) and **Evil Under the Sun** (1982). As a singer she collaborated with French singer and composer Sergie Gainsbourgh, her partner for 13 years. A bag designed by Hermes is named after her.
6. Born in 1936 in Cheshire to a working class family. She won two Oscars in leading roles for Ken Russel's **Women in Love** (1969) and **A Touch of Class** (1973). Her other films are **Sunday Bloody Sunday** (1971) and **The Music Lovers** (1971). She was elected a Member of Parliament.
7. Born in 1966 in London. Her first major film was **A Room with a View** (1985). She was nominated for Best Actress Oscar for **The Wings of the Dove** (1997) and for Best Supporting Actress for **The King's Speech** (2010). Her other films include **Where Angels Fear to Tread** (1991) and **Howards End** (1992).
8. Born in 1975 in Berkshire. She acted as Marianne Dashwood in Ang Lee's **Sense and Sensibility** (1995). She played the rebellious Sue in **Jude** (1996) and Ophelia in Kenneth Branagh's **Hamlet** (1996). She acted as Rose DeWitt Bukater in James Cameron's **Titanic** (1997). Her other films are **Quills** (2000) and **Eternal Sunshine of the Spotless Mind** (2004). She won the Best Actress Oscar for **The Reader** (2008), playing a former concentration camp guard.
9. Born in 1959 in London. She won the Best Actress award for **Howards End** (1992). She was nominated for Oscar for

leading roles in **The Remains of the Day** (1993) and **Sense and Sensibility** (1995). She was nominated for Oscar (supporting role) for **In the Name of the Father** (1993). Her other films include **Howards End** (1992) and **Much Ado About Nothing** (1993). She played the novelist P. L. Travers in **Saving Mr. Banks** (2013).

10. Born in 1985 in Middlesex. She was nominated for Oscar for leading role in **Pride & Prejudice** (2005). She played the title role in **Anna Karenina** (2012). Her other films are **Bend It Like Beckham** (2002), **Atonement** (2007) and **The Imitation Game** (2014).

Answers: 1. Audrey Hepburn. 2. Maggie Smith. 3. Vanessa Redgrave. 4. Helen Mirren. 5. Jane Birkin. 6. Glenda Jackson. 7. Helena Bonham Carter. 8. Kate Winslet. 9. Emma Thompson. 10. Keira Knightley

Afro-American Actresses

Hattie McDaniel was born in 1893 in Kansas. She played the role of "Mammy" in **Gone with the Wind** (1939), for which she won the best supporting actress Oscar, the first won by an African American. She acted and sang in the musical **Showboat** (1936). Her other films are **They Died with Their Boots On** (1941) and **Song of the South** (1946). Her last film was **The Big Wheel** (1949). Can you identify these Afro-American actresses?

1. Born in 1917 in Brooklyn, New York. She quit school when she was 14 and started singing first in Harlem, then at Broadway musicals. She made her first film, **The Duke Is Tops** (1938). She starred in the musical Cabin in the Sky (1943) directed by Vincente Minnelli. Her other films are **Broadway Rhythm** (1944), **Ziegfeld Follies** (1945) and **The Wiz** (1978).
2. Born in 1922 in Ohio. She was nominated for the best actress Oscar for **Carmen Jones** (1954), becomg the first Afro-American to do so. She played the role of Bess in the musical **Porgy and Bess** (1959).
3. Born in 1955 in Manhattan. She won the best supporting actress Oscar for **Ghost** (1990). She was nominated for an

Oscar her role in **The Color Purple** (1985). Her other films are **Sister Act** (1992), **Girl, Interrupted** (1999) and **Kambakkht Ishq** (2009, Hnd).

4. Born in 1966 in Ohio. She won the best actress Oscar for **Monster's Ball** (2001), becoming the first African-American to do so. Her other films include **Die Another Day** (2002) and **Catwoman** (2004).
5. Born in 1965 in South Carolina. She won the best supporting actress Oscar for **Fences** (2016). She was nominated for the best actress Oscar for **The Help** (2011). Her other films are **Doubt** (2008) and **Get On Up** (2014).
6. Born in 1970 in New Jersy as Dana Elaine Owens. She achieved fame as a hip-hop singer. She was nominated for a best supporting actress Oscar for **Chicago** (2002). She plays NY taxi driver Isabelle Williams in **Taxi** (2004). Her other films are **The Bone Collector** (1999), **Hairspray** (2007) and **The Secret Life of Bees** (2008).
7. Born in 1972 in Alabama. She won the best supporting actress Oscar for **The Help** (2011). She was nominated for the best supporting actress Oscar for **Hidden Figures** (2016) and **The Shape of Water** (2017).

Answers: 1. Lena Horne. 2. Dorothy Dandridge. 3. Whoopi Goldberg. 4. Halle Berry. 5. Viola Davis. 6. Queen Latifah. 7. Octavia Spencer.

French Actresses

Simone Signoret was born in 1921 in Germany. She married French star Yves Montand. She won a best actress Oscar for **Room at the Top** (1959). Her other films were **Diabolique** (1955, Fr), **Ship of Fools** (1965) and **I Sent a Letter to My Love** (1980, Fr). Can you identify these French actresses?

1. Born in 1928 in Paris. She is famous for playing the role of Catherine in François Truffaut's **Jules and Jim** (1962, Fr). Louis Malle's **The Lovers** (1958, Fr) was an early hit. Her other films are Peter Brooks' **Seven Days... Seven Nights** (1960, Fr) and Luis Bunue's **Diary of a Chambermaid** (1964, Fr).

2. Born in 1932 in Paris. She acted in Federico Fellini's ***La Dolce Vita*** (1960, It) and ***8½*** (1963, It). She was nominated for a best actress Oscar for ***Un Homme et une femme*** (1966, Fr). Her other films are George Cukor's ***Justine*** (1969), Bernardo Bertolucci's ***Tragedy of a Ridiculous Man*** (1981, Fr) and Robert Altman's ***Prêt à Porter*** (1994).
3. Born in 1934 in Paris. She is recognizable by her platinum blonde hair and large eyes. She starred in ***And God Created Women*** (1956, Fr). Her other films were Henri-Georges Clouzot's ***The Truth*** (1960, Fr) and Louis Malle's ***Viva Maria!*** (1965, Fr). She campaigns for animal rights.
4. Born in 1943 in Paris. She was nominated for best actress Oscar for ***Indochine*** (1992, Fr). She starred in Jacques Demy's ***The Umbrellas of Cherbourg*** (1964, Fr). Her other film was Luis Bunuel's ***Belle de Jour*** (1967, Fr).
5. Born in 1953 in Paris. She was nominated for best Actress Oscar for Paul Verhoeven's ***Elle*** (1916, Fr). Two of her early films were ***The Lacemaker*** (1977, Fr) and Claude Chabrol's ***Violette Nozière*** (1978, Fr). Her other films are Michael Cimino's ***Heaven's Gate*** (1980) and ***Deep Water*** (1981, Fr).
6. Born in 1955 in Paris to an Algerian father and German Catholic mother. She was nominated for Oscars for her roles in ***The Story of Adèle H.*** (1975, Fr) and ***Camille Claudel*** (1988, Fr). Her other films are ***The Driver*** (1978), ***Nosferatu*** (1979, Ger) and ***Possession*** (1981).
7. Born in 1964 in Paris. Her first major breakthrough was Philip Kaufman's ***The Unbearable Lightness of Being*** (1988). She acted in Krzysztof Kieslowski's Colors trilogy: ***Blue*** (1993, Fr), ***White*** (1994, Fr) and ***Red*** (1994, Fr). Her French films were Louis Malle's ***Damage*** (1992, Fr) and Jean-Paul Rappeneau's ***The Horseman on the Roof*** (1995, Fr). She won an Oscar for best supporting actress for ***The English Patient*** (1996). She was nominated for an Oscar for ***Chocolat*** (2000).
8. Born in 1975 in Paris. She won an Oscar for playing Edith Piaf in ***La Vie en Rose*** (2007, Fr). Her other films are ***Taxi*** (1998, Fr), ***Love Me If You Dare*** (2003, Fr). She starred in English films such as ***Big Fish*** (2003) and ***Nine*** (2009). She acted in ***Inception*** (2010) and ***The Dark Knight Rises*** (2012), both directed by Christopher Nolan.

Answers: 1. Jeanne Moreau. 2. Anouk Aimée. 3. Brigitte Bardot. 4. Catherine Deneuve. 5. Isabella Huppert. 6. Isabelle Adjani. 7. Juliette Binoche. 8. Marion Cotillard.

Italian Actresses

Anna Magnani was born in 1908 in Rome of an Italian mother and an Egyptian father. Her breakthrough film was Roberto Rossellini's **Rome, Open City** (1945, Fr). She won an Oscar for **The Rose Tattoo** (1955). Her other notable film was **The Passionate Thief** (1960, Fr) and Federico Fellini's **Roma** (1972, Fr). Can you identify these Italian actresses?

1. Born in 1921. She starred in many film directed by her husband Fellini: **La Strada** (1954, It), **Il Bidone** (1955, It), **The Nights of Cabiria** (1957, It), and **Juliet of the Spirits** (1965, It).
2. Born in 1922 in Rome. She won the best actress Oscar for **Two Women** (1960, It). She acted in **El Cid** (1961) and **The Fall of the Roman Empire** (1964), both directed by Anthony Mann.
3. Born in 1927. Her notable film are **Fanfan la Tulipe** (1952, Fr) and **Bread, Love and Dream** (1953, It). She starred in **Come September** (1961) opposite Rock Hudson. Her other films are **The Hunchback of Notre Dame** (1956) opposite Anthony Quinn and **Buona Sera, Mrs. Campbell** (1968).
4. Born in 1931 in Rome. She starred in many of Michelangelo Antonioni films such as **L'Avventura** (1960, It), **La Notte** (1961, It), and **Red Desert** (1964, It).
5. Born in 1964 in Umbria. She started her career as a fashion model and then moved to Italian films. She played the role of Persephone in **The Matrix Reloaded** (2003) and **The Matrix Revolutions** (2003). Her other films include **Bram Stoker's Dracula** (1992) and **The Passion of the Christ** (2004). Her foreign films include **The Apartment** (1996, Fr) and **Malèna** (2000, It). She acted in the James Bond film **Spectre** (2015).

Answers: 1. Giulietta Masina. 2. Sophia Loren. 3. Gina Lollobrigida. 4. Monica Vitti. 5. Monica Bellucci.

German Actresses

Pola Negri was born in 1887 in Poland. Brought up by her impoverished mother, she acted in Polish and German films, before Paramount Studio invited her to come to Hollywood in 1921. In US she had a string of success and was romantically linked with stars like Charlie Chaplin and Rudolph Valentino. Her films include **Madame DuBarry** (1919) and **Madame Bovary** (1937). Can you identify these German Actresses?

1. Born in 1901 in Berlin. In 1930, she got a breakthrough in **The Blue Angel** (Ger), where she played Lola Lola, a cabaret singer. With the success of this film, she signed a contract with Paramount Studio, who saw her as their answer to MGM's Greta Garbo. Her first US film was **Morocco** (1930) for which she was nominated for a best actress Oscar. Her other films were **Shanghai Express** (1932) and **Destry Rides Again** (1939).
2. Born in 1910 in Dusseldorf. She was the first actress to win two best actress Oscars in successive years for **The Great Ziegfeld** (1936) and **The Good Earth** (1937). Her other films include **The Gambler** (1997).
3. Born in 1914 in Prussia. When Nazis took over Germany, her family fled to Paris. She acted in British films such as Alfred Hitchcock's **Secret Agent** (1936). Her films in US include **Body and Soul** (1947) and **The Boys from Brazil** (1978) Her German films include **Mädchen in Uniform** (1958, Ger) *and* **Mrs. Warren's Profession** (1960, Ger).
4. Born in 1914 in Vienna. In 1932 she appeared in a German film called **Ecstasy** (1933, Ger), whose nude scenes made a sensation all over the world. She was invited to the US by MGM mogul Louis B. Mayer where she acted in **Algiers** (1938), **White Cargo** (1942), and Cecil B. DeMille's epic **Samson and Delilah** (1949).
5. Born in 1938 in Vienna. She acted as Princess Elisabeth of Austria in the Sissi trilogy (1955, 1956, 1957). Her other films are **Boccaccio '70** (1962), **Le combat dans l'île** (1962, Fr) and **What's New Pussycat** (1965).

6. Born in 1961 in Berlin. She played the title role in Roman Polanski's *Tess* (1979). Her films include Paul Schrader's *Cat People* (1982) and Wim Wenders' *Paris, Texas* (1984).

Answers: 1. Marlene Dietrich. 2. Luise Rainer. 3. Lilli Palmer. 4. Hedy Lamarr. 5. Romy Schneider. 6. Nastassja Kinski.

Canadian Actresses

Born in 1868 in Ontario. Marie Dressler played the title role in the first full-length screen comedy, *Tillie's Punctured Romance* (1914), opposite Charlie Chaplin. She won the best actress Oscar for her role as Min in *Min and Bill* (1930). Can you identify these Canadian actresses?

1. Born in 1886 in Ontario. She was known as The Biograph Girl after the film company in which she acted. Later she became the first actor to be publicized under her name and so became "The First Movie Star".
2. Born in 1893 in Toronto, she was silent era's most famous female star. She won an Oscar (leading role) for *Coquette* (1930).
3. Born in 1902 in Montreal. She won an Oscar (leading role) for *The Divorcee* (1930). She was nominated for Oscar for *The Barretts of Wimpole Street* (1934), *Romeo and Juliet* (1936) and *Marie Antoinette* (1938).
4. Born in 1907, in Alberta. She is famous for her role of Ann Darrow in *King Kong* (1933). Her other films include *The Wedding March* (1928) and *Doctor X* (1932).
5. Born in 1948. She won an Oscar (leading role) for *Superman* (1978). He other films include *Sisters* (1973), *The Gravy Train* (1974) and *The Reincarnation of Peter Proud*.
6. Born in 1957 in British Columbia. She starred as C.J. Parker in TV series *Baywatch*. Her films are *Scary Movie 3* (2003) and *Baywatch* (2017).

Answers: 1. Florence Lawrence. 2. Mary Pickford. 3. Norma Shearer. 4. Fay Wray. 5. Margot Kidder. 6. Pamela Anderson.

Foreign-born Actresses

Greta Garbo was born in 1905 in a working class family of Stockholm. Her first major role was in *The Saga of Gosta Berling* (1924, Sw). Louis Mayer of MGM spotted her and brought her to US. Here her first hit was *Torrent* (1926). In 1930, she was cast in her first speaking role in *Anna Christie*. In 1931, she played the role of a spy in *Mata Hari*. In *Grand Hotel* (1932), she played the role of a Russian ballerina. Her other films were *Anna Karenina* (1935), *Camille* (1936) and the comedy *Ninotchka* (1939). Towards the end of the life, she because a recluse and rarely met people. Can you identify these actresses?

1. Born in 1909, in Portugal, but moved to Rio de Janeiro, Brazil with her family. She started as a singer and went into Brazilian films. Her first big Hollywood hit was *That Night in Rio* (1941 with Don Ameche. Her trademark fruit hat became a fad. Her other films were *Copacabana* (1947) with Groucho Marx and *Week-End in Havana* (1941).
2. Born in 1911 in Dublin. She played the role of Jane Parker opposite Johnny Weismuller's *Tarzan the Apeman* (1932) and other Tarzan films. Her other films were *David Copperfield* (1935) and *Anna Karenina* (1935).
3. Born in 1917 in Budapest. She was a blonde actress, famous for her nine marriages and catty wit. She had a starring role opposite José Ferrer in *Moulin Rouge* (1952).
4. Born in 1919 in Stockholm, Sweden. She acted in many American films, first of which was *Intermezzo* (1939). She starred in *Casablanca* (1942) opposite Humphrey Bogart. She received two Oscars for *Gaslight* (1944) and *Anastasia* (1956). Her affair with Italian director Rossellini created a scandal and she moved to Europe. Her other roles were in *Murder on the Orient Express* (1974) and *Autumn Sonata* (1978).
5. Born in 1920 in Athens, Greece. Her first film was Michael Cacoyannis' *Stella* (1955, Grk). She was nominated for Oscar for *Never on Sunday* (1960). She starred with Anthony Perkins in *Phaedra* (1962).
6. Born in 1926 in Corynth, Greece. She is known for *The Guns of Navarone* (1961), *Z* (1969, Fr), *The Message* (1976) and *Electra* (1962, Grk).

7. Born in 1936 in Bern, Switzerland. She played Honey Ryder in James Bond film **Dr. No** (1962) and starred with Woody Allen in **What's New Pussycat** (1965). She acted in **Clash of the Titans** (1981).
8. Born in 1938 in Tokyo, Japan. She was a Norwegian actress, and worked extensively with Swedish director Ingmar Bergman in films such as **Persona** (1966, Swe) and **Autumn Sonata** (1978, Swe). She was nominated for Oscar for **The Emigrants** (1971, Swe) and **Face to Face** (1976, Swe).
9. Born in 1952 in Teheran. She starred in Iranian films such as Abbas Kiarostami's **The Report** (1977, Far) and Ali Hatami's **Desiderium** (1978, Far). After the 1978 Islamic Revolution, she left for England. She was nominated for Oscar for **House of Sand and Fog** (2003). Her other English films are **The Stoning of Soraya M.** (2008) and **Rosewater** (2014).
10. Born in 1963, this tall Danish actress and model was once married to Sylvester Stallone. Her films include **Red Sonja** (1985) and **Rocky IV** (1985).
11. Born in 1967 in Honolulu, Hawai. She has won the Best Actress Oscar for **The Hours** (2002). She starred with Val Kilmer in **Batman Forever** (1995). Her other films are **The Portrait of a Lady** (1996), **Eyes Wide Shut** (1999) and **Australia** (2008). She was nominated for Best Actress Oscar for **Moulin Rouge!** (2001).
12. Born in 1968 in Sweden. Her films include **The Night They Raided Minsky's** (1968), **The Wicker Man** (1973) and **The Man with the Golden Gun** (1974).
13. Born in 1974 in Madrid. She won an Oscar for supporting actress for **Vicky Cristina Barcelona** (2008). After several Spanish films such as **Belle Epoque** (1992, Spa) and **Live Flesh** (1997, Spa), her international hit was Pedro Almodóvar's **All About My Mother** (1999). Her other English films are **Elegy** (2008) and **Pirates of the Caribbean: On Stranger Tides** (2011).
14. Born in 1989 in Canberra. She acted as Alice in Tim Burton's **Alice in Wonderland** (2010) and **Alice: Through the Looking Glass** (2016). Her other films were **Jane Eyre** (2011), **Stoker** (2013) and **Madame Bovary** (2014).

Answers: 1. *Carmen Miranda.* 2. *Maureen O' Sullivan.* 3. *Zsa Zsa Gabor.* 4. *Ingrid Bergman.* 5. *Melina Mercouri.* 6. *Irene Papas.* 7. *Ursula Andress.* 8. *Liv Ullman.* 9. *Shohreh Aghdashloo.* 10. *Brigitte Nielsen.* 11. *Nicole Kidman.* 12. *Britt Ekland.* 13. *Penelope Cruz.* 14. *Mia Wasikowska.*

Actresses with India Connection

Merle Oberon was born in 1911 in Bombay, India (though she claimed she was born in Tasmania, Australia) to half-Indian parents. She moved to Calcutta, where she worked as a telephone operator. In London, Alexander Korda, (whom she later married) cast her as Anne Boleyn in **The Private life of Henry VIII** (1933). Her other films include **The Scarlet Pimpernel** (1934) and **Wuthering Heights** (1939). Can you identify these actresses with Indian connections?

1. Born in 1913, in Darjeeling, India. She played the role of Scarlett O'Hara in **Gone with the Wind** (1939) for which she won the Best Actress Oscar. Her second Oscar-winning performance was in **A Streetcar Named Desire** (1951). Her last film was **Ships of Fools** (1965) in which she plays a middle-aged divorcee trying to recapture her youth.
2. Born in 1934 in Darjeeling, India. This Indian actress was Marlon Brando first wife. According to newspapers, her real name was Joan O'Callaghan, daughter of a Welsh factory worker. She starred in **Battle Hymn** (1957) and **Night of the Quarter Moon** (1959).
3. Born in 1941 in Chukua, Assam. John Schlesinger cast her in **Billy Liar** (1963). She won the Best Actress Oscar for **Darling** (1965). She played the role of Lara in David Lean's **Doctor Zhivago** (1965). She was nominated for Best Actress Oscar for **McCabe & Mrs. Miller** (1971). Her other films are François Truffaut's **Fahrenheit 451** (1966), **Far from the Madding Crowd** (1967) and **Heat and Dust** (1983).
4. Born in 1947 in British Guiana but originally from Kashmir. She wed Michael Caine in 1973. She played the role of Roxanna in John Houston's **The Man Who Would Be King** (1975). She acted in **Son of Dracula** (1974).

5. Born in 1948 in Mumbai, where she became a model and took part in beauty pageants. In 1967, she acted in a Hindi movie directed by K. A. Abbas. She has small role in Hollywood films **The Wilby Conspiracy** (1975). Her other films were **Star Trek: The Motion Picture** (1979), **Nighthawks** (1981), **Megaforce** (1982) and **Warrior of the Lost World** (1983).
6. Born in 1980 in Pune. She is best known for her role of Nazneen Ahmed in **Brick Lane** (2007). She acted as Rani in Leena Yadav's feminist film **Parched** (2015). Her other films are **Anna Karenina** (2012), and **Lion** (2016).
7. Born in 1984 in Mumbai. Her breakout role was Danny Boyle's **Slumdog Millionaire** (2008). She starred in the sci-fi **Rise of the Planet of the Apes** (2011). She played the title role in Michael Winterbottom's **Trishna** (2011). Her other films are **Miral** (2010) and **The Immortals** (2011).

Answers: 1. Vivien Leigh. 2. Anna Kashfi. 3. Julie Christie. 4. Shakira Baksh. 5. Persis Khambatta. 6. Tannishtha Chatterjee 7. Freida Pinto.

Musicans-Actresses

Eartha Kitt was born in 1927 in South Carolina. With her distinctive voice, she had hits like "C'est si bon," "Just an Old Fashioned Girl," "Monotonous," "Love for Sale," and "Uska Dara". Among her films are **The Mark of the Hawk** (1957), **St. Louis Blues** (1958) and **Anna Lucasta** (1958). In 1992, she had a supporting role in **Boomerang** starring Eddie Murphy. Can you identify the following musican-actresses?

1. Born in 1942 in New York. She started as a Broadway singer and actress. She won an Oscar for Best Actress for **Funny Girl** (1968). Her other films were **Hello, Dolly!** (1969), **The Owl and the Pussycat** (1970) **What's Up, Doc?** (1972), **The Way We Were** (1973) and **A Star Is Born** (1976). She directed and acted in musical drama **Yentl** (1983).
2. Born in 1944 in Detroit, Michigan. She was the lead singer of the 1960s group The Supremes. She was nominated for an Oscar for **Lady Sings the Blues** (1972). Her other films are **Mahogany** (1975) and **The Wiz** (1978).

3. Born in 1945 in Hawaii, she is a Grammy award-winning singer. She played the role of a female rock star in **The Rose** (1979). She acted in **Beaches** (1988) and **The Stepford Wives** (2004).
4. Born in 1946 in California, as a singer she had several hits like "Bang Bang", "I got you Babe". She acted in films like **Chastity** (1969), **Silkwood** (1983) and **Mask** (1985). She won the Best Actress Oscar for **Moonstruck** (1987).
5. Born in 1946 in Tennessee. She is a well known country singer. Her films include **The Best Little Whorehouse in Texas** (1982) and **9 to 5** (1980).
6. Born in 1958 in Michigan. She is a seven-time Grammy Award-winner who dominated the 80s as a singer. Her films were **Desperately Seeking Susan** (1985), **Who's That Girl** (1987), **Dick Tracy** (1990) and **Evita** (1996).
7. Born in 1980 in Los Angeles. She starred in **500 Days of Summer** (2009) along with Joseph Gordon-Levitt. Her other films are **Almost Famous** (2000), **Elf** (2003) **The Hitchhiker's Guide to the Galaxy** (2005). She sang songs in films such as **Elf** (2003), **Bridge to Terabithia** (2007) and **Yes Man** (2008). She is a part of a music duo She and Him, formed in 2006. In addition to vocals, she plays piano and ukulele in the group.

Answers: 1. Barbra Streisand. 2. Diana Ross. 3. Bette Midler. 4. Cher. 5. Dolly Parton. 6. Maddona. 7. Zooey Deschanel.

Guess the Actress

Can you identify the actresses who starred in the following films?

1. Born 1926. **The Fountainhead** (1949), **A Face in the Crowd** (1957) and **Hud** (1963).
2. Born 1932. **Singin' in the Rain** (1952) and **The Unsinkable Molly Brown** (1964).
3. Born 1937. **They Shoot Horses, Don't They?** (1969), **Klute** (1971), **Julia** (1977), **Coming Home** 1978. **The China Syndrome** (1979), **On Golden Pond** (1981).

4. Born 1956. *Shampoo* (1975), *Star Wars* (1977), *The Blues Brothers* (1980), *Hannah and Her Sisters* (1986) and *When Harry Met Sally.* (1989).
5. Born 1957. *Mississippi Burning* (1988), *Fargo* (1996), *Almost Famous* (2000), *Three Billboards Outside Ebbing, Missouri* (2017).
6. Born 1960. *Heat and Dust* (1983) *White Mischief* (1987) *Jefferson in Paris* (1995) and *Brideshead Revisited* (2008).
7. Born 1969. *Elizabeth* (1998), *The Talented Mr. Ripley* (1999), *Veronica Guerin* (2003), *The Aviator* (2004) and *Blue Jasmine* (2013).
8. Born 1981. *Star Wars: Episode I - The Phantom Menace* (1999), *V for Vendetta* (2005), *Black Swan* (2010), *Thor* (2011), *Jackie* (2016).
9. Born 1988. *The Help* (2011), *The Amazing Spider-Man* (2012), *La La Land* (2016), *Battle of the Sexes* (2017), *The Favourite* (2018).

Answers: *1. Patricia Neal. 2. Debbie Reynolds. 3. Jane Fonda. 4. Carrie Fisher. 5. Frances McDormand. 6. Greta Scacchi. 7. Cate Blanchett. 8. Natalie Portman. 9. Emma Stone.*

Mixed Bag - Actresses

Hedy Lamarr was co inventor (with composer George Antheil) of the earliest known form of the telecommunications method known as "frequency hopping", which used a piano roll to change between 88 frequencies and was intended to make radio-guided torpedoes harder for enemies to detect or to jam. The method received a U.S. patent on 11 August 1942, under the name "Secret Communications System". Frequency hopping is now widely used in cellular phones and other modern technology. However, neither she nor Antheil profited from this fact, because their patents were allowed to expire decades before the modern wireless boom.

1. Which 40s and 50s Hollywood actress had a pair of peaks in Alaska named after her?

2. After which film star did US pilots and crewmen in the Pacific in World War II named their inflatable life vests, because of her well-endowed attributes?
3. Which actress, married to Roman Polanski, was murdered by follower of Charles Manson? She starred in **Valley of Dolls** (1967).
4. Which British born actress and singer has a bag designed by French luxury good company Hermes named after her?
5. Which German actress was photographed by Richard Avedon in 1981 with a boa constrictor wrapped around her?
6. Which actress was married to Mike Todd, Eddie Fisher and Richard Burton successively?
7. Which actress was married to Tony Richardson and Franco Nero successively?

Answers: *1. Jane Russell. 2. Mae West. 3. Sharon Tate. 4. Jane Birkin. 5. Nastassja Kinski. 6. Elizabeth Taylor. 7. Vanesa Redgrave.*

Characters

Characters played by Actors - I

French comedian Max Linder played the role of Dart-In-Again in The Three Must-Get-Theres (1922). Who played the roles in the following films?

1. Johnny Gray, the engine driver in **The General** (1926).
2. Gen. Dolgorucki in **The Last Command** (1928).
3. Sherlock Holmes in **The Hound of the Baskervilles** (1939).
4. Sam Spade in **The Maltese Falcon** (1941).
5. Rick Blaine in **Casablanca** (1942).
6. Stanley Kowalsky in **A Streetcar named Desire** (1951).
7. Atticus Finch in **To Kill a Mockingbird** (1962).
8. Inspector Jacques Clouseau in **Pink Panther** (1963).
9. Dr. Strangelove in **Dr Strangelove** (1964).
10. Col. Mortimer in **For a Few Dollars More** (1965).
11. Virgil Tibbs in **In the Heat of the Night** (1967).
12. Caractacus Potts in **Chiti Chiti Bang Bang** (1968).
13. Ratso Rizzo in **Midnight Cowboy** (1969).
14. Ostap Bender in **The Twelve Chairs** (1970).
15. Alex in **A Clockwork Orange** (1971).
16. Willy Wonka in **Willy Wonka & the Chocolate Factory** (1971).

Answers: 1. Buster Keaton. 2. Emil Jannings. 3. Basil Rathbone. 4. Humphrey Bogart. 5. Humphrey Bogart. 6. Marlon Brando. 7. Gregory Peck. 8. Peter Sellers. 9. Peter Sellers. 10. Lee Van Cleef. 11. Sidney Poitiers. 12. Dick Van Dyke. 13. Dustin Hoffman. 14. Frank Langella. 15. Malcolm McDowell. 16. Gene Wilder.

Characters played by Actors - II

Al Pacino played the role of Michael Corleone in **The Godfather** (1972). Who played the roles in the following films?

1. Hercule Poirot in **Murder on the Orient Express** (1974).
2. Travis Bickle in **Taxi Driver** (1976).
3. R2-D2 in **Star Wars: Episode IV - A New Hope** (1977).
4. CP-3O in **Star Wars: Episode IV - A New Hope** (1977.
5. Hanibal Lecter in **Silence of the Lambs** (1991).
6. Lt. Col. Frank Slade in **Scent of a Woman** (1992).
7. Stanley Ipkiss in **The Mask** (1994).
8. Thomas Fowler in **The Quiet American** (2002).
9. Willy Wonka in **Charlie and the Chocolate Factory** (2005).
10. Colonel Claus von Stauffenberg in **Valkyrie** (2008).
11. Mad Hatter in **Alice in Wonderland** (2010).
12. Gatsby in **The Great Gatsby** (2013).
13. Tonto in **The Lone Ranger** (2013).
14. Mowgli in **The Jungle Book** (2016).
15. Mowgli in **Mowgli: Legend of the Jungle** (2018).

Answers: 1. Albert Finney. 2. Robert De Nero. 3. Kenny Baker. 4. Anthony Daniels. 5. Anthony Hopkins. 6. Al Pacino. 7. Jim Carrey. 8. Michael Caine. 9. Johnny Depp. 10. Tom Cruise. 11. Johnny Depp. 12. Leonardo DiCaprio. 13. Johnny Depp. 14. Neel Sethi. 15. Rohan Chand.

Characters played by Indian Actors

I. S. Johar played the role of Gupta in **North West Frontier** (1959), a film set in colonial British India. Who played the roles in the following films?

1. Maharaja in **Shakespeare-Wallah** (1965).
2. Gobinda in **Octopussy** (1983).
3. Vijay in **Octopussy** (1983).
4. Inder lal in **Heat and Dust** (1983).
5. Mola Ram in **Indiana Jones and the Temple of Doom** (1984).
6. Papa Hussein in **My Beautiful Laundrette** (1985).
7. Captain Nemo in **League of Extraordinary Gentlemen** (2003).
8. Ashoke in **The Namesake** (2006).

9. Young Saleem Sinai in **Midnight's Children** (2012).
10. Adult Saleem Sinai in **Midnight's Children** (2012).
11. Meyer Wolfshein in **The Great Gatsby** (2013).
12. Piscine Patel in **Life of Pi** (2012).
13. Rajit Ratha in **The Amazing Spider-Man** (2012).

Answers: *1. Utpal Dutt. 2. Kabir Bedi. 3. Vijay Amritraj. 4. Zakir Hussain. 5. Ambrish Puri. 6. Roshan Seth. 7. Naseeruddin Shah. 8. Irrfan Khan. 9. Darsheel Safary. 10. Satya Bhabha. 11. Amitabh Bacchan. 12. Suraj Sharma. 13. Irrfan Khan.*

Actors playing Kings

Peter Ustinov played the Emperor Nero in **Quo Vadis** (1951). Who played the following parts in the following films?

1. Oliver Cromwell in **Cromwell** (1970).
2. Nawab Wajid Ali Shah of Awadh in **The Chess Players** (1977).
3. Pu Yi in **The Last Emperor** (1987).
4. Robert the Bruce in **Braveheart** (1995).
5. King Edward I (Longshanks) in **Braveheart** (1995).
6. Alexander in **Alexander** (2004).
7. King Priam of Troy (2004).
8. King George VI in **The King's Speech** (2010).
9. King George VI in **Hyde Park on Hudson** (2012).

Answers: *1. Richard Harris. 2. Amjad Khan. 3. John Lone. 4. Angus MacFadyen. 5. Patrick McGoohan. 6. Colin Farrell. 7. Peter O' Toole. 8. Colin Firth. 9. Samuel West.*

Actors playing Presidents and Prime Ministers

Nick Nolte played the role of Thomas Jefferson in James Ivory's **Jefferson in Paris** (1995). Who played these roles in the following films?

1. John Quincy Adams in **Amistad** (1997).
2. Martin Van Buren in **Amistad** (1997).

3. Muhammad Ali Jinnah in *Jinnah* (1998).
4. Lyndon B. Johnson in *Path to War* (2002).
5. Idi Amin in *The Last King of Scotland* (2006).
6. George W. Bush in *W* (2008).
7. Richard Nixon in *Frost/Nixon* (2008).
8. Nelson Mandela in *Invictus* (2009).
9. Abraham Lincoln in *Lincoln* (2012).
10. Franklin D. Roosevelt in *Hyde Park on Hudson* (2012).
11. Dwight D. Eisenhower in *The Butler* (2013).
12. Ronald Reagan in *The Butler* (2013).
13. Mandela in *Mandela: Long Walk to Freedom* (2013).
14. Lyndon B. Johnson in *Selma* (2014).
15. Lyndon B. Johnson in *LBJ* (2016).
16. Winston Churchill in *Churchill* (2017).
17. George W. Bush in *Vice* (2018).

Answers: 1. Anthony Hopkins. 2. Nigel Hawthorne. 3. Christopher Lee. 4. Michael Gambon. 5. Forest Whitaker. 6. Josh Brolin. 7. Frank Langella. 8. Morgan Freeman. 9. Daniel Day-Lewis. 10. Bill Murray. 11. Robin Williams. 12. Alan Rickman. 13. Idris Alba. 14. Tom Wilkinson. 15. Woody Harrelson. 16. Brian Cox. 17. Sam Rockwell

Character Played by Multiple Actors

Can you identify the character played by the following actors?

1. Kenneth Branagh, Benedict Cumberbatch, Mel Gibson, Ethan Hawke, Laurence Olivier, Innokentiy Smoktunovskiy and Kishore Sahu.
2. Elmo Lincoln, Perce Dempsey Tabler, Gene Pollar, Johnny Weissmuller, Casper Van Dien, Glenn Morris, Joe Lara, Mike Henry, Gordon Scott, Miles O'Keefe and Christopher Lambert.
3. George Clooney, Ben Affleck, Christian Bale, Val Kilmer, Adam West and Michael Keaton?
4. Christopher Reeve, Brandon Routh and Henry Cavill.
5. Robert John Downey Jr., Benedict Cumberbatch, Basil Rathbone, Jeremy Brett, Peter Cushing and Richard Roxburgh.

6. Henry Fonda, Burt Lancaster and Kurt Russell and Val Kilmer.
7. Victor Mature, Kirk Douglas and Val Kilmer.
8. John Wayne, Warren Oates, and Jeff Bridges.

Answers: 1. Hamlet. 2. Tarzan. 3. Batman. 4. Superman. 5. Sherlock Holmes. 6. Wyatt Earp. 7. Doc Holliday. 8. Rooster Cogburn.

Characters played by Actress

Fay Wray played the role of Ann Darrow in **King Kong** (1933). Who played the roles in the following films?

1. O-Lan Ling in **The Good Earth** (1937).
2. Lola Lola in **The Blue Angel** (1940).
3. Concha Perez in **The Devil is a Woman** (1935).
4. Scarlett O' Hara in **Gone with the Wind** (1939).
5. Norma Desmond in **Sunset Boulevard** (1950).
6. Blanche DuBois in **A Streetcar Named Desire** (1951).
7. Lorelei Lee in **Gentlemen Prefer Blondes** (1953).
8. Victoria Jones in **Bhowani Junction** (1956).
9. Mrs Robinson in **The Graduate** (1967).
10. Lois Lane in **Superman: The Movie** (1978).
11. Margaret Bourke-White in **Gandhi** (1982).
12. Clarice Starling in **The Silence of the Lambs** (1991).
13. Catherine Trammel in **Basic Instinct** (1992).
14. Rose DeWitt Bukater in **Titanic** (1997).
15. Nyota Uhura in Star Trek (2009).

Answers: 1. Luise Rainer. 2. Marlene Dietrich. 3. Marlene Dietrich. 4. Vivien Leigh. 5. Gloria Swanson. 6. Vivien Leigh. 7. Marilyn Monroe. 8. Ava Gardner. 9. Anne Bancroft. 10. Margot Kidder. 11. Candice Bergen. 12. Jodie Foster. 13. Sharon Stone. 14. Kate Winslet. 15. Zoe Saldana.

Characters played by Indian Actress

Leela Naidu played the role of Indu in James Ivory's **The Householder** (1963). Who played the roles in the following films?

1. Manjula in **Shakespeare-Wallah** (1965).
2. Ghazala in **The Guru** (1969).
3. Anjana Devi in **Bombay Talkies** (1970).
4. Lieutenant Ilya in **Star Trek: The Motion Picture** (1979).
5. Sushila in **Madame Sousatzka** (1988).
6. Radha in **Fire** (1996).
7. Maid Shanta in **Earth** (1998).
8. Kalyani in **Water** (2005).
9. Ashima in **The Namesake** (2006).
10. Older Latika in **Slumdog Millionaire** (2008).
11. Caroline Aranha in **Rise of the Planet of the Apes** (2011).
12. Mary Pereira in **Midnight's Children** (2012).

Answers: 1. Madhur Jaffrey. 2. Arpana Sen. 3. Nadira. 4. Persis Khambatta. 5. Shabana Azmi. 6. Shabana Azmi. 7. Nandita Das. 8. Lisa Ray. 9. Tabu. 10. Freida Pinto. 11. Freida Pinto. 12. Seema Biswas.

Actresses playing women in power

Greta Garbo played the role of Queen Christina of Sweden in **Queen Christina** (1933). Who played the following parts in the following films:

1. Cleopatra in **Cleopatra** (1963).
2. Eleanor of Aquitaine in **The Lion in Winter** (1968).
3. Princess Leia in **Star Wars: Episode IV - A New Hope** (1977).
4. Golda Meir in **A Woman Called Golda** (1982).
5. Queen Elizabeth in **Elizabeth** (1998).
6. Queen Elizabeth II in **The Queen** (2006).
7. Margaret Thatcher in **The Iron Lady** (2011).
8. Princess Diana in **Diana** (2013).
9. Queen Victoria in **Victoria & Abdul** (2017).

Answers: 1. Elizabeth Taylor. 2. Katharine Hepburn. 3. Carrie Fisher. 4. Ingrid Bergman. 5. Cate Blanchett. 6. Helen Mirren. 7. Meryl Streep. 8. Naomi Watts. 9. Judi Dench.

Directors

US Directors

D.W. Griffith was born in 1875 in Kentucky. His signature film was the epic **Birth of a Nation** (1915). Soon after it, he made **Intolerance** (1916), to counter charge of racism in the previous film. Can you identify the following US directors?

1. Born in 1881 in Massachusetts. He made **The Squaw Man** (1914), said to be the first feature length film to be made in Hollywood. He is known for biblical epics like **The Ten Commandments** (1923), **The King of Kings** (1927) and **The Ten Commandments** (1956).
2. Born in 1884 in Michigan. Considered to be the father of documentary film for his films **Nanook of the North** (1922) and **Man of Aran** (1934). He directed **Elephant Boy** (1937) starring Sabu.
3. Born in 1896 in Indiana. His first hit was crime film **Scarface** (1932), starring Paul Muni. He made two westerns starring John Wayne **Red River** (1948) and **Rio Bravo** (1959). His other films were the film-noir **The Big Sleep** (1946) and the comedy **Gentlemen Prefer Blondes** (1953).
4. Born in 1899 in New York. He won an Oscar for **My Fair Lady** (1964). His other films include **The Philadelphia Story** (1940) **Gaslight** (1944) and **Bhowani Junction** (1956).
5. Born in 1906 in Missouri. He was an amateur boxer, Broadway actor and a cavalry officer in Mexico. His first hit was **The Maltese Falcon** (1941). He won Oscar for **The Treasure of the Sierra Madre** (1948). He made **Key Largo** (1948) and **The African Queen** (1951), both starring Bogart. His other films

are **The Asphalt Jungle** (1950), **The Red Badge of Courage** (1951) and **Moulin Rouge** (1952).

6. Born in 1913 in New York. He was nominated for Oscar for **The Defiant Ones** (1958), **Judgment at Nuremberg** (1961) and **Guess Who's Coming to Dinner** (1967). His other films include **Inherit the Wind** (1960) starring Spencer Tracy and **Ships of Fools** (1965) starring Vivian Leigh.
7. Born in 1910 in Tokyo. He won Oscar for **Patton** (1970). His other films were **Planet of the Apes** (1968), **Papillion** (1973) and **Islands in the Stream** (1977).
8. Born in 1924 in New York. His first film **Glen or Glenda** (1953) starred Bela Lugosi. **Bride of the Monster** (1955) is about an evil doctor (Bela Lugosi) who is conducting experiments to turn people into super-beings using atomic power. His magnum opus, **Plan 9 from Outer Space** (1959), is about the plan of aliens to resurrect the dead. He is dubbed The World's Worst Director.

Answers: 1. Cecil B. DeMille. 2. Robert Flaherty. 3. Howard Hawks. 4. George Cukor. 5. John Huston. 6. Stanley Kramer. 7. Franklin J. Schaffner. 8. Edward D. Wood Jr.

Foreign-born directors in Hollywood

Mack Sennett was born in 1880 in Quebec. He formed Keystone Studios in 1912. He provided break to comedians such as Charles Chaplin, Fatty Arbuckle and Harry Langdon. Describing his films, he said: "We have no scenario--we get an idea, then follow the natural sequence of events until it leads up to a chase, which is the essence of our comedy." He won an Honorary Oscar in 1938 for his lasting contribution to comedy. Can you identify the following Hollywood directors?

1. Born in 1886 in Budapest as Manó Kaminer. He was an established director in Hungary when he moved to US in 1926. He won an Oscar for **Casablanca** (1942). His film **The Adventures of Robin Hood** (1938) starring Errol Flynn was nominated for Oscar. His other films are **The Charge**

of the Light Brigade (1936), **Mildred Pierce** (1945) and **The Adventures of Huckleberry Finn** (1960).

2. Born in 1894 in Vienna, he moved to the US when he was 14. He was invited to Germany to make the **The Blue Angel (1930)** starring Marlene Dietrich. He persuaded Marlene Dietrich to come to US and star in his films. He directed **Morocco** (1930) and **Shanghai Express (1932)**.

3. Born in 1897 in Sicily, immigrated to the US when he was 5. He wrote scripts for comedies and then joined Columbia under Henry Cohn. He won Oscars for **It Happened One Night** (1934), **Mr. Deeds Goes to Town** (1936) and **You Can't Take It with You** (1938). His other films are **Mr. Smith Goes to Washington** (1939), **Meet John Doe** (1941) and **It's a Wonderful Life.** (1946).

4. Born in 1902 in what was then Germany. He emigrated to the US in 1920. He started working in Universal's New York offices as an errand boy. He won Oscars for **Mrs. Miniver** (1942), **The Best Years of Our Lives** (1946) and **Ben-Hur** (1959). He was nominated for Oscars 12 times. He is famous for long takes and frequent retakes. His other films were **Wuthering Heights** (1939), **The Little Foxes** (1941) and **Roman Holiday** (1953).

5. Born in 1905 in Ukraine, central Europe. His early hit was **Laura** (1944) starring Gene Tierney, for which he was nominated for Oscar. His other films include **Carmen Jones** (1954), **Porgy and Bess** (1959), **Anatomy of a Murder** (1959) and **The Human Factor** (1979). He broke the blacklist by hiring screewriter Trumbo for **Exodus** (1960).

6. Born in Austria in 1906 but the rise of the Nazism forced him to move to the US in 1933. He wrote the screenplay for **Ninotchka** (1939). He directed **Sunset Boulevard** (1950) and **Stalag 17** (1953). Later he became famous for comedies like **The Seven-Year Itch** (1955), **Some Like It Hot** (1959), and **The Apartment** (1960).

7. Born in 1907 in central Europe. He won Oscars for **From Here to Eternity** (1953) and **A Man for All Seasons** (1966). Other films he directed were **High Noon** (1952), **Oklahoma!** (1955), **The Day of the Jackal** (1973) and **Julia** (1977). His films have received 65 Oscar nominations, winning 24.

8. Born in 1909 in Constantinople (now Istanbul). He won Oscars for **Gentleman's Agreement** (1947) and **On the Waterfront** (1954). He other films include **A Streetcar named Desire** (1951) and **East of Eden** (1955). He introduced Method Acting in Hollywood films.
9. Born in 1922 in Lithuania but left it in 1944 because of the Nazism. Emigrated to the U.S after escaping from a prison in Germany. He worked with the cream of the New York 1960s avant garde, including Allen Ginsberg, Andy Warhol, John Lennon and Yoko Ono. His film **The Brig** (1964) was awarded the Grand Prize at the Venice Film Festival in 1964. His **Reminiscences of a Journey to Lithuania**, from 1972, was added to the National Film Registry of the Library of Congress. Other films include **Walden** (1969), **Lost Lost Lost** (1975), **In Between** (1978) and **As I was Moving Ahead I saw Brief Glimpses of Beauty** (2000). He is known as The Godfather of American Avant-Garde Cinema. He died 2019.
10. Born in 1931 in Berlin. He won Oscar for **The Graduate** (1967) starring Dustin Hoffman. His other films were **Catch 22** (1970), **Silkwood** (1983) and **Who's afraid of Virginia Woolf** (1966)..

Answers: 1. Michael Curtiz. 2. Josef von Sternberg. 3. Frank Capra. 4. William Wyler. 5. Otto Preminger. 6. Billy Wilder. 7. Fred Zinnemann. 8. Elia Kazan. 9. Jonas Mekas. 10. Mike Nichols.

American New Wave Directors

Filmmakers of the New Hollywood or American New Wave emerged in the late 60s. They were influenced by European, especially French, cinema. Arthur Penn was one of them. He was born in 1922 in Philadelphia. He was nominated for Oscar for **The Miracle Worker** (1962) and **Alice's Restaurant** (1969). He is famous for the gangster film **Bonnie and Clyde** (1967), which was a defining film of the New Hollywood generation. Can you identify these American New Wave directors?

1. Born in 1924 in Philadelphia. He made his directing debut with **12 Angry Men** (1957) for which he was nominated for an Oscar. He was nominated for Oscar for **Dog Day Afternoon**

(1975), **Network** (1976) and **The Verdict** (1982). In 2005 he received an honourary Oscar. His other films were **Eqqus** (1977), **The Verdict** (1982) and **Family Business** (1989).
2. Born in 1925 in Kansas City. He was nominated for Oscars for **M.A.S.H.** (1970), **Nashville** (1975) and **Gosford Park** (2001). In 2006, he received an Honorary Award from the Academy. His other films are **McCabe & Mrs. Miller** (1971) and **Ready to Wear** (1994).
3. Born in 1935 in Chicago. He won an Oscar for **The French Connection** (1971) starring Gene Hackman. His other films were **The Night They Raided Minsky's** (1968) and **The Exorcist**, (1973).
4. Born in 1939 in Michigan. He won an Oscar for **Godfather Part II**. He was nominated for Oscar for **Godfather** (1972), **Apocalypse Now** (1979) and **Godfather Part III** (1990). Other films he directed are **Bram Stoker's Dracula** (1992) and **The Rainmaker** (1997).
5. Born in 1943 in Illinois. Reclusive director who taught philosophy in France. He was nominated for Oscar for the multistarrer **The Thin Red Line** (1998). His other films include **Badlands** (1973), **The New World** (2005) and **The Tree of Life** (2011).
6. Born in 1944 in California. He was nominated for Oscars for **American Graffiti** (1973) and **Star Wars** (1977). His other films are **THX 1138** (1971) and the **Star Wars** series.
7. Born in 1948 in New York. He has helmed classic horror films like **Halloween** (1978), **The Fog** (1980), and **The Thing** (1982). He directed sci-fi films like **Escape from New York** (1981) and **Starman** (1984). His other films were **The Assault on Precinct 13** (1976), **Escape from New York** (1981), and **They Live** (1988).

Answers: 1. Sidney Lumet. 2. Robert Altman. 3. William Friedkin. 4. Francis Ford Coppola. 5. Terence Malik. 6. George Lucas. 7. John Carpenter.

More US Directors

Richard Lester was born in 1932 in Philadelphia. He is well known for helming two films starring The Beatles: **A Hard Day's Night** (1964) and **Help!** (1965). His other films are **A Funny Thing Happened on the Way**

to the Forum (1966) and **Juggernaut** (1974). He was hired the direct **Superman II** (1980) and **Superman III** (1982) when the original director Richard Donner was fired. Can you identify these American directors?

1. Born in 1936 in Chicago. Some of his notable films are **The Right Stuff** (1983), **The Unbearable Lightness of Being** (1998) and **Quills** (2000).
2. Born in 1940 in Minnesota. He is part of the Monty Python comedy group. He is well known for fantasy films such as **Monty Python and the Holy Grail** (1975), **Time Bandits** (1981), **The Adventures of Baron Munchausen** (1988) and **The Imaginarium of Doctor Parnassus** (2009). His other films are **Brazil** (1985) and **Fear and Loathing in Las Vegas** (1998).
3. Born in 1940 in New Jersey. His first hit was **Carrie** (1976) based on a Steven King novel. **Scarface** (1983) starring Al Pacino, was a commercial success. **The Untouchables** (1987) starred Robert De Niro as Al Capone. His other films include **Casualties of War** (1989) and **Mission Impossible** (1996) starring Tom Cruise.
4. Born in 1954 in Oklahoma. He won an Oscar for **A Beautiful Mind** (2001). He made films based on real-life event such as **Apollo 13** (1995), **Cinderella Man** (2005) and **Frost/Nixon** (2008). His other films are **How the Grinch Stole Christmas** (2000) starring Jim Carrey, and **The Da Vinci Code** (2006).
5. Born in 1958 in California. His first major hit was **Batman** (1989) starring Michael Keaton and Jack Nicholson. His first film starring Johnny Depp was **Edward Scissorhands** (1990), with whom he would make **Ed Wood** (1994), **Sleepy Hollow** (1999) and **Charlie and the Chocolate Factory** (2005). His other films include the dark **Batman Returns** (1992), **Planet of the Apes** (2001) and **Big Fish** (2003).
6. Born in 1960 in Houston, Texas. He was nominated for Oscar for **Boyhood** (2014) starring Ethan Hawke. His trilogy **Before Sunrise** (1995), **Before Sunset** (2004) and **Before Midnight** (2013) stars Jesse (Ethan Hawke) and Celine (Julie Delpy). His other films are **Dazed and Confused** (1993), **Waking Life** (2001) and **School of Rock** (2003).
7. Born in 1963 in Tennessee. He was nominated for Oscars for **Pulp Fiction** (1994) and **Inglourious Basterds** (2009). His other

films are **Reservoir Dogs** (1992) starring Harvey Keitel, **Kill Bill Vol 1** (2003), **Kill Bill Vol** 2 (2004), both starring Uma Thurman and **Django Unchained** (2012) starring Jamie Foxx.
8. Born in 1969 in Texas. He was nominated for Oscar for **The Grand Budapest Hotel** (2014). He directed **Rushmore** (1998) starring Jason Schwartzman as a precocious schoolboy. **The Royal Tenenbaums** (2001) starring Gene Hackman was about a dysfunctional family. His other films include **The Life Aquatic with Steve Zissou** (2004) starring Bill Murray and **Darjeeling Limited** (2007) starring Adrien Brody. He made animated film **Fantastic Mr. Fox** (2009), based on Raoul Dahl book.
9. Born in 1985 in Rhode Island. His first major film was **Whiplash** (2014) about a young drummer. He won Oscar for **La la Land** (2016) starring Ryan Gosling.

Answers: 1. Philip Kaufman. 2. Terry Gilliam. 3. Brian De Palma. 4. Ron Howard. 5. Tim Burton. 6. Richard Linklater. 7. Quentin Tarantino. 8. Wes Anderson. 9. Damien Chazelle.

French Directors

Brothers Auguste and Louis Lumiere improved and patented cinematograph in 1895. Using it they made several short films for public viewing. Their short films included **Workers leaving the Lumière factory** (1895) and **Arrival of a Train at a Station** (1896). The late 1950s saw the emergence of the French New Wave (*Nouvelle Vague*) some of whose famous members were Francois Truffaut, Jean-Luc Godard, Claude Chabrol, and Eric Rohmer. Can you identify these directors?

1. Born in 1861 in Paris, he was an illusionist and a pioneer of early films, some of which lasted a minute. His films **A Trip to the Moon** (1902) and **The Impossible Voyage** (1904) were influenced by Jules Verne. He built the first film studio in Europe. D. W. Griffith said "I owe everything to him" and Terry Gilliam called him "the first great film magician."
2. Born in 1889 in Paris, his first major masterpiece was **J'accuse!** (1919), a monumental anti-war statement. His most famous

film was the six-hour long **Napoleon** (1927). His other films were **Tower of Lust** (1955, Fr) and **The Battle of Austerlitz** (1960, Fr). He is known as D.W. Griffith of Europe.

3. Born in 1889, he is now regarded as one of the most important avant-garde directors. He was a poet, novelist, painter, playwright and actor. He made the much acclaimed **Beauty and the Beast** (1946, Fr) starring Jean Marais. His other films are **The Eagle with Two Heads** (1948, Fr) and **Orpheus** (1950, Fr).

4. Born in 1894 he made more than forty films. He made **The Lower Depths** (1936, Fr) and **La Grande Illusion** (1937, Fr), both starring Jean Gabin. His other films are **La Chienne** (1931, Fr), **The Rules of the Game** (1939, Fr) and **The River** (1951, Fr). His father was the painter Pierre-Auguste Renoir. He was one of the first filmmakers to be known as an *auteur*.

5. Born in 1898 in Paris. Made his reputation with socio/political satires directed against the middle- and upper-classes in France. His crowning achievement is **À Nous la Liberté** (1931, Fr). Some of his films are **Le Million** (1931, Fr), **Les belles de nuit** (1952, Fr) and **And Then There Were None** (1945).

6. Born in 1901, he is a highly regarded director known for his minimalist films using non-professional actors. His films include **Diary of a Country Priest** (1951, Fr), **A Man Escaped** (1956, Fr), **Pickpocket** (1959, Fr) and **Balthazar** (1966, Fr). Jean-Luc Godard said about him that he was to French cinema, "as Dostoevsky is the Russian novel and Mozart is the German music."

7. Born in 1920 in Lorraine as Jean-Marie Maurice Scherer. He co-authored with Chabrol, a book on Hitchcock (1957). His film **My Night at Maud's** (1969, Fr) was nominated for best foreign film Oscar. His other films are **Claire's Knee** (1970, Fr), **The Marquise of O** (1976, Fr) and **A Tale of Winter** (1992, Fr).

8. Born in 1922, his career extended over more than six decades. **Night and Fog** (1955, Fr), an influential documentary about the Nazi concentration camps. His first feature film was **Hiroshima Mon Amour** (1959, Fr), with a screenplay by Marguerite Duras, which is a fusion of fiction and documentary.

9. Born in 1928 in Paris. His first major film was **And God Created Woman** (1956, Fr) staring Brigitte Bardot. His other films

include **Les Liaisons Dangereuses** (1959, Fr), starring Jeanne Moreau, and **La Ronde** (1964, Fr).
10. Born in 1930 in Paris, he was associated with the 1960 New Wave movement. He directed **Breathless** (1960, Fr), starring Jean-Paul Belmondo, in which a small time thief steals a car, kills a policemen, and runs away with an American girl. His other films were **Contempt** (1963, Fr) starring Brigitte Bardot and **Pierrot le Fou** (1965, Fr) starring Belmondo.
11. Born in 1930 in Paris, he was the most prolific of the New Wave directors. His **Le Beau Serge** (1958, Fr) has been cited as the first product of the French New Wave. His other films are **Les Biches** (1968, Fr), **The Butcher**, (1970, Fr) and the controversial **Violette Noziere** (1978, Fr). He made **Madame Bovary** (1991, Fr) based on Gustave Flaubert's novel.
12. Born in 1932 in Paris, he was one of the founders of the French New Wave. His **400 Blows** (1959, Fr) is a defining film of the French New Wave movement. He directed **Shoot the Piano Player** (1960, Fr) and **Jules et Jim** (1961, Fr) starring Jeanne Moreau.
13. Born in 1932 in France. He directed with Jacques-Yves Cousteau, the 1956 documentary **Le Monde du Silence (The Silent World)** which used underwater cinematography to show the ocean depths in color. In US he made films like **Pretty Baby** (1978) starring Brooke Shields. He was nominated for Oscar for **Atlantic City** (1980) starring Susan Sarandon. His other films are **My Dinner with Andre** (1981) and **Vanya on the 42nd Street** (1994). His **Au Revoir les Enfants** (1987, Fr) was nominated for best foreign language film.

Answers: 1. Georges Méliès. 2. Abel Gance. 3. Jean Cocteau. 4. Jean Renoir. 5. René Clair. 6. Robert Bresson. 7. Eric Rohmer. 8. Alain Resnais. 9. Roger Vadim. 10. Jean Luc Godard. 11. Claude Chabrol. 12. François Truffaut. 13. Louis Malle.

Italian Directors

Born in 1901 in Lazio, Vittorio De Sica was one of the masters of Italian neo-realism. His **Shoeshine** (1946, It) and **The Bicycle Thieves** (1948, It), which won honorary Oscars, depicted post-war Italy's

searing poverty. **Umberto D** (1952, It) was a bleak film about an old man and his dog. Another notable film was **Two Women** (1960, It) starring Sophia Loren. Can you identify these Italian directors?

1. Born in 1906 in Milan. He was one of the masters of Italian neo-realism. His film **Ossessione** (1943, It), based on *The Postman Always Rings Twice*, was banned by the censors. His film **The Leopard** (1963, It) starred Burt Lancaster as The Prince of Salina. His masterpiece is **Death in Venice** (1971, It) starring Dick Bogarde.
2. Born in 1906 in Rome. He was one of the masters of the Italian Neorealist movement. He made the anti-fascist **Rome, Open City** (1945, It), which won the Grand Prize at Cannes. Two other films on the World War II were **Paisan** (1946, It) and **Germany Year Zero** (1948, It).
3. Born in 1912 in Ferrara. He was nominated for Oscar for **Blow-up** (1966). His other films are **L'Avventura** (1960, It) and **Red Desert** (1964, It), both starring Monica Vitti and **La Notte** (1961, It) starring Jeanne Moreau. He received an Honorary Oscar in 1995.
4. Born in 1920 in Rimini. His first notable film was **I Vitellone** (1953, It). His **La Strada** (1954, It), starring Giulietta Masina his wife, won the best foreign film Oscar in 1957. His other famous films are **La Dolce Vita** (1960, It) and **8 ½**, (1963, It), both starring Marcello Mastroianni.
5. Born in 1922 in Bologna. He was a famous poet and novelist before he entered films. He made his debut with Accattone (1961) starring Franco Citti. In **The Gospel according to St Matthew** (1964, It) he presented a radical Jesus Christ. He adapted many classical literary text into films such as **Oedipus Rex** (1967, It) and **The Decameron** (1971, It) and **The Canterbury Tales** (1972, It).
6. Born in 1923 in Florence. He worked with Visconti for some time. He was nominated for Oscar for **Romeo and Juliet** (1968). His other films are **The Champ**, (1979), **Hamlet** (1990) and **Jane Eyre** (1996). His film **Otello** (1986, It) starred Plácido Domingo. He died in 2019.
7. Born in 1929 in Rome. He was assistant to Vittorio De Sica. He is famous for making spaghetti westerns, such as **A Fistful**

of Dollars (1964), **For a Few Dollars More** (1965) and **The Good the Bad the Ugly** (1966), starring Clint Eastwood. He made a gangster film **Once upon a time in America** (1984) starring Robert De Niro.
8. Born in 1941 in Parma. He won an Oscar for **The Last Emperor** (1987). His other films were **The Last Tango in Paris** (1972) and **Little Buddha** (1993).

Answers: 1. Luchino Visconti. 2. Roberto Rossellini. 3. Michelangelo Antonioni. 4. Federico Fellini. 5. Pier Paolo Pasolini. 6. Franco Zeffirelli. 7. Sergio Leone. 8. Bernardo Bertolucci.

John Ford

Born in 1894 in Maine, his parents came to the US in 1872 from Ireland. Although his name was John Martin Feeney, he started working as actor under the name of Jack Ford. And later renamed himself John Ford. In 1924 he directed his first western **The Iron Horse**. Ford won four Oscars for direction. Can you identify the following John Ford films?

1. (1935). A former IRA member Gypo Nolan (Victor McLaglen) betrays his friend to the British authorities. Ford won his first Oscar for this film.
2. (1939). Travelling with a group of passengers in a stagecoach from Tonto is the outlaw Ringo Kidd (John Wayne).
3. (1940). Tom Joad (Henry Fonda) returns home to Oklahoma after four years in prison, and finds that his family is evicted from their farm.
4. (1941). Educated and young Huw Morgan (Roddy McDowall) wants to move away from his Welsh coal mining village.
5. (1946). Wyatt Earp (Henry Fonda) takes revenge for his brother's death in the famous gunfight at the OK Corral.
6. (1948). Capt. Kirby York (John Wayne) has differences with his commanding officer Lt Col Thursday (Henry Fonda) over the Apache chief Cochise (Miguel Inclan).
7. (1949). 60-year-old Capt. Nathan Brittles (John Wayne) is told to evacuate young Olivia Dandridge (Joanne Dru) from the fort, which is threatened by an attack by the Indians.

8. (1950). Lt. Col. Kirby Yorke (John Wayne), trying to re-build relationship with his wife Kathleen (Maureen O'Hara), must defend the fort against attacks by Apache Indians.
9. (1952). A retired American boxer Sean Thornton (John Wayne) returns to his native Ireland and wants to settle down with Mary Kate Danaher (Maureen O'Hara).
10. (1956). Ethan Edwards (John Wayne) sets out to rescue his niece Laurie (Vera Miles) from the Indians.
11. (1962). Senator Ransom Stoddard (James Stewart) reveals a long held secret about Tom Doniphon (John Wayne).

Answers: 1. *The Informer*. 2. *The Stagecoach*. 3. *The Grapes of Wrath*. 4. *How Green was my Valley*. 5. *My Darling Clementine*. 6. *Fort Apache*. 7. *She Wore a Yellow Ribbon*. 8. *Rio Grande*. 9. *The Quiet Man*. 10. *The Searchers*. 11. *The Man who shot Liberty Valence*.

German Directors

Expressionism is the depiction of reality that is widely distorted for emotional effect. It is one of the most recognisable styles of German cinema after World War I. It offers a subjective representation of the world, revealing the angst of human figures through distorted, nightmarish surroundings. Can you identify the following German directors?

1. He was born in 1885 in Bohemia (now Czech Republic). **Secrets of a Soul** (1926) and **Pandora's Box** (1929) were silent films, the latter starring Louise Brooks. His film **Westfront 1918** (1930, Ger) set in World War I was banned by the Nazis. His other films are **The Three-Penny Opera** (1931, Ger) and **Kameradschaft** (1931, Ger).
2. He was born in 1888. His film **Nosferato** (1922) is a golden piece of the silent era. His masterpiece **Faust** (1926, Ger) is a formidable adaptation of Goethe's novel with Emil Jannings starring as Mephisto. He emigrated to Hollywood in 1926, where he made movies, of which **Sunrise** (1927) starring Janet Gaynor, is a masterpiece.

3. He was born in 1890 in Vienna. He made a stunning film *Die Nibelungen* (1924) based on the epic Nibelungenlied. His other famous movies are *Metropolis* (1927, Ger) and *M* (1931, Ger). He left Germany in 1934 after Goebbels banned his movies. He made a few movies in Hollywood including *Fury* (1936) starring Spencer Tracy. He died in 1976.
4. He was born in 1892 in Berlin. After making *Madame DuBarry* (1919) and *Anne Boleyn* (1920) in Germany, he moved to America in 1922 where he achieved fame for films like *The Love Parade* (1929), *Trouble in Paradise* (1932) and *Ninotchka* (1939).
5. He was born in 1893 in Silesia. He directed many silent and expressionist films. In 1920, he made the horror film *The Cabinet of Dr. Caligari* (Ger). With the coming of Nazism, he left Germany and never came back.
6. He was born in 1942 in Munich. He has made *Aguirre, the Wrath of God* (1972, Ger) about the Spanish conquest of Peru in the sixteenth century and *Woyzeck* (1979, Ger) about a soldier in nineteenth century German who kills his wife. Another film *Fitzcarraldo* (1982) starred Klaus Kinski.
7. He was born in 1945 in Bavaria and was a part of the New German cinema movement. He made *Fear Eats the Soul* (1974, Ger), which dealt with the love affair of an aging women to a black young man. His other films were *The Marriage of Maria Braun* (1979, Ger) and *Veronika Voss* (1982, Ger).
8. Born In 1945 in Düsseldorf. His film *Paris, Texas* (1984), starring Harry Dean Stanton, is a study of alienation. His *Wing of Desires* (1987, Ger) is the story of two angels in Berlin. His other films are *The American Friend* (1977, Ger) and *Faraway, So Close!* (1993, Ger).

Answers. 1. Georg Wilhelm Pabst. 2. F. W. Murnau. 3. Fritz Lang. 4. Ernst Lubitsch. 5. Robert Wiene. 6. Werner Herzog. 7. Rainer Werner Fassbinder. 8. Wim Wenders.

Hitchcock

Alfred Hitchcock said in an interviewer in 1960, "Drama is life with the dull bits cut out." Born in 1899, Alfred Hitchcock was the Master of

Suspense. In 1929, he directed **Blackmail** which is often cited as the first British sound feature film. He made 50 films in a career spanning six decades. Can you identify the following Hitchcock films?

1. (1935). Richard Hannay (Robert Donat) gets entangled in a spy chase when he tries to shelter a counter-espionage agent Annabella Smith (Lucie Mannheim) in his house. When Annabella is killed by the spies, he is on the run from the Police and the killers.
2. (1938). Iris (Margaret Lockwood) and Gilbert (Michael Redgrave) search for the kindly old English woman, Mrs Froy (May Whitty), who disappears while on board a train.
3. (1940). When Maxim de Winter (Laurence Olivier) takes his new bride (Joan Fontaine) to Manderley, his country house, she is intimidated by the presence of his first wife. This was Hitchcock's first American film.
4. (1941). Lina (Joan Fontaine) suspect her husband Johnnie (Cary Grant) may be a murderer.
5. (1946). The dream sequence is this film was designed by Salvadore Dali.
6. (1946). Devlin (Gregory Peck) who asks Alicia (Ingrid Bergman) to spy on a group of her father's Nazi friends operating out of Rio de Janeiro.
7. (1954). Tony (Ray Milland) frames his wife Margot (Grace Kelly) for murder.
8. (1954). Photographer Jeff (James Stewart) on a wheelchair spies on his neighbours from his apartment window and notices that a murder might have been committed.
9. (1959). Advertising executive Roger Thornbill (Cary Grant) is mistaken for George Kaplan and is chased by a crop duster plane.
10. (1960). Marion Crane (Janet Leigh) embezzles her employer's money and is on the run. On the way she stops at Bates Motel for the night where she meets Norman Bates (Anthony Perkin).
11. (1963). When birds inexplicably start attacking people, will Melanie Daniels (Tippi Hendren) survive their attack?

Answers: *1. The 39 Steps. 2. The Lady Vanishes. 3. Rebecca. 4. Suspicion. 5. Spellbound. 6. Notorious. 7. Dial M for Murder. 8. Rear Window. 9. North by North-West. 10. Psycho. 11. The Birds.*

British Directors

Laurence Olivier was born in 1907 in Surrey. He won an honorary Oscar for directing **Henry V** (1944) and was nominated for Oscar for **Hamlet** (1948). His other films were **Richard III** (1955) and **Three Sisters** (1970). Can you identify these British directors?

1. Born in 1913 in Berkshire. He directed the 1948 *film noir* **Brighton Rock** starring Richard Attenborough. He directed **Lucky Jim** (1957) based on Kingley Amis's novel.
2. Born in 1921 in Brighton. He was nominated for Oscar for **Room at the Top** (1959). His gothic horror film **The Innocents** (1961) was based on Henry James novel. He made **The Great Gatsby** (1974) starring Robert Redford.
3. Born in 1928 in Yorkshire. He won an Oscar for **Tom Jones** (1963). His other films include **Look Back in Anger** (1959), **The Entertainer** (1960) and **The Loneliness of Long Distance Runner** (1962).
4. Born in 1926 in the Czech Republic. His film include **Saturday Night and Sunday Morning** (1960) starring Albert Finny and **The French Lieutenant's Woman** (1981) starring Meryl Streep. He made **Isadora** (1968) based on the life of dancer Isadora Duncan.
5. Born in 1923 in Bangalore, British India. His films include **This Sporting Life** (1963) starring Richard Harris and **If...** (1968) starring Malcolm McDowell.
6. Born in 1926 in London. He won an Oscar for **Midnight Cowboy** (1969). He was nominated for Oscars for **Darling** (1965) and **Sunday Bloody Sunday** (1971). His other films include **Billy Liar** (1963), **Far from the Madding Crowd** (1967) and **Madame Sousatzka** (1988).
7. Born in 1927 in Hampshire. He was nominated for **Women in Love** (1969). He made several films based on musicians such as **The Music Lovers** (1971), **Mahler** (1974), **Tommy** (1975) and **Lisztomania** (1975). His other film include **The Rainbow** (1989).
8. Born in 1937 in Tyne and Wear. He was nominated for Oscars for **Thelma & Louise** (1991), **Gladiator** (2000) and **Black Hawk Down** (2001). **The Duellist** (1977) was his first major film,

followed by the science fiction horror film **Alien** (1979). His sci-fi films were **Blade Runner** (1982) and **The Martian** (2015). His other films are **1492: Conquest of Paradise** (1992) and **Exodus: Gods and Kings** (2014).

9. Born in 1970 in London. His first major films was **Memento** (2000) about a short term memory loss. He directed the Batman trilogy **Batman Begins** (2005), **The Dark Knight** (2008) and **The Dark Knight Rises** (2012). He directed **The Prestige** (2006), starring Christian Bale and Hugh Jackman as magicians. His other films are **Inception** (2010) and **Interstellar** (2014). He helmed Superman film **Man of Steel** (2013).

Answers: 1. John Boulting. 2. Jack Clayton. 3. Tony Richardson. 4. Karel Reisz. 5. Lindsay Anderson. 6. John Schlesinger. 7. Ken Russell. 8. Ridley Scot. 9. Christopher Nolan.

David Lean

David Lean was born in 1908 in Surrey. He worked as tea boy, clapper boy, and cutting room assistant. By 1935, he had become chief editor. His first film as director was **In Which we Serve** (1942). Can you identify the following David Lean films?

1. (1945). Charles Condomine (Rex Harrison) and his second wife Ruth (Constance Cummings) are haunted by the spirit of his first wife, Elvira (Kay Hammond).
2. (1945). Laura Jesson (Celia Johnson) and Dr. Alec Harvey (Trevor Howard), both married, meet by chance at a railway station, fall in love.
3. (1946). A mysterious benefactor sends money to orphan Pip (John Mills) so that he become a gentleman.
4. (1954). When bootmaker Henry Hobson (Charles Laughton) is against his daughters' marriages, the eldest daughter Maggie proposes to the timid and poor boot hand Willy Mossop (Sir John Mills).
5. (1957). British Col. Nicholson (Alec Guinness) takes control of building a proper bridge for his Japanese captors.

6. (1962). With the help of Sherif Ali (Omar Sharif), Lt Lawrence (Peter O' Toole) makes a daring camel journey across the harsh desert to attack the well-guarded Turkish port of Aqaba.
7. (1965). Dr. Yuri (Omar Sharif) falls in love with beautiful Lara Guishar (Julie Christie) but ends up marrying his cousin, Tonya (Geraldine Chaplin).
8. (1970). Irish Rosy (Sarah Miles), married to schoolmaster Charles (Robert Mitchum), falls in love with the British Major Randolph Doryan (Christopher Jones).
9. (1984). Dr Aziz (Victor Bannerjee) invites Adela Quested (Judy Davis) and Mrs Moore (Peggy Ashcroft) for an outing to the nearby Marabar caves, which goes horribly wrong.

Answers: 1. Blithe Spirit. 2. Brief Encounter. 3. Great Expectations. 4. Hobson's Choice. 5. Bridge on the River Kwai. 6. Lawrence of Arabia. 7. Dr Zhivago. 8. Ryan's Daughter. 9. A Passage to India.

Stanley Kubrick

Stanley Kubrick was born in 1928 in New York City. In 1957, he directed Kirk Douglas in **Paths of Glory**. Unhappy with Hollywood, he moved to the United Kingdom in 1961. Can you identify the following Kubrick films?

1. (1960). A Thracian slave (Kirk Douglas) leads a revolt against the mighty Roman Republic.
2. (1962). Prof. Humbert Humbert (James Mason) is infatuated by a young girl Lolita (Sue Lyon).
3. (1964). US General Jack D. Ripper triggers a nuclear attack on the Soviet Union. Can the former Nazi and nuclear scientist Dr. Strangelove (Peter Sellers) mitigate an all-out nuclear war?
4. (1968). Science fiction writer Arthur C. Clark collaborated with Kubrick for this film.
5. (1971). Alex (Malcolm MacDowell) and his gang go on the rampage every night beating and raping helpless victims. When he is arrested, he agrees to become a guinea pig for experiments to curb the destructive impulses of men.

6. (1975). In the 18th century, to climb up the social ladder, a young Irish farm boy Redmond Barry (Ryan O' Neil) marries the wealthy Lady Lyndon (Marisa Berenson).
7. (1980). Jack Torrance (Jack Nicholson) and wife Wendy (Shelley Duvall) become the winter caretakers of an isolated hotel. Jack is writing a book when he slowly slips into insanity.
8. (1987). Foul-mouthed Gunnery Sergeant Hartman (R. Lee Ermey) trains a group of young Marine recruits the till one of them, Gomer Pyle (Vincent D'Onofrio) goes insane and kills the Sergeant.
9. (1999). Dr Bill Harford (Tom Cruise) married to Alice (Nicole Kidman) for nine year becomes obsessed with sex.

Answers: 1. Spartacus. 2. Lolita. 3. Dr. Strangelove or: How I Learned to Stop Worrying and Love the Bomb. 4. 2001: Space Odyssey. 5. A Clockwork Orange. 6. Barry Lyndon. 7. The Shining. 8. Full Metal Jacket. 9. Eyes Wide Shut.

European Directors

Born in 1922 in Limassol, Cyprus, Michael Cacoyannis was nominated for Oscar for **Zorba The Greek** (1964, Grk). His other films are **Elecktra** (1962, Grk) and **Iphigenia** (1977, Grk). Can you identify these European directors?

1. Danish filmmaker born in Copenhagen in 1889. His best known films include **The Passion of Joan of Arc** (1928, Fr), **Day of Wrath** (1943, Dan) and **Gertrud** (1965, Dan). His film **Ordet** (1955) won the Golden Lion in Venice Film Festival.
2. Swedish filmmaker born in 1918 in Uppsala. He was nominated for Oscars for **Cries & Whispers** (1972, Sw), **Face to Face** (1976, Sw) and **Fanny and Alexander** (1982, Sw). **The Seventh Seal** (1957, Sw), a bleak meditation of death, brought him international renown. His other famous films are **Wild Strawberries** (1957, Sw), **Through a Glass Darkly** (1961, Sw) and **Autumn Sonata** (1978, Sw).
3. Polish filmmaker born in 1926. Some of his films are **Promised Land** (1975, Pol), **Man of Iron** (1981, Pol), **Danton** (1983, Fr),

and **Katyn** (2007, Pol). In 2000 he was presented with an honorary Oscar for his contribution to world cinema.
4. Czech filmmaker born in the Czech Republic in 1932. He won Oscars for **One Flew over the Cuckoo's Nest** (1975) and **Amadeus** (1984). His other films are **Ragtime** (1981), **Man on the Moon** (1999) and **The People vs. Larry Flynt** (1996).
5. Polish filmmaker born in Paris in 1933 but moved to Poland in 1936. He won an Oscar for **The Pianist** (2002). His well known films are **Knife in the Water** (1962, Pol), **Rosemary's Baby** (1968), **Chinatown** (1974), and **Tess** (1979).
6. Greek filmmaker born in 1933 in Arcadia, Greece but made his films either in French or English. He was assistant to Rene Clair. His comic thriller **Z** (1969, Fr) won the Oscar for Best Foreign Language Film. He is known for **State of Siege** (1972, Fr) and **Missing** (1982, Fr).
7. Dutch filmmaker born in Amsterdam in 1938. **Soldier of Orange** (1977, Du) was his first film to receive international recognition. Other films he made in the US were **Robocop** (1987), **Basic Instinct** (1992) and **Starship Troopers** (1997).
8. Polish filmmaker born in 1941 in Warsaw. He is a most famous for his colours Trilogy: **Blue** (1993, Fr), **White** (1994, Fr) and **Red** (1994, Fr). He was nominated for Oscar for **Red** (1994). He won the Silver Bear for Best Direction in Berlin film festival for **White** (1994).
9. Swedish filmmaker born in 1946 in Stockholm. He was nominated for Oscar for **The Cider House Rules** (1999). His other films are **My Life as a Dog** (1985), **What's Eating Gilbert Grape** (1993), **Chocolat** (2000) and **The Hundred-Foot Journey** (2014).

Answers: 1. Carl Theodor Dreyer. 2. Ingmar Bergman. 3. Andrzej Wajda. 4. Milos Forman. 5. Roman Polanski. 6. Costa Gravas. 7. Paul Verhoeven. 8. Krzysztof Kieślowski. 9. Lasse Hallström.

Russian Directors

Born in 1898 in Riga (Latvia), Sergei Eisenstein is considered the father of cinematic montage as he used heavily edited sequences for emotional impact and historical propaganda. **Battleship Potemkin**

(1925), **Alexender Nevsky** (1938, Ru), *Ivan the Terrible* (1944, Ru) and *Ivan the Terrible, Part II* (1958, Ru) are some of his memorable films. Can you identify the following Russian directors?

1. Born in 1893. He won the best director award in the Karlovy Vary International Film Festival 1950 for **Zhukovsky** (1950, Ru). He made the silent film **Mother** (1926). His other films are **The End of St Petersburg** (1927, Ru) and **Storm over Asia** (1928, Ru).
2. Born in 1899. His film **Po Zakonu** (1926) (By the Law) was based on a Jack London story. He is famous for editing technique named after him. His other films are **The Great Consoler** (1933, Ru) and **We from the Urals** (1944, Ru).
3. Born in 1903, in Georgia. He made **The Cranes are Flying** (1957, Ru). His other famous works are **The Unsent Letter** (1959, Ru), **I am Cuba** (1964, Sp) and **The Red Tent** (1969, Ru).
4. Born in 1920 in Ukraine. He directed the epic film **War and Peace** (1965-7, Ru) in four parts in which he played the role of Pierre Besukhov. In 1970, he directed **Waterloo** (1970), in which Rod Steiger played Napoleon's role. His directed **Boris Godunov** (1986, Ru) in which he also played the title role.
5. Born in 1932. His first film was **Ivan's Childhood** (1962, Ru). His second **Andre Rublev** (1966, Ru) was suppressed by the authorities but is considered a masterpiece now. **Solaris** (1972, Ru) and **Stalker** (1979, Ru) were his sci-fi films. After **Nostalgia** (1983, Ru), he defected to the West.
6. Born in 1937. His first film, **The First Teacher** (1966, Ru), was acclaimed but his second film, **Asya Klyachina's Story** (1967, Ru) was acclaimed as a masterpiece only when it was released 20 years later. He made **Uncle Vanya** (1970, Ru) which was based on a Chekov's play. He moved to the US in 1980 where he made films like **Runaway Train** (1985), **Homer and Eddie** (1989) and **The Postman's White Nights** (2014).

Answers: 1. Vsevolod Pudovkin. 2. Lev Kuleshov. 3. Mikhail Kalatozov. 4. Sergei Bondurchuk. 5. Andre Tarkovsky. 6. Andrei Konchalosky.

Akira Kurosawa

Born in 1910 in Tokyo. He worked as a painter before entering films. He made **Rashomon** (1950, Jp) which won the top prize at the Venice Film Festival. Francis Ford Coppola said about him: "One thing that distinguishes [him] is that he didn't make one masterpiece or two masterpieces. He made, you know, eight masterpieces." Can you identify these Kurosawa films?

1. About which movie Satyajit Ray said: "The effect of the film on me was electric. I saw it three times on consecutive days, and wondered each time if there was another film anywhere which gave such sustained and dazzling proof of a director's command over every aspect of film making."
2. (1957). A warrior assassinates his king at the urging of his ambitious wife. Adapted from Shakespeare's Macbeth.
3. (1954) Villagers hire seven *samurais* to combat bandits who plan to raid the village to steal their crop.
4. (1961). In a town divided between two gangsters, a wandering samurai plays one side off against the other. Sergio Leone's **A Fistful of Dollars** was inspired by this film.
5. (1980). A thief is forced to impersonate as a dying lord to dissuade the enemy from attacking the clan. It won the Palme d'Or at Cannes Film Festival.
6. (1985). A warlord abdicates in favour of his three sons with disasterous consequenses. Adapted from Shakespeare's King Lear.

Answers: 1. Rashmon. 2. Throne of Blood (Kumonosu-jō). 3. Seven Samurai. 4. Yojimbo. 5. Kagemusha. 6. Ran.

Luis Bunuel

Although he was born in Spain in 1900, Bunuel is associated with France and Mexico. At the University, he became friends with the famous Surrealist artist Salvadore Dali and playwright Fredrico Garcia Lorca. He received the inaugural Golden Lion Honorary Award in Venice Film Festival. Can you identify these Bunuel films?

1. (1929). Bunuel directed a 16-minute surrealist film. He said, "Our only rule was very simple: no idea or image that might lend itself to a rational explanation of any kind would be accepted. We had to open all doors to the irrational and keep only those images that surprised us, without trying to explain why."
2. (1930). A man (Gaston Modot) and a woman (Lya Lys) are in love with each other but cannot consummate that passion because of their families, the Church, and bourgeois society. This surrealist film was attacked by the fascists and banned.
3. (1949). A family's tries to change Don Romiro (Fernando Soler)'s somewhat indulgent and hedonistic ways by fooling him into thinking his large fortune is gone.
4. (1950). This film was based on slum children of Mexico City. Bunuel won the Best Director award at the Cannes film festival 1951.
5. (1961). Before she enter the convent as a nun, a young novice (Silvia Pinal) is told by her Mother Superior to visit her Uncle Jaime (Fernando Rey) at his farm. The film won Palme d'Or at Cannes in 1961.
6. (1962). A group of people in formal dress arrive for a dinner party. After the dinner they are inexplicably unable to leave.
7. (1964). Célestine (Jeanne Moreau) takes a job as a maid in the country with a strange family.
8. (1967) Young housewife Séverine Serizy (Catherine Deneuve) starts frequenting a high-class brothel.
9. (1972). Six middle-class people are unable to have a meal together because of various interruptions. This film won the Academy award for the best foreign language film in 1972.
10. (1977). Wealthy and middle-aged Mathieu (Fernando Rey) falls desperately in love with his 19-year-old former chambermaid Conchita (Carole Bouquet and Angela Molina).

Answers: 1. *En Chien Andalou*. 2. *The Age of Gold. (L'Age d'Or)* 3. *El Gran Calavera (The Great Madcap)*. 4. *Los Ollvidados (The Forgotten Ones)*. 5. *Viridiana*. 6. *The Exterminating Angel*. 7. *Diary of a Chambermaid*. 8. *Bella de Jour*. 9. *The Discreet Charm of the Bourgeoisi*. 10. *That Obscure Object of Desire*.

Satyajit Ray

Satyajit Ray was born in Calcutta in 1921. He worked at D.J. Keymer, a British-run advertising agency, as a junior visualizer. He entered the international cinema with his first film, **Pather Panchali** (1955, Bn), which won 11 international prizes. The Apu trilogy, consisting of **Pather Panchali, Aparajito** and **Apor sansar**, was based on novels of Bibhutibhushan Bandyopadhyay. Akira Kurosawa said about Ray's work: "Not to have seen the cinema of Ray means existing in the world without seeing the sun or the moon." Can you identify these Ray films?

1. (1958). Biswamghar Roy (Chhobi Biswas), landowner of a dwindling estate, wants to throw a magnificient music party in spite of his meagre resources. Famous singer Begum Akhtar and shehnai maestro Bismillah Khan appeared in this film.
2. (1962). A neglected wife (Madhabi Mukherjee) of a newspaper editor falls in love with a visiting cousin Amal (Soumitra Chatterjee).
3. (1962). Wealthy Indranath (Chhobi Biswas) visits a hill station hoping that his daughter Monisha (Alakananda Ray) will approve of well settled Banerjee (N. Viswanathan) as groom. This was Ray's first film in color.
4. (1970) Fed up of struggling to find a job in Calcutta and family frictions, educated Siddharta (Dhritiman Chatterjee), moves to faraway Balurghat to work as a medical salesman. This was the first part of Calcutta trilogy which included films **Company Limited** (**Seemabaddha**, 1971, Bn) and **Jana Aranya** (1976, Bn).
5. (1977). Noblemen Mirza Sajjad Ali (Sanjeev Kumar) and Mir Roshan Ali (Saeed Jaffrey) are so engrossed in chess that they are indifferent to the annexation of Awadh by General James Outram (Richard Attenborough). This was Ray's first Hindi film.
6. (1984). Nikhilesh (Victor Banerjee) is a peace-loving and progressive landlord. When his revolutionist friend, Sandip (Soumitra Chatterjee) visits him, he is able to influence innocent Bimal, Nikhilesh's wife.

7. (1989). Dr Ashok Gupta (Soumitra Chatterjee) discovers that holy water of the Tripureshwar temple, a tourist attraction of the town, is contaminated. When he publicizes his findings, the community turns against him.

Answers: 1. *Jalsagar.* 2. *Charulata.* 3. *Kanchenjunga.* 4. *Pratidwandi.* 5. *Shatranj Ke Khiladi.* 6. *Ghare Baire.* 7. *Ganashatru.*

Woody Allen

Woody Allen was born Allan Stewart Konigsberg in 1935 in Brooklyn. He named himself after clarinetist Woody Herman. He himself plays the clarinet. He began his career as a comedy writer in the 1950s. Can you identify these Woody Allen films?

1. (1966). Woody Allen dubbed a Japanese film about the search of a microfilm into an English film about the search of a recipe for egg salad. Woody Allen stars as himself.
2. (1969). An incompetent bank robber Virgil Starkwell (Woody Allen) falls in love with Louise (Janet Margolin), a laundress who comes from a dysfunctional household.
3. (1971). Fielding Melish (Woody Allen) travels to the tiny Latin American nation of San Marcos where he joins the rebels and eventually becomes its President.
4. (1975). As Napoleon (James Tolkan) attacks Russia, the cowardly Boris (Allen) is forced to joins the Russian army to battle Napoleon's forces and ends up a war hero. He and Sonja (Diane Keaton) plot to assassinate Napoleon.
5. (1977). Alvy Singer (Woody Allen), a neurotic Jewish comedian, reflects on his latest failed love affair with a WASP girl (Diane Keaton).
6. (1979). Forty-two years old Isaac (Allen), a divorced and out-of-job writer, is dating a teenage girl Tracy (Mariel Hemingway), but falls in love with Mary (Diane Keaton).
7. (1986). Eliot (Michael Caine), married to Hannah (Mia Farrow), is having an affair with her sister Lee (Barbara Hershey). Mickey (Woody Allen), Hannah's first husband, is courting her other sister, Holly (Dianne Wiest).

8. (1993). Larry Lipton's (Woody) wife Carol (Diana Keaton) is suspicious that her neighbour Paul (Jerry Adler) may have murdered his wife Lillian.
9. (2004). A young Manhattan couple throw a dinner party when their long-lost friend Melinda (Radha Mitchell) appears at their front door, bedraggled and woebegone.
10. (2008). Vicky (Rebecca Hall) and Cristina (Scarlett Johansson) travel on holiday to Spain and fall in love with same person (Javier Bardem).

Answers: 1. *What's up, Tiger Lily.* 2. *Take the Money and Run.* 3. *Bananas.* 4. *Love and Death.* 5. *Annie Hall.* 6. *Manhattan.* 7. *Hanna and Her Sisters.* 8. *Manhattan Murder Mystery.* 9. *Melinda and Melinda.* 10. *Vicky Cristina Barcelona.*

Martin Scorsese

Martin Scorsese was born in 1942 in New York City. He won an Oscar for **The Departed** (2006). His other films are **Gangs of New York** (2002), **The Aviator** (2004) and **Hugo** (2011). Can you identify these Scorsese films?

1. (1974). When Alice Hyatt (Ellen Burstyn) is suddenly widowed after years of domesticity, she decides to travel to Monterey, California with her 11-year-old son Tommy (Alfred Lutter) to resume a singing career.
2. (1976). Loner Vietnam veteran Travis (Robert De Niro) plots to assassinate a Presidential candidate and rescue Iris (Jodie Forster), an adolescent prostitute.
3. (1977). Big band singer Francine Evans (Liza Minnelli) is trapped in an abusive marriage with Jimmy Doyle (Robert De Niro).
4. (1978). Robbie Robertson and othe members of The Band talk about their life on the road.
5. (1980). One of the reasons Martin Scorsese made this film in black and white was because didn't want to depict all that blood in a color picture.

6. (1986). Retired pool player Eddie "Fast" Felson (Paul Newman) coaches a promising young player Vincent (Tom Cruise) to be a hustler and make money.
7. (1988). Jesus (Willem Dafoe), a carpenter in Nazareth, Judea, during the Roman occupation, believes that God has a special plan for him.
8. (1990). Irish-Italian American Henry Hill (Ray Liotta) and his friends graduate from petty crime to violent murders as members of Mafia.
9. (1993). Wealthy New York lawyer Newland Archer (Daniel Day-Lewis) is engaged to May Welland (Winona Ryder), but his life is upset when he meets May's unconventional cousin, the beautiful Countess Ellen Olenska (Michelle Pfeiffer).
10. (1995). When mobster Ace Rothstein (Robert De Niro) moves to Las Vegas to operate the Tangiers casino, his ruthless and volatile friend Nicky Santoro (Joe Pesci) joins him there. Ace falls in love with a hustler, Ginger (Sharon Stone).
11. (2006). Police detective Colin Sullivan (Matt Damon) is actually a paid informant for Irish mobster Costello (Jack Nicholson). Billy Costigan (Leonardo DiCaprio) working for Costello, actually is an undercover policeman, spying on Costello.

Answers: *1. Alice doesn't live here anymore. 2. Taxi Driver. 3. New York, New York. 4. The Last Waltz. 5. The Raging Bull. 6. The Color of Money. 7. The Last Temptation of Christ. 8. Goodfellas. 9. The Age of Innocence. 10. Casino. 11. The Departed.*

Steven Spielberg

Steven Spielberg has directed more commercially successful and critically acclaimed films than anyone has. He was born in 1946 in Ohio, USA. He won Oscars for **Schindler's List** (1993) and **Saving Private Ryan** (1998). He was nominated for Oscars for **Close Encounters of the Third Kind** (1977), **Raiders of the Lost Ark** (1981), **E.T. the Extra-Terrestrial** (1982), **Munich** (2005) and **Lincoln** (2012). His other films are **Jaws** (1975), **The Color Purple** (1985), **Empire of the Sun** (1987), **Jurassic Park** (1993) and **Amistad** (1997). Can you identify these Spielberg films?

1. (1977). Lineman Roy Neary (Richard Dreyfus) and single mother Jillian Guiler (Melinda Dillon) separately experience paranormal activity before some flashes of bright lights in the sky, which they believe to be a UFO.
2. (1981). College professor Indiana Jones (Harrison Ford) is hired by the U.S. government to find the Ark of the Covenant before Rene Belloq (Paul Freeman), hired by the Nazis, can get it.
3. (1982). A young boy named Elliott (Henry Thomas) brings an alien into his suburban California house.
4. (1984). Archaeologist Indiana Jones (Harrison Ford) lands in a village in India where priest Mola Ram (Ambrish Puri) has kidnapped all the children and is using them to dig for magical stones.
5. (1989). When Dr. Henry Jones (Sean Connery) goes missing while searching for the cup of Christ, the Holy Grail, his adventurer son (Harrison Ford) goes to rescue him in Germany. He finds that Hitler's Nazis are also after the Holy Grail.
6. (1991). Lawyer Pater Banning (Robin Williams) is grown-up Peter Pan. When Peter Pan's arch-rival pirate (Dustin Hoffman) kidnaps his children, he has to become Peter Pan again to rescue his children from Neverland.

Answers: *1. Close Encounters of the Third Kind. 2. Raiders of the Lost Ark. 3. E.T. The Extra-Terrestrial. 4. Indiana Jones and the Temple of Doom. 5. Indiana Jones and the Last Crusade. 6. Hook.*

Oliver Stone

Born in 1946 in New York. He became a soldier in the Vietnam War, where he was awarded a Bronze Star for Gallantry and a Purple Heart. He won Oscars for **Platoon** (1986) and **Born on the Fourth of July** (1989). He was nominated for Oscar for **JFK** (1991). He dedicated his film **Wall Street** (1987) to his father who was a stockbroker. Can you identify these Oliver Stone films?

1. (1981). Horror film based on Marc Brandel's novel *The Lizard's Tail* starring Michael Caine.

2. (1986). Photojournalist Richard Boyle (James Woods) visits El Salvador to write about the events of the 1980 military dictatorship, including the assassination of Archbishop Oscar Romero (José Carlos Ruiz).
3. (1986). New recruit Chris Taylor (Charlie Sheen) faces a moral crisis when confronted with the horrors of war in in Vietnam.
4. (1987). Ambitious stockbrocker Bud Fox (Charlie Sheen) becomes embroiled in underhanded schemes, some of which eventually threaten the livelihood of his scrupulous father (Martin Sheen).
5. (1991). Controversial rock star Jim Morrison (Val Kilmer)'s excessing alcohol and drug use leads to his premature death in Paris.
6. (1991). State attorney Jim Garrison (Kevin Kostner) unearths a right-wing conspiracy to murder US President John F. Kennedy.
7. (1994). Mickey (Woody Harrelson) and Mallory (Juliette Lewis) go on a killing spree just for kicks.
8. (2004). King Philip II (Val Kilmer) of Macedon relationship with his wife Olympias (Angelina Jolie) and his son (Colin Farrel) are strained.
9. (2010). Gordon Gekko (Michael Douglas), out from prison, is reunited with his estranged daughter Winnie (Carey Mulligan).

Answers: *1. The Hand. 2. Salvadore. 3. Platoon. 4. Wall Street. 5. The Doors. 6. JFK. 7. Natural Born Killer. 8. Alexander. 9. Wall Street: Money Never Sleeps.*

Women Directors

Alice Guy, born in 1873 in Paris, is considered to the first female director. She made **The Birth, the Life and the Death of Christ** (1906) a film that inspired Dadasaheb Phalke to start making films in India. In 1910 she moved to the US and set up a studio in New Jersey. Among her numerous films are **The Woman of Mystery** (1914) and **House of Cards** (1917). Can you identify these women directors?

1. Born in 1892 in New York, she one of Mack Sennet's Bathing Beauties and later a comic actress along with actors like Fatty Arbuckle and Charlie Chaplin. She was one of the earliest female directors. One of the films she directed was *Mabel's Strange Predicament* (1914), starring Chaplin as a Tramp.
2. She was born in 1902 in Berlin. She directed *Triumph of the Will* (1935, Ger) and *Olympia* (1938, Ger) which are among the most effective, and technically innovative, propaganda films. *Triumph of the Will*, however, damaged her career and reputation after the war. The nature of her ties with Nazism remains a matter of debate.
3. Born in 1928 in Brussels, Belgium and died in 2019. In 2018 she received an Honorary Academy award. She was married to director Jacques Demy. Some of her films are *Cleo from 5 to 7* (1962, Fr), *The Beaches of Agnès* (2008, Fr) and *Jacquot de Nantes* (1991, Fr).
4. Born in 1941 in New York City. Well known as a screenplay writer, she helmed two romantic comedies *Sleepless in Seattle* (1993) and *You've Got Mail* (1998) both starring Tom Hanks and Meg Ryan. Her other films are *Julie & Julia* (2009) and *Bewitched* (2005).
5. Born in 1950 in Melbourne. She made *Little Women* (1994) starring Winona Rider. Her other films include *My Brilliant Career* (1979) starring Judy Davis and *Oscar and Lucinda* (1997) starring Ralph Fiennes.
6. Born in 1951 in California. She won the Oscar for *The Hurt Locker* (2008), becoming the first woman director to do so. She won best Director Golden Globe for *Zero Dark Thirty* (2012). Her other films include *K-19: The Widowmaker* (2002) and *Detriot* (2017).
7. Born in 1952 in Massachusetts. She directed Shakespearean film *Titus*, with Anthony Hopkins playing the title role. Her film, *Frida* (2002), starred Salma Hayek as artist Frida Kahlo. She directed the musical *Across the Universe* (2007) which had over thirty songs by The Beatles. Her other film was *The Tempest* (2010).
8. Born in 1954 in Wellington. She was nominated for Oscar for *The Piano* (1993). Her other films include *The Portrait of a Lady* (1996) starring Nicole Kidman and *Sweetie* (1989).

9. Born in 1957 in Orissa, India. Her debut film **Salaam Bombay!** (1988) was nominated for the Academy Award for Best Foreign Language. **Monsoon Wedding** (2001) won the Golden Lion at the 2001 Venice Film Festival. Her other films are **Mississippi Masala** (1991), **The Namesake** (2006), and **The Reluctant Fundamentalist** (2012).
10. Born in 1971 in New York City. She is the first American woman director to be nominated for Oscar for **Lost in Translation** (2003). Her other films include **Marie Antoinette** (2006) and **The Beguiled** (2017).
11. She was born in Amritsar, but migrated to Canada in 1973. She is well known for her trilogy **Elements: Fire** (1996), **Earth** (1998) and **Water** (2005). In 2002 she directed **Bollywood/Hollywood**. Her other films include **Midnight's Children** (2012) and **Beeba Boy** (2015).

Answers: 1. Mabel Normand. 2. Leni Riefenstahl. 3. Agnes Varda. 4. Nora Ephron. 5. Gillian Armstrong. 6. Kathryn Bigelow. 7. Julie Taymor. 8. Jane Campion. 9. Mira Nair. 10. Sofia Coppola. 11. Deepa Mehta.

Australia and New Zealand Directors

Peter Weir was born in 1944 in Sydney. He became famous for **The Picnic at Hanging Rock** (1975), **Gallipoli** (1981) and **The Year of Living Dangerously** (1983). He moved to Hollywood where he directed **Dead Poets' Society** (1989) starring Robin Williams and **Truman Show** (1998) starring Jim Carrey. Can you identify these Australian and New Zealand directors?

1. Born in 1945 in Queensland. Starting with **Mad Max** (1979), he made other films of the series. His other films include **Babe: Pig in the City** (1996) and **Happy Feet** (2007).
2. Born in 1950 in New South Wales. He moved to Hollywood where he made **Patriot Games** (1992), **Clear and Present Danger** (1994), and **The Bone Collector** (1999) starring Denzel Washington and Angelina Jolie. Back in Australia, he made **The Quiet American** (2002) starring Michael Caine and

Rabbit-Proof Fence (2002). His spy thriller *Salt* (2010) was his recent big box-office hit.
3. Born in 1961 in North Island, New Zealand. He won Oscar for *The Lord of the Rings: The Return of the King* (2003). His other films include *Bad Taste* (1987), *King Kong* (2005) and other films of *Lord of the Ring* and *The Hobbits* franchise.
4. Born in 1962 in New South Wales. He made *Moulin Rouge* (2001) starring Nicole Kidman. Among his other films, Leonardo Di Caprio star in *Romeo + Juliet* (1996) and *The Great Gatsby* (2013) and Nicole Kidman star in *Australia* (2008). His films show the influence of Italian Grand opera and Bollywood films.
5. Born in 1967 in Wellington, New Zealand. Her early success came with *Whale Rider* (2002). *North Country* (2005) starring Charlize Theron was her first American film. Her other films were *McFarland, USA* (2015) and *The Zookeeper's Wife* (2017).
6. Born in 1967 in Wellington, New Zealand. He first became well known for *Chopper* (2000) starring Eric Bana. His other films are *The Assassination of Jesse James by the Coward Robert Ford* (2007) and *Killing Them Softly* (2012), both starring Brad Pitt.

Answers: 1. George Miller. 2. Phillip Noyce. 3. Peter Jackson. 4. Baz Luhrman. 5. Niki Caro. 6. Andrew Dominik.

Canada

Arthur Hiller was born in 1923 in Edmonton to Polish Jewish immigrants. He was nominated for Oscar for *Love Story* (1970). His other well known films are *The Hospital* (1971) and *See No Evil, Hear No Evil* (1989). He helmed a musical, *Man of La Mancha* (1972) starring Peter O'Toole as Don Quixote. Can you identify these Canadian directors?

1. He was born in 1926 in Toronto. He is the only director who was nominated for Oscars three times in three separate decades (*In the Heat of the Night* (1967), *Fiddler on the Roof* (1971) and *Moonstruck* (1987). His other films are *The

Cincinnati Kid (1965) starring Steve McQueen, **The Thomas Crown Affair** (1968) starring Pierce Brosnan, and **The Hurricane** (1999) starring Denzel Washington.
2. Born in 1954 in Ontario. He won Oscar for **Titanic** (1997) and was nominated for Oscar for **Avatar** (2009). He found success with the science-fiction action film **The Terminator** (1984). He then became a popular Hollywood director and was hired to direct **Aliens** (1986). He found further critical acclaim for his use of special effects in **Terminator 2: Judgment Day** (1991). He helmed **True Lies** (1994) starring Arnold Schwarzenegger.
3. Born in 1943 in Toronto. He is known for horror and science fiction films such as **Scanners** (1981) and **Videodrome** (1983). His **Naked Lunch** (1991) was based on William S. Burroughs' controversial book. His other films are **The Fly** (1986), **Crash** (1996) and **A History of Violence** (2005).
4. Born in 1946 in Czechoslovakia (now Slovak Republic). His directed **Meatballs** (1979), **Stripes** (1981) and **Ghostbusters** (1984), all starring Bill Murray. His **Junior** (1994) and **Twins** (1988) starred Arnold Schwarzenegger in comic roles. His other films are **Six Days Seven Nights** (1998) and **No Strings Attached** (2011).
5. Born in 1953 in Ontario. He made his directorial debut with **Red Hot** (1993). He was nominated for Oscar for **Crash** (2005) starring Don Cheadle. His other films are **The Next Three Days** (2010) starring Russel Crowe and **Third Person** (2013) starring Liam Neeson.
6. Born in 1967 in Quebec. He made sci-fi films such as **Arrival** (2016) and **Blade Runner 2049** (2017). His other films are **Enemy** (2013) starring Jake Gyllenhaal, and **Sicario** (2015) starring Emily Blunt.

Answers: *1. Norman Jewison. 2. James Cameron. 3. David Cronenberg. 4. Ivan Reitman. 5. Paul Haggis. 6. Denis Villeneuve.*

Latin American

Tomas Guitarez Alea was born in 1928 in Havana. His comedy **The Twelve Chairs** (1962, Sp) was nominated for best film in Moscow

Film Festival. His ***Death of a Bureaucrat*** (1966, Sp) is a satire against bureaucracy and red tapism. ***Memories of Underdevelopment*** (1968, Sp) is said to be his best film. ***Strawberry and Chocolate*** (1993, Sp) was nominated for Oscar for best foreign film. Can you identify these Latin American directors?

1. Born in 1936 in Argentina. He was a part of Film Liberation Group and a vocal critic of the Right. His films include ***Tangos, the Exile of Gardel*** (1985, Sp), ***The South*** (1988, Sp), ***The Journey*** (1992, Sp) and ***Clouds*** (1998, Sp).
2. He was born in 1939 in Brazil. ***Black God White Devil*** (1964, Por), a seminal fim of the Brazilian New Cinema, was about the adventures of a hired gunman Antonio das Mortes. He made ***Entranced Earth*** (1967, Por) for which he was banned in Brazil for some time. He won Palm D'Or for best director in Cannes Festival, in 1969 for ***Antonio das Mortes*** (1969, Por).
3. Born in 1946 in Buenos Aires, Argentina, but settled in Brazil. His first international success was ***Pixote*** (1981, Po). He was nominated for Oscar for ***Kiss of the Spider Woman*** (1985), the first Latin American director to be nominated. His other film are ***Lucio Flavio*** (1977, Po) and ***Ironweed*** (1987), starring Jack Nicholson.
4. Born in 1956 in Rio de Janeiro. His film ***The Motorcycle Diaries*** (2004) won the BAFTA film award for non-English film. His other films were ***Central Station*** (1998) and ***On the Road*** (2012).
5. Born in 1961 in Mexico City, Mexico. His first film was ***Sólo con Tu Pareja*** (1991, Sp). He was invited by Sydney Pollack to shoot in Hollywood where he made films such as ***A Little Princess*** (1995) and ***Harry Potter and the Prisoner of Azkaban*** (2004). He received Oscars for ***Gravity*** (2013) and ***Roma*** (2018, Sp).
6. Born in 1963 in Mexico City, Mexico, he is the first Mexican director to be nominated for Oscar for ***Babel*** (2006) starring Brad Pitt. He won Oscars for ***The Birdman*** (2014) and ***The Revenant*** (2015).
7. Born in 1964 in Mexico. Won an Oscar for ***The Shape of Water*** (2017) starring Sally Hawkins. His other films are ***The Devil's Backbone*** (2001), ***Blade II*** (2002) and ***Hellboy*** (2004).

Answers: 1. Fernando Solanas. 2. Glauber Rocha. 3. Héctor Eduardo Babenco. 4. Walter Salles. 5. Alfonso Cuarón. 6. Alejandro González Iñárritu (ih-nyar-ee-too). 7. Guillermo del Toro.

Japanese Directors

Teinosuke Kinugasa was born in 1896. He started his career as a female impersonator and turned to direction. His best known film, **A Page of Madness** (1926, Jp) was lost for 45 years before the director rediscovered it in his shed in 1971. His **Gate of Hell** (1953, Jp) won the best foreign language film Academy Award. Another well-known film is the silent **Jujiro** (Crossroads, 1928, Jp). Can you identify these Japanese directors?

1. Born 1898 in Tokyo. He started as an actor performing female roles and moved to direction. He has reputation as a feminist director. His films **The Life of Oharu** (1952, Jp) and **Street of Shame** (1956, Jp) were based on the lives of prostitutes. Some of his other films were **Ugetsu** (1953, Jp) and **Sansho the Bailiff** (1954, Jp).
2. Born in 1903 in Tokyo. He was imprisoned by the British as a captured Japanses POW in Singapore. His films mostly deal with family, marriage and parents. His most famous film **Tokyo Story** (1953, Jp) is about an aged couple from the countryside who travel to visit their children and find that they have no time to them. **Floating Weeds** (1959, Jp) is about changes in post-war Japan. His other films are **Flavor of Green Tea over Rice** (1952, Jp) and **An Autumn Afternoon** (1962, Jp).
3. Born in 1915 in Japan. His film **The Burmese Harp** (1956, Jp) won San Giorgio Prize in Venice film Festival (1956). Among his screen adaptations of literary works is Yukio Mishima's **Conflagration** (1958, Jp). His other films are **Odd Obsession** (1959, Jp), **The Outcast** (1962, Jp) and **Actress** (1987, Jp).
4. Born in 1916 in Hokkaido. He was imprisoned as a Japanese POW in Okinawa. He directed **The Human Condition** trilogy on the effects of World War II on a Japanese socialist. The epic consisted of **No Greater Love** (1959, Jp), **Road to Eternity** (1959, Jp) and **A Soldier's Prayer** (1961, Jp). His samurai film **Harakiri** (1962, Jp) won the Jury Prize at the 1963 Cannes Film Festival.

5. Born in 1932 in Kyoto. He was associated with Japanese New Wave. His *In the Realm of the Senses* (1976, Jp) created a furore due to its explicit scenes. His other films are *Merry Christmas Mr. Lawrence* (1983) and *Taboo* (1999, Jp).
6. Born in 1933. His **Eros+Massacre** (1969, Jp) is a seminal film of the Japanese New Wave and based on the life of anarchist Sakae Ōsugi. His other films are **A Promise** (1986, Jp) and **Wuthering Heights** (1988, Jp).
7. Born in 1962 in Tokyo. He won the Best Director award at the 1995 Venice Film Festival for **Maborosi** (1995, Jp). His film **Shoplifters** (2018, Jp) was a critical success. His other films are **After Life** (1998, Jp) and **Nobody Knows** (2004, Jp).

Answers: *1. Kenji Mizoguchi. 2. Yasujiro Ozu. 3. Kon Ichikawa. 4. Kobayashi Masaki. 5. Nagisa Oshima. 6. Yoshishige Yoshida. 7. Hirokazu Kore-eda.*

Actor-Directors

Charles Chaplin was born in 1889 in London. Among the many films he directed and acted in include **The Circus** (1928), **Modern Times** (1936), **The Great Dictator** (1940) and **Limelight** (1952).

Can you identify the following directors who also acted in these films?

1. Born in 1915 in Wisconsin. He directed and acted in his first film **Citizen Kane** (1941) when he was 26. Other films which he acted and directed include **Macbeth** (1948), **Othello** (1951), **Touch of Evil** (1958) and **Chimes at Midnight** (1965). He was awarded an Honarary Oscar in 1971 for "superlative artistry and versatility in the creation of motion pictures". He is known for low camera angles, tracking shots, deep focus and elaborate crane shots in his films.
2. Born in 1920 in Ukraine. He played the title role in **Othello** (1956). He directed the epic film **War and Peace** (1965-7) in four parts in which he played the role of Pierre Besukhov. His directed **Boris Godunov** (1986) in which he played the title role.

3. Born in 1930 in San Francisco. He won an Oscar for Best Director for **Unforgiven** (1992), in which he was also nominated for Best Actor Oscar. He also acted in and directed **The Bridges of Madison County** (1995). He won another best director Oscar for **Million Dollar Baby** (2004) in which he also acted.
4. Born in 1947 in Tokyo. He started as a comedian and was a part of the comedy duo Two Beat. He was the host of a popular television game show, Takeshi's Castle. His early films such as **Violent Cop** (1990), **Boiling Point** (1990) and **Sonatine** (1993) are gangster films starring himself. He acted in **Merry Christmas Mr. Lawrence** (1983) and **Taboo** (1999) both directed by Nagisa Ôshima.
5. Born in 1960 in Belfast. In late 1960s his family moved to England where he joined Royal Shakespeare Company. At 29, he directed and starred in **Henry V** (1989). In 1993, he directed and starred in another Shakespeare play **Much Ado About Nothing** (1993). In 1996, he directed and starred in a lavish adaptation of **Hamlet** (1996). His other films were **Mary Shelley's Frankenstein** (1994) and **Murder on the Orient Express** (2017).
6. Born in 1966 in New York City. Some of his films as actor are **Swingers** (1996), **Daredevil** (2003) and **The Big Empty** (2003). He acted and directed **Iron Man** (2008), **Iron Man** 2 (2010) and **Chef** (2014).

Answers: 1. Orson Welles. 2. Sergei Bondurchuk. 3. Clint Eastwood. 4. Takeshi Kitano. 5. Kenneth Branagh. 6. Jon Favreau.

Musican-Directors

Can you identify the following directors who also composed music for their films?

1. **Modern Times** (1936), **City Lights** (1931), **Limelight** (1942), **Monsieur Verdoux** (1947) and A **King in New York** (1957).

2. *Teen Kanya* (1961, Bn), **The Big City** (*Mahanagar,* 1963, Bn), *Charulata* (1964, Bn), **Company Limited** (*Seemabaddha*, 1971, Bn), **Shatranj Ke Khilari** (1977, Hn) and **Ganashatru** (1989, Bn).
3. **The Assault on Precinct 13** (1976), **Halloween** (1978), **Escape from New York** (1981), **The Fog** (1980) and **They Live** (1988).
4. **Mystic River** (2003), **Million Dollar Baby** (2004), **Flags of our Fathers** (2006), **Changeling** (2008) and **J Edgar** (2011).
5. **Eraserhead** (1977), **Blue Velvet** (1986) (additional music), **Wild at Heart** (1990) (additional music) and **Mulholland Drive** (2001) (additional music).
6. **Spykids** (2001), **Spy Kids 2: Island of Lost Dreams** (2002), **Once Upon a Time in Mexico** (2003), **Sin City** (2005).

Answers: 1. Charlie Chaplin. 2. Satyajit Ray. 3. John Carpenter. 4. Clint Eastwood. 5. David Lynch. 6. Robert Rodriguez.

Guess the Director

Guess the film directors from the films they directed:

1. Born 1921. **Butch Cassidy and the Sundance Kid** (1969), **The Sting** (1973), **Slaughterhouse-Five** (1972).
2. Born 1925 in London. **Seven Days... Seven Nights** (1960), **Lord of the Flies** (1963), **Marat/Sade** (1967), **King Lear** (1971). **The Mahabharata** (1990).
3. Born 1928. **Klute** (1971), **All the President's Men** (1976), **Sophie's Choice** (1982).
4. Born 1934. **They Shoot Horses, Don't They?** (1969). **The Way We Were** (1973), **Tootsie** (1982), **Out of Africa**, (1985), **Havana** (1990).
5. Born 1945. **Bandit Queen** (1994), **Elizabeth** (1998), **Elizabeth: The Golden Age** (2007).
6. Born 1962 in Denver. **Se7en** (1995), **Fight Club** (1999), **The Curious Case of Benjamin Button** (2008), **The Social Network** (2010), **Gone Girl** (2014).
7. Born 1970. **Magnolia** (1999), **There Will Be Blood** (2007). **The Master** (2012), **Inherent Vice** (2014).

Answers: 1. George Roy Hill. 2. Peter Brooks. 3. Alan J. Pakula. 4. Sydney Pollack. 5. Shekhar Kapoor. 6. David Fincher. 7. Paul Thomas Anderson.

Mixed Bag – Directors

In 1955, 20th Century Fox, briefly employed Claude Chabrol as a publicity man at their French offices but let him go saying that he was "the worst press officer they'd ever seen". He was replaced by another French director Jean-Luc Godard, who they said was even worse!

Identify the following film directors:

1. Who was the first director to utter the catchphrase "Lights, camera, action!"? He said it on the set of **In Old California** (1910).
2. What was Orson Welles answer when he was asked who his three favorite directors were?
3. Born in 1905 in Texas. He directed **Hell's Angels** (1930), the most expensive film of its time. His films **Scarface** (1932) and **The Outlaw** (1943) starred Jane Russel. He produced two films that were nominated for best film Oscars, **The Racket** (1928) and **The Front Page** (1931).
4. In 1938, he produced a radio drama *War of the Worlds* which was so realistic thar the audience thought that Martians had indeed landed on earth to attack it.
5. Who formed an advertising production company RSA, two of whose campaign were for Hovis bread (1973) and Apple Macintosh Computer (aired during the Superbowl 1984)?
6. Who formed film production companies Hawk Films, Peregrine Productions and Harrier films?
7. Who was the French director who visited India in 1968 and made a 7-part documentary which was broadcast by the BBC? The Indian government did not like the film and asked the BBC to stop it. The BBC was asked to leave their Delhi bureau.

8. Who was the British director who was selected to appear in Sgt. Peppers Lonely Heart Club Band's cover by Sir Peter Blake?
9. Who was criticized in 1980, by the Indian M.P. and former actress Nargis Dutt for "exporting poverty"?
10. Who was the French director Satyajit Ray met when he was filming for his movie, *The River* in India?
11. In 1957, Jawaharlal Nehru, the Indian Prime Minister invited a French director to India to make the documentary on India and put some life into the Indian Films Division. Though married to Ingrid Bergman, he had an affair with Sonali Das Gupta, a screenwriter, herself married to a local filmmaker. This led to a huge scandal in India as well as in Hollywood. Who was this director who was told by Nehru to leave India?

Answers: *1. D. W. Griffith. 2. John Ford, John Ford, and John Ford. 3. Howard Hughes. 4. Orson Welles. 5. Ridley Scott. 6. Stanley Kubrick. 7. Louis Malle. 8. David Lean. 9. Satyajit Ray. 10. Jean Renoir. 11. Roberto Rossellini.*

Rewards and Recognition

Academy Awards for Best Picture

The Academy of Motion Pictures Arts and Sciences (AMPAS) gives 24 Academy awards (aka Oscars) every year. Each statuette is made of gold-plated bronze on a black metal base, it is 13.5 in tall, weighs 8.5 lb and depicts a knight holding a crusader's sword. The first Academy Award (Oscar) ceremony in 1929 lasted only 15 minutes.

Can you identify the following films which won the Best Picture Award?

1. First film to win the Academy Award for Best Picture (16 May 1929).
2. First sound film to win the Best Picture Award. (Apr 1930).
3. First western to win the Best Picture Award (Nov 1931).
4. First film to win three Oscars, including the Best Picture Award (Mar 1934).
5. First color film to win the Best Picture Award (Feb 1940).
6. First film to win seven Oscars including the Best Picture Award (Mar 1947).
7. First non-American film to win the Best Picture Award (Mar 1949).
8. First film to win 14 nominations including the Best Picture nomination (Mar 1951).
9. Shortest film to win the Best Picture Award (91 minutes) (Mar 1956).
10. First film to win 11 Oscars including the Best Picture (Apr 1960).
11. Only X-rated film to win the Best Picture Award (Apr 1970).

12. First sequel to win the Best Picture Award (Apr 1975).
13. First sports film to win the Best Picture Award (Mar 1977).
14. First horror film to win the Best Picture Award (Mar 1992).
15. Second film to win 11 academy awards including the Best Picture Award (Mar 1998).
16. Second film to win 14 nominations including the Best Picture Award (Mar 1998).
17. Second sequel to the Best Picture Award (Feb 2004).
18. First film directed by a black director to win the Best Picture Award (Mar 2014).

Answers: 1. Wings (1927). 2. Broadway Melody (1929). 3. Cimmarron (1931). 4. Cavalcade (1933). 5. Gone with the Wind (1939). 6. The Best Years of Our Lives (1946). 7. Hamlet (1948). 8. All about Eve (1950). 9. Marty. (1955). 10. Ben Hur (1959). 11. Midnight Cowboy (1969). 12. Godfather II (1974). 13. Rocky (1976). 14. Silence of the Lambs (1991). 15. Titanic (1997). 16. Titanic (1997). 17. The Lord of the Rings: The Return of the King (2003). 18. 12 Years a Slave (2013).

Big Five Academy Awards

The Big Five Awards are those for Best Picture, Best Director, Best Actor, Best Actress, and Best Screenplay.

Identify the films which won or were nominated for the Big Five Awards.

1. First film to be nominated for Big Five awards (Nov 1931).
2. First to win the Big Five Awards (Feb 1935).
3. Second film to be nominated for Big Five (Mar 1938).
4. Third film to be nominated for Big Five (Feb 1940).
5. Third film to be nominated for Big Five (Feb 1940).
6. Second to win the Big Five Awards (Mar 1975).
7. Third film to win the Big Five awards (Mar 1992).

Answers: 1. Cimmarron (1931). 2. It Happened One Night (1934). 3. A Star is Born (1937) 4. Gone with the Wind (1939). 5. Goodbye Mr Chips (1939). 6. One Flew over the Cuckoo Nest (1975). 7. Silence of the Lambs (1991).

Academy Awards for Best Actor

German actor Emil Jannings received the first Best Actor Oscar in 1929 for **The Way of all the Flesh** and **The Last Command**. Daniel Day-Lewis has received the most awards in this category with three Oscars. Henry Fonda was the oldest actor (76 years) to win the Best Actor Oscar for **On Golden Pond** (1981).

Can you name the actor who received the Best actor award for the following films?

1. George M. Cohan in **Yankee Doodle Dandy** (1942).
2. Hamlet in **Hamlet** (1948).
3. Charlie Allnut in **African Queen** (1951).
4. Sgt. F. F. Sefton in **Stalag 17** (1953).
5. Terry Molloy in **On the Waterfront** (1954). Elia Kazan writes about this performance in his 1988 memoir: "If there is a better performance by a man in the history of film in America, I don't know what it is".
6. Ben Hur in **Ben Hur** (1959).
7. Rooster Cogburn in **True Grit** (1969).
8. Homer Smith in **Lilies of the Field** (1963).
9. Gen Patton in **Patton** (1970) but declined the Oscar describing the ceremony as a "meat parade".
10. Don Vito Corleone in **Godfather** (1972). He refused his award in 1972 citing the film industry's discrimination and mistreatment of Native Americans.
11. Jake LaMotta in **The Raging Bull** (1980).
12. Gordon Gecko in **Wall Street** (1987).
13. Raymond Babbitt in **Rain Man** (1988).
14. Guido Orefice in **Life is Beautiful** (1997).
15. Władysław Szpilman in **The Pianist** (2002), becoming the youngest to win The Best Actor Oscar at the age of 29.
16. Singer Ray Charles in **Ray** (2004).
17. Ron Woodroof in **Dallas Buyers Club** (2013).

Answers: 1. James Cagney. 2. Laurence Olivier. 3. Humphrey Bogart. 4. William Holden. 5. Marlon Brando. 6. Charleston Heston. 7. John Wayne. 8. Sidney Poitier. 9. George C Scott. 10. Marlon Brando. 11. Robert De

Niro. 12. Michael Douglas. 13. Dustin Hoffman. 14. Robert Benigni. 15. Adrien Brody. 16. Jamie Foxx. 17. Matthew McConaughey.

Academy Awards for Best Actress

Janet Gaynor received the first Best Actress award in 1929 for her roles in 7ᵗʰ **Heaven** (1927), **Street Angel** (1928) and **Sunrise** (1927). In 1969, Katharine Hepburn and Barbara Streisand tied for the Best Actress award. Katharine Hepburn won four Best Actress Oscars while Meryl Streep won most nominations (17) for Best Actress Oscar.

Can you name the actress who received the Best actress Oscar for the following films?

1. France-born actress won the Best Actress Oscar for **It Happened One Night** (1934).
2. England-born actress won the award for **Gone with the Wind** (1939).
3. French actress won the award for **Room at the Top** (1959).
4. Italian actress was the first to win the award for her role in non-English language film **Two Women** (1960).
5. Oldest actress to win the Best Actress Oscar. The film was **Driving Miss Daisy** (1989).
6. First African-American to win Best Actress Oscar. This film was **Monster's Ball** (2001).
7. Youngest to win Best Actress Oscar. The film was **Children of a Lesser God** (1986).
8. French actress who won the Best Actress Oscar for **La Vie en Rose** (2007).

Answers: 1. Claudette Colbert. 2. Vivien Leigh. 3. Simone Signoret. 4. Sophia Loren. 5. Jessica Tandy. 6. Halle Berry. 7. Marlee Matlin. 8. Marion Cotillard.

Academy Awards for Best Supporting Actor

Walter Brennan in 1937 was the first winner of the Oscar for Best Supporting Actor for his role in **Come and Get It** (1936). He is the only actor to win it three times.

Can you name these actors who won academy award for best supporting actor for portraying the following roles:

1. Howard in John Houston's **The Treasure of Sierra Madre** (1948).
2. Paul Gaughin in **Lust for life** (1956).
3. The village idiot Michael in **Ryan's Daughter** (1970).
4. Vito Andolini in **The Godfather**: Part II (1974).
5. Nick in Michael Cimono's **Deerhunter** (1978).
6. Dith Pran in **The Filling Fields** (1984).
7. Private Trip in **Glory** (1989).
8. Elliott Daniels in **Hanna and her Sisters** (1986).
9. John Bayley in **Iris** (2000).
10. The Joker in **The Dark Knight** (2008) posthumously.
11. Hal Fields in **Beginners** (2010). This actor, at 82, was the oldest winner of a competitive Oscar in an acting category, surpassing the achievement of Jessica Tandy.
12. Drumming instructor Terence Fletcher in **Whiplash** (2014).

Answers: 1. Walter Houston. 2. Anthony Quinn. 3. Sir John Mills. 4. Robert de Niro. 5. Christopher Walken. 6. Haing S. Ngor. 7. Denzel Washington. 8. Micheal Caine. 9. Jim Broadbent. 10. Heath Ledger. 11. Christopher Plummer. 12. J. K. Simmons.

Academy Awards for Supporting Actress

Gale Sondergaard was the first winner of Best Supporting Oscar in Mar 1937 for her role in **Anthony Adverse** (1936).

Can you name these actress who won Academy Award for best supporting actress for playing the following roles

1. Mammy in **Gone with the Wind** (1939).
2. Edie Doyle in **On the Waterfront** (1954).
3. Anita in **West Side Story** (1961).
4. Greta in **Murder on the Orient Express** (1974).
5. Julia in **Julia** (1977).
6. Joanna Kramer in **Kramer vs. Kramer** (1979).
7. Billy Kwan in **The Year of Living Dangerously** (1982).
8. Holly in **Hanna and her Sisters** (1986).
9. Velma Kelly in **Chicago** (2002).
10. Fantine in **Les Miserables** (2012).
11. Maria Elena in **Vicky Cristina Barcelona** (2008).

Answers: 1. Hattie McDaniel. 2. Eva Marie Saint. 3. Rita Moreno. 4. Ingrid Bergman. 5. Vanessa Redgrave. 6. Meryl Streep. 7. Linda Hunt. 8. Dianne Weist. 9. Catherine Zeta Jones. 10. Anne Hathaway. 11. Penelope Cruz.

Academy Awards for Best Director

In the first Academy Awards ceremony in 1919 May 29, the best director Oscar was given for two categories: Dramatic and Comedy. Frank Borzage won for **7th Heaven** (Dramatic) and Lewis Milestone for **Two Arabian Knights** (Comedy). John Ford has received the most awards (four) in this category. Damien Chazelle at 32 became the youngest director to receive this award for **La La Land** (2012).

Can you name the directors who won Academy Award for best direction for the following films?

1. **All Quiet on the Western Front** (1930) starring Lew Ayres.
2. **Cavalcade** (1933) starring Diana Wynyard.
3. **It Happened one Night** (1934) starring Claudette Colbert.
4. **Gone with the Wind** (1939) starring Clark Gable.
5. **How Green was my Valley** (1941) starring Walter Pidgeon.
6. **The Best Years of our Lives** (1946) starring Dana Andrews.
7. **The Treasure of Sierra Madre** (1948) starring Humphrey Bogart.
8. **On the Waterfront** (1954) starring Marlon Brando.
9. **Ben Hur** (1959) starring Charlton Heston.

10. **The French Connection** (1971) starring Gene Hackman.
11. **Annie Hall** (1977) starring Woody Allen
12. **The Last Emperor** (1987) starring John Lone.
13. **Rain Man** (1988) starring Dustin Hoffman.
14. **Deerhunter** (1978) starring Robert De Niro.
15. **Saving Private Ryan** (1998) starring Tom Hanks.
16. **Brokebank Mountain** (2005) starring Jake Gyllenhaal.

Answers: 1. Lewis Milestone. 2. Frank Lloyd. 3. Frank Capra. 4. Victor Fleming. 5. John Ford. 6. William Wyler. 7. John Houston. 8. Elia Kazan. 9. William Wyler. 10. William Friedkin. 11. Woody Allen. 12. Bernardo Bertoluci. 13. Barry Levinson. 14. Michael Cimono. 15. Steven Spielberg. 16. Ang Lee.

The Academy Award for Best Foreign Language Film

Between 1947 and 1955, the Academy presented Special/Honorary Awards to the best foreign language films released in the US. Italian film **Shoeshine** (1947) by Vittorio De Sica was nominated for the first Special/Honorary award. For the 1956 (29th) Academy Awards, a competitive Academy Award of Merit, known as the Best Foreign Language Film Award, was created for non-English speaking films. Federico Fellini's **La Strada** (1954) won the Best Foreign Film Oscar in 1956 for Italy. Italy has won the most best foreign film Oscars.

Can you identify these films which won the Best Foreign language Academy award?

1. (Mar 1958). Italian film directed by Federico Fellini which beat **Mother India** (1957, Hnd).
2. (Apr 1967). French film directed by Claude Lelouch.
3. (Apr 1969) Russian film directed by Sergei Bondurchuk.
4. (Apr 1970). Algerian film directed by Costa Gravas.
5. (Mar 1973). French film directed by Luis Buñuel.
6. (Feb 1999). Italian film directed by Roberto Bengini about a Jewish waiter who protects his son in a Nazi concentration camp.
7. (Mar 2001). Chinese film directed by Ang Lee.

Answers: 1. Nights of Cabiria. 2. A Man and a Woman. 3. War and Peace. 4. Z. 5. The Discreet Charm of the Bourgeoisie. 6. Life is Beautiful. 7. Crouching Tiger, Hidden Dragon.

Academy Award for Best Screenplay

The screenplay of **The Treasure of the Sierra Madre** (1948) was written by John Houston who received Oscars for both direction and screenplay.

Can you name the Academy award wining screenplays writer of the following films?

1. Elia Kazan's **A Streetcar Named Desire** (1951).
2. Elia Kazan's **On the Waterfront** (1954).
3. Tony Richardson's **Tom Jones** (1963).
4. David Lean's **Dr Zhivago** (1965).
5. Franklin J. Schaffner's **Patton** (1970).
6. Alan Parker's **Midnight Express** (1978).
7. Richard Attenborough's **Gandhi** (1982).
8. James Ivory's **A Room with a View** (1985).
9. Woody Allen's **Hannah and Her Sisters** (1986):
10. Ang Lee's **Sense and Sensibility** (1995).
11. Joel Coen's **Fargo** (1996):
12. Sofia Coppola's **Lost in Translation** (2003).

Answers: 1. Tennessee Williams. 2. Budd Schulberg. 3. John Osborne. 4. Robert Bolt. 5. Francis Ford Coppola. 6. Oliver Stone. 7. John Briley. 8. Ruth Prawer Jhabvala. 9. Woody Allen. 10. Emma Thompson. 11. Coen Brothers. 12. Sofia Coppola.

Academy Award for Best Song

The Academy Award for Best Original Song is presented to the songwriters (not the performers) who have composed the best original song written specifically for a film.

Can you identify the films which featured the following best Original Songs?

1. Doris Day, "*Que Sera, Sera*" (1956 film).
2. Audrey Hepburn, "*Moon River*" (1961 film).
3. Dick Van Dyke and Julie Andrews, "*Chim Chim Cher-ee*" (1964 film).
4. Noel Harrison (composer Michel Legrand) "*Windmills of Your Mind*". (1968 film).
5. B J Thomas, "*Raindrops keep fallin on my head*", (1969 film).
6. Lionel Richie, "*Say You, Say Me*" (1985 film).
7. Sukhvinder Singh (composed by Rahman) "*Jai Ho*" (2008 film).

Answers: *1. The man who knew Too Much. 2. Breakfast at Tiffany's. 3. Mary Poppins. 4. The Thomas Crown Affair. 5. Butch Cassidy and the Sundance Kid. 6. White Nights. 7. Slumdog Millionaire.*

Other Academy Awards

Charlie Chaplin received the longest standing ovation in Oscar's history in 1972.

Can you name these Academy Awards?

1. Which Academy Award did Michael Kahn win for **Raiders of the Lost Ark** (1981), **Schindler's List** (1993), and **Saving Private Ryan** (1998)?
2. The only personal Academy Award Kubrick received was for **2001: Space Odyssey:** (1968). In which category did he win?
3. Cedric Gibbons, who designed the Oscar statuette in 1928, himself won 11 of them. Some of the film were **Gaslight** (1944), **Little Women** (1949), **An American in Paris** (1951), **Julius Caesar** (1953) and **Somebody Up There Likes Me** (1956) In which field did he win them?
4. This award is given periodically to producers whose body of work reflect consistently high quality films.

5. Which Academy Award did Douglas Shearer win for **The Big House** (1930), **Naughty Marietta** (1935), **San Francisco** (1936), **Strike Up the Band** (1940) and **The Great Caruso** (1951).
6. Which first ever Academy Award was won by the 2001 film **Shrek**?

Answers: 1. Best Film Editing. 2. Best Visual Effect. 3. Best Art direction. 4. The Irving G. Thalberg Memorial Award. 5. Best Sound Recording. 6. Best Animated Feature.

Academy Honorary Award Awards

The Board of Governors of the Academy of Motion Picture Arts and Sciences (AMPAS) presents these awards to celebrate motion picture achievements that are not covered by existing Academy Awards. Charlie Chaplin received the first Honorary Award in the 1st Academy Award in 1929.

1. Who won this award in 1954 for "for their contributions to the advancement of the motion picture industry."
2. Who was awarded in 1948 "for his services to the industry over a period of forty years." The citation also described him as "a man who has been called the father of the feature film in America" .
3. Who in 1960 was awarded "for his creative pioneering in the field of cinema comedy?"
4. Who in 1974 was bestowed the Award for being "a genius who, with grace, responsibility and enviable devotion through silent film, sound film, feature, documentary and television, has won the world's admiration".
5. Who in 1992 was rewarded for "recognition of his rare mastery of the art of motion pictures, and of his profound humanitarian outlook?"
6. Who in 2016, was rewarded because he " starred in – and sometimes wrote, directed and produced – more than 30 martial arts features in his native Hong Kong, charming audiences with his dazzling athleticism, inventive stunt work and boundless charisma".

Answers: 1. Bausch & Lomb Optical Company. 2. Adolphe Zukor. 3. Stan Laurel. 4. Jean Renoir. 5. Satyajit Ray. 6. Jackie Chan.

Mixed Bag – Oscars Awards

The Treasure of Sierra Madre (1948) is the first in which both father and son received Oscars. John Houston received best director Oscar while his father Walter Houston received for best supporting actor.

1. In the first Academy Award competition in 1929, he polled more votes than anyone else for the Best Actor, but his name was removed from the list of contenders. Who was he?
2. The youngest person to win a competitive Oscar was Tatum O' Neal who won Best Supporting Actress for **Paper Moon** (1973). How old she was when she won the Oscar?
3. Youngest person to be nominated for a Best Supporting Actor Oscar and the youngest Oscar nominee in any category was 8-year-old Justin Henry. For which film was he nominated for Oscar?
4. Peggy Ashcroft was 76 when she became the oldest actress to win a Best Supporting Actress Oscar. For which film did she win?
5. Who was the first African-American male to win a competitive Oscar?
6. Cimmarron is one of the two films which received nominations in every eligible category (13 nominations). Which was the other?
7. In 1935, the Academy retained an accounting firm to tabulate the ballots and ensure the secrecy of the results. Name the firm which continues to tabulate the voting to this day.
8. Who were the first brother and sister pair to win Oscars?
9. Who were the first brother and sister pair to win Oscars for acting.
10. In 1946, the short film **The House I live in** (1945) starring Frank Sinatra was awarded an honorary Oscar. What was the subject?
11. Who is the first person to win an Oscar for playing a character of the opposite sex.

12. How is a native American girl Sacheen Littlefeather connected to Academy Awards?.
13. What is common to **Cimarron** (1931), **Dances with the Wolves** (1990) and **Unforgiven** (1992)?
14. The only film in Oscar history to receive four female acting nominations (Bette Davis and Anne Baxter as Best Actress, Celeste Holm and Thelma Ritter as Best Supporting Actress).
15. In 1951, José Ferrer won a Best Actor Oscar for **Cyrano de Bergerac** (1950). In 2006, his nephew won Best Supporting Actor Oscar for **Syriana** (2005). Who was he?
16. Who was the first Spanish actor to win an Oscar?
17. First mother and daughter pair to be nominated for Oscar?
18. What is common to Carmine Caridi, Harvey Weinstein, Roman Polanski, and Bill Cosby?
19. This director-screenwriter won Oscars for both best director and best screenplay Oscars back to back for **All About Eve** (1950) and **A Letter to Three Wives** (1949).
20. Which Roman Polanski's 1974 film was nominated for 11 Oscars but won only one - Best writing, original screenplay?
21. Which 1993 film directed by James Ivory was nominated for eight Oscars but did not win any?
22. For what did H. R. Giger and Carlo Rambaldi together win the 1980 Academy Award for Visual Effects?
23. Who wrote the story and screenplay for **Roman Holiday** (1953)?

Answers: 1.Rin Tin Tin. 2. She was ten. 3. Kramer vs Kramer. 4. A Passage to India. 5. Sidney Poitier. 6. Who's Afraid of Virginia Woolf? 7. PricewaterhouseCoopers. 8. Nora Shearer won Best actress Oscar in **The Divorcee** (1930) and Douglas Shearer won Best sound recording Oscar for **The Big House** (1930). 9. Lionel Barrymore won Best Actor Oscar for **A Free Soul** (1931) and Ethel Barrymore won Best Supporting Actress Oscar for **None But the Lonely Heart** (1944). 10. Tolerance. 11. Linda Hunt in **The Years of Living Dangerously** (1982). 12. She was sent by Marlon Brando to denounce the treatment of Native Americans by the film industry. Brando refused the Best Actor Oscar for **The Godfather**. 13. Western films to win best film Oscars. 14. **All About Eve**. 15. George Clooney. 16. Javier Bardem. 17. Judy Garland, Liza Minelli. 18. Only members of the The Academy of Motion Picture

Arts and Sciences (AMPAS) to have had their membership revoked. 19. Joseph L. Mankiewicz. 20. **Chinatown**. 21. **Remains of the Day**. 22. For their design of the Alien. 23. Dalton Trumbo (Ian McLellan Hunter, who fronted for Dalton Trumbo, received the award. In December 1992 the Academy decided to change the records and credited Mr. Trumbo with the achievement.

Other Awards

Cannes Film Festival

Cannes International film festival started in September 1946 and 21 countries presented their films in it. Palme d'Or (The Golden Palm), earlier called Grand Prix du Festival International du Film, is the most prestigious award given at Cannes for the best film, for which 20 films compete in the Official Selection. The second-most prestigious prize of the festival after the Palme d'Or is the Grand Prix, bestowed by the jury of the festival. In 1946, Indian film **Neecha Nagar** shared the Grand Prix du Festival International du Film (Best Film) award with 11 of the 18 entered feature films. It's the only Indian film to win a best film award at Cannes.

Identify the following films:

1. In 1955, US director Dilbert Mann won the first Palme d'Or for this film starring Ernest Borgnine.
2. In 1958, Russian director Mikhail Kalatozov won the Palme d'Or for this film.
3. In 1967, Italian director Michelangelo Antonioni won the Grand Prix du Festival International du Film for this film starring David Hemmings.
4. In 1970, US director Robert Altmann won the Grand Prix du Festival International du Film for this film starring Donald Sutherland.
5. In 1971 US director Dalton Trumbo won the Grand Prix Spécial du Jury for this film.
6. In 1979, US director Francis Ford Coppola won the Palme d'Or for this film starring Marlon Brando.

7. In 1980, Japanese director Akira Kurasava won the Palme d'Or for this film.
8. In 1989, Italian director Giuseppe Tornatore won the Grand Prix du Jury for this film.
9. In 1993 Chinese director Chen Kaige's won the Palme d'Or for this film starring Gong Li.
10. In 1993 News Zealand director Jane Campion won the Palme d'Or for the film starring Holly Hunter.
11. In 2000, Icelandic actress Bjork won the best actress award for this film directed by Lars von Trier.
12. In 2000, Chinese actor Tony Chiu-Wai Leung won the best actor award for this film directed by Wong Kar-wai.

Answers: 1. Marty. 2. The Cranes are Flying. 3. Blow-up. 4. M.A.S.H. 5. Johnny Got His Gun. 6. Apocalypse Now. 7. Kagemusha. 8. Cinema Paradiso. 9. Farewell My Concubine. 10. The Piano. 11. Dancer in the Dark.12. In the Mood of Love.

Venice Film Festival

Venice Film Festival (Mostra), founded in 1932, is the oldest film festival in the world. The Golden Lion awarded for the best film screened in the competition was introduced in 1949. In 1970, a second Golden Lion award was introduced to honor people for important contribution to cinema. Silver Lion is awarded for the best director in the competition.

Identify the following award-winning films:

1. Akira Kurusawa's 1950 film which won the Golden Lion for Best film.
2. Satyajit Ray's 1956 film which won the Golden Lion for Best film.
3. Andre Tarkovsky's 1962 film which won the Golden Lion for Best film.
4. Goutam Ghosh's 1984 film in which Naseeruddin Shah won the Best Actor Award (also called Volpi Award) in 1984 for his role as Naurangiain.

5. Eric Rohmer's 1986 film which won Golden lion.
6. Louis Malle's 1987 film which won the Golden Lion for Best film in 1987.
7. Martin Scorsese's 1990 film which won the Silver Lion for Best Direction award in 1990.
8. Buddhadeb Dasgupta's 2000 film which won the Silver Lion for Best Direction award.
9. Mira Nair's 2002 film which won the Golden Lion for Best film.
10. Andrei Konchalosky's 2014 film which won the Silver Lion.

Answers: 1. *Rashoman*. 2. *Aparajito*. 3. *Ivan's Childhood*. 4. *Paar*. 5. *The Green Ray*. 6. *Au revoir les Enfants*. 7. *Goodfellas*. 8. *Uttara*. 9. *Monsoon Wedding*. 10. *The Postman's White Nights*

Berlin Film Festival

Berlin International Film Festival (Berlinale), started in West Berlin in 1951, is one of the "Big Three" alongside the Venice Film Festival and Cannes Film Festival.

A Golden Bear in the Berlin film festival is awarded to the best film, the best short film and lifetime achievement. Silver Bear, introduced in 1956, is awarded for Individual achievement in direction and acting.

Identify the films which were awarded in the Berlin Film Festival.

1. Henri-Georges Clouzot's 1953 film which won the Golden Bear for Best film.
2. Sidney Lumet's 1957 film which won the Golden Bear for Best film.
3. Satyajit Ray's 1963 film which won the Silver Bear for Best Director.
4. Satyajit Ray's 1964 film which won the Silver Bear for Best Director.
5. Madhur Jaffrey won the Silver Bear for Best Actress for this 1965 film.

6. Mrinal Sen's 1981 film which won the Silver Bear - Special Jury Prize.
7. Zhang Yimou's 1987 film won the Golden Bear for Best film.
8. Asghar Farhadi's 2011 film won the Golden Bear for Best film.

Answers: 1. The Wages of Fear. 2. 12 Angry Men. 3. The Big City. 4. Charulata. 5. Shakespeare Wallah. 6. Akaler Sandhane. 7. Red Sorghum. 8. Separation.

Karlovy Vary Film Festival

This international film festival is held in the Czech Republic city of Karlovy Vary. The first film festival was held in 1946, and became competitive in 1948. The festival awards Crystal Globe as the main award of the festival.

1. Who won the inaugural Best Director award in 1948 for **The Best Years of Our Lives**?
2. Who directed **Jagte Raho** (1956, Hn), which won the Grand Prix Crystal Globe in 1957?
3. Who won the best actress award in 1958 for the film for **Mother India** (Hnd)?
4. Who directed **Kes** (1969) which won the Grand Prix Crystal Globe in 1970?
5. Who won the Best Actor award in 1971 for **Interview** (Bn)?
6. Who won the Best Actor award in 1984 (ex aequo) for **Half Truth** (Hn)?

Answers: 1. William Wyler. 2. Sombhu Mitra and Amit Maitra. 3. Nargis. 4. Ken Loach. 5. Ranjit Mallick. 6. Om Puri.

Mixed Bag – Awards

The Golden Rasberry awards (Razzie) were bestowed by film industry veterans John J. B. Wilson and Mo Murphy, in recognition of the worst in American films. The first ceremony was held in Wilson's living room after the Oscar show ended in 1981. Halle Barry was the

first actress to accept a Worst Actress Razzie in 2005 for her role in **Catwoman** (2004).

1. Which award is France's main annual film award and was first awarded in 1976. It is the French equivalent of Academy Award?
2. Which award is Spain's main annual film awards and was first awarded in 1987. It is Spanish equivalent of Academy Award?
3. Which award is Belgium's main annual film award and given for excellence in cinematic achievements?
4. Which award is Mexico's main annual film awards and was first awarded in 1947. It is Mexican equivalent of Academy Award?
5. What was started in 1978 by Hastings Bad Cinema Society, a Los Angeles-based group of film buffs and movie critics devoted to honoring the worst films of the year?
6. Which award, presented annually by the Academy of Science Fiction, Fantasy and Horror Films since 1973, honor science fiction, fantasy, and horror on film?
7. Which awards, presented annually by the World Science Fiction Society since 1953, are given annually for the best science fiction or fantasy works and achievements of the previous year?
8. In 1978, Harry Medved, with Randy Dreyfuss and Michael Medved, wrote *The Fifty Worst Films of All Time (And How They Got That Way)*. The Medved brothers also wrote *The Golden Turkey Awards* and *The Hollywood Hall of Shame*. According to Medved brothers' *The Golden Turkey Awards* who is the worst actor?
9. This festival started as US/Utah Film Festival in 1978. It was renamed after Robert Redford's film **Butch Cassidy and the Sundance Kid** (1969). Redford was the inaugural chairman of the festival. Which is the largest independent film festival in the United State and takes place in Park City, Utah?

Answers: 1. The Cesar Award. 2. The Goya award. 3. The Magritte Award. 4. The Ariel Award. 5. The Stinkers Bad Movie Awards. 6. The Saturn Award (aka a Golden Scroll). 7. The Hugo Awards (aka Science Fiction Achievement Awards). 8. Richard Burton. 9. Sundance Film Festival.

No Mean Roles

Child Stars

Identify the following child actors and actresses.

1. Born in 1914 in Los Angeles. He used to perform on stage since he was five and was spotted by Charles Chaplin. His first major role was in Charlie Chaplin's **The Kid** (1921).
2. Born in 1920 in Brooklyn, New York. Starting in 1927 he played lead character Mickey McGuire in a film series. He acted in **The Adventures of Huckleberry Finn** (1939), **National Velvet** (1944) and **Breakfast at Tiffany's** (1961). He received an Honarary Academy Award in 1983.
3. Born in 1928 in California. She started acting at the age of three. Famous for her curly hairy. Her films were **Little Miss Marker** (1934), **Curly Top** (1935) and **Heidi** (1937). At age six she became the youngest person ever to receive an Academy Award.
4. Born in 1962 in Los Angeles. She is famous for her role in **Taxi Driver** (1976).
5. Born in 1963 in Los Angeles. She won an Oscar for her role in **Paper Moon** (1973).
6. Born in 1975 in California. At the age of six she played the part of Gertie, Eliot's sister, in Steven Spielberg's, **E.T. the Extra-Terrestrial** (1982).
7. Born in 1980 in New York City. He was 9 when he acted in **Uncle Buck** (1989) along with John Candy. His most memorable role was as Kevin McCallister in **Home Alone** (1990).
8. Born in 1988 in Los Angeles. His first film role was as **Forrest Gump's** son. He starred in **The Sixth Sense** (1999) and **A.I. Artificial Intelligence** (2001).

9. Born in 1982 in Canada. She was nine when she acted in **The Piano** (1993), a role for which she won a best supporting actress Oscar.
10. Born in 1984 in New York City. She was noticed for role in **Manny & Lo** (1996) and **The Horse Whisperer** (1998).

Answers: 1. Jackie Coogan. 2. Mickey Rooney. 3. Shirley Temple. 4. Jodie Forster. 5. Tatum O Neal. 6. Drew Barrymore. 7. Macaulay Culkin. 8. Haley Joel Osment. 9. Anna Paquin. 10. Scarlett Johansson.

Producers

Sam Goldwyn was born in 1879 in Warsaw as Schmuel Gelbfisz. He reached the US in 1898 and became a successful glove salesman. He produced films such as **Wuthering Heights** (1939), **The Little Foxes** (1941), and **The Best Years of Our Lives** (1946), many directed by William Wyler. Can you identify the following film producers?

1. Born in 1884 in Russia now in Ukraine as Lazar Meir. His family moved to the US and he was raised in poverty. He started as a scrap metal dealer and went into theatrical business. He hired Irving Thalberg as his production manager. He became the highest paid corporate executive in the United State. After mergers with other studios, he was one of the founders of MGM.
2. Born in 1891 in New York of Jewish parents. Crude, uneducated, and foul-mouthed, he was one of the most loathed Hollywood directors. He, along with his brother Jack, set up Columbia Pictures, which started producing B grade films. He secured the services of Fritz Capra who made several hit films such as **It Happened One Night** (1934) for him. Under his leadership, Columbia posted profits for 38 consecutive years (1920 to 1958), a record unmatched by any other Hollywood studio.
3. He was born in 1893 in Hungary as Sándor László Kellne. He became a British subject. In 1933 he started his production company, London Films, which produced **The Private Life of Henry VIII.** (1933), **The Scarlet Pimpernel** (1934) and **Elephant Boy** (1937).

4. Born in 1899. He was a studio manager with Universal Studios for over 3 years where he produced over a hundred films. In 1925 he became the head of production of MGM. Under him, MGM became the most successful studio. Some of the films he produced were **Broadway Melody** (1929), **Grand Hotel** (1932) **Mutiny of the Bounty** (1935) and **A Night at the Opera** (1935).
5. Born in 1902 in Nebraska. He had no formal education, no inherited fortune, shared no religious background with his employers and no family connections to open any doors. He started with Mack Sennet and then joined Warner Brothers, as writer for the The Rin Tin Tin series. He produced three Oscar winners: **How Green Was My Valley** (1941), **Gentleman's Agreement** (1947) and **All About Eve** (1950). His other films were **The Grapes of Wrath** (1940), **The Razor's Edge** (1946), and **The Longest Day** (1962).
6. Born in 1902 in Pennsylvania. He produced back-to-back Oscar best picture winners **Gone with the Wind** (1939) and **Rebecca** (1940). Other films he produced were **Anna Karenina** (1935) and **The Prisoner of Zenda** (1937).
7. Born in 1912 in Lombardy, Italy. With Dino De Laurentiis, he produced the first Italian color films: **Toto in Color** (1952, It). His partnership with Dino produced films such as **La Strada** (1954, It), **Attila** (1954, It) and **Ulysses** (1954). His other films are **Doctor Zhivago** (1965) and **Blow-Up** (1966).
8. Born in 1919 in Naples province. As a child he sold spaghetti made by his father. After the War, he produced many realistic Italian films, such as **Bitter Rice** (1949, It). His partnership with Dino produced films such as **La Strada** (1954, It), **Ulysses** (1954, It) and **Attila** (1954, It). He produced Felllini's **The Nights of Cabiria** (1957, It). He relocated to the US where he made films such as **Serpico** (1973), **King Kong** (1976). **Flash Gordon** (1980) and **Ragtime** (1981).
9. He was born in 1952 in New York City. His film **Shakespeare in Love** (1998) won the best picture Oscar. He produced **Pulp Fiction** (1994) and **Gangs of New York** (2002). In 2017, he was dismissed from his company and later arrested after allegations of sexual abuse surfaced.

Answers: 1. Louis B. Mayer. 2. Harry Cohn. 3. Alexander Korda. 4. Irving Thalberg. 5. Darryl F. Zanuck. 6. David O. Selznick. 7. Carlo Ponti. 8. Dino De Laurentiis. 9. Harvey Weinstein.

Screenplay Writers

Cesare Zavattini was born in 1902 in Italy. As a writer and screenplay writer he was the main force in Italy's neo-realist movement. His three decade-long collaboration with director Vittorio de Sica resulted in classics such as **Shoeshine** (1946), **Bicycle Thieves** (1948), **Umberto D** (1952) and **Two Women** (1960). Can you identify the following screenplay writers?

1. He was born in 1906 in Sucha, present Poland. He won best writing Oscars for **The Lost Weekend** (1945), **Sunset Boulevard** (1950) and **The Apartment** (1960). His other films are **Ninotchka** (1939), **Some Like It Hot** (1959) and **Irma la Douce** (1963).
2. Born in 1915 in New York City. He received an Honorary Oscar in 2001. He was nominated for Oscars for **North by Northwest** (1959), **West Side Story** (1961), **The Sound of Music** (1965) and **Who's Afraid of Virginia Woolf?** (1966).
3. Born in 1924 in Cheshire, England. He won Oscar for **Dr Zhivago** (1965) and **A Man for All Seasons** (1966). His other films are **Lawrence of Arabia** (1962) and **The Mission** (1986).
4. Born in 1928 in New York City. He was nominated for Oscar for **Dr. Strangelove** (1964), **2001: A Space Odyssey** (1968), **A Clockwork Orange** (1971) and **Full Metal Jacket** (1987). His other films as writer are **Barry Lyndon** (1975), **The Shining** (1980) and **Eyes Wide Shut** (1999).
5. Born in 1939 in Detriot. He won Oscars for **Patton** (1970), **The Godfather** (1972) and **The Godfather Part II** (1974). He was nominated for Oscar for **Apocalypse Now** (1979).
6. Born in 1946 in New York City. Served in Vietnam war and was awarded for gallantry. Awarded an Oscar for screenplay of **Midnight Express** (1978). He was nominated for Oscars for **Platoon** (1986) and **JFK** (1991). He wrote screenplays for **Conan the Barbarian** (1982), and **Scarface** (1983).

7. Born in 1946 in Michigan. He wrote the screenplays for **Taxi Driver** (1976), **Raging Bull** (1980) and **The Last Temptation of Christ** (1988).
8. Born in 1968 in New Jersey. He won an Oscar for Bryan Singer's **The Usual Suspect** (1995). He wrote the screenplays of films **Valkyrie** (2008) and **Jack the Giant Slayer** (2013), both directed by Bryan Singer. His other films are **The Way of the Gun** (2000) and **The Tourist** (2010).

Answers: *1. Billy Wilder. 2. Ernst Lehman. 3. Robert Bolt. 4. Stanley Kubrick. 5. Francis Ford Coppola. 6. Oliver Stone. 7. Paul Schrader. 8. Christopher McQuarrie.*

Famous writers

The Russian poet Vladimir Mayakovsky wrote the screenplay of Nikandr Turkin's **Shackled by Film** (1918).

Match the film with its literary screenplay writers:

	Film	Screenplay writer
1	Vsevolod Pudovkin's **Storm Over Asia** (1928, Ru)	Gore Vidal
2	Josef von Sternberg's **The Devil Is a Woman** (1935)	John Dos Passos
3	Howard Hawk's **The Big Sleep** (1946)	Osip Brik
4	William Wyler's **The Best Years of Our Lives** (1946)	Robert E. Sherwood
5	Carol Reed's **The Third Man** (1949)	Ray Bradbury
6	John Houston's **Moby Dick** (1956)	Graham Greene
7	John Houston's **The Misfits** (1961)	Roald Dahl
8	Lewis Gilbert's **You Only Live Twice** (1967)	Arthur Miller
9	Ken Hughes' **Chitti Chitti Bang Bang** (1968)	Ruth Prawar Jhabvala
10	Tinto Brass's **Caligula** (1979)	William Faulkner
11	Karel Reisz's **The French Lieutenant's Woman** (1981)	Harold Pinter
12	James Ivory's **Heat and Dust** (1983)	Ruth Prawar Jhabvala
13	James Ivory's **A Room with a View** (1985)	Tom Stoppard
14	Steven Spielberg's **Empire of the Sun** (1987)	Ruth Prawar Jhabvala
15	James Ivory's **Howards End** (1992)	Roald Dalh
16	James Ivory's **The Remains of the Day** (1993)	Ruth Prawar Jhabvala

Answers: 1. Osip Brik. 2. John Dos Passos. 3. William Faulkner. 4. Robert E. Sherwood. 5. Graham Greene. 6. Ray Bradbury. 7. Arthur Miller. 8. Roald Dahl. 9. Roald Dalh. 10. Gore Vidal. 11. Harold Pinter. 12. Ruth Prawar Jhabvala. 13. Ruth Prawar Jhabvala. 14. Tom Stoppard. 15. Ruth Prawar Jhabvala. 16. Ruth Prawar Jhabvala.

Screenplay Writers

French poet Jacques Prévert wrote the screenplay of Marcel Carné's *Les Enfants du Paradis* (1943, Fr).

Match the film with its screenplay writers:

	Film	Screenplay writer
1	Charles Chaplin's *Limelight* (1952)	Alan Jay Lerner
2	George Cukor's *My Fair Lady* (1964)	Charles Chaplin
3	John G Avildsen's *Rocky* (1976)	George Lukas
4	Woody Allen's *Annie Hall* (1977)	Ethan and Joel Coen
5	George Lukas' *Star Wars: Episode IV - A New Hope* (1977)	Sylvester Stallone
6	David Lean's *A Passage to India* (1984)	Eric Roth
7	Quentin Tarantino's *Reservoir Dogs* (1992)	Quentin Tarantino
8	Steven Spielberg's *Schindler's List* (1993)	Stevan Zaillian
9	Quentin Tarantino's *Pulp Fiction* (1994)	Quentin Tarantino
10	Robert Zemeckis' *Forrest Gump* (1994)	Santha Rama Rau
11	Joel Coen's *Fargo* (1996)	Ethan and Joel Coen
12	James Cameron's *Titanic* (1997)	James Cameron
13	Joel Coen's *The Big Lebowski* (1998)	Woody Allen
14	Michael Mann's *The Insider* (1999)	Eric Roth
15	Martin Scorsese's *Gangs of New York* (2002)	Stevan Zaillian
16	James Cameron's *Avatar* (2009)	James Cameron

Answers: 1. Charles Chaplin. 2. Alan Jay Lerner. 3. Sylvester Stallone. 4. Woody Allen. 5. George Lukas. 6. Santha Rama Rau. 7. Quentin Tarantino. 8. Stevan Zaillian. 9. Quentin Tarantino. 10. Eric Roth. 11. Ethan and Joel Coen. 12. James Cameron. 13. Ethan and Joel Coen. 14. Eric Roth. 15. Stevan Zaillian. 16. James Cameron.

US Cinematographers

Arthur Edeson was born in 1891 in New York. He was nominated for Oscars for *In Old Arizona* (1929), *All Quiet on the Western Front* (1930) and *Casablanca* (1943). His other films include Raoul Walsh's *The Thief of Bagdad* (1924) and James Whale's *Frankenstein* (1931). He was one of the founders of the American Society of Cinematographers.

Identify the following cinematographer:

1. Born in 1896 in California. He won an Oscar for *Gone with the Wind* (1939). His other films are *Jezebel* (1938), starring Bette Davis and *Rebel Without a Cause* (1955) starring James Dean. He was also the cinematographer for Sohrab Modi's *Jhansi Ki Rani* (1953, Hnd).
2. Born in Illinois in 1904. He won an Oscar in 1939 for *Wuthering Heights* (1939). His other works includes *Citizen Kane* (1941), *The Long Voyage Home* (1940), *The Grapes of Wrath* (1940) and *Intermezzo: A Love Story* (1939).
3. Born in 1909 in California. He was the favorite cinematographer of Alfred Hitchcock who used him in *Strangers on a Train* (1951), *Vertigo* (1958), *Rear Window* (1954) and *North by Northwest* (1959). He won an Oscar for *To Catch a Thief* (1955). His other films are *The Fountainhead* (1949) starring Gary Cooper and *The Glass Menagerie* (1950) starring Jane Wyman.
4. Born in 1926 in Tahiti. He was nominated for Oscar for *In Cold Blood* (1967) and *The Day of the Locust* (1975). He won Oscars for *Butch Cassidy and the Sundance Kid* (1969), *American Beauty* (1999) and *Road to Perdition* (2002).
5. Born in 1946 in California. He was nominated for Oscar for *Who Framed Roger Rabbit?* (1988). He is associated with John Carpenter's films such as *Halloween* (1978), *The Fog* (1980), *Escape from New York* (1981) and *The Thing* (1982). He collaborated with Robert Zemeckis in all *Back to the Future* film. His other films are *Hook* (1991), *Jurassic Park* (1993) and *Apollo 13* (1995).
6. Born in 1955 in Massachusetts. He won Oscars for *JFK* (1951), *The Aviator* (2004) and *Hugo* (2011). His other films include *Platoon* (1986), *Born on the Fourth of July* (1989), *Casino*

(1995), **Nixon** (1995), **Inglourious Basterds** (2009) and **Django Unchained** (2012).

Answers: 1. Ernest Haller. 2. Gregg Tolland. 3. Robert Burks. 4. Conrad L. Hall. 5. Dean Cundey. 6. Robert Richardson.

British Cinematographers

Freddie Young was born in 1902 in London. He is best known for **Lawrence of Arabia** (1962), **Doctor Zhivago** (1965) and **Ryan's Daughter** (1970), all of which won him Academy Awards for Best Cinematography. His best work was for director David Lean, whom he once had rebuffed on the set of **Major Barbara** (1941), saying "Don't teach your grandmother to suck eggs." His other films are **Goodbye, Mr Chips** (1939), **Ivanhoe** (1952), **Lust for Life** (1956), **Lord Jim** (1965) and **You Only Live Twice** (1967).

1. Born in 1913 in London. He started as a photojournalist and had no formal training as cinematographer. He won BAFTA awards for **The Servant** (1963), **The Great Gatsby** (1974) and **Julia** (1977). His other films are **The Lion in Winter** (1968), **The Italian Job** (1969), and **Raiders of the Lost Ark** (1981).
2. Born in 1914 in Hertfordshire, England. He was a founder member of the British Society of Cinematographers. He was associated with **Dr. Strangelove** (1964), **A Hard Day's Night** (1964), **The Omen** (1976) and **Star Wars** (1977).
3. Born in 1914 in Lancashire. He is known for his work in two very different genres, period pieces and science fiction. He won Oscars for **Cabaret** (1972) and **Tess** (1979). He won BAFTA film award for **Becket** (1964), **2001: A Space Odyssey** (1968), **A Bridge Too** Far (1977) and **Superman** (1978).
4. Born in Norfolk, England in 1914. He won an Oscar for **Black Narcissus** (1947). His other films were **The African Queen** (1951), **The Prince and the Showgirl** (1957) and **Death on the Nile** (1978). He was the first cinematographer to win an honorary Oscar in 2001.
5. Born in 1915 in Hillingdon, Middlesex. In World War II, he served as an RAF bomber pilot. He won an Oscar for

Fiddler on the Roof (1971). He won BAFTA film award for ***The Pumpkin Eater*** (1964), ***The Hill*** (1965) and ***The Spy Who Came In from the Cold*** (1965).

Answers: 1. Douglas Slocombe. 2. Gilbert Taylor. 3. Geoffrey Unsworth. 4. Jack Cardiff. 5. Oswald Morris.

Other Cinematographers

Eduard Tisse was born in 1897 in Russia. He was known for for his collaboration with Sergei M. Eisenstein. He is known for ***Battleship Potemkin*** (1925, Ru), ***Alexander Nevsky*** (1938, Ru) and ***Ivan the Terrible, Part I*** (1944, Ru). Can you identify the following cinematographers?

1. Born in 1908 in Kyoto, Japan. He is known for his work on Kurosawa's ***Rashomon*** (1950, Jp) and ***Yojimbo*** (1961, Jp). His other films are Kenji Mizoguch's ***Ugetsu*** (1953, Jp) and Kon Ichikawa's ***Brother*** (1960, Jp).
2. Born in 1922 in Sweden. He first worked with Ingmar Bergman in films such as ***The Virgin Spring*** (1960, Sw), ***Through a Glass Darkly*** (1961, Sw), ***Winter Light*** (1963, Sw) and ***Persona*** (1966, Sw). He received Oscar for ***Fanny and Alexander*** (1982, Sw). His other films include ***Pretty Baby*** (1978), ***The Unbearable Lightness of Being*** (1988), ***Sleepless in Seattle*** (1993), ***Crimes and Misdemeanors*** (1989), ***Chaplin*** (1992), and ***What's Eating Gilbert Grape*** (1993).
3. Born in 1930 in Spain but moved to Cuba by age 18. After his films were banned in Cuba, he moved to Paris and became the favourite cameraman of Éric Rohmer and François Truffaut. He was nominated for Oscar for ***Kramer vs. Kramer*** (1979), ***The Blue Lagoon*** (1980) and ***Sophie's Choice*** (1982). He won an Oscar for Terence Malik's ***Days of Heaven*** (1978). His other films are Éric Rohmer's ***Claire's Knee*** (1970, Fr) and François Truffaut's ***The Last Metro*** (1980, Fr).
4. Born in 1931 in Calcutta. He was associated in Satyajit Ray's films such as ***Pather Panchali*** (1955, Bn). ***The World of Apu*** (1959, Bn), ***Devi*** (1960, Bn). ***The Big City*** (1963, Bn)

and ***Charulata*** (1964, Bn). His other film is James Ivory's ***Householder*** (1963).
5. Born in 1933. He was associated in Satyajit Ray's films such as ***Days and Nights in the Forest*** (1970, Bn), ***Company Limited*** (1971, Bn) and ***Ghare-Baire*** (1984, Bn).
6. Born in 1940 in Rome. He received Oscars for ***Apocalypse Now*** (1979). ***Reds*** (1981) and ***The Last Emperor*** (1987). He was nominated for Oscar for ***Dick Tracy*** (1990).
7. Born in Mexico City in 1964. He won successive Oscars for ***Birdman or (The Unexpected Virtue of Ignorance)*** (2014) and ***The Revenent*** (2015). His other films were ***The New World*** (2005) and ***The Tree of Life*** (2011).
8. He was born in 1924 in Paris, France. He is known for Truffaut's ***Shoot the Piano Player*** (1960, Fr) and ***Jules and Jim*** (1962, Fr) and Goddard's ***Breathless*** (1960, Fr) and ***Pierrot le Fou*** (1965, Fr).

Answers: 1. Kazuo Miyagawa. 2. Sven Nykvist. 3. Néstor Almendros. 4. Subrata Mitra. 5. Soumendu Roy. 6. Vittorio Storaro. 7. Emmanuel Lubezki. 8. Raoul Coutard.

Music Composers

Max Steiner was born in 1888 in Vienna, where he completed an eight-year music course in one year. He studied music under Gustav Mahler and, like another gifted Austrian Eric Wolfgang Korngold, moved to the US. He won Oscars for ***The Informer*** (1935), ***Now, Voyager*** (1942) and ***Since You Went Away*** (1944). His other films are ***Gone with the Wind*** (1939), ***Sergeant York*** (1941) and ***Casablanca*** (1942). Can you identify these music composers?

1. Born in 1894 in Kremenchuk, Russia, now in Ukraine. He was a virtuoso pianist. He gave score for ***Lost Horizon*** (1937) and ***It's a Wonderful Life*** (1946), both directed by Frank Capra. He won Oscar for ***High Noon*** (1952) and ***The Old Man and the Sea*** (1958). His other films are ***Mr. Smith Goes to Washington*** (1939), ***The Moon and Sixpence*** (1942), and ***Giant*** (1956). He composed music for Alfred Hitchcock's ***Strangers on a Train***

(1951). He wrote the score for Howard Hawk's **Red River** (1948).
2. Born in 1897 in Brunn, now in Czech. A child prodigy, he composed an orchestral piece at 14. He came to the US at the invitation of Max Reinhardt to score music for his play. He won an Oscar for **The Adventures of Robin Hood** (1938). His other films are **The Sea Hawk** (1940) and **The Private Lives of Elizabeth and Essex** (1939).
3. Born in 1907 in Budapest, now in Hungary. A child prodigy, he graduated with honors from the Leipzig Conservatory in 1929. He won Oscars for **Spellbound** (1945), **A Double Life** (1947) and **Ben-Hur** (1959). His other films are **The Thief of Bagdad** (1940), **Quo Vadis** (1951) and **Ivanhoe** (1952).
4. Born in 1911 in New York City. He wrote nine scores for Hitchcock's films including **Psycho** (1960) and **Vertigo** (1958). His only Oscar was for **The Devil and Daniel Webster.** (1941). He was nominated for Oscars for **Citizen Kane** (1941), **Anna and the King of Siam** (1946), **Obsession** (1976) and **Taxi Driver** (1976). His other films are **The Day the Earth Stood Still** (1951) and **Fahrenheit 451** (1966).
5. Born in 1911 in Milan. His partnership with Felliini yielded scores for **I Vitelloni** (1953, It), **La Strada** (1954, It) and **La Dolce Vita** (1960, It). He composed music for Visconti's **The Leopard** (1963, It) and Zeffirelli's **Romeo and Juliet** (1968). He was nominated for an Oscar for **The Godfather** (1972) and won for **The Godfather: Part II** (1974).
6. Born in 1924 in Lyon, France. He is associated with David Lean's films, three of which won Oscars for him: **Lawrence of Arabia** (1962), **Doctor Zhivago** (1965) and **A Passage to India** (1984). He wrote the scrore for **The Year of Living Dangerously** (1982), **Witness** (1985) and **Dead Poets Society** (1989), all directed by Peter Weir. His other films are **The Tin Drum** (1979) and **The Last Tycoon** (1976).
7. Born in 1928 in Rome. He provided score for Sergio Leone's spaggeti westerns such as **For a Few Dollars More** (1965) and **The Good, the Bad and the Ugly** (1966). His lone competitive Oscar was for **The Hateful Eight** (2015). Of the over 400 musical scores that he wrote, the notable ones are **The**

Mission (1986), **The Untouchables** (1987) and **Cinema Paradiso** (1988).
8. Born in 1932 in New York. He started as a pianist and when he was 19, he gave his first public performance of his first original composition, a piano sonata. He won five Oscars for **Fiddler on the Roof** (1971), **Jaws** (1975), **Star Wars** (1977), **E.T. the Extra-Terrestrial** (1982) and **Schindler's List** (1993). He scored many of Stephen Spielberg films such as **Raiders of the Lost Ark** (1981), **Amistad** (1997) **Saving Private Ryan** (1998), **Artificial Intelligence: AI** (2001) and **Munich** (2005). He scored for **Star Wars** (1977) and all its sequels. He was nominated for Oscar for **Valley of the Dolls** (1967), **The Towering Inferno** (1974), **Superman** (1978), **Born on the Fourth of July** (1989), **Home Alone** (1990) and **JFK** (1991).
9. Born in 1936 in New York City, settled in UK since 1961. His score for **The French Lieutenant's Woman** (1981) won the BAFTA Award for Film Music. He has written the score for films such as **The Rainbow** (1989) and **The Trial** (1993). He has provided new scores for many silent films such as **Ben-Hur** (1925), **The Phantom of the Opera** (1925), **Safety Last** (1923), Chaplin's **City Lights** (1931) and Erich von Stroheim's **Greed** (1924).
10. Born in 1946 in Toronto. His early films were **The Silence of the Lambs** (1991), **Mrs. Doubtfire** (1993) and **Se7en** (1995). He won Oscars for **The Lord of the Rings: The Fellowship of the Ring** (2001) and **The Lord of the Rings: The Return of the King** (2003). He scored for many of David Cronenberg's films, including **The Fly** (1986). He also composed the music for many of Martin Scorsese's films such as **Gangs of New York** (2002) and **The Aviator** (2004).
11. Born in 1953 in Los Angeles. He was nominated for Oscar for **Good Will Hunting** (1997), **Men in Black** (1997), **Big Fish** (2003), and **Milk** (2008). He has scored for most of Tim Burton's films such as **Batman** (1989), **Edward Scissorhands** (1990), **Planet of the Apes** (2001) **Charlie and the Chocolate Factory** (2005) and **Alice in Wonderland** (2010). His other films are **Mission: Impossible** (1996), **Charlotte's Web** (2006) **Fifty Shades of Grey** (2015).
12. Born in 1957 in Frankfurt. He has scored over 100 films, the 100th being **The Last Samurai** (2003). He won Oscar for **The Lion King** (1994). He was nominated for Oscar for **Rain Man**

(1988), **As Good as It Gets** (1997), **The Thin Red Line** (1998), **Gladiator** (2000) and **Dunkirk** (2017). His other films include **Pearl Harbor** (2001), **Black Hawk Down** (2001), **Batman Begins** (2005) and **The Dark Knight Rises** (2012).
13. Born in 1961 in Paris. He won Oscars for **The Grand Budapest Hotel** (2014) and **The Shape of Water** (2017). Among his many films that were nominated for Oscars are **The Curious Case of Benjamin Button** (2008), **The King's Speech** (2010), **Argo** (2012), **The Imitation Game** (2014) and **Isle of Dogs** (2018). He scored for Wes Anderson's **Fantastic Mr. Fox** (2009) and George Clooney **The Monuments Men** (2014), and Gareth Edwards' **Godzilla** (2014).

Answers: 1. Dimitri Tiomkin. 2. Eric Wolfgang Korngold. 3. Miklos Rosza. 4. Bernard Herrmann. 5. Nino Rota. 6. Maurice Jarre. 7. Ennio Morricone. 8. John Williams. 9. Carl Davis. 10. Howard Shore. 11. Danny Elfman. 12. Hans Zimmer. 13. Alexandre Desplat.

The Voice behind the Face

Walt Disney provided voice for Mickey Mouse in **Steamboat Willie** (1928).

Match the character to the actor who provided the voice:

	Character	Voice
1	Baloo the bear in **The Jungle Book** (1967)	Peter Ustnov
2	Prince John and King Richard in **Robin Hood** (1973)	Phil Harris
3	Genie in **Aladdin** (1992)	Rowan Atkinson
4	Zazu the hornbill in **The Lion King** (1994)	Robin Williams
5	Shenzi the Hyena in **The Lion King** (1994)	Whoopi Goldberg
6	Scar the villainous Lion in **The Lion King** (1994)	Jeremy Irons
7	Simba the Lion in **The Lion King** (1994)	Matthew Broderick
8	Woody, the cowboy doll in **The Toy Story** (1995)	Tom Hanks
9	Kala, Tarzan's adoptive mother, in **Tarzan**	Eartha Kitt
10	The villainous Yzma in **The Emperor's New Groove** (2000)	Glenn Close
11	The ogre Shrek in **Shrek** (2001)	Mike Myers
12	Princess Fiona in **Shrek** (2001)	Scarlett Johansson

	Character	Voice
13	Donkey in **Shrek** (2001)	Eddie Murphy
14	Baloo in **Jungle Book** (2016)	Bill Murray
15	Sher Khan in **Jungle Book** (2016)	Idris Elba
16	Kaa in **Jungle Book** (2016)	Cameron Diaz

Answers: 1. Phil Harris. 2. Peter Ustnov. 3. Robin Williams. 4. Rowan Atkinson. 5. Whoopi Goldberg. 6. Jeremy Irons. 7. Matthew Broderick. 8. Tom Hanks. 9. Glenn Close. 10. Eartha Kitt. 11. Mike Myers. 12. Cameron Diaz. 13. Eddie Murphy. 14. Bill Murray. 15. Idris Elba. 16. Scarlett Johansson.

Costume Designers

The Best Costume Design Oscar was first given out at the 21st Academy Awards in 1949 to **Hamlet** (1948) and **Joan of Arc** (1948). Can you identify the following costume designers?

1. Born in 1987 in California. With 35 Oscar nominations she is the most rewarded costume designer. Among her Oscars wins were **The Heiress** (1949), **All About Eve** (1950), **A Place in the Sun** (1951), **Roman Holiday** (1953) and **The Sting** (1973). Other films she worked for were **To Catch a Thief** (1955) **The Ten Commandments** (1956) and **The Man Who Shot Liberty Valance** (1962).
2. Born in 1904 in London. He received Oscars for **Gigi** (1958) and **My Fair Lady** (1964). He designed costumes for **Anna Karenina** (1958).
3. Born in 1910 in Boston. She won five Oscars for Best Costume Design for **Who's Afraid of Virginia Woolf?** (1966), **Cleopatra** (1963), **West Side Story** (1961), **The King and I** (1956) and **An American in Paris** (1951). She also worked on **Madame Curie** (1943), **Porgy and Bess** (1959) and **Hello, Dolly!** (1969) and **Justine** (1969).
4. He was born near Venice, Italy in 1922 of French parents. He designed men's wardrobe in Jean Cocteau's **Beauty and the Beast** (1946, Fr).

5. Born in 1927 in France, he designed Audrey Hepburn's wardrobes in **Funny Face** (1957), **Breakfast at Tiffany's** (1961) and **Paris When It Sizzles** (1967).
6. Born in 1934 in Italy, he designed the wardrobe for **The Untouchables** (1987). He designed costumes for Richard Gere in **American Gigolo** (1980).
7. He was born in 1936 in Algeria of French parents. He designed the costumes for **Pink Panther** (1963).
8. She designed costumes of **Bandit Queen** (1994), **Earth** (1998), **Water** (2005) and **Midnight's Children** (2012).

Answers: 1. Edith Head. 2. Cecil Beaton. 3. Irene Shraff 4. Pierre Cardin 5. Hubert de Givenchy. 6. Giorgio Armani. 7. Yves Saint-Laurent. 8. Dolly Ahluwalia.

Film Critics

Born in 1890 in France, Louis Delluc was one of the first critics to consider film as an art form. He co-founded the first-ever film society. He coined the term cineaste for a film maker. Can you identfy these well known critics?

1. Born in 1905 in Maryland. He was the film critic of *The New York Times* from 1940 to 1967. He approved of films with social content, such as **The Grapes of Wrath** (1940) and **All the King's Men** (1949). He admired foreign-language films, including many of the Italian neorealist films such as **Rome, Open City** (1945. It) and **The Bicycle Thief** (1948. It).
2. Born in 1909 in Tennessee. In 1941, he became *Time's* film critic. In 1942, he worked as a film critic for *The Nation*. He championed some of Charles Chaplin's underappreciated work such as **Monsieur Verdoux** (1947). He wrote the screenplays for **The African Queen** (1951), for which he was nominated for Oscar, and **The Night of the Hunter** (1955).
3. Born in 1918 in France, he was one of the co-founders of *Cahiers du Cinéma*, the French film magazine founded in 1951. François Truffaut dedicated **The 400 Blows** to him.

4. Born in 1919 in California, she started writing about films in the *New Yorker Magazine* from 1968 to 1991. She wrote the book of essays *I Lost It at the Movies* (1965).
5. Born in 1928 in New York, he was a movie critic of *Village Voice*. He was a leading proponent of the auteur theory of filmmaking in which the director is viewed as the major creative force in a motion picture.
6. Born in 1942 in Illinois, he was a film critic of *Chicago Sun-Times* from 1967 till 2011. He was the first film critic to receive a Pulitzer Prize for criticism in 1975.
7. Born in 1946 in Michigan. He started as a film critic for the *Los Angeles Free Press* and wrote *Transcendental Style in Film: Ozu, Bresson, Dreyer* in 1988. He wrote screenplays for **Taxi Driver** (1976) and **Raging Bull** (1980). He directed 18 films including **Cat People** (1982), **Mishima: A Life in Four Chapters** (1985) and **First Reformed** (2017).
8. Born in Hertfordshire in 1963. He reviewed films for *The Observer* and the *New Statesman*. He used to host programmes for the BBC.

Answers: *1. Bosley Crowther. 2. James Agee. 3. Andre Bazin. 4. Pauline Kael. 5. Andrew Sarris. 6. Roger Ebert. 7. Paul Schrader. 8. Mark Kermode.*

Mixed Bag: No Mean Roles

Although French writer Pierre Boulle received the Oscar for Best Adapted Screenplay for writing the screenplay of **The Bridge over River Kwai** (1952), he was a front for Carl Foreman and Michael Wilson. They could not receive the award because they were blacklisted as communist sympathizers. The Motion Picture Academy added their names to the award in 1984.

1. Who was the only writer to have won three solo Academy Awards for best screenplay? He won for **Marty** (1955), **The Hospital** (1971) and **Network** (1976).
2. Who wrote the screenplay for **Good Will Hunting** (1997) for which they won an Oscar?

3. Who was the French writer and aviator who wrote the story, screenplay and dialogues of *Southern Carrier/ Courrier Sud* (1937, Fr)?
4. What did Garrett Brown invent which was used to shoot many films beginning with *Rocky* (1976) for which he was won a technical Oscar?
5. What was the designation of Elizabeth Himelstein who played roles in over a hundred films including *Fargo* (1996), *The Big Lebowski* (1998), *Pearl Harbor* (2001) and *The Amazing Spider-Man* (2002)?
6. Who was nominated for the Best Makeup Oscar ten times, winning on seven occasion, both records in his field? His other films as special make-up artist were *Ed Wood* (1994), *Escape from L.A.* (1996), *Batman Forever* (1995) and *Wild Wild West* (1999). He was born in 1950 in New York and received the inaugural Oscar for Best Makeup for his work on *An American Werewolf in London* (1981).
7. Born in 1959 in Los Angeles. He worked with John Carpenter on *The Fog* (1980) and *The Thing* (1982). In the latter he created the famous "chest chomp" scene. He worked with Paul Verhoeven on *RoboCop* (1987) and *Basic Instinct* (1992). He worked with David Fincher on *Se7en* (1995) and *Fight Club* (1999). His other film credits include *Fear and Loathing in Las Vegas* (1998). His designation was special make-up effects creator.

Answers: *1. Paddy Cheyefsky. 2. Matt Damon and Ben Affleck. 3. Antoine de Saint-Exupéry. 4. Steadicam camera stabilizer. 5. Dialect coach. 6. Rick Baker. 7. Robin R. Bottin.*

Trivia

Film Titles

The title of **The Little Foxes** (1941) starring Bette Davis is taken from *Song of Solomon* from *The Bible*. The verse is "Catch for us the foxes, the little foxes that ruin the vineyards, our vineyards that are in bloom." Can you identify the sources of the titles of the following films?

1. Stanley Kubrick's **Paths of Glory** (1957).
2. Stanley Kramer's **Inherit the Wind** (1960).
3. Ralph Nelson's **Lilies of the Field** (1963).
4. Orson Welles' **Chimes at Midnight** (1965).
5. Hugh Hudson's **Chariots of Fire** (1981).
6. Victor Fleming's **Gone with the Wind** (1939).
7. James Mangold's **Girl, Interrupted** (1999).
8. Ethan Coen, Joel Coen's **No Country for Old Men** (2007).
9. Clint Eastwood's **Invictus** (2009).

Answers: 1. Thomas Gray's 'Elegy written in a country churchyard': "The paths of glory lead but to the grave." 2. Bible, Book of Proverbs, 11:29. "He that troubleth his own house shall inherit the wind." 3. Bible, Gospel of St Matthews. "Consider the lilies of the field, how they grow; they toil not, neither do they spin." 4. Shakespeare's Henry IV part II. "We have heard the chimes at midnight, Master Shallow." 5. William Blake's poem. "Bring me my chariot of fire." 6. Ernest Dowson's poem. "I have forgot much, Cynara! Gone with the wind." 7. Dutch artist Johannes Vermeer's painting *Girl Interrupted at Her Music*. 8. William Butler Yeats' poem. *Sailing to Byzantium*. 9. William Ernest Henley's poem. "I am the master of my fate: I am the captain of my soul."

Flop Films

The Conqueror (1956) starred John Wayne as the Mongol conqueror Genghis Khan. The failure of this epic film at the box-office was responsible for the demise of RKO Radio Picture. Can you identify the following flop films?

1. Rock Hudson played the role of Fredrick Henry in this 1957 film. The film did so badly that David O. Selznick produced no more film.
2. This 1970 film set in Ireland was such a disaster that David Lean did not make a film for years. It stars Sarah Miles and Robert Mitchum.
3. Though this 1975 film failed at the box office, it was Kubrick's most authenticated film. Many interior scenes were shot with a special high-speed f/0.7 Zeiss camera lens originally developed for NASA to be used in satellite photography.
4. This was a 1980 epic Western film written and directed by Michael Cimino. It portrays a fictional dispute between land barons and European immigrants in Wyoming in the 1890s. The film stars Kris Kristofferson, Christopher Walken, Isabelle Huppert, Jeff Bridges, and John Hurt. This was disaster at the biggest box office as United Artist could recover only a fraction of the cost.
5. This 1988 film is based on the tall tales about the 18th-century German nobleman and his wartime exploits against the Ottoman Empire. It was directed by Terry Gilliam with John Neville in a leading role.
6. This 1996 erotic film stars Demi Moore and Burt Reynolds. The film is about a stripper who becomes involved in a chid custody dispute. The film won the Raspberry award for the worst film of 1996.
7. This is a 2002 World War II film set in the Battle of Saipan. Directed by John Woo, it has Nicholas Cage in the leading role.

Answers: 1. A Farewell to Arms. 2. Ryan's Daughter. 3. Barry Lyndon. 4. Heaven's Gate. 5. The Adventures of Baron Munchausen. 6. Striptease. 7. Windtalkers.

Deaths (Male)

The great French comic actor Max Linder killed himself in a suicide pact with his wife in 1925. Can you match the film personalities with their cause of death?

	Male (Year of Death)	Cause of death
1	F. W. Murnau (1931)	Pneumonia
2	Irving Thalberg (1936)	Car accident
3	Leslie Howard (1943)	Car accident
4	James Dean (1955)	Airplane shot down by German fighters
5	Humphrey Bogart (1957)	Death due to combination of alcohol and sedatives (Suicide)
6	Mike Todd (1958)	Airplane crash
7	Alan Ladd (1964)	Throat cancer
8	Walt Disney (1966)	Lung cancer
9	Ramon Novarro (1968)	AIDS
10	Audie Murphy (1971)	Airplane crash
11	George Sanders (1972)	Suicide
12	Pier Paolo Pasolini (1975)	Murdered
13	Rock Hudson (1985)	Murdered
14	Yul Brynner (1985)	Lung cancer
15	River Phoenix (1993)	Drug-induced heart failure
16	Derek Jarman 1994)	AIDS
17	John Candy (1994)	Heart attack
18	Heath Ledger (2008)	Accidental intoxication from prescription drugs
19	Philip Seymour Hoffman (2014)	Suicide by hanging
20	Robin Williams (2014)	Drug overdose

Answers: *1. Car accident. 2. Pneumonia. 3. Airplane shot down by German fighters. 4. Car accident. 5. Throat cancer. 6. Airplane crash. 7. Death due to combination of alcohol and sedatives (Suicide). 8. Lung cancer. 9. Murdered. 10. Airplane crash. 11. Suicide. 12. Murdered. 13. AIDS. 14. Lung cancer. 15. Drug-induced heart failure. 16. AIDS. 17. Heart attack. 18. Accidental intoxication from prescription drugs. 19. Drug overdose. 20. Suicide by hanging*

Deaths (Female)

Actress Peggy Entwistle jumped off the 50-foot "capital H" of the HOLLYWOOD sign in 1932. Can you match the film personalities with their cause of death?

	Female Star (Year of death)	Cause of death
1	Florence Lawrence (1938)	Airplane crash
2	Carol Lombard (1941)	Suicide
3	Marilyn Monroe (1962)	Heart attack due to overdone of barbiturates
4	Jayne Mansfield (1967)	Drowned from a yatch
5	Sharon Tate (1969)	Suicide
6	Jean Seberg (1979)	Murdered
7	Natalie Wood (1981)	Road Accident
8	Grace Kelly (1982)	Car accident

Answers: 1. Suicide. 2. Airplane crash. 3. Heart attack due to overdone of barbiturates. 4. Road Accident. 5. Murdered. 6. Suicide. 7. Drowned from a yatch. 8. Car accident.

Odd Jobs

Film producer and the founder of Paramount Pictures Adolph Zukor arrived in New York in 1891 and started as a furrier before entering the movies industry. Can you match the film personalities with their profession before they joined films?

	Actor	Profession
1	Maurice Chevalier	Cartoonist
2	Yves Montand	Hairdresser in Marseille (France)
3	Alfred Hitchcock	Title-card designer
4	Burt Lancaster	Circus acrobat
5	Michael Caine	Physician
6	George Miller	Porter in London's meat market
7	Kon Ichikawa	Circus acrobat

Answers: 1. Circus acrobat. 2. Hairdresser in Marseille. 3. Title-card designer. 4. Circus acrobat. 5. Porter in London's meat market. 6. Physician. 7. Cartoonist.

Quotations

"Wait a minute! Wait a minute! You ain't heard nothin' yet. Wait a minute, I tell ya, you ain't heard nothin'!" Al Jolson in **The Jazz Singer** (1927). These were the first spoken words in a feature film. Can you identify the source of the following quotations?

1. "Gimme a whisky, ginger ale on the side, and don't be stingy, baby."
2. "I never drink...wine."
3. "Here's another nice mess you've gotten me into."
4. "Come up and see me sometime" (The actual words spoken were: "Why don't you come up sometime 'n see me? I'm home everyy evening").
5. "I'm working so hard I have to go to bed early every night."
6. "I generally avoid temptation... unless I can't resist it."
7. "Frankly, my dear, I don't give a damn."
8. "Play it, Sam. Play As Time Goes By".
9. "You don't understand! I coulda had class. I coulda been a contender. I could've been somebody, instead of a bum, which is what I am."
10. "I'm sorry, Dave. I'm afraid I can't do that."
11. "Love means never having to say you're sorry."
12. "I love the smell of napalm in the morning."
13. "You talking to me?"
14. "May the Force be with you!"
15. "I've seen things you people wouldn't believe. Attack ships on fire off the shoulder of Orion. I watched C-beams glitter in the dark near the Tannhauser gate. All those moments will be lost in time... like tears in rain... Time to die."
16. "Go ahead, make my day."
17. "I will be back."
18. "My mama always said life was like a box of chocolates. You never know what you're gonna get."
19. "Greed, for lack of a better word, is good."
20. "Carpe diem. Seize the day, boys. Make your lives extraordinary."

Answers: 1. Anna Christie (Greta Garbo) in **Anna Christie** (1930). 2. Count Dracula (Bela Lugosi) in **Dracula** (1931). 3. Oliver Hardy in **Sons of the**

Desert (1933). 4. Lady Lou (Mae West) in **She Done Him Wrong** (1933). 5. Lily (Barbara Stanwyck) in **Baby Face** (1933). 6. Flower Belle Lee (Mae West) in **My Little Chickadee** (1940). 7. Rhett Butler (Clark Gable) in **Gone With The Wind** (1939). 8. Ilsa Lund (Ingrid Bergman) in **Casablanca** (1942). 9. Terry Malloy (Marlon Brando) in **On The Waterfront** (1954). 10. HAL 9000 in **2001: A Space Oddysey** (1968).11. Jennifer Cavilleri (Ali MacGraw) in **Love Story** (1970). 12. Colonel Kilgore (Robert Duvall) in **Apocalypse Now** (1979). 13. Travis Bickle (Robert DeNiro) in **Taxi Driver** (1976). 14. Han Solo (Ford Harrison) to Luke Skywalker in **Star Wars** (1977). 15. Roy Batty (Rutger Hauer) in **Blade Runner** (1982). 16. Harry Callahan (Clint Eastwood) in **Sudden Impact** (1983). 17. Terminator (Arnold Schwarzenegger) in **Terminator** (1984). 18. Forrest Gump (Tom Hanks) in **Forrest Gump** (1994). 19. Gordon Gekko (Michael Douglas) in **Wall Street** (1987). 20. John Keating (Robin Williams) in **Dead Poets Society** (1989).

What's in a name? (Male) I

The birth name of Cary Grant (born 1904) was Archibald Alexander Leach. Can you match the film personalities with their birth or given names?

	Birth Name	Personality
1	Mikhail Sinot (1880)	Max Linder
2	John Sidney Blyth (1882)	John Barrymore
3	Max Aronson (1882)	G. M. "Broncho Billy" Anderson
4	Gabriel-Maximilien Leuvielle (1883)	Mack Sennett
5	Douglas Elton Thomas Ullman (1983)	Douglas Fairbanks
6	Adolph Marx (1888)	Zeppo Marx
7	Julius Henry Marx (1890)	Groucho Marx
8	Jose Ramón Gil Samaniego (1899)	Ramon Navarro
9	Herbert Marx (1901)	Harpo Marx
10	Theodor Geisel (1904)	"Dr Seuss"
11	Louis Francis Cristillo (1906)	Lou Costello
12	David Daniel Kaminski (1911)	Danny Kaye
13	Issur Danielovitch Demsky (1916)	Kirk Douglas
14	Jean-Marie Maurice Schere (1920)	Eric Rohmer
15	Stanley Martin Lieber (1922)	Stan Lee
16	Sabu Dastagir (1924)	Sabu

Answers: 1. Mack Sennett. 2. John Barrymore. 3. G. M. "Broncho Billy" Anderson. 4. Max Linder. 5. Douglas Fairbanks. 6. Harpo Marx. 7. Groucho Marx. 8. Ramon Navarro. 9. Zeppo Marx. 10. "Dr. Seuss". 11. Lou Costello. 12. Danny Kaye. 13. Kirk Douglas. 14. Eric Rohmer. 15. Stan Lee. 16. Sabu.

What's in a name? (Male) II

The birth name of Tony Curtis (born 1925) was Bernard Schwartz. Can you match the film personalities with their birth or given names?

	Birth Name	Personality
1	Melvin Kaminsky (1926)	Martin Sheen
2	Zvi Mosheh Skikne (1928)	Mike Nichols
3	Carlo Pedersoli (1929)	Bud Spencer
4	Michael Igor Peschkowsk (1931)	Lawrence Harvey
5	Michel Demitri Shalhoub (1932)	Omar Sharif
6	Jerome Silberman (1933)	Gene Wilder
7	Maurice Joseph Micklewhite (1933)	Michael Caine
8	Allan Stewart Konigsberg (1935)	Woody Allen
9	Ismail Rehman (1936)	Ismail Merchant
10	Mario Girotti (1939)	Terence Hill
11	Ramón Gerard Antonio Estévez (1940)	Mel Brooks
12	Eric Marlon Bishop (1967)	Jamie Foxx

Answers: 1. Mel Brooks. 2. Lawrence Harvey. 3. Bud Spencer. 4. Mike Nichols. 5. Omar Sharif. 6. Gene Wilder. 7. Michael Caine. 8. Woody Allen. 9. Ismail Merchant. 10. Terence Hill. 11. Martin Sheen. 12. Jamie Foxx.

What's in a name? (Female)

The birth name of Marie Dressler (born 1868) was Leila Marie Koerber. Can you match the film personalities with their birth or given names?

	Birth name	Personality
1	Theodosia Goodman (1885)	Cher
2	Gladys Louise Smith (1892)	Pola Negri
3	Barbara Apolonia Chałupec (1897)	Mary Pickford
4	Émilie Claudette Chauchoin (1903)	Claudette Colbert

	Birth name	Personality
5	Lucille Fay LeSueur (1905)	Joan Crawford
6	Greta Lovisa Gustafsson (1905)	Greta Garbo
7	Estelle Merle O'Brien Thompson (1911)	Merle Oberon
8	Hedwig Eva Maria Kiesler (1914)	Hedy Lamarr
9	Margarita Carmen Cansino (1918)	Rita Hayworth
10	Henriette Charlotte Simone Kaminker (1921)	Simone Signoret
11	Frances Ethel Gumm (1922)	Judy Garland
12	Betty Joan Perske (1924)	Lauren Bacall
13	Norma Jeane Mortenson (1926)	Marilyn Monroe
14	Jeanette Helen Morrison (1927)	Janet Leigh
15	Cherilyn Sarkisan (1946)	Theda Bara
16	Caryn Elaine Johnson (1955)	Whoopi Goldberg

Answers: *1. Theda Bara. 2. Mary Pickford. 3. Pola Negri. 4. Claudette Colbert. 5. Joan Crawford. 6. Greta Garbo. 7. Merle Oberon. 8. Hedy Lamarr. 9. Rita Hayworth. 10. Simone Signoret. 11. Judy Garland. 12. Lauren Bacall. 13. Marilyn Monroe. 14. Janet Leigh. 15. Cher. 16. Whoopi Goldberg.*

Star Fathers

The director John Houston (born 1906) was the son of the actor Walter Houston. Match the film personalities with their star fathers.

	Personality	Father
1	Vanessa Redgrave (1937)	Kirk Douglas
2	Michael Douglas (1944)	Michael Redgrave
3	Mia Farrow (1945)	John Houston
4	Angelica Houston (1951)	John Farrow
5	Nastassja Kinski (1961)	Klaus Kinski
6	Tatum O'Neal (1963)	Martin Sheen
7	Charlie Sheen (1965)	Ryan O'Neal
8	Angelina Jolie (1975)	Jon Voight
9	Drew Barrymore (1975)	John Drew Barrymore

Answers: *1. Michael Redgrave. 2. Kirk Douglas. 3. John Farrow. 4. John Houston. 5. Klaus Kinski. 6. Ryan O'Neal. 7. Martin Sheen. 8. Jon Voight. 9. John Drew Barrymore.*

Star mothers

Liza Minelli (born 1946) was the daugther of Judy Garland. Match the film personalities with their star mothers.

	Personality	Mother
1	Mia Farrow (1945)	Debbie Reynolds
2	Carrie Fisher (1956)	Maureen O'Sullivan
3	Melanie Griffith (1957)	Janet Leigh
4	Jamie Lee Curtis (1958)	Tippi Hedren
5	Laura Dern (1967)	Diane Ladd
6	Jason Schwartzman (1980)	Melanie Griffith
7	Dakota Johnson (1989)	Talia Shire

Answers: *1. Maureen O'Sullivan. 2. Debbie Reynolds 3. Tippi Hedren. 4. Janet Leigh. 5. Diane Ladd. 6. Talia Shire. 7. Melanie Griffith.*

Star Siblings

The older brother of director Jean Renoir was Pierre Renoir, who played the part of Jericho in Carne's **Children of Paradise** (1945).

Match the film personalities with their star siblings.

	Personality	Sibling
1	Joseph L. Mankiewicz's brother	Casey
2	Zsa Zsa Gabor's sister	Eva
3	Warren Beatty's sister	Shirley MacLean
4	Joan Fontaine's sister	Olivia de Haviland
5	Francis Ford Coppola's sister	Talia Shire
6	Lynn Redgrave sister	Douglas
7	Nora Shearer brother	Vanessa
8	Ben Affleck's brother	Herman J.

Answers: *1. Herman J. Mankiewicz. 2. Eva Gabor. 3. Shirley MacLean. 4. Olivia de Haviland. 5. Talia Shire. 6. Vanessa Redgrave. 7. Douglas Shearer. 8. Casey Affleck.*

Star Wives

The swashbuckling actor Douglas Fairbanks (1883) was married to Mary Pickford. Match the film personalities with their star wives.

	Personality	Wife
1	Alexander Korda (1893)	Lauren Bacall
2	Humphrey Bogart (1899)	Merle Oberon
3	Irving Thalberg (1899)	Carol Lombard
4	Clark Gable (1901)	Norma Shearer
5	Roberto Rossellini (1906)	Ingrid Bergman
6	Laurence Olivier (1907)	Vivian Leigh
7	José Ferrer (1912)	Rosemary Clooney
8	Orson Welles (1915)	Rita Hayworth
9	Arthur Miller (1915)	Marilyn Monroe
10	Frank Sinatra (1915)	Ava Gardner
11	Roald Dahl (1916)	Patricia Neal
12	Yves Montand (1921)	Simone Signoret
13	Prince Rainier of Monaco (1923)	Grace Kelly
14	Peter Sellers (1925)	Britt Ekland
15	Paul Newman (1925)	Joanne Woodward
16	Tony Curtis (1925)	Janet Leigh
17	Michael Caine (1933)	Shakira Baksh
18	Louis Malle (1932)	Candice Bergen
19	Antonio Banderas (1960)	Emma Thompson
20	Kenneth Branagh (1960)	Melanie Griffith

Answers: 1. Merle Oberon. 2. Lauren Bacall. 3. Norma Shearer. 4. Carol Lombard. 5. Ingrid Bergman. 6. Vivian Leigh. 7. Rosemary Clooney. 8. Rita Hayworth. 9. Marilyn Monroe. 10. Ava Gardner. 11. Patricia Neal. 12. Simone Signoret. 13. Grace Kelly (1929). 14. Britt Ekland. 15. Joanne Woodward. 16. Janet Leigh. 17. Shakira Baksh. 18. Candice Bergen. 19. Melanie Griffith. 20. Emma Thompson.

Star Husbands

The German born actress Lilli Palmer (1914) was married to the Briton Rex Harrison. Match the film personalities with their star husbands:

	Personality	Husband
1	Zsa Zsa Gabor (1917)	Vincente Minnelli
2	Judy Garland (1922)	George Sanders
3	Sophia Loren (1934)	Roger Vadim
4	Bridgitte Bardot (1934)	Carlo Ponti
5	Julie Andrews (1935)	Blake Edwards
6	Ursula Andress (1936)	John Derek
7	Barbra Streisand (1942)	Joel Coen
8	Frances McDormand (1957)	Eliot Gould
9	Nicole Kidman (1967)	Javier Bardem
10	Penelope Cruz (1974)	Tom Cruise

Answers: 1. George Sanders. 2. Vincente Minnelli. 3. Carlo Ponti. 4. Roger Vadim. 5. Blake Edwards. 6. John Derek. 7. Eliot Gould. 8. Joel Coen. 9. Tom Cruise. 10. Javier Bardem.

Nicknames (Male)

Mack Sennett (1880), the founder of Keystone Film Company, was known as King of Comedy. Match the film personalities with their nicknames?

	Nickname	Personality
1	Father of the Westerns (1880)	Lon Chaney
2	The Great Profile (1882)	John Barrymore
3	Man with a Thousand Faces (1883)	Thomas H. Ince
4	The Man You Love to Hate (1885)	Toto
5	The Great Stone Face (1895)	Buster Keaton
6	The Prince of Laughter (1898)	Erich von Stroheim
7	The Wonder Boy of Hollywood (1899)	Henri-Georges Clouzot
8	The King (1901)	Clark Gable
9	The French Hitchcock (1907)	Irving Thalberg
10	The Duke (1907)	Frank Sinatra
11	The Father of Contemporary Animation (1912)	Chuck Jones
12	Ol' Blue Eyes (1915)	John Wayne
13	The Godfather of US Avant-Garde Cinema (1922)	Jonas Mekas
14	The World's Worst Director (1924)	Edward D. Wood Jr.

Answers: 1. Thomas H. Ince. 2. John Barrymore. 3. Lon Chaney. 4. Erich von Stroheim. 5. Buster Keaton. 6. Toto. 7. Irving Thalberg. 8. Clark

Gable. 9. Henri-Georges Clouzot. 10. John Wayne. 11. Chuck Jones. 12. Frank Sinatra. 13. Jonas Mekas. 14. Edward D. Wood Jr.

Nicknames (Female)

Mary Pickford (1883) is known as America's Sweetheart. Match the film personalities with their nicknames

	Nickname	Personality
1	The Biograph Girl (1886)	Carmen Miranda
2	The It Girl (1905)	Clara Bow
3	Brazilian Bombshell (1909)	Florence Lawrence
4	Platinum Blonde (1911)	Esther Williams
5	The Love Goddess (1918)	Rita Hayworth
6	America's Mermaid (1921)	Jean Harlow
7	Mona Lisa of 20 century (1927)	Madonna
8	The Blonde Bombshell (1933)	Jayne Mansfield
9	The Material Girl (1958)	Gina Lollobrigida

Answers: 1. Florence Lawrence. 2. Clara Bow. 3. Carmen Miranda. 4. Jean Harlow. 5. Rita Hayworth. 6. Esther Williams. 7. Gina Lollobrigida. 8. Jayne Mansfield. 9. Madonna.

In their own Words (Male)

Dashing star Errol Flynn wrote *My Wicked Wicked Way* (1959). Match the film personalities with the book they wrote:

	Book Title	Film Personality
1	My Wonderful World of Slapstick (1960)	Frank Capra
2	The Name above the Title (1971)	Buster Keaton
3	Moon's a Balloon (1972)	Alec Guinness
4	Bring on Empty Horses (1975)	David Niven
5	The Eternal Male: My Own Story (1977) translated	William Friedkin
6	Confession of an Actor: Laurence (1982)	Laurence Olivier
7	Blessing in Disguise (1985)	David Niven
8	My Life with the Three Most Beautiful Women in the World (1986)	Kirk Douglas
9	Ragman's Son (1988)	Roger Vadim

	Book Title	Film Personality
10	Songs My Mother Taught Me (1994)	Marlon Brando
11	Loitering With Intent (1995)	Peter O'Toole
12	In the Arena (1995)	Charlton Heston
13	My Word is My Bond (2008)	Michael Caine
14	The Elephant to Hollywood (2010)	Roger Moore
15	The Friedkin Connection (2013)	Omar Sharif

Answers: 1. Buster Keaton. 2. Frank Capra. 3. David Niven. 4. David Niven. 5. Omar Sharif. 6. Laurence Olivier. 7. Alec Guinness. 8. Roger Vadim. 9. Kirk Douglas. 10. Marlon Brando. 11. Peter O'Toole. 12. Charlton Heston. 13. Roger Moore. 14. Michael Caine. 15. William Friedkin.

In their own Words (Female)

The *Life Story of an Ugly Duckling* (1924) was written by Marie Dressler, Canadian born comedienne who won a best actress Oscar for her performance in **Min and Bill** (1930). Match the film personalities with the book they wrote:

	Book Title	Film Personality
1	Goodness has nothing to do with it (1959)	Bette Davis
2	The Lonely Life (1962)	Mae West
3	A Girl Like I (1966)	Shirley Maclean
4	You Can Get There from Here (1975)	Anita Loos
5	Past imperfect (1978)	Joan Collins
6	No Bed of Roses (1978)	Joan Fontaine
7	This 'n That (1987)	Shirley Temple Black
8	Child Star (1988)	Bette Davis
9	Now (1994)	Lauren Bacall
10	My Lucky Stars (1995)	Esther Williams
11	The Million Dollar Mermaid (1999)	Shirley Maclean
12	'Tis Herself (2004)	Maureen O'Hara
13	A Paper Life (2004)	Carrie Fisher
14	The Princess Diarist (2016)	Tatum O' Neal

Answers: 1. Mae West. 2. Bette Davis. 3. Anita Loos. 4. Shirley Maclean. 5. Joan Collins. 6. Joan Fontaine. 7. Bette Davis. 8. Shirley Temple Black. 9. Lauren Bacall. 10. Shirley Maclean. 11. Esther Williams. 12. Maureen O'Hara. 13. Tatum O' Neal. 14. Carrie Fisher.

Taglines I

The tagline of Sergio Leone's **The Good, the Bad, and the Ugly** (1966) was: For three men the Civil War wasn't hell. It was practice. Match the tagline of the film to the film:

	Year	Tagline	Film
1	1968	The ultimate trip.	Superman
2	1974	For Harry and Lloyd, every day is a no-brainer.	Dumb and Dumber
3	1977	Catch it.	Alien
4	1978	You will believe man can fly.	2001: Space Odyssey
5	1979	In space, no one can hear you scream.	Saturday Night Fever
6	1979	The horror! The horror!	Apocalypse Now
7	1984	The thing that won't die, in the nightmare that won't end.	The Shawshank Redemption
8	1986	Be afraid. Be very afraid.	The Terminator
9	1986	The first causality of war is innocence.	RoboCop
10	1987	The future of law enforcement.	Platoon
11	1993	The adventure 65 million years in the making.	Jurassic Park
12	1994	Fear can hold you prisoner. Hope can set you free.	The Fly

Answers: 1. *2001: Space Odyssey*. 2. *Dumb and Dumber*. 3. *Saturday Night Fever*. 4. *Superman*. 5. *Alien*. 6. *Apocalypse Now*. 7. *The Terminator*. 8. *The Fly*. 9. *Platoon*. 10. *RoboCop*. 11. *Jurassic Park*. 12. *The Shawshank Redemption*.

Taglines II

The tagline of Robert Redford directed **Quiz Show** (1994) was: Fifty million people watching but no one saw a thing. Match the tagline of the film to the film:

	Year	Tagline	Film
1	1995	Houston, we have a problem.	Fargo
2	1996	A lot can happen in the middle of nowhere.	Psycho
3	1998	Check in. Unpack. Relax. Take a shower.	Apollo 13

	Year	Tagline	Film
4	1998	Earth. It was fun while it lasted.	Armegaddon
5	1998	The mission is a man.	Matrix
6	1999	Reality is a thing of past.	Chicken Run
7	1999	There is something about your first piece.	American Pie
8	2000	Escape or die frying.	Saving Private Ryan
9	2000	She brought a small town to its feet and a huge corporation to its knees.	Erin Brockovich
10	2001	Family isn't a word. It's a sentence.	Royal Tenenbaums
11	2007	See our family. And feel better about yours.	The Simpson movie
12	2010	You don't get to 500 million friends without making a few enemies.	The Social Network

Answers: *1. Apollo 13. 2. Fargo. 3. Psycho. 4. Armegaddon. 5. Saving Private Ryan. 6. Matrix. 7. American Pie. 8. Chicken Run. 9. Erin Brockovich. 10. Royal Tenenbaums. 11. The Simpson movie. 12. The Social Network.*

Famous Cars

The car in which James Dean had his fatal crash in 1955 was Silver Porsche 550 Spyder. Match the car with the film in which it appears:

	Car in film	Car model
1	James Bond's car in **Goldfinger** (1964), **Thunderball** (1965) and **The Living Daylights** (1987)	1989 Ferrari Mondial t Cabriolet
2	Steve McQueen's car in **Bullit** (1968)	1968 Ford Mustang Fastback
3	Herbie in **The Love Bug** (1968)	1963 Volkswagen Beetle
4	Edward's car in **Pretty Woman** (1980)	DeLorean DMC-12
5	Doc Brown's car in **Back to Future** (1985)	Lotus Esprit
6	Raymond's father's car in **Rainman** (1988)	Lamborghini Murcielago
7	Car driven by Col Slade in **Scent of a Woman** (1992)	Aston Martin DB5
8	Bruce Wayne's car in **The Dark Knight** (2008)	Buick Roadmaster

Answers: *1. Aston Martin DB5. 2. 1968 Ford Mustang Fastback. 3. 1963 Volkswagen Beetle. 4. Lotus Esprit. 5. DeLorean DMC-12. 6. Buick*

Roadmaster. 7. 1989 Ferrari Mondial t Cabriolet. 8. Lamborghini Murcielago.

Famous Ships and Boats

Charlie Allnutt's (Humphrey Bogart) dilapidated steamboat in **The African Queen** (1951) was called The African Queen. Match the ship/boat with the film in which it appears.

	Ship/boat in Film	Ship/Boat Name
1	Captain Nemo's (James Mason) ship in **20,000 Leagues under the Sea** (1954)	Moshulu
2	Capt Ahab's (Gregory Peck) ship in **Moby Dick** (1956)	HMS Avenger
3	Captain Vere's (Peter Ustinov) ship in **Billy Budd** (1962)	Pequod
4	Emilio Largo's (Adolfo Celi) ship in **Thunderball** (1965)	Disco Volante
5	Ship which brings Vito Andolini to America in 1901 in **Godfather Part II** (1974)	Nautilus
6	Quint (Robert Shaw)'s boat in **Jaws** (1975)	Orca
7	Hans Solo's (Harrison Ford) ship in **Stars Wars** (1977)	Millennium Falcon
8	Forrest Gump's (Tom Hanks) shrimping boat in **Forrest Gump** (1994)	Jenny
9	Morpheus' (Lawrence Fishburne) ship in **Matrix** (1999)	Nebuchadnezzar
10	Captain Jack Sparrow's (Johnny Depp) ship in the **Curse of Black Pearl** (2003)	Karaboudjan
11	Steve Zissou's (Bill Murphy) ship in **The Life Aquatic with Steve Zissou** (2004)	Black Pearl
12	Captain Haddock's ship in **The Adventures of Tintin** (2011)	Belafonte
13	Lex Luthor's (Kevin Spacey) boat in **Superman Returns** (2006)	Wonder
14	Alice's (Mia Wasikowska) ship in **Alice: Through the Looking Glass** (2016)	The Gertrude

Answers: 1. Nautilus. 2. Pequod. 3. HMS Avenger. 4. Disco Volante. 5. Moshulu. 6. Orca. 7. Millennium Falcon. 8. Jenny. 9. Nebuchadnezzar. 10. Black Pearl. 11. Belafonte. 12. Karaboudjan. 13. The Gertrude. 14. Wonder.

Dog Breeds I

Rin Tin Tin, an international star having acted in 27 silent films, was a German Shepherd. Can you match these famous dogs with their breeds?

	Dog	Breed
1	Toto, Dorothy's dog in **The Wizard of Oz** (1939)	Rough Collie
2	Lassie, Joe's dog in **Lassie Come Home** (1943)	Cairn Terrier
3	Flike, Umberto's dog in **Umberto D** (1952)	Mixed breed/Jack Russel
4	Lady, Skeeter's dog in **Good-bye, My Lady** (1956)	Basenji, The barkless dog
5	Willie, Gen Patton's dog in **Patton** (1970)	Bull Terrier
6	Butkus, Rocky's dog in **Rocky** (1976)	Berger Picard
7	Einstein, Doc Brown's dog in **Back to the Future** (1985)	Bull Mastiff
8	Hooch in **Turner & Hooch** (1989)	Dogue de Bordeaux
9	Beethoven in **Beethoven** (1992).	St Bernard.
10	Milo, Stanley Ipkiss's dog in **The Mask** (1994).	Jack Russell Terrier

Answers: 1. *Cairn Terrier.* 2. *Rough Collie.* 3. *Mixed breed/Jack Russel.* 4. *Basenji, The barkless dog.* 5. *Bull Terrier.* 6. *Bull Mastiff.* 7. *Berger Picard.* 8. *Dogue de Bordeaux.* 9. *St Bernard.* 10. *Jack Russell Terrier*

Dog Breeds II

Skip, Willie's dog in **My Dog Skip** (2000) was a Jack Russell Terrier. Can you match these famous dogs with their breeds?

	Dog	Breed
1	Scooby Doo in **Scooby-Doo** (2002)	Labrador Retriever
2	Marley in **Marley and Me** (2008)	Great Dane
3	Hachi, Prof. Wilson's dog in **Hachi: A Dog's Tale** (2009)	Japanese Akita
4	Snowy, Tintin's dog in **The Adventures of Tintin** (2011)	Jack Russell terrier
5	Uggie, George Valentin in **The Artist** (2011)	Wire Fox Terrier
6	Bailey, Ethan's dog in **A Dog's Purpose** (2017)	Golden Retriever
7	Ellie in **A Dog's Purpose** (2017)	German Shepherd/ Belgian mala
8	Toby/ Tino in **A Dog's Purpose** (2017)	St Bernard mix
9	Buddy in **A Dog's Purpose** (2017)	Corgi
10	Hugo Drax's hunting dogs in **Moonraker** (1979)	Beauce Shepherds or Beauceron

Answers: 1. Great Dane. 2. Labrador Retriever. 3. Japanese Akita. 4. Wire Fox Terrier. 5. Jack Russell terrier. 6. Golden Retriever. 7. German Shepherd/ Belgian mala. 8. Corgi. 9. St Bernard mix. 10. Beauce Shepherds or Beauceron.

Famous Animals

Match the animal in the film with its name:

	Animal in Film	Animal name
1	Jack Woltz' black horse who is beheaded	Tornado
2	The Black Stallion in **The Black Stallion** (1976)	Rosie
3	Zorro's steed in **The Mask of Zorro** (1998)	Khartoum
4	Doc Brown's dog in **Back to The Future** (1985)	Einstein
5	The pig in **Charlotte's Web** (2006)	Richard Parker
6	The elephant in Francis Lawrence's **Water for Elephants** (2011)	Black
7	The tiger in Ang Lee's **Life of Pi** (2012)	Wilbur

Answers: 1. Khartoum. 2. Black. 3. Tornado. 4. Einstein. 5. Wilbur. 6. Rosie. 7. Richard Parker.

Mixed Bag- Trivia I

In March 1983, President Reagan proposed a complex defensive system intended to defend the US from nuclear attacks by intercepting intercontinental ballistic missiles using laser battle stations based both on Earth and in space. This project's name was the Strategic Defense Initiative (SDI). It is commonly known as Star Wars after the sci-fi film.

1. What was the term for early film theaters in US whose admission ticket was 5-cent?
2. In 1908, what did the French film production company Pathé invent?
3. Who or what is The General in **The General** (1926) starring Buster Keaton?

4. What was created in 1932 by sound recordist Douglas Shearer using special audio effects, including an Austrian yodel played backwards at quickened speed?
5. What is The 39 steps in Hitchcock's **The 39 Steps** (1935)?
6. In context of films, what is diegetic sound?
7. In context of films, what is non-diegetic sound?
8. Who created a perfume for Audrey Hepburn in **Paris when it Sizzles** (1964)?
9. In **The Man of the Flying Trapeze** (1935), W. C. Fields plays the role of a henpecked husband and a hardworking worker Ambrose Wolfinger. Why does he take a day off from work?
10. In Mary Poppins, who lives in Number Seventeen Cherry Tree Lane, London?
11. What is common to Singapore, Hong Kong, Bali, Zanzibar, Morocco, Rio and Utopia?
12. If US is to Hollywood, what is to Trollywood?
13. **The Adventures of Tintin: The Secret of the Unicorn** (2011) is an amalgamation of three Tintin books. One of them in The Secret of the Unicorn. What are the other two?
14. The story of the **Lion King** (1994) was inspired by which Shakespearean play?
15. Who produced the movie **Pather Panchali** in 1955?
16. In **Slumdog Millionaire** (2008), how does Prem (Anil Kapoor) the host of Who wants to be a Millionaire? (2000) address Jamal Malik (Dev Patel) as?
17. Film producer and aviator Howard Hughes said this about which Hollywood great: His ears made him look like a taxicab with both doors open.
18. In **The Third Man** (1949), Harry Lime (Orson Welles) says: Don't be so gloomy. After all it's not that awful. Like the fella says, in Italy for 30 years under the Borgias they had warfare, terror, murder, and bloodshed, but they produced Michelangelo, Leonardo da Vinci, and the Renaissance. In Switzerland they had brotherly love - they had 500 years of democracy and peace, and what did that produce? X. Complete the quote.

Answers: 1. Nickelodeon. 2. The newsreel that was shown in theatres prior to the feature film. 3. A steam locomotive. 4. Tarzan's distinctive

call was first heard in **Tarzan The Ape Man**. 5. An organisation of spies, collecting information. 6. Sound whose source is visible on the screen or whose source is implied to be present by the action of the film (aka actual sound). 7. Sound whose source is neither visible on the screen nor has been implied to be present in the action (aka commentary sound). 8. Hubert de Givenchy. 9. To watch a wrestling match. 10. The Banks family. 11. Road films starring Bing Crosby, Bob Hope, and Dorothy Lamour. 12. Sweden. 13. The Crab with the Golden Claws and Red Rackham's Treasure. 14. Hamlet. 15. The government of West Bengal. 16. Chaiwala (Tea-seller). 17. Clark Gable. 18. The Cuckoo clock.

Mixed Bag- Trivia II

Auteur theory sees the director as the major creative force in a film. It was a part of the French cinematic movement of the fifties known as the nouvelle vague, or New Wave. The auteur theory was an outgrowth of the cinematic theories of André Bazin's periodical *Cahiers du cinéma* (founded in 1951). Two of its theoreticians—François Truffaut and Jean-Luc Godard—later became major directors of the French New Wave

1. In **The Great Dictator** (1940), if Adenoid Hynkel (Chaplin) caricatures Hitler, whom does Napolini (Jack Oakie) caricature?
2. If you were a member of the Sons of the Desert organization, you would be a fan of which actor or actors?
3. Which Rogers and Hammerstein II song was adopted as both an official song and anthem of an American state in 1953?
4. What is the trilogy of Western films made by John Ford **Fort Apache** (1948), **She Wore A yellow ribbon** (1949) and **Rio Grande** (1950), starring John Wayne, collectively called?
5. Which character was created by Robert E. Howard (1906) and brought to the screen by John Millus in a 1982 film starring Arnold Schwarzenegger?
6. Only two persons have won both the awards of Best Director and Best Actor for the same film. One of them was Robert Benigni for **Life Is Beautiful** (1997)). Who was the other?

7. In which 1992 film, you can hear the song, "A Whole New World" which won the best music award for Original Song.
8. What is the name given to Westerns such as **A Fistful of Dollars, For a Few Dollars More** (1965) and **The Good the Bad the Ugly** (1965), which were made by Italian directors such as Sergio Leone?
9. Italian historical or Biblical films that dominated the Italian film industry in the fifties and sixties are called peplum films (pepla plural) after peplum the tunic-style Greek and Roman garment often worn by characters in those films. What are they also known?
10. What name is given to British films and plays that developed in the late 1950s, whose protagonists usually could be described as "angry young men" who were disillusioned with modern society. The films such as **Look Back in Anger** and **A Taste of Honey** depicted the domestic situations of working class men and women.
11. Japanese period films often set during the Edo period of Japanese history (1603 to 1868) are known as Jidai-geki. What are they commonly known as?
12. What kind of Japanese films are known as Gendaigeki?
13. Which 2017 TV series depicts the rivalry between Joan Crawford (Jessica Lange) and Bette Davis (Susan Sarandon)?
14. Who is the world's fastest Indian in **The World's Fastest Indian** (2005) starring Anthony Hopkins.
15. In **Stanley and Livingstone** (1939), what famous words were said by Spencer Tracy to Cedrick Hardwicke?
16. In which 1937 film would you find Doc, Grumpy, Happy, Sleepy, Bashful, Sneezy, and Dope?
17. In which 1960 film would you find Chris Adams, Chico, Harry Luck, Vin, Bernardo O'Reilly, Britt and Lee.
18. In which 1990 film would you find Raphael, Donatello, Michelangelo and Leonardo?
19. In which 2018 film would you find Peter, Flopsy, Mopsy, Cotton Tail, and Benjamin?

Answers: 1. Mussolini. 2. Laurel and Hardy. 3. The song, "Oklahoma". 4. Cavalry Trilogy. 5. Conan the Barbarian. 6. Laurence Olivier for Hamlet (1948). 7. Aladin. 8. Spaghetti western. 9. Sword-and-sandal films. 10.

Kitchen sink drama. 11. Sabre or samurai films. 12. Films set in modern times. 13. The Feud. 14. Indian Scout motorcycle. 15. Dr Livingstone I presume? 16. Snow White and the Seven Dwarfs. 17. The Magnificent Seven. 18. Teenage Mutant Ninja Turtles. 19. Peter Rabbit.

Mixed Bag- Trivia III

According to Robin Williams, Chuck Jones was the Orson Welles of cartoons. He was awarded an honorary Academy award for his contributions. He created characters like Wile E. Coyote and The Road Runners.

1. What is the name of Snow White's stepmother in **Snow White and the Seven Dwarfs** (1937)?
2. Who or what is The Blue Angel in **The Blue Angel** (1930, Ger) starring Marlene Dietrich?
3. What is the name of the woodcarver who creates Pinocchio, the wooden puppet In Disney's **Pinocchio** (1940)?
4. What is the name of the character created in 1928 by Ub Iwerks for Disney and who was earlied called Mortimer?
5. Who brought animated characters such as KoKo the Clown, Betty Boop, Popeye the Sailorman and Superman to the movie screen?
6. What is the name of the award given for accomplishments in animation in the US?
7. Alfred Hitchcock is famous for popularizing this word in his films. This is how he decribes it: "It might be a Scottish name, taken from a story about two men on a train. One man says, 'What's that package up there in the baggage rack?' And the other answers, 'Oh, that's an X. The first one asks, 'What's an X?' 'Well,' the other man says, 'it's an apparatus for trapping lions in the Scottish Highlands.' The first man says, 'But there are no lions in the Scottish Highlands,' and the other one answers, 'Well then, that's no X!' So you see that an X is actually nothing at all. What is X?
8. What was the language spoken by young teenagers in **A Clockwork Orange** (1971)?

9. In 1929 sound pictures were introduced in Hollywood. Because there were no censorship guidelines, many early pictures had sexual innuendos, profanity and extreme violence. To prevent such depiction, censorship guidelines, released by major studios, were strictly imposed in 1934. What was this code popularly known as?
10. For what are Golden Raspberry awards given?
11. Both Robert De Niro and Marlon Brando won Oscars for portraying the same fictional character. Which one?
12. What runs west from Gower Street to La Brea Avenue and south to north on both sides of Vine Street between Yucca Street and Sunset Boulevard?
13. What would you find in the forecourt of Los Angeles' Grauman's Chinese Theatre, now TCL Chinese Theatre?
14. Who was the first actress to give her hand and footprints in Hollywood in 1927?
15. Who played three roles in Stanley Kubric's **Dr Strangelove or How I learnt to stop worrying and love the Bomb** (1964), including that of Dr Strangelove?
16. Where would you find Graham Chapman, John Cleese, Terry Gilliam, Eric Idle, Terry Jones, and Michael Palin?
17. Which was the only Indian film watched by Mahatma Gandhi?
18. According to Rajmohan Gandhi, on 21 May 1944, Gandhi was persuaded to watch the only American film he saw. Which was this film which was directed by Micheal Curtiz and starred Walter Huston?
19. What is common to: Beam me up, Scotty, Play it again, Sam and Elementary, my dear Watson?

Answers: 1. Queen Grimhilde. 2. A cabaret. 3. Geppetto. 4. Mickey Mouse. 5. Max Fleischer. 6. The Annie Award. 7. MacGuffin. 8. Nadsat. 9. The Hays Code. 10. For the worst in films (worst film, worst actor etc). 11. Vito Corleone. 12. Hollywood Walk of Fame. 13. Footprints and Handprints of Hollywood stars. 14. Mary Pickford. 15. Peter Sellers. 16. Monty Python and the Flying Circus. 17. Vijay Bhatt's Ram Rajya (1943). A special screening of the movie was held at Juhu on June 2, 1944. 18. Mission to Moscow (1943). 19. Quotes from films which were misquotes (never actually said).

Academy Awards

Academy Awards

The Academy Award for Best Picture is presented annually by the Academy of Motion Picture Arts and Sciences (AMPAS). The first Academy Awards took place on 16 May 1929 and awarded the best films of 1927 and 1928. The ceremony was held at the Hollywood Roosevelt Hotel in Los Angeles, California. AMPAS president Douglas Fairbanks hosted the show.

Award ceremony	Film	Best Actress	Best Actor
15 May 1929 (1st)	The Wings	Janet Gaynor (7th Heaven, Street Angel, Sunrise)	Emil Jannings (The Last Command, The Way of All Flesh)
1930 Apr (2nd)	Broadway Melody	Mary Pickford (Coquette)	Warner Baxter (In Old Arizona)
1930 Nov (3rd)	All Quiet on the Western Front	Norma Shearer (The Divorcee)	George Arliss (Disraeli)
1931 Nov (4th)	Cimarron	Maria Dressler (Min and Bill)	Lionel Barrymore (A Free Soul)
1932 Nov (5th)	Grand Hotel	Helen Hayes (The Sin of Madelon Claudet)	Fredric March (Dr. Jekyll and Mr. Hyde) and Wallace Beery (The Champ)
1934 Mar (6th)	Cavalcade	Kathrine Hepburn (Morning Glory)	Charles Laughton (The Private Life of Henry VIII)
1935 Feb (7th)	It Happened One Night	Claudette Colbert (It Happened One Night	Clark Gable (It Happened One Night)
1936 Mar (8th)	Mutiny on the Bounty	Bette Davis (Dangerous)	Victor McLagen (The Informer)
1937 Nov (9th)	The Great Ziegfeld	Luise Rainer (The Great Ziegfeld)	Paul Muni (The Story of Louis Pasteur)

Award ceremony	Film	Best Actress	Best Actor
1938 Nov (10th)	Life of Emil Zola	Luise Rainer (The Good Earth)	Spencer Tracy (Captains Courageous)
1939 Feb (11th)	You Can't Take it With You	Bette Davis (Jezebel)	Spencer Tracy (Boys Town)
1940 Feb (12th)	Gone with the Wind	Viv Leigh (Gone with the Wind)	Robert Donat (Goodbye, Mr. Chips)
1941 Feb (13th)	Rebecca	Ginger Rogers (Kitty Foyle)	James Stewart (The Philadelphia Story)
1942 Feb (14th)	How Green was my Valley	Joan Fontaine (Suspicion)	Gary Cooper (Sergeant York)
1943 Mar (15th)	Mrs Miniver	Greer Garson (Mrs Miniver)	James Cagney (Yankee Doodle Dandy)
1944 Mar (16th)	Casablanca	Jennifer Jones (The Song of Bernadette)	Paul Lukas (Watch on the Rhine)
1945 Mar (17th)	Going my Way	Ingrid Bergman (Gaslight)	Bing Crosby (Going My Way)
1948 Mar (18th)	The Lost Weekend	Joan Crawford (Mildred Pierce)	Ray Miland (The Lost Weekend)
1947 Mar (19th)	The Best Years of Our Lives	Olivia de Havilland (To Each His Own)	Fredric March (The Best Years of Our Lives)
1948 Mar (20th)	Gentleman Agreement	Loretta Young (The Farmer's Daughter)	Roland Colman (A Double Life)
1949 Mar (21st)	Hamlet	Jane Wyman (Johnny Belinda)	Laurence Olivier (Hamlet)
1950 Mar (22nd)	All the King's Men	Olivia de Havilland (The Heiress)	Broderick Crawford (All the King's Men)w
1951 Mar (23rd)	All about Eve	Judy Holiday (Born Yesterday)	Jose Ferrer (Cyrano de Bergerac)
1952 Mar (24th)	An American In Paris	Vivian Leigh (A Streetcar named Desire)	Humphrey Bogart (The African Queen)
1953 Mar (25th)	Greatest Show on Earth	Shirlie Booth (Come Back, Little Sheba)	Gary Cooper (High Noon)
1954 Mar (26th)	From Here to Eternity	Audrey Hepburn (Roman Holiday)	William Holden (Stalag 17)
1955 Mar (27th)	On the Waterfront	Gracy Kelly (The Country Girl)	Marlon Brando (On the Waterfront)
1956 Mar (28th)	Marty	Anna Magnani (The Rose Tatoo)	Ernest Borgnine (Marty)
1957 Mar (29th)	Around the World in 80 days	Ingrid Bergman (Anastasia)	Yul Brynner (The King and I)
1958 Mar (30th)	The Bridge on the River Kawai	Joanne Woodward (The Three Faces of Eve)	Alec Guinness (The Bridge on the River Kawai)

Award ceremony	Film	Best Actress	Best Actor
1959 Apr (31st)	Gigi	Susan Hayward (I Want to Live)	David Niven (Separate Tables)
1960 Apr (32nd)	Ben Hur	Simone Signotte (Room at the Top)	Charlton Heston (Ben Hur)
1961 Apr (33rd)	The Apartment	Liz Taylor (BUtterfield 8)	Burt Lancaster (Elmer Gantry)
1962 Apr (34th)	Westside Story	Sophia Loren (Two Women) (1960)	Maximilian Schell (Judgment at Nuremberg)
1963 Apr (35th)	Lawrence of Arabia	Ann Bancroft (The Miracle Worker)	Gregory Peck (To Kill a Mockingbird)
1964 Apr (36th)	Tom Jones	Patricia Neal (Hud)	Sidney Poitier (Lilies of the Field)
1965 Apr (37th)	My Fair Lady	Julie Andrews (Mary Poppins)	Rex Harrison (My Fair Lady)
1966 Apr (38th)	The Sound of Music	Julie Cristie (Darling)	Lee Marvin (Cat Ballou)
1967 Apr (39th)	A Man for all Seasons	Liz Taylor (Who's Afraid of Virginia Woolf?	Paul Scofield (A Man for all Seasons)
1968 Apr (40th)	In the Heat of the Night	Kat Hepburn (Guess Who's Coming to Dinner)	Rod Stieger (in the Heat of the Night)
1969 Apr (41st)	Oliver	Kat Hepburn (The Lion in Winter) and Barbara Streisand (Funny Girl)	Cliff Robertson (Charly)
1970 Apr (42nd)	Midnight Cowboy	Maggie Smith (The Prime of Miss Jean Brodie)	John Wayne (True Grit)
1971 Apr (43rd)	Patton	Glenda Jackson (Women in Love)	George C Scott (Patton)
1972 Apr (44th)	French Connection	Jane Fonda (Klute)	Gene Hackmann (French Connection)
1973 Mar (45th)	Godfather	Liza Minelli (Cabaret)	Marlon Brando (Godfather)
1974 Apr (46th)	The Sting	Glenda Jackson (A Touch of Class)	Jack Lemmon (Save the Tiger)
1975 Apr (47th)	The Godfather II	Ellen Burstyn (Alice Doesn't Live Here Anymore)	Art Carney (Harry and Tonto)

Award ceremony	Film	Best Actress	Best Actor
1976 Mar (48th)	One Flew over the Cuckoo's Nest	Louise Fletcher (One Flew Over the Cuckoo's Nest)	Jack Nicolson (One Flew Over the Cuckoo's Nest)
1977 Mar (49th)	Rocky	Faye Dunaway (Network)	Peter Finch (Network)
1978 Apr (50th)	Annie Hall	Diane Keaton (Annie Hall)	Richard Dreyfuss (The Goodbye Girl)
1979 Apr (51st)	The Deer Hunter	Jane Fonda (Coming Home)	Jon Voight (Coming Home)
1980 Apr (52nd)	Kramer vs Kramer	Sally Field (Norma Mae)	Dustin Hoffman (Kramer vs Kramer)
1981 Mar (53rd)	Ordinary People	Sissy Spacek (Coal Miner's daughter)	Robert De Niro (Raging Bull)
1982 Mar (54th)	Chariots of Fire	Kat Hepburn (On Golden Pond)	Fonda (On Golden Pond)
1983 Apr (55th)	Gandhi	Meryl Streep (Sophie's Choice)	Ben Kingsley (Gandhi)
1984 Apr (56th)	Terms of Endearment	Shirley Maclaine (Terms of Endearment)	Robert Duvall (Tender Mercies)
1985 Mar (57th)	Amadeus	Sally field (Places in the Heart)	Murray Abrahm (Amadeus)
1986 Mar (58th)	Out of Africa	Geraldine Page (The Trip to Bountiful)	John Hurt (Kiss of the Spider Woman)
1987 Mar (59th)	Platoon	Marlee Matlin (Children of a Lesser God)	Paul Newman (The Color of Money)
1988 Apr (60th)	The Last Emperor	Cher (Moonstruck)	Michael Douglas (Wall Street)
1989 Mar (61st)	Rainman	Jodie Forster (The Accused)	Dustin Hoffman (Rainman)
1990 Mar (62nd)	Driving Miss Daisy	Jessica Tandy (Driving Miss Daisy)	Daniel Day Lewis (My Left Foot)
1991 Mar (63rd)	Dances with the Wolves	Katy Bates (Misery)	Jeremy Irons (Reversal of Fortune)
1992 Mar (64th)	Silence of the Lambs	Jodie Forster (Silence of the Lambs)	Anthony Hopkins (Silence of the Lambs)
1993 Mar (65th)	Unforgiven	Emma Thompson (Howards Ends)	Al Pacino (Scent of a Woman)
1994 Mar (66th)	Schlinder's List	Holly Hunter (The Piano)	Tom Hanks (Phildelphia)
1995 Mar (67th)	Forrest Gump	Jessica Lange (Blue Sky)	Tom Hanks (Forrest Gump)

Award ceremony	Film	Best Actress	Best Actor
1996 Mar (68th)	Braveheart	Susan Sarandon (Dead Man Walking)	Nicolas Cage (Leaving Las Vegas)
1997 Mar (69th)	The English Patient	Francise McDormand (Fargo)	Geofrey Rush (Shine)
1998 Mar (70th)	Titanic	Helen Hunt (As Good as it Gets)	Jack Nicolson (As Good as it Gets)
1999 Mar (71st)	Shakespeare in Love	Gwenth Paltrow (Shakespeare in Love)	Robert Benigni (Life is Beautiful)
2000 Mar (72nd)	American Beauty	Hilary Swank (Boys Don't Cry)	Kevin Spacey (American Beauty)
2001 Mar (73rd)	The Gladiator	Julia Roberts (Erin Brockovich)	Russel Crowe (The Gladiator)
2002 Mar (74th)	A Beautiful Mind	Halle Berry (Monster's Ball)	Denzel Washington (Training Day)
2003 Mar (75th)	Chicago	Nicole Kidman (The Hours)	Adrian Brody (The Pianist)
2004 Feb (76th)	Lord of the Rings	Charlize Theron (Monster)	Sean Penn (Mystic River)
2005 Feb (77th)	Million Dollar Baby	Hilary Swank (Million Dollar Baby)	Jamie Foxx (Ray)
2006 Mar (78th)	Crash	Reese Witherspoon (Walk the Line)	Phillip Seymore Hoffman (Capote)
2007 Feb (79th)	Departed	Helen Mirren (The Queen)	Forest Whitaker (Last King of Scotland)
2008 Feb (80th)	No Country of Old Men	Marion Cortilard (La Vie en Rose)	Daniel Day Lewis (There will be Blood)
2009 Feb (81st)	Slumdog Millionare	Kate Winslet (The Reader)	Sean Penn (Milk)
2010 Mar (82nd)	The Hurt Locker	Sandra Bullock (The Blind Side)	Jeff Bridges (Crazy Heart)
2011 Feb (83rd)	The King's Speech	Natalia Portman (Black Swan)	Colin Firth (The King's Speech)
2012 Feb (84th)	The Artist	Meryl Streep (Iron Lady)	Jean Dujardin (Artist)
2013 Feb (85th)	Argo	Jeniffer Lawrence (Silver Linings Playbook)	Daniel Day Lewis (Lincoln)
2014 Mar (86th)	12 Years a Slave	Cate Blanchet (Blue Jasmine)	Matthew McConaughey (Dallas Buyers Club)
2016 Feb (87th)	The Birdman	Juliana Moore (Still Alice)	Eddie Redmayne (Theory of Everything)
2016 Feb (88th)	Spotlight	Brie Larson (Room)	Leonardo Di Caprio (The Ravenant)

Award ceremony	Film	Best Actress	Best Actor
2017 Feb (89th)	Moonlight	Emma Stone (La la Land)	Casey Affleck (Manchester by the Sea)
2018 Mar (90th)	The Shape of Water	Frances McDormand (Three Billboards Outside Ebbing, Missouri)	Gary Oldman (Darkest Hour)
2019 Feb (91st)	Green Book	Olivia Colman (The Favourite)	Rami Malek (Bohemian Rhapsody)

Photo Gallery

BUSTER KEATON (1895–1966)

GROUCHO MARX (1890–1977)

CLARK GABLE (1901–1960)

JAMES STEWART (1908–1997)

LUISE RAINER (1910–2014)

HEDY LAMARR (1914–2000)

INGRID BERGMAN (1915–1982)

PAUL NEWMAN (1925–2008)

MARILYN MONROE (1926–1962)

CLINT EASTWOOD (1930-)

ELIZABETH TAYLOR (1932–2011)

Brigitte Bardot (1934-)

Brad Pitt (1963-)

Yul Brynner (1920–1985)

Richard Burton (1925–1984) in *The Robe* (1953)

AUDREY HEPBURN (1929–1993)
IN ***BREAKFAST AT TIFFANY'S*** (1961)

RONALD COLMAN (1891–1958) IN ***THE PRISONER
OF ZENDA*** (1937) WITH MADELEINE CARROLL

Greta Garbo (1905–1990) in *A Woman of Substance* (1928) with John Gilbert

Cary Grant (1904–1986) in *His Girl Friday* (1940) with Ralph Bellamy and Rosalind Russell

www.ingramcontent.com/pod-product-compliance
Lightning Source LLC
Chambersburg PA
CBHW020730180526
45163CB00001B/175